FIVE HUNDRED
BUILDINGS OF
NEW YORK

PHOTOGRAPHY BY JORG BROCKMANN
TEXT BY BILL HARRIS

Foreword by Judith Dupré

BLACK DOG
& LEVENTHAL
PUBLISHERS
NEW YORK

ISBN 978-1-57912-856-2

Library of Congress Cataloging-in-Publication Data available upon request
Book design: Sheila Hart Design, Inc.

Printed in China

Published by
Black Dog & Leventhal Publishers, Inc.
151 West 19th Street
New York, New York 10011

Distributed by
Workman Publishing Company
225 Varick Street
New York, New York 10014

h g f e d c

The photographer would like to acknowledge
James Driscoll and Erik Freeland for providing additional photography for this book.

CONTENTS

All building with 🐚 are landmarks

FOREWORD

Tall masts of Mannahatta! Superb-faced Manhattan! Beautiful hills of Brooklyn! Vast, unspeakable show and lesson! My city! Has anyone since Walt Whitman done justice to the ecstatic inventory of New York? This book comes close, with a thousand portraits, some familiar, some less so. It is a yearbook of sorts, picking out individuals in a cast of thousands, putting names to faces that are sometimes overlooked in the presence of New York's powerful, indivisible gestalt.

On New York streets, time, history, and memory converge and disperse with breathtaking speed. It is a living space, framed by street after street of widely disparate structures, every corner, every inch impossibly cobbled together by generations alike only in their ambition. It is gritty with dirt and failed dreams, a gray city made alabaster by virtue of the hopes of the sheer numbers who call it home.

There is no ambivalence in New York. It's too tough a place. Sure, there are days of ambivalence, years even, but the thought of living anywhere else is unfathomable to those under its spell. Native birth has nothing to do with being a New Yorker. Nor years—one can become a New Yorker in an instant. Even those who have physically left never leave completely. Welded into a wrought-iron fence at the World Financial Center, overlooking the Hudson River, are Frank O'Hara's words: "One need never leave the confines of New York to get all the greenery one wishes. I can't even enjoy a blade of grass unless I know there's a subway handy, or a record store, or some other sign that people do not totally regret life."

Another poet. Describing the world pulse that beats here always comes down to distillation. One can attempt to categorize New York, realizing all the while that its essence, like the elephant described by the six blind men, defies pat definition. Aficionados of skyscrapers, churches, bridges, restaurants, or residences in any of the five boroughs could speak volumes on all those subjects, and have. In its infinite variety and fluidity, the city cannot be pinned down. One view can merely be added to the thousands that have been offered and yet will come.

Kurt Vonnegut coined the phrase "Skyscraper National Park" to describe Manhattan. The idea of the city as a national park, a rare configuration that deserves protection, approaches truth. Some call the deep spaces that are formed by New York's tall buildings "canyons" but, with a connotation more geologic than urban, the word seems inadequate to describe the city's chiseled verticality. Skyscrapers, the most spectacular display of our civilization's technical prowess, are made by human hands. We are dwarfed by their shadows and yet they are our creations. This uneasy possession, we by them or them by us, sets up a reflexive tension that adds to the city's nerve.

Manhattan's brash ascendancy is made possible by the island's solid schist foundation

and exaggerated by the two rivers that contain its twenty-two square miles. Because of her skyscrapers, Manhattan invariably claims the lion's share of visibility, though it is but a fraction of the 320 square miles that make up New York City.

Everyone in New York weighs 150 pounds. As any elevator mechanic can tell you, that's the weight those "maximum occupancy" notices in elevators are based on. Ask him about skyscrapers and he'll speak the language of his profession—"low-rise, high-rise and freight"—about twenty such elevators in a building a block wide. It was all uphill once Elijah Otis figured out in 1854 that people get grumpy if they have to climb more than six flights of stairs. Though every other aspect of a skyscraper can change, its core— the elevators—rarely do. If you pause too long between car and lobby, the door will begin to close, a process known in the business as "nudging," no doubt with New Yorkers in mind. Don't try to stop them. The doors will win every time.

What is a skyscraper? Existing beyond the debate of steel skeletons versus the inclusion of elevators is the one true definition: intent of scale. Only in New York would a fifty-story building appear a modest proposal. Louis Sullivan built only one building here, the Bayard Building on Bleecker Street, yet surely he had New York's swagger in mind when he defined a skyscraper: "The force and power of altitude must be in it, the glory and pride of exaltation must be in it. It must be every inch a proud and soaring thing, rising in sheer exaltation that from bottom to top it is a unit without a single dissenting line."

The Empire State, Chrysler, Daily News, American Radiator buildings and Rockefeller Center epitomize the golden age of the skyscraper between the two World Wars. Mies van der Rohe's bronze Seagram Building heralded the arrival of the International Style, presaged six years earlier and just across Park Avenue, by the remarkable glass-clad Lever House. Only a New York character like Philip Johnson could recycle the past with postmodern buildings that have been notoriously compared to Chippendale furniture (the Sony Building) or a tube of lipstick (53rd at Third). The current hybrids bred from modernist, postmodern, and vernacular styles pale beside a true original, Frank Lloyd Wright's Guggenheim Museum.

It was in October 2001, in Washington, DC, that I began to grasp the enormity of New York's loss after the fall. When that city was laid out it was conceived as a star, with each of the main avenues punctuated by a view of the domed Capitol, a constant reminder of democratic ideals. When the World Trade Center went up, the twin towers shunned the mere scale of the streets, preferring instead to be creatures of the sky. They had no relationship to human measure, their size was beyond even New York's large grasp. They were always there, a navigational constant that was taken for granted. We are exhausted by the effort of understanding the new emptiness left in their wake. Like New York itself, they have entered the realm of myth, as real now in memory as they once were in steel

and concrete. Perhaps more so. My ferocious love of the skyline has never been stronger.

I cannot decide if New York is a city of sidewalks or of sky. The sidewalks are addictive in their turbulence, theatricality, and liberating anonymity. The latter quality, the city's most delectable by far, left few convinced that a certain gentleman was innocent of his crimes by virtue of insanity, proof of which, his lawyers argued, was his propensity for walking around the Village in a bathrobe. I've ignored worse.

If you want to know New York, walk. Many of the gems portrayed in this book are tucked away in neighborhoods known best on foot. The shops comprise a world bazaar, especially in Brooklyn and Queens, the latter a veritable United Nations, just without the seats. The sidewalks are wide enough to hold despair and elation. The energy rising off them, whether yours or another's, can change the face of a day. It's theater at its finest, and free. Gawk upwards if you must, but gimmeabreak, don't block the flow. New York's greatest mystery is the collective knowledge of its inhabitants, which travels from one to another through some strange osmosis that may or may not be related to the 96-point type used in the headlines of the New York Post. The street cannot be switched on or off. Its spiritual force is a religion.

The Woolworth Building, in lower Manhattan, is called the "cathedral of commerce." The uptown Asphalt Green, a parabolic-arched sanctuary for pothole repair, was condemned by Robert Moses as the "cathedral of asphalt." Between and beyond them are cathedrals that are, well, cathedrals. New York City is home to St. Patrick's Cathedral, spiritual anchor of Midtown; Cathedral of St. John the Divine, the world's largest cathedral; and Temple Emanu-El, the world's largest synagogue. From Abyssinian to Zion, the five boroughs boast hundreds of churches, temples, mosques, and synagogues. In Brooklyn, known as the Borough of Churches, spires are still visible on the skyline. It recalls the century, from 1790 to 1890, when Trinity Church at the head of Wall Street was the city's tallest building. Like New York's museums, theaters, and libraries, each of these houses of worship offers a presence and a possibility that enrich the city and our conception of it whether one enters them or not.

Bridges, those momentous doorways, connect New York City to itself and so to the world. A daily flood pours over them. The Gothic arches of the Brooklyn Bridge, the filigreed grace of the Queensboro Bridge, the immense span of the Verrazano Narrows Bridge, and the muscular heroics of the George Washington Bridge, known familiarly as George, are monuments. Each of them, along with their depots and innumerable smaller bridges, is breathtaking in history, conception, and utility.

On the day I moved to Manhattan, twenty years old and hungry, I missed the exit that takes you across the Triborough Bridge, into the city and away from everything that is small, safe, and predictable. I still question that ridiculously diminutive exit sign, which leads to the greatest city on earth. On that day, I landed somewhere in Brooklyn. A helpful

soul gave me directions three times, and three times I squinted back at this exotic creature. I couldn't understand a word he was saying. Years later, I learned that this particular accent, of the "toidy-toid and toid" variety that has been mercilessly parodied in the media, is nearly extinct. Now I know it is a treasure, one of the many that come together to form this improbable, intriguing, demanding, generous place. On that day though, I would have handed over my passport if asked. Truly, New York was another world.

<div align="right">

Judith Dupré
January 2002

</div>

Judith Dupré is a cultural historian with a background in art, architecture, and education. She is the author of six books which have been translated into ten languages, including the best-selling titles *Skyscrapers, Bridges,* and *Churches.* She graduated from Brown University with degrees in English literature and studio art, and studied architecture at the Open Atelier of Design and Architecture in New York City. She has been a New Yorker all of her life, although she managed to be born somewhere else.

Photographer's Note

On the morning of September 11, 2001, I was in the kitchen with my family, twelve blocks from the World Trade Center, when the first plane flew just over our heads. I was scheduled to make a portrait of Castle Clinton in Battery Park, but I was running a little late. Within the next hour, the nature and meaning of this project changed just as the whole world changed. It became harder to accomplish—emotionally as well as logistically—but it also became much more personally important and meaningful. What had been a challenging job became a passion.

I use the term "portrait" when I refer to the pictures in this book because I have tried to capture the unique life within each building, the soul inside the stones and bricks of even the most mundane structures, the experiences and history they have absorbed over the years they have been silently serving us. And I have tried, as much as possible, to pare away the world surrounding the buildings, the confusion of city life, in order to unleash the true essence of each building.

But the buildings of New York don't exist in isolation—they live crowded together in sometimes unlikely juxtapositions just as its people do, presenting endless contrasts of style, size, materials, and function. And out of this visual chaos there emerges a kind of harmony. It wasn't until that harmony was so suddenly and radically disrupted that we paused to contemplate it. I mean this book to celebrate it.

I would like to dedicate Five Hundred Buildings of New York to my kids, Léo and Sasha, to my wife Céline, and to all of our American friends who made our stay in New York so wonderful over the seven years we lived there. I gratefully thank J. P. Leventhal, Laura Ross, True Sims, and Magali Veillon of Black Dog & Leventhal for recruiting me to work on this book and supporting my efforts at every turn. It has been one of the most fulfilling projects in my photography career. Photographers Erik Freeland and James Driscoll and my assistant Devin Hartmann were indispensable in helping me get the book finished on time, on budget, and with style. I salute the creativity and care of author Bill Harris, designer Sheila Hart, and master separator Thomas Palmer. I would like to thank Jim and Cornelia from MV Lab for carefully handling the film, and the team at Fotocare for their assistance. Finally, I would like to thank all of the people who provided access, encouragement, and sometimes even coffee throughout the months that I hauled cameras and equipment around the streets of New York.

Jorg Brockmann
January 2002

LOWER MANHATTAN

There is history around every corner in New York, but few neighborhoods have the abundance of it that Lower Manhattan has. It was here that the Dutch established their trading post in the seventeenth century, and it was here that the English moved in and named it "New York." It was the site of the first capital of the new United States, and not long afterward, it became the financial capital of the world. George Washington walked its streets, and so did J. P. Morgan. And over the last several generations, nobody is considered a bona fide hero without first riding down lower Broadway through a shower of tickertape and confetti.

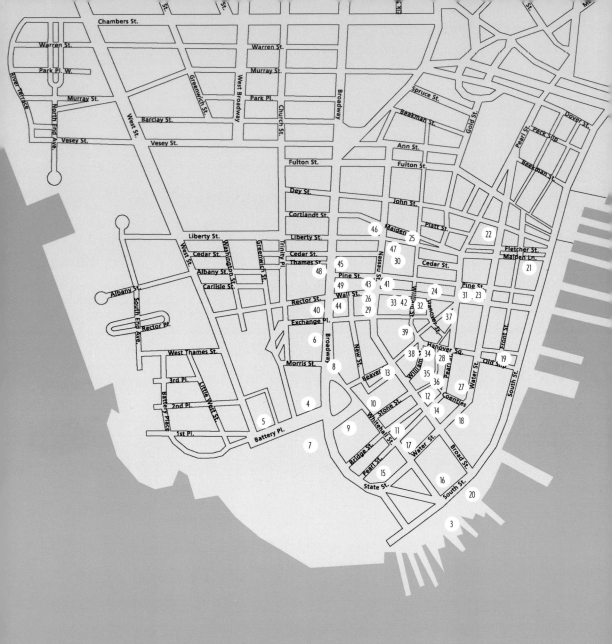

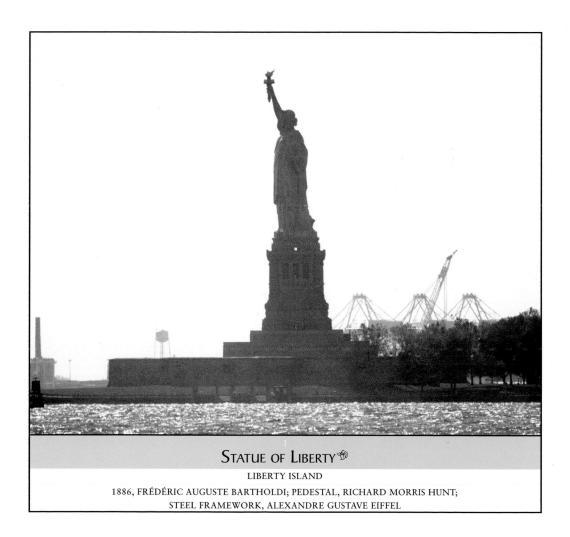

STATUE OF LIBERTY

LIBERTY ISLAND

1886, FRÉDÉRIC AUGUSTE BARTHOLDI; PEDESTAL, RICHARD MORRIS HUNT;
STEEL FRAMEWORK, ALEXANDRE GUSTAVE EIFFEL

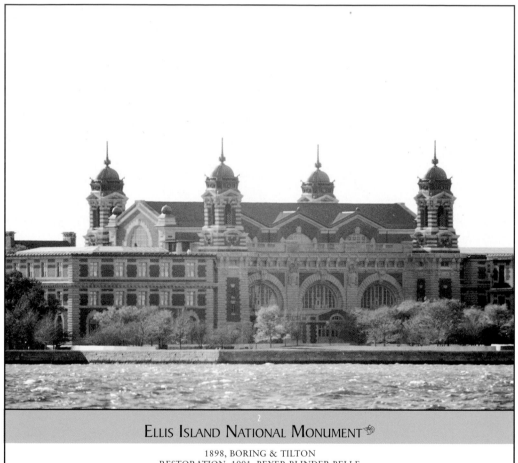

ELLIS ISLAND NATIONAL MONUMENT ✍

1898, BORING & TILTON
RESTORATION, 1991, BEYER BLINDER BELLE
AND NOTTER FINEGOLD & ALEXANDER

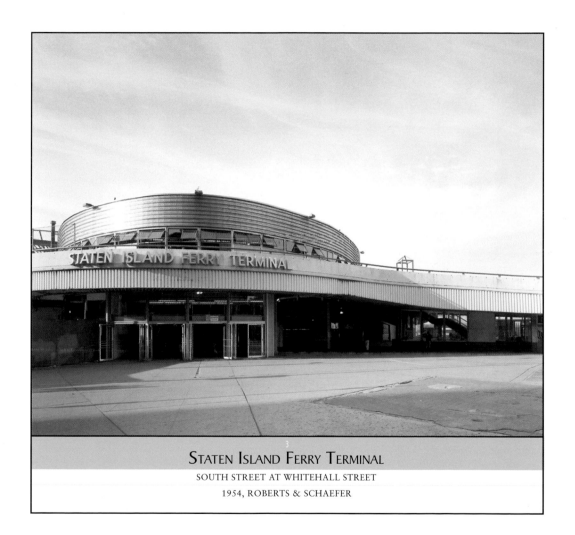

STATEN ISLAND FERRY TERMINAL

SOUTH STREET AT WHITEHALL STREET

1954, ROBERTS & SCHAEFER

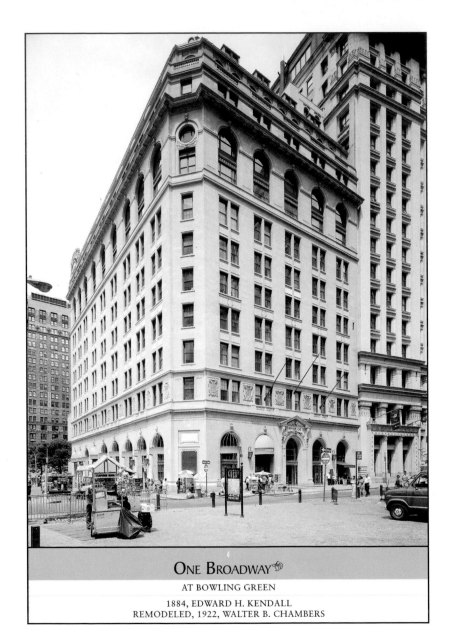

4

ONE BROADWAY

AT BOWLING GREEN

1884, EDWARD H. KENDALL
REMODELED, 1922, WALTER B. CHAMBERS

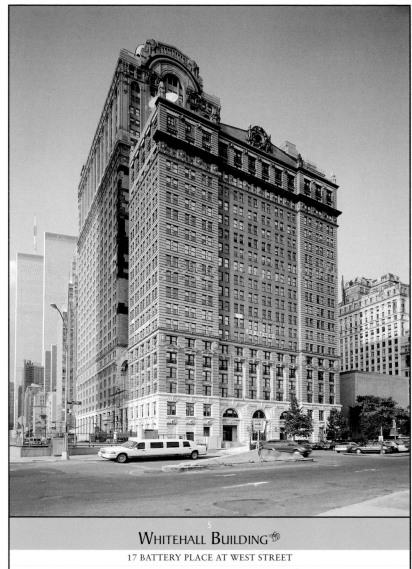

WHITEHALL BUILDING

17 BATTERY PLACE AT WEST STREET

1900, HENRY J. HARDENBURGH
REAR ADDITION, 1910, CLINTON & RUSSELL

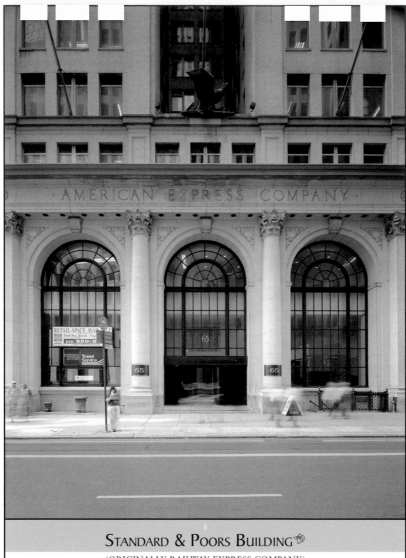

Standard & Poors Building 🦅

(ORIGINALLY RAILWAY EXPRESS COMPANY)
65 BROADWAY BETWEEN EXCHANGE ALLEY AND RECTOR STREET

1919, RENWICK, ASPINWALL & TUCKER

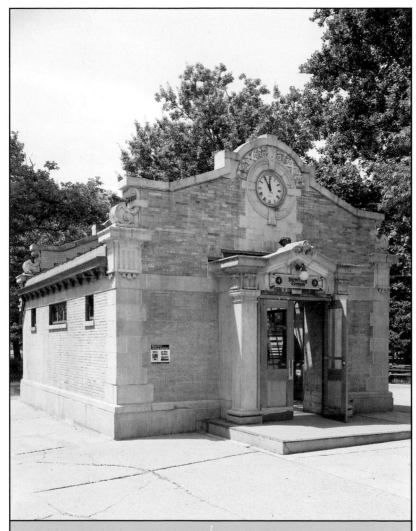

BOWLING GREEN IRT CONTROL HOUSE

BATTERY PLACE AT STATE STREET
1905, HEINZ & LA FARGE

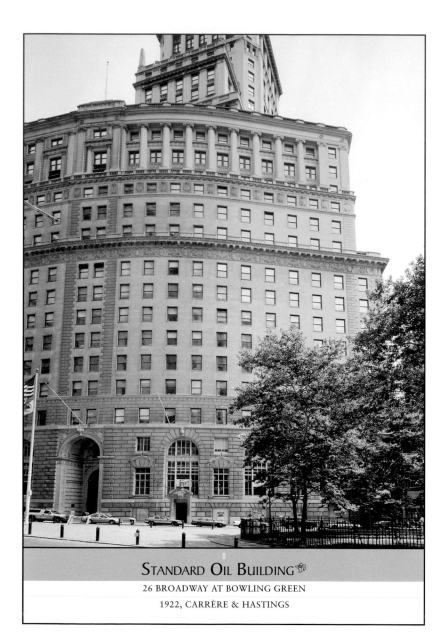

8

STANDARD OIL BUILDING

26 BROADWAY AT BOWLING GREEN

1922, CARRÈRE & HASTINGS

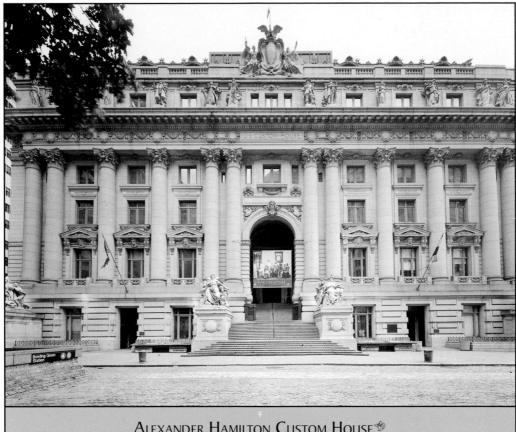

ALEXANDER HAMILTON CUSTOM HOUSE 🦞

ONE BOWLING GREEN BETWEEN STATE AND WHITEHALL STREETS

1907, CASS GILBERT; "FOUR CONTINENTS" SCULPTURES, DANIEL CHESTER FRENCH
ROTUNDA MURALS, 1937, REGINALD MARSH; ALTERATIONS, 1994 EHRENKRANTZ & EKSTUT

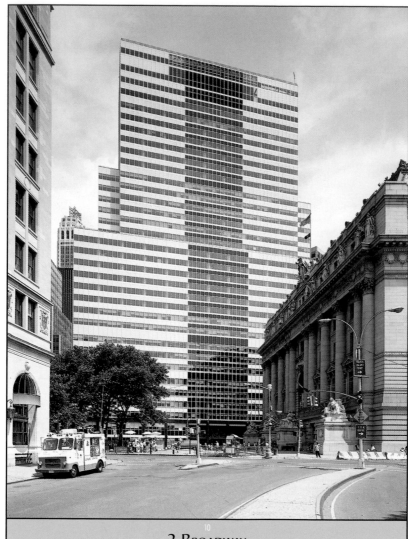

2 Broadway

BETWEEN STONE AND BEAVER STREETS

1959, EMERY ROTH & SONS
REMODELED, 1999, SKIDMORE, OWINGS & MERRILL

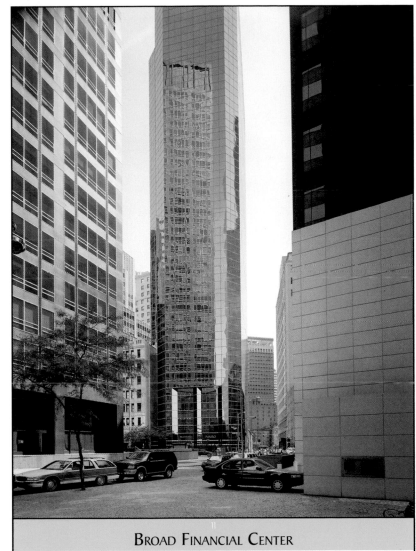

11

BROAD FINANCIAL CENTER

33 WHITEHALL STREET AT PEARL STREET

1986, FOX & FOWLE

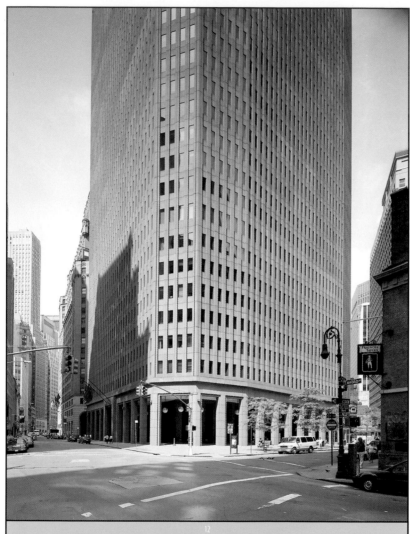

GOLDMAN-SACHS BUILDING

85 BROAD STREET AT PEARL STREET

1983, SKIDMORE, OWINGS & MERRILL

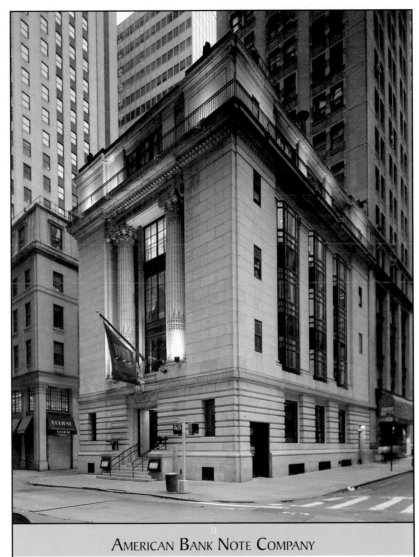

13
AMERICAN BANK NOTE COMPANY

70 BROAD STREET
BETWEEN MARKETFIELD AND BEAVER STREETS

1908, KIRBY, PETIT & GREEN

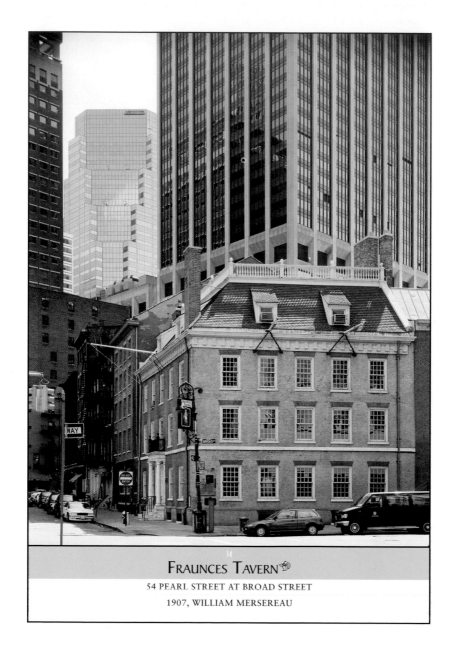

FRAUNCES TAVERN

54 PEARL STREET AT BROAD STREET

1907, WILLIAM MERSEREAU

◆ LOWER MANHATTAN ◆

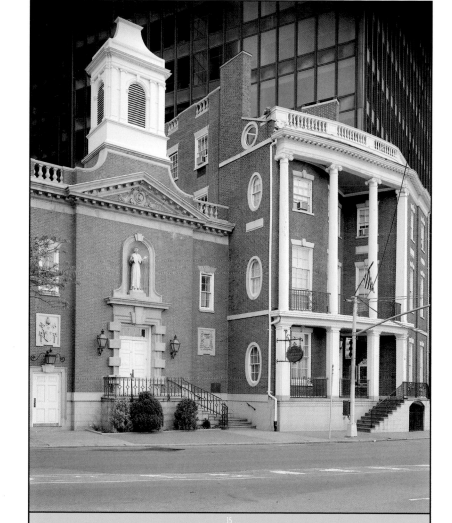

SHRINE OF ST. ELIZABETH ANN BAYLEY SETON

7 STATE STREET BETWEEN PEARL AND WHITEHALL STREETS

1806, JOHN MCCOMB, JR.
RESTORATION, 1965, SHANLEY & STURGIS

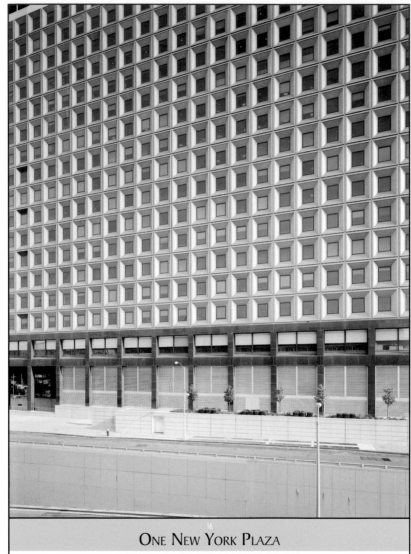

ONE NEW YORK PLAZA

WHITEHALL STREET AT SOUTH STREET

1969, WILLIAM LESCASE & ASSOCIATES
DESIGN BY KAHN & JACOBS

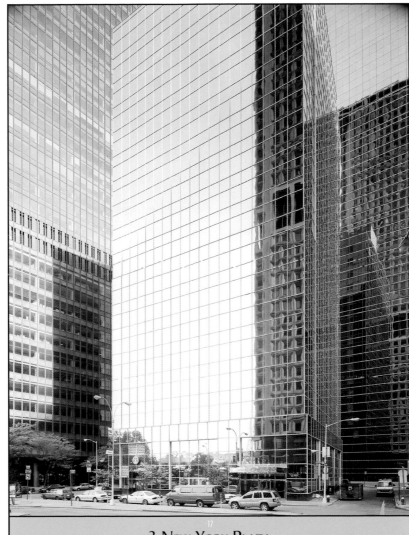

3 NEW YORK PLAZA

39 WHITEHALL STREET BETWEEN WATER AND PEARL STREETS

1886, S. D. HATCH
RECONSTRUCTED, 1986, WECHSLER, GRASSO & MENZIUSO

4 NEW YORK PLAZA

WATER STREET
BETWEEN BROAD STREET AND COENTIES SLIP

1968, CARSON, LUNDIN & SHAW

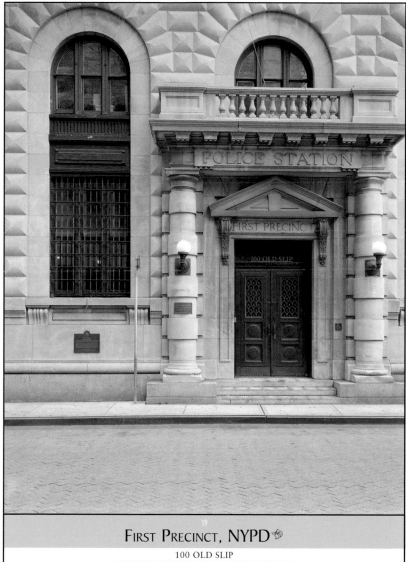

FIRST PRECINCT, NYPD

100 OLD SLIP
BETWEEN FRONT AND SOUTH STREETS

1911, HUNT & HUNT

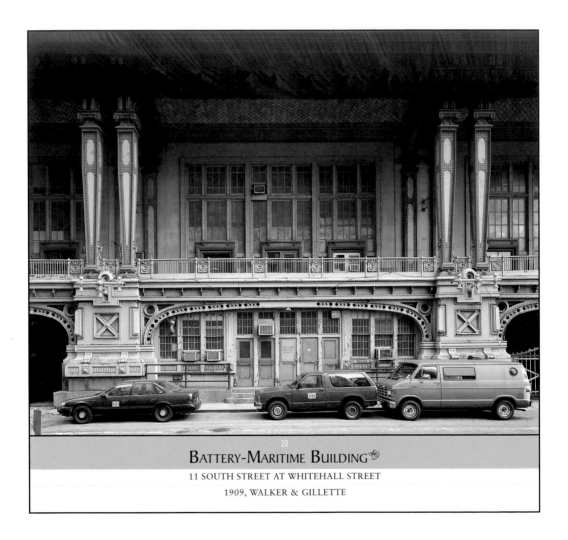

BATTERY-MARITIME BUILDING

11 SOUTH STREET AT WHITEHALL STREET

1909, WALKER & GILLETTE

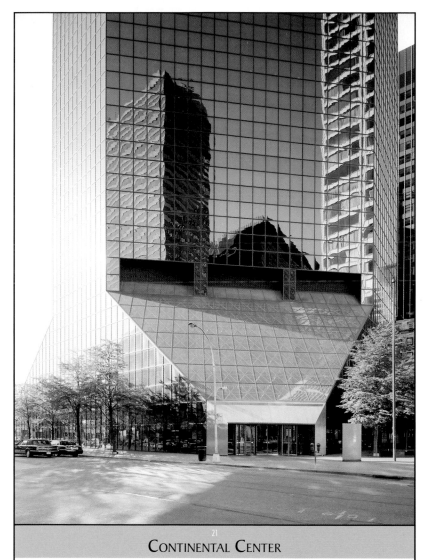

21
CONTINENTAL CENTER

180 MAIDEN LANE
BETWEEN PINE, FRONT, AND SOUTH STREETS

1983, SWANKE HAYDEN CONNELL & PARTNERS

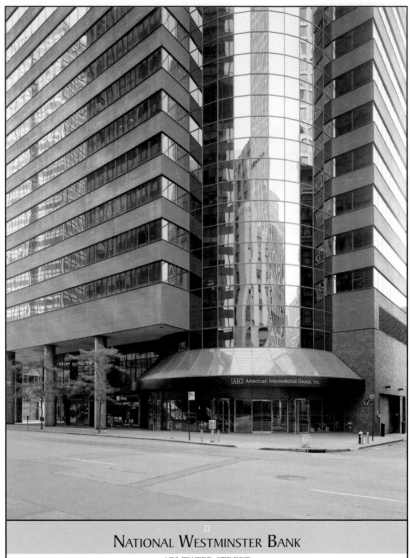

22
NATIONAL WESTMINSTER BANK

175 WATER STREET
BETWEEN FLETCHER AND JOHN STREETS

1983, FOX & FOWLE

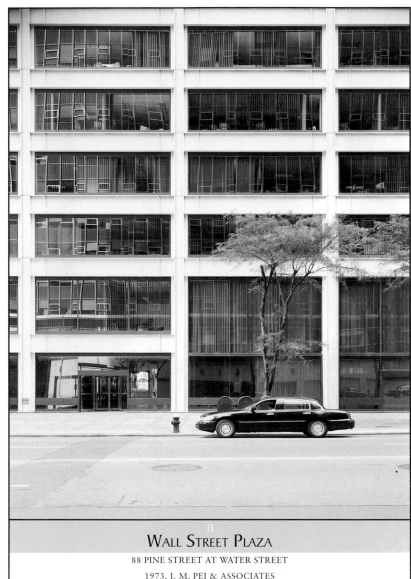

WALL STREET PLAZA

88 PINE STREET AT WATER STREET

1973, I. M. PEI & ASSOCIATES

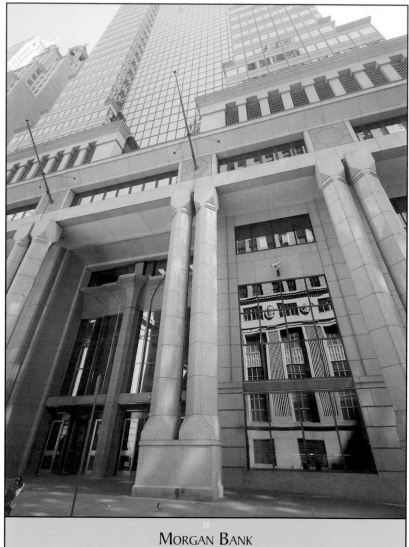

MORGAN BANK

60 WALL STREET, BETWEEN PEARL AND WILLIAM STREETS
1988, KEVIN ROCHE, JOHN DINKELOO & ASSOCIATES

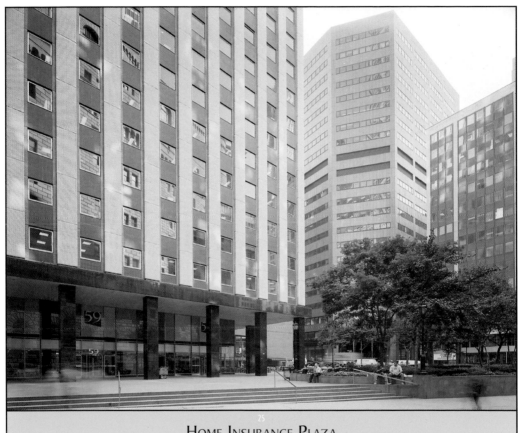

25

HOME INSURANCE PLAZA

59 MAIDEN LANE AT WILLIAM STREET

1966, ALFRED EASTON POOR

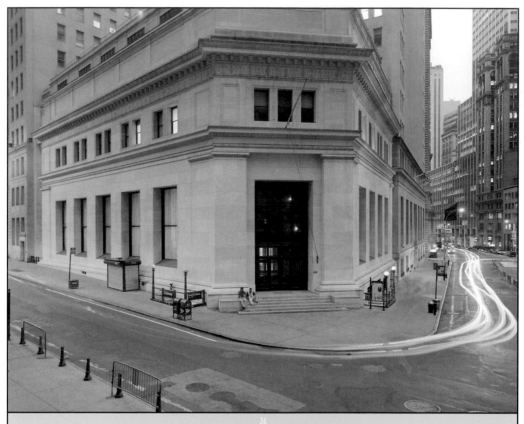

Morgan Guaranty Trust Building

23 WALL STREET AT BROAD STREET

1913, TROWBRIDGE & LIVINGSTON

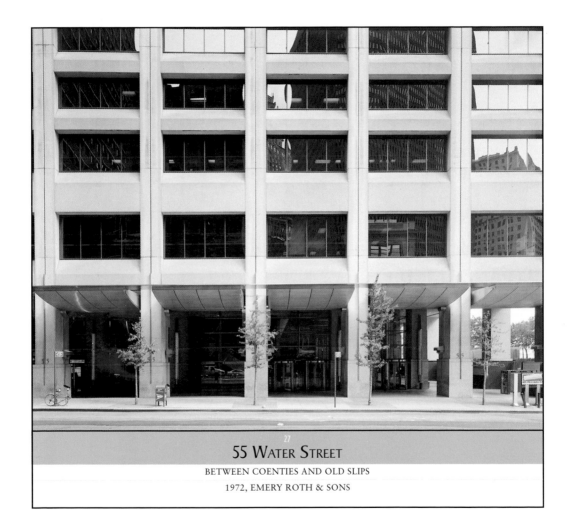

55 WATER STREET

BETWEEN COENTIES AND OLD SLIPS

1972, EMERY ROTH & SONS

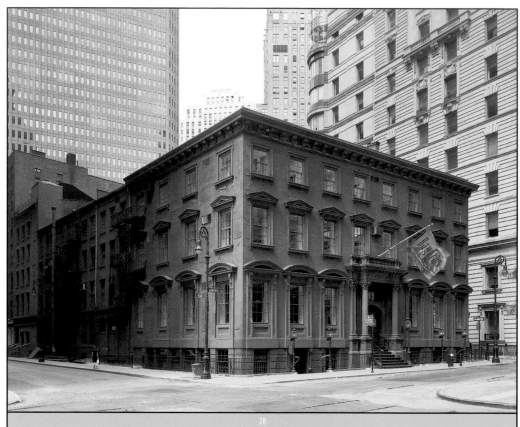

India House

ONE HANOVER SQUARE
BETWEEN PEARL AND STONE STREETS

1853, RICHARD F. CARMAN

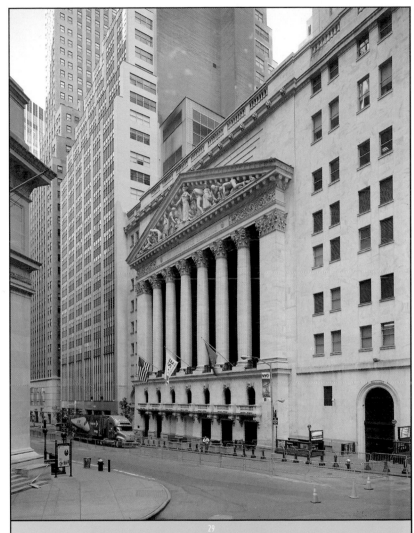

New York Stock Exchange

8 BROAD STREET
BETWEEN WALL STREET AND EXCHANGE PLACE

1903, GEORGE B. POST PEDIMENT BY J. Q. A. WARD AND PAUL BARTLETT

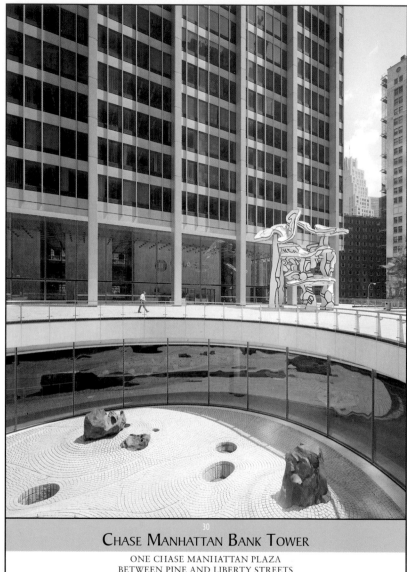

30
Chase Manhattan Bank Tower

ONE CHASE MANHATTAN PLAZA
BETWEEN PINE AND LIBERTY STREETS

1960, SKIDMORE, OWINGS & MERRILL

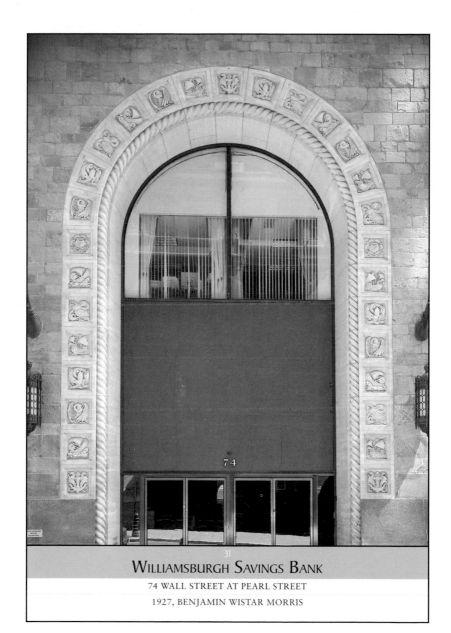

WILLIAMSBURGH SAVINGS BANK

74 WALL STREET AT PEARL STREET

1927, BENJAMIN WISTAR MORRIS

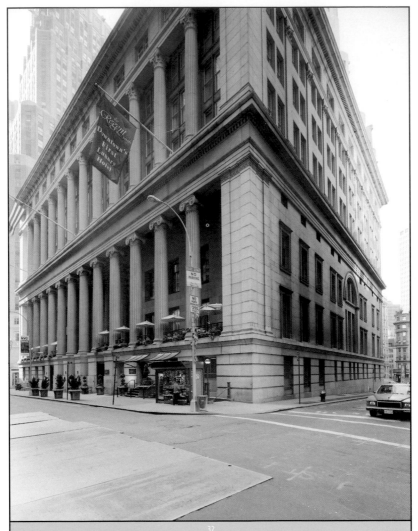

Regent Wall Street Hotel

(FORMERLY CITIBANK), 55 WALL STREET AT WILLIAM STREET

1841, ISAIAH ROGERS; CONVERTED TO CUSTOM HOUSE, 1863, WILLIAM A. POTTER
REMODELED, 1910, MCKIM, MEAD & WHITE

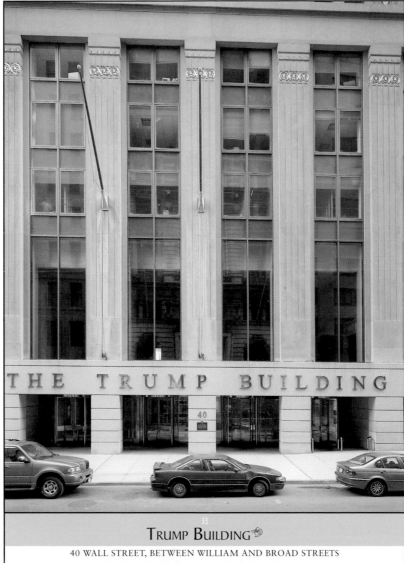

THE TRUMP BUILDING

TRUMP BUILDING

40 WALL STREET, BETWEEN WILLIAM AND BROAD STREETS

1930, H. CRAIG SEVERANCE WITH YASUO MATSUI AND SHREVE & LAMB
LOBBY ALTERATIONS, 1997, DERR SCUTT

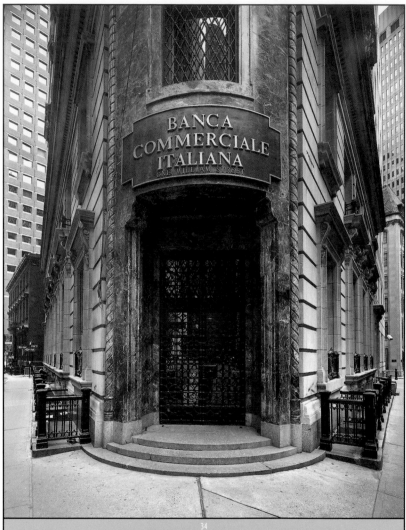

BANCA COMMERCIALE ITALIANA

ONE WILLIAM STREET AT HANOVER SQUARE

1907, FRANCIS H. KIMBALL & JULIAN C. LEVI
ALTERATIONS, 1929, HARRY R. ALLEN

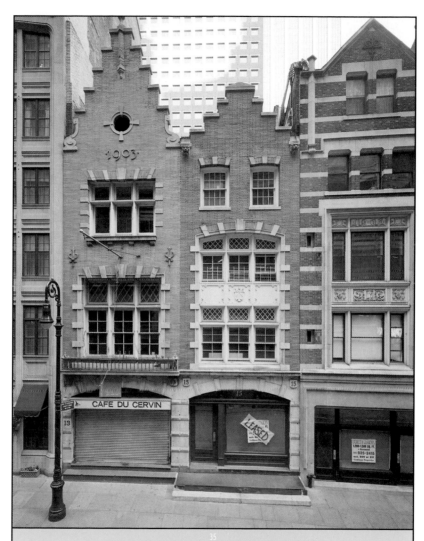

13–15 South William Street

AND 57 STONE STREET
BETWEEN COENTIES ALLEY AND HANOVER SQUARE

1903–1908, C. P. H. GILBERT

CHUBB & SONS

54 STONE STREET
BETWEEN COENTIES ALLEY AND HANOVER SQUARE

1919, ARTHUR C. JACKSON

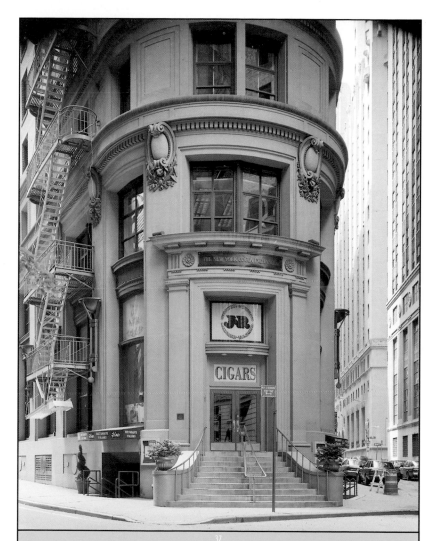

NEW YORK COCOA EXCHANGE

82–92 BEAVER STREET, AT PEARL STREET

1904, CLINTON & RUSSELL

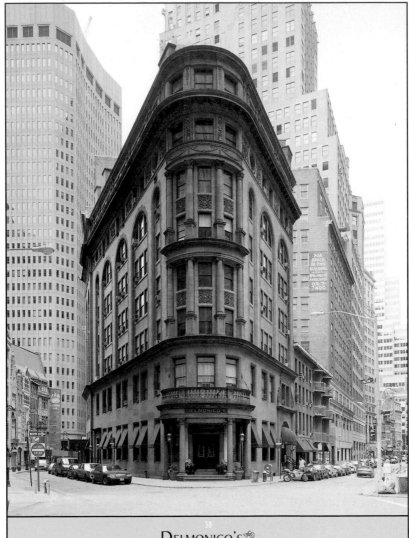

DELMONICO'S

56 BEAVER STREET AT SOUTH WILLIAM STREET

1891, JAMES BROWN LORD
CONDOMINIUM CONVERSION, 1996, MARK KEMENY

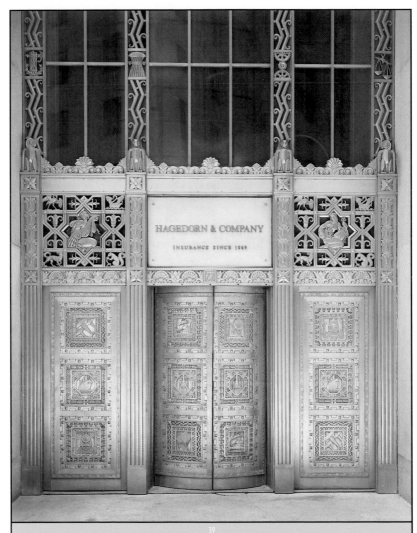

HAGEDORN & COMPANY

INSURANCE SINCE 1869

39

CANADIAN IMPERIAL BANK OF COMMERCE

22 WILLIAM STREET
BETWEEN BEAVER STREET AND EXCHANGE PLACE

1931, CROSS & CROSS

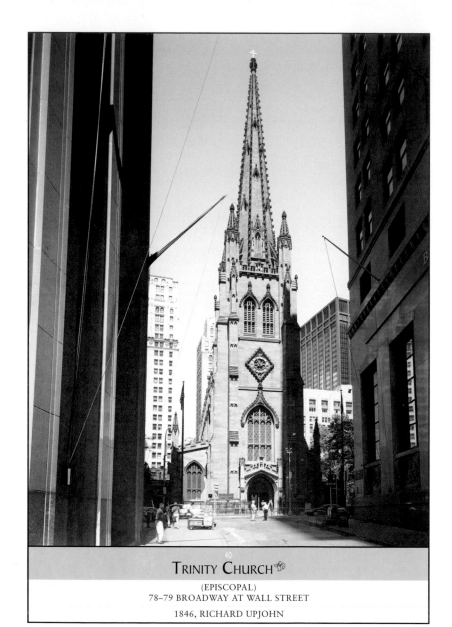

TRINITY CHURCH

(EPISCOPAL)
78–79 BROADWAY AT WALL STREET

1846, RICHARD UPJOHN

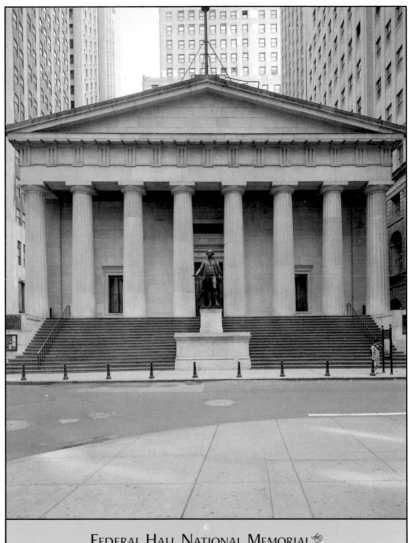

FEDERAL HALL NATIONAL MEMORIAL

28 WALL STREET AT NASSAU STREET

1842, TOWN & DAVIS

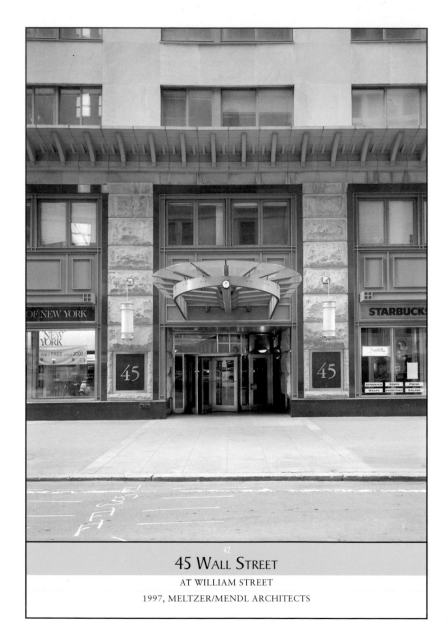

42

45 WALL STREET

AT WILLIAM STREET

1997, MELTZER/MENDL ARCHITECTS

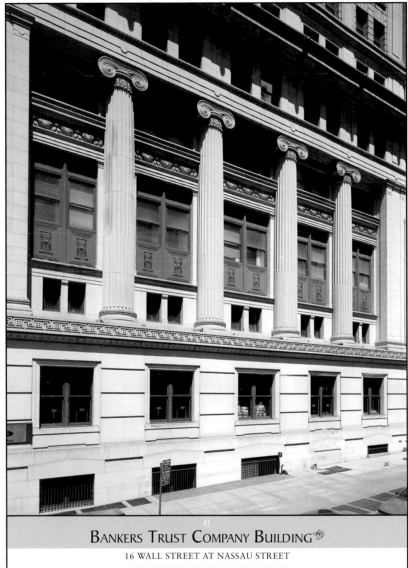

BANKERS TRUST COMPANY BUILDING

16 WALL STREET AT NASSAU STREET

1912, TROWBRIDGE & LIVINGSTON
ADDITION, 1933, SHREVE, LAMB & HARMON

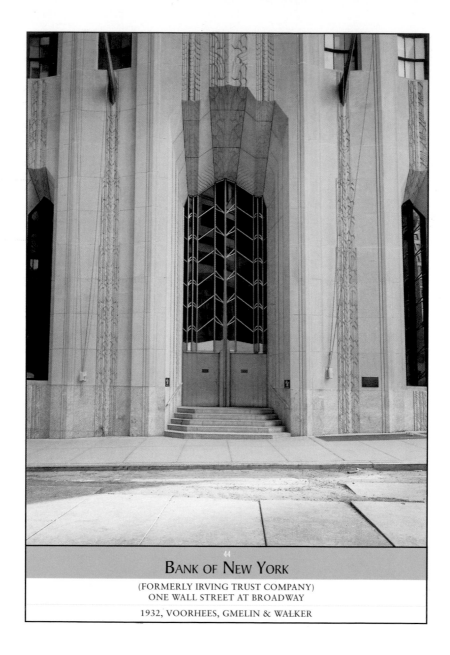

BANK OF NEW YORK

(FORMERLY IRVING TRUST COMPANY)
ONE WALL STREET AT BROADWAY

1932, VOORHEES, GMELIN & WALKER

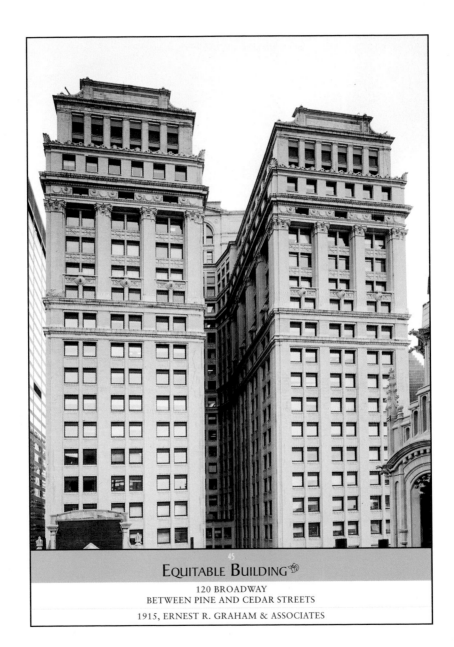

45
EQUITABLE BUILDING

120 BROADWAY
BETWEEN PINE AND CEDAR STREETS

1915, ERNEST R. GRAHAM & ASSOCIATES

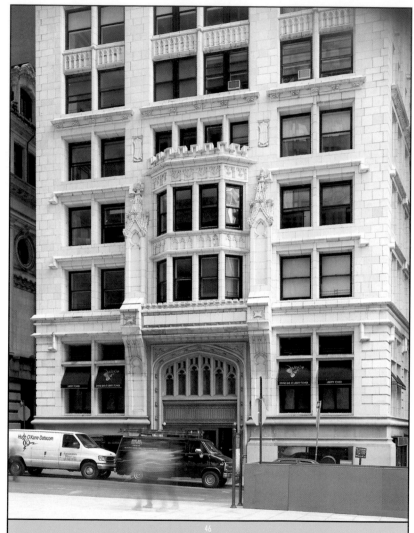

LIBERTY TOWER

55 LIBERTY STREET AT NASSAU STREET

1910, HENRY IVES COBB

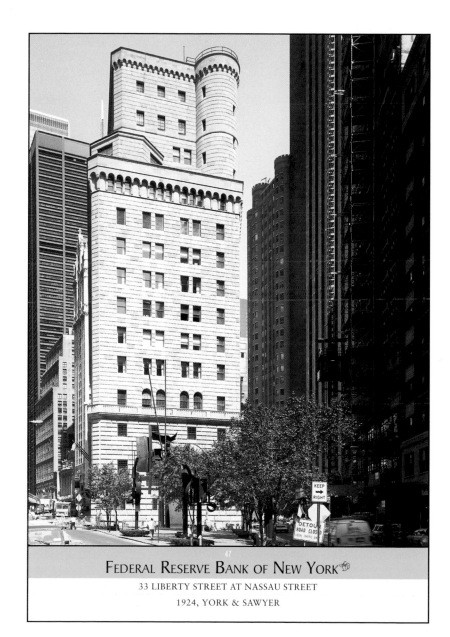

FEDERAL RESERVE BANK OF NEW YORK

33 LIBERTY STREET AT NASSAU STREET

1924, YORK & SAWYER

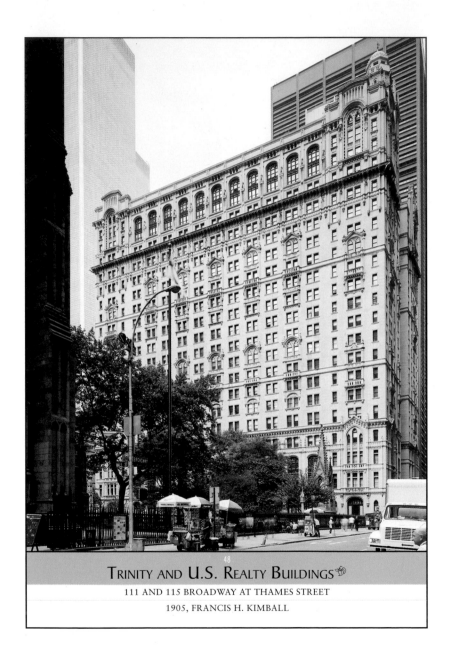

TRINITY AND U.S. REALTY BUILDINGS

111 AND 115 BROADWAY AT THAMES STREET

1905, FRANCIS H. KIMBALL

◆ LOWER MANHATTAN ◆

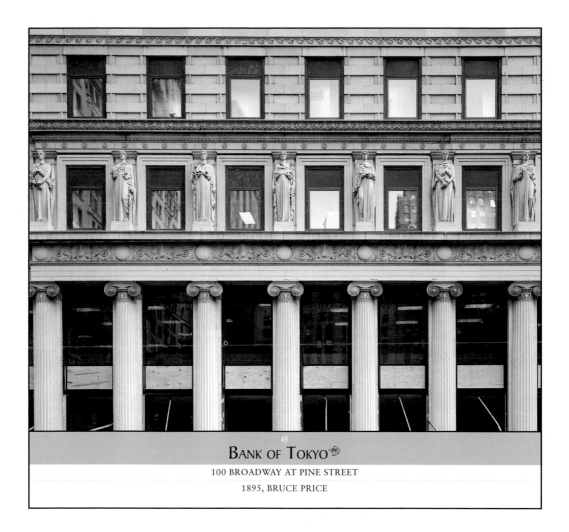

BANK OF TOKYO

100 BROADWAY AT PINE STREET

1895, BRUCE PRICE

WORLD TRADE CENTER

When terrorists flew two passenger jets into the World Trade Center on September 11, 2001, they did more than change New York's downtown skyline. These photographs, from before the disaster, serve as a reminder for all of us to treasure even those buildings that are not designated landmarks. Every generation has fond memories of buildings that have made way for others or met with tragic destruction. But never before has an entire planet shared the same visual memory of the moment-by-moment loss of a major building. Whether it was viewed live at the scene or on television, the crumbling of the Twin Towers in virtually a matter of moments had an immediate, unprecedented impact worldwide.

It is important to remember, too, that along with Towers 1 and 2, several other structures within the complex collapsed or sustained damage. In addition, more than a dozen nearby buildings experienced anything from minor window breakage to serious structural damage. Even before the dust cleared, speculation began about what kinds of buildings would replace the fallen. Terrorism has not prevented New York from reaching for the skies, and we can be sure that some new, and certain to be stunning, architectural phoenixes will rise from the ashes of the September 11th attacks.

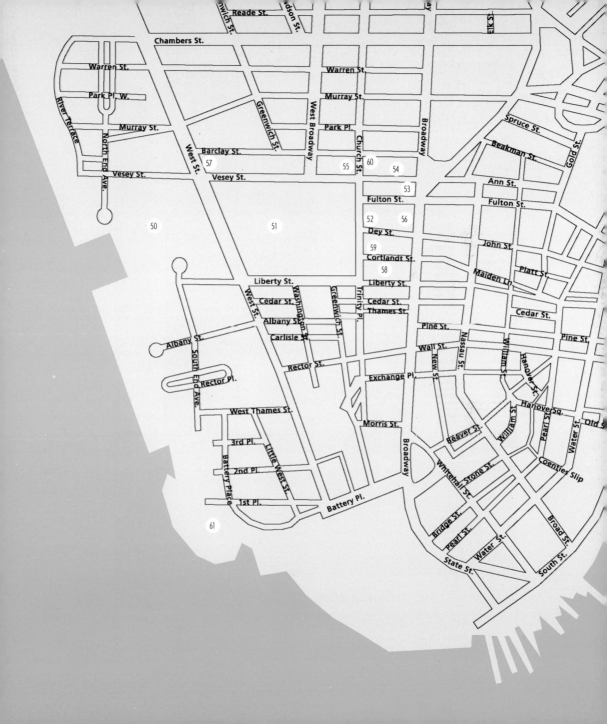

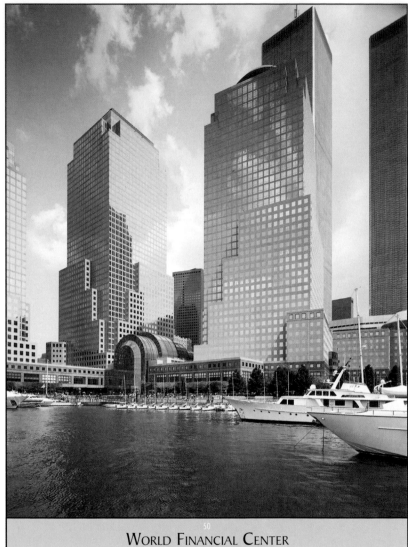

⁵⁰

WORLD FINANCIAL CENTER

WEST STREET BETWEEN LIBERTY
AND VESEY STREETS ON THE HUDSON RIVER

1980S, CESAR PELLI WITH ADAMSON & ASSOCIATES

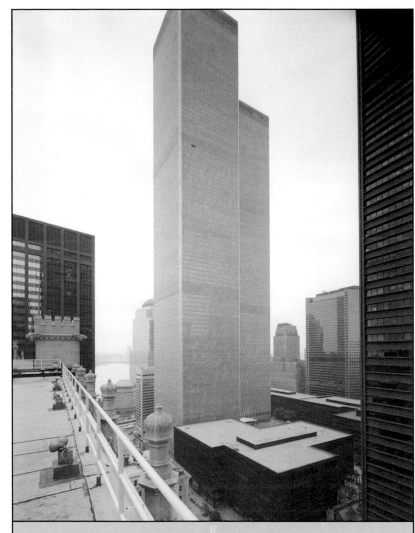

WORLD TRADE CENTER

CHURCH TO WEST STREETS; LIBERTY TO VESEY STREETS

1972–1977, MINORU YAMASAKI & ASSOCIATES
WITH EMERY ROTH & SONS

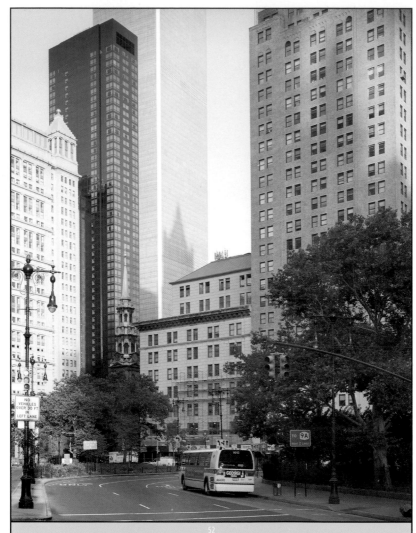

52

MILLENIUM HILTON HOTEL

55 CHURCH STREET
BETWEEN FULTON AND DEY STREET

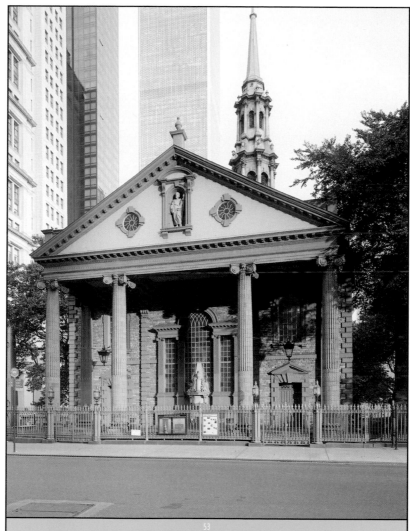

St. Paul's Chapel

BROADWAY BETWEEN FULTON AND VESEY STREETS

1768, THOMAS MCBEAN

GARRISON BUILDING

20 VESEY STREET; BETWEEN CHURCH STREET AND BROADWAY

1907, ROBERT D. KOHN
SCULPTURES BY GUTZON BORGLUM AND ESTELLE RUMBOLD KOHN

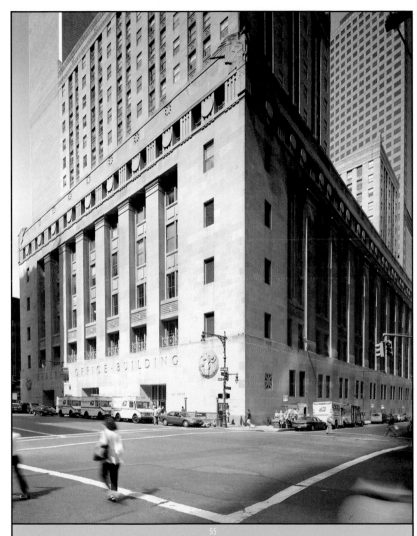

55

FEDERAL OFFICE BUILDING

90 CHURCH STREET
BETWEEN VESEY AND BARCLAY STREETS

1935, CROSS & CROSS

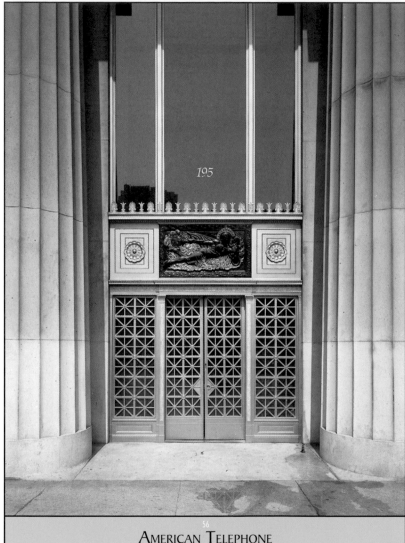

56

AMERICAN TELEPHONE

AND TELEGRAPH BUILDING
195 BROADWAY BETWEEN DEY AND FULTON STREETS

1923, WELLES BOSWORTH

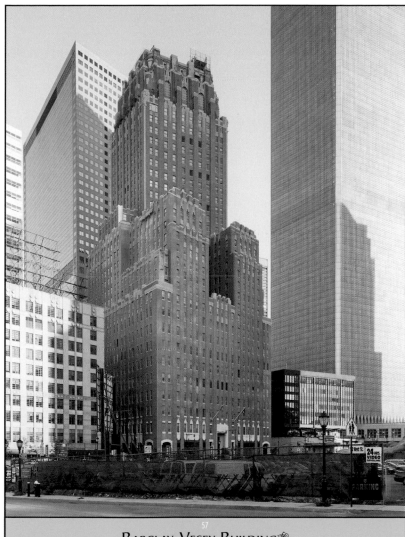

BARCLAY-VESEY BUILDING

140 WEST STREET
BETWEEN BARCLAY AND VESEY STREETS

1927, MCKENZIE, VOORHEES & GMELIN

ONE LIBERTY PLAZA

BROADWAY, LIBERTY, CHURCH, AND CORTLANDT STREETS

1974, SKIDMORE, OWINGS & MERRILL

◆ WORLD TRADE CENTER ◆

59 East River Savings Bank

(NOW CENTURY 21 DEPARTMENT STORE)
26 CORTLANDT STREET AT CHURCH STREET

1934, WALKER & GILLETTE

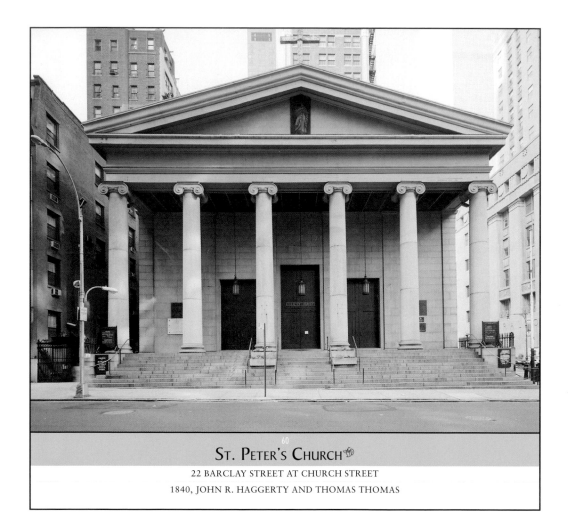

St. Peter's Church

22 BARCLAY STREET AT CHURCH STREET

1840, JOHN R. HAGGERTY AND THOMAS THOMAS

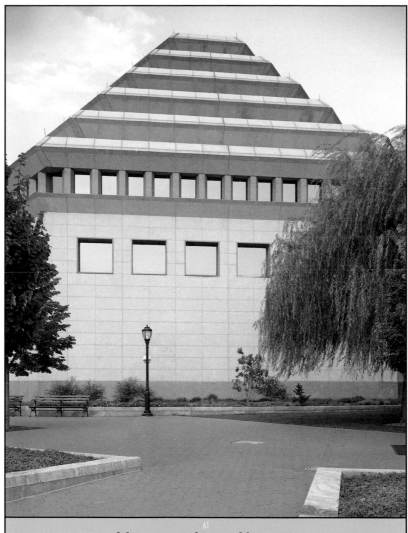

61

Museum of Jewish Heritage

ONE BATTERY PARK PLAZA
FOOT OF BATTERY PLACE

1996, KEVIN ROCHE, JOHN DINKELOO & ASSOCIATES

THE SEAPORT AND CIVIC CENTER

In the early eighteenth century, the neighborhood along Water Street and South Street constituted the city's primary seaport, and as such it was a rough and ready place, filled with sailors and stevedores—and sharpies bent on relieving them of their money. The more genteel aspects of the old port have been revived in the restoration of South Street Seaport, but if you should happen to see a ghost there, run west by northwest and you'll arrive at City Hall and the concentration of civic buildings and courthouses around it. The ghosts there may be more benign, but don't forget that many of those old city fathers were as adept at picking pockets as any denizen of South Street.

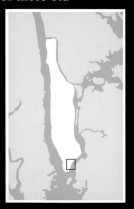

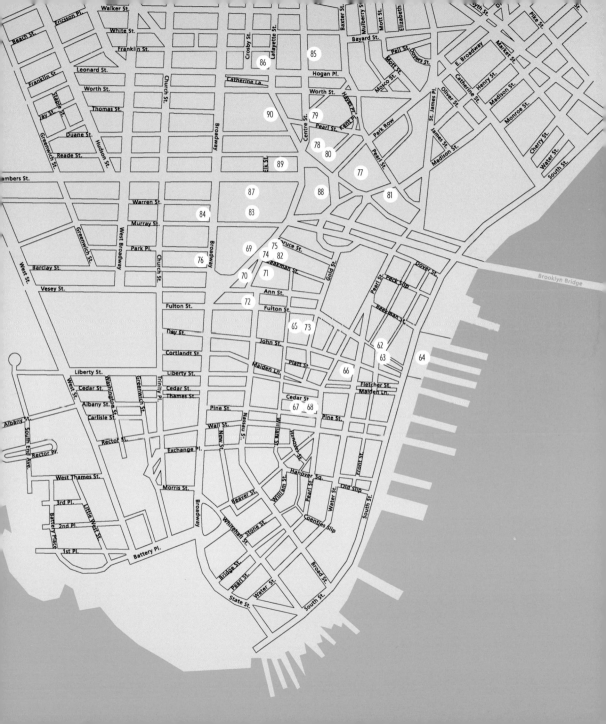

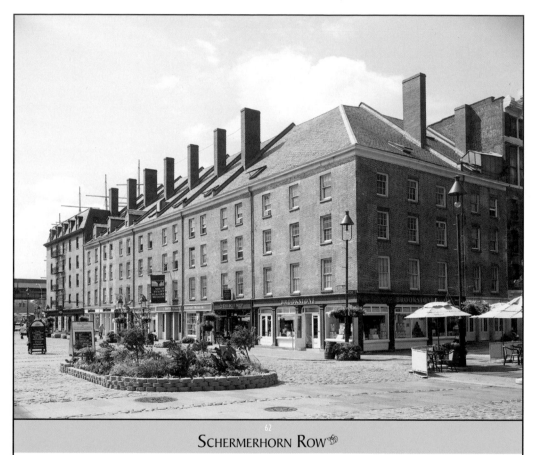

SCHERMERHORN ROW

2–18 FULTON STREET
(ALSO 91, 92 SOUTH AND 195 FRONT STREETS)

1812, BUILT BY PETER SCHERMERHORN

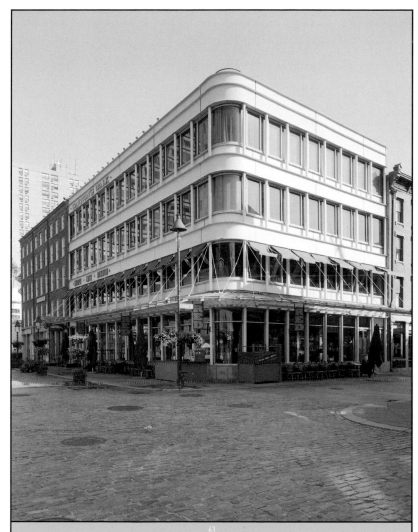

BOGARDUS BUILDING

15–19 FULTON STREET AT FRONT STREET

1983, BEYER BLINDER BELLE

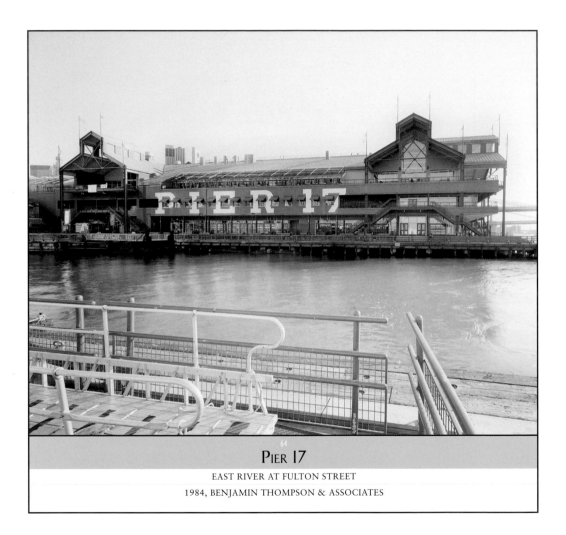

⁶⁴

PIER 17

EAST RIVER AT FULTON STREET

1984, BENJAMIN THOMPSON & ASSOCIATES

65
ILX Systems

(AETNA INSURANCE COMPANY BUILDING)
151 WILLIAM STREET AT FULTON STREET

1940, CROSS & CROSS WITH EGGERS & HIGGINS

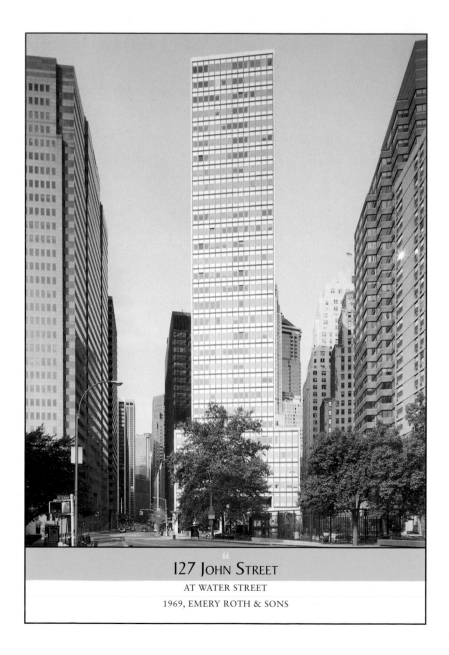

127 JOHN STREET

AT WATER STREET

1969, EMERY ROTH & SONS

DOWN TOWN ASSOCIATION

60 PINE STREET BETWEEN PEARL AND WILLIAM STREETS

1887, CHARLES C. HAIGHT
ADDITION, 1911, WARREN & WETMORE

AMERICAN INTERNATIONAL BUILDING

(FORMER CITIES SERVICE BUILDING)
70 PINE STREET AT PEARL STREET

1932, CLINTON & RUSSELL WITH HOLTON & GEORGE

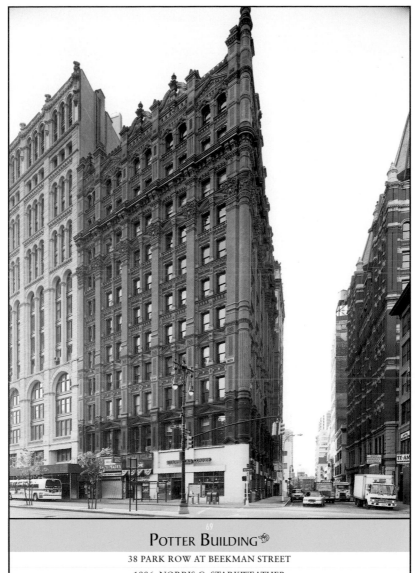

POTTER BUILDING

38 PARK ROW AT BEEKMAN STREET

1886, NORRIS G. STARKWEATHER

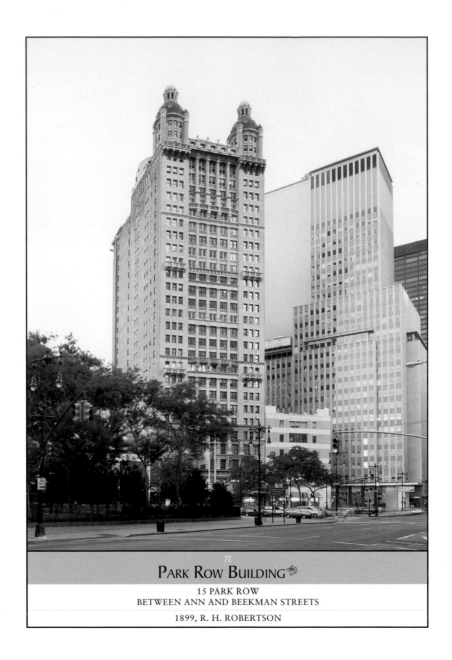

70

Park Row Building

15 PARK ROW
BETWEEN ANN AND BEEKMAN STREETS

1899, R. H. ROBERTSON

◆ SEAPORT AND CIVIC CENTER ◆

Morse Building

12 BEEKMAN STREET AT NASSAU STREET

1879, SILLIMAN & FARNSWORTH

72
Bennett Building

93–99 NASSAU STREET AT FULTON STREET

1873, ARTHUR D. GILMAN
ADDITIONS, 1892 AND 1894, JAMES M. FARNSWORTH

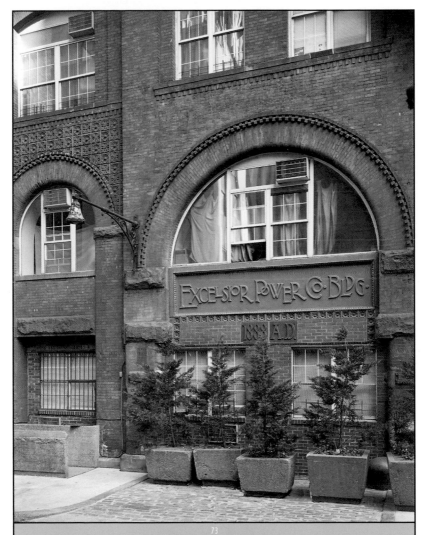

EXCELSIOR POWER COMPANY

33–48 GOLD STREET
BETWEEN FULTON AND JOHN STREETS

1888, WILLIAM MILNE GRINNELL

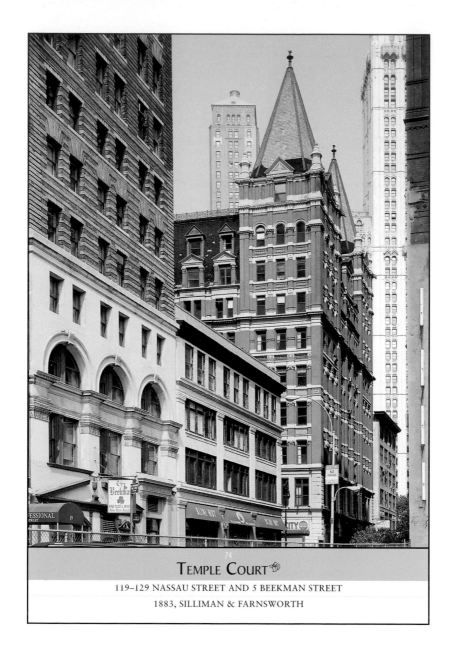

Temple Court

119–129 NASSAU STREET AND 5 BEEKMAN STREET

1883, SILLIMAN & FARNSWORTH

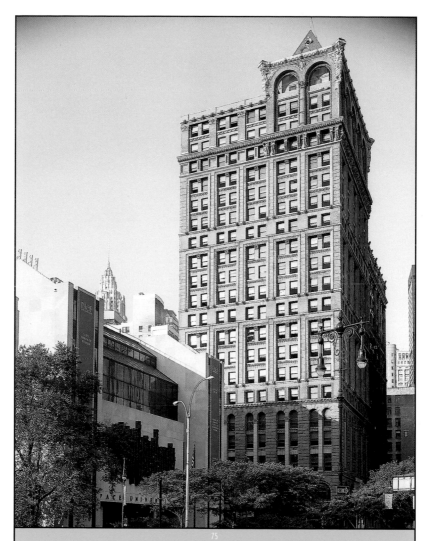

AMERICAN TRACT SOCIETY BUILDING

150 NASSAU STREET AT SPRUCE STREET

1896, R. H. ROBERTSON

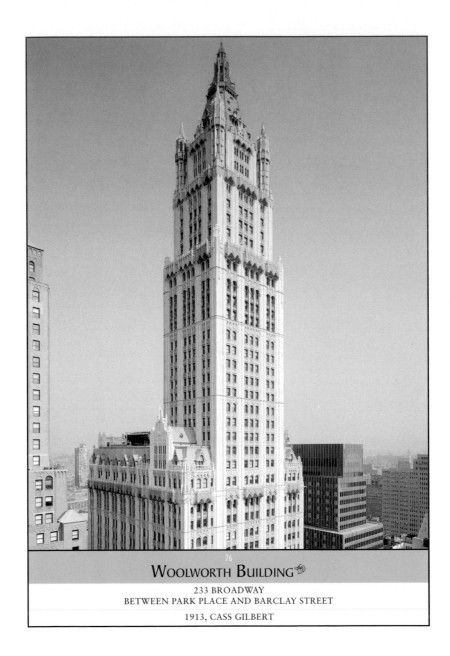

Woolworth Building

233 BROADWAY
BETWEEN PARK PLACE AND BARCLAY STREET

1913, CASS GILBERT

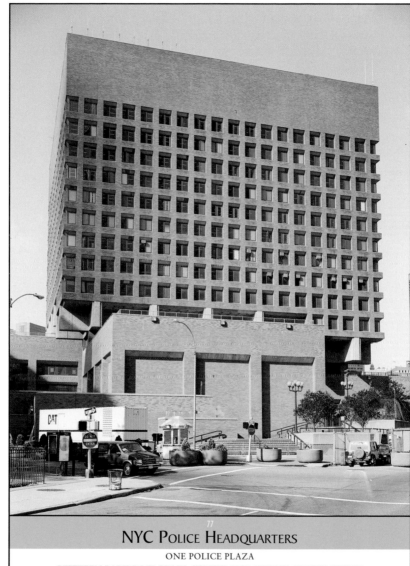

77

NYC Police Headquarters

ONE POLICE PLAZA
BETWEEN PARK ROW, PEARL STREET, AND AVENUE OF THE FINEST

1973, GRUZEN & PARTNERS

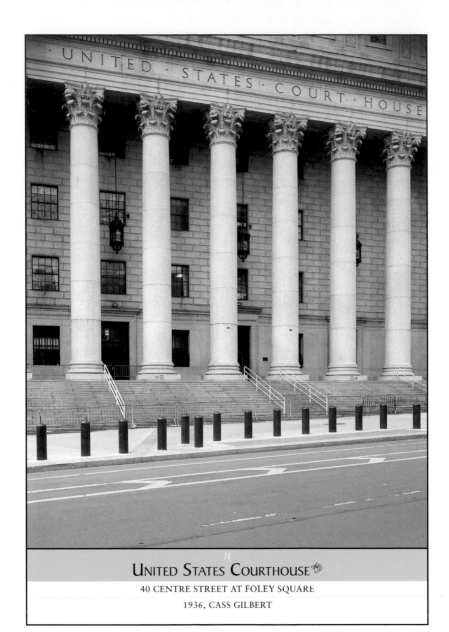

UNITED STATES COURTHOUSE 78

40 CENTRE STREET AT FOLEY SQUARE

1936, CASS GILBERT

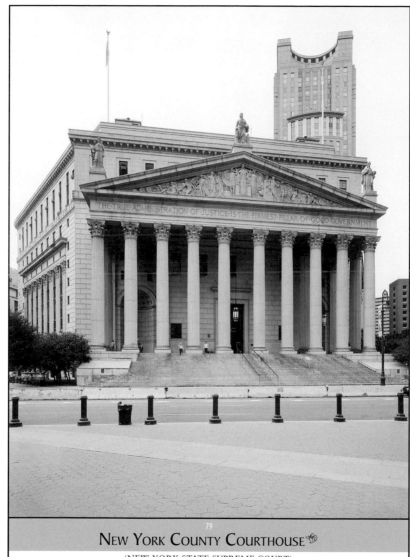

THE·TRUE·ADMINISTRATION·OF·JUSTICE·IS·THE·FIRMEST·PILLAR·OF·GOOD·GOVERNMENT

79
NEW YORK COUNTY COURTHOUSE

(NEW YORK STATE SUPREME COURT)
60 CENTRE STREET AT FOLEY SQUARE

1927, GUY LOWELL

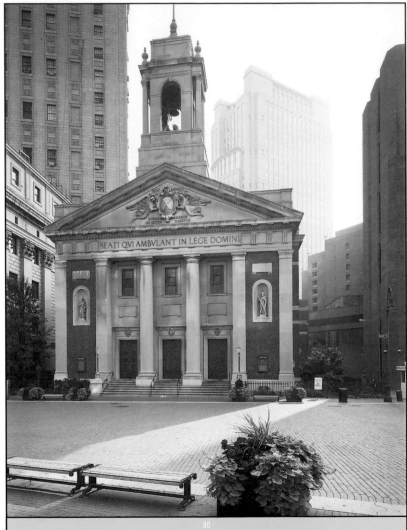

ST. ANDREW'S CHURCH

EAST OF FOLEY SQUARE ON CARDINAL HAYES PLACE AT DUANE STREET

1939, MAGINNIS & WALSH AND ROBERT J. REILLY

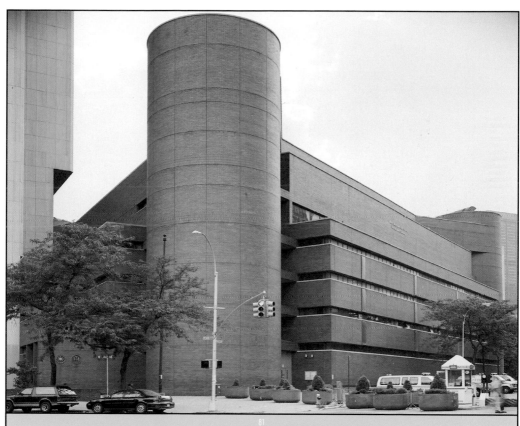

MURRAY BERGTRAUM HIGH SCHOOL

411 PEARL STREET AT MADISON STREET

1976, GRUZEN & PARTNERS

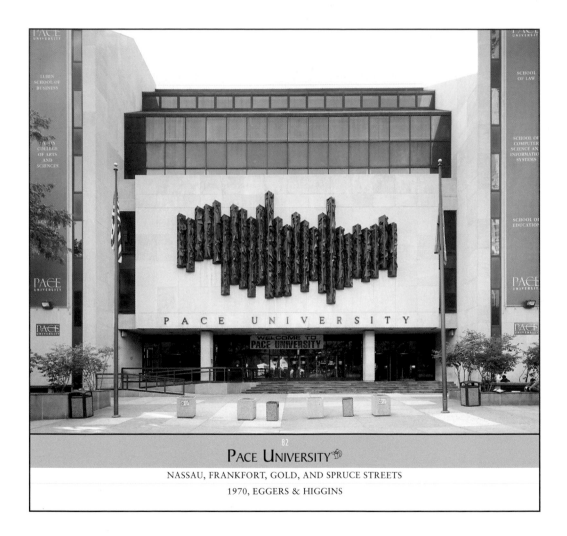

PACE UNIVERSITY

NASSAU, FRANKFORT, GOLD, AND SPRUCE STREETS

1970, EGGERS & HIGGINS

◆ SEAPORT AND CIVIC CENTER ◆

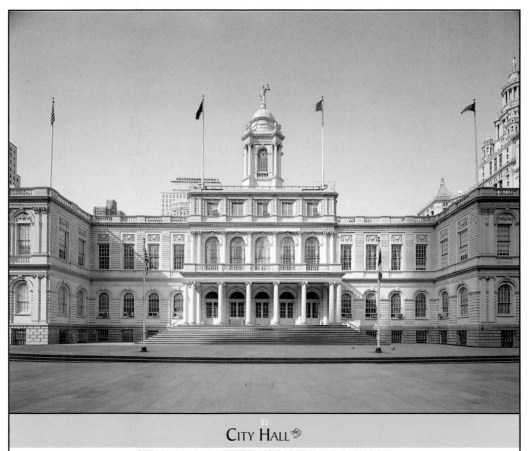

83

CITY HALL

CITY HALL PARK BETWEEN BROADWAY AND PARK ROW

1812, JOSEPH FRANCOIS MANGIN AND JOHN MCCOMB, JR.

Home Life Insurance Company Building

253 BROADWAY
BETWEEN MURRAY AND WARREN STREETS

1894, NAPOLEON LE BRUN & SON

85
CRIMINAL COURTS BUILDING AND MEN'S HOUSE OF DETENTION

100 CENTRE STREET
BETWEEN LEONARD AND WHITE STREETS

1939, HARVEY WILEY CORBETT AND CHARLES B. MEYERS

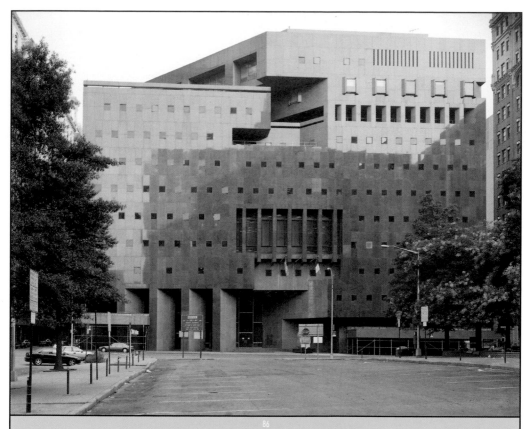

NEW YORK CITY FAMILY COURT

60 LAFAYETTE STREET
BETWEEN LEONARD AND FRANKLIN STREETS

1975, HAINES, LUNDBERG & WAEHLER

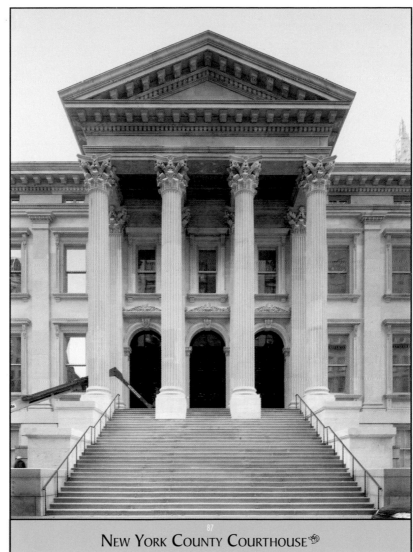

87

New York County Courthouse

52 CHAMBERS STREET
BETWEEN BROADWAY AND CENTRE STREET

1872, JOHN KELLUM AND THOMAS LITTLE

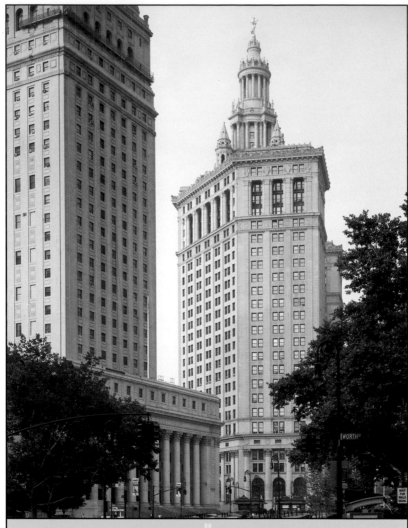

MUNICIPAL BUILDING 🖐

ONE CENTRE STREET

1914, WILLIAM KENDALL OF MCKIM, MEAD & WHITE

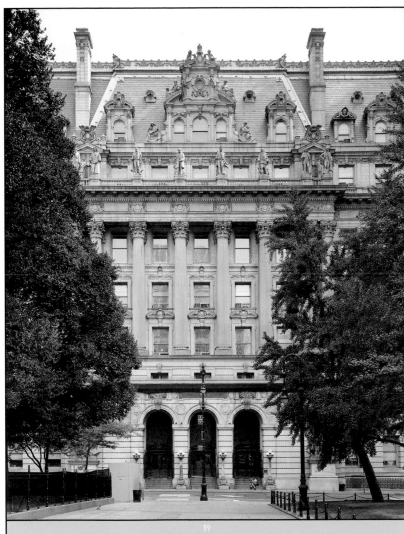

SURROGATE'S COURT/HALL OF RECORDS

31 CHAMBERS STREET AT CENTRE STREET
1907, JOHN ROCHESTER THOMAS AND

HORGAN & SLATTERY

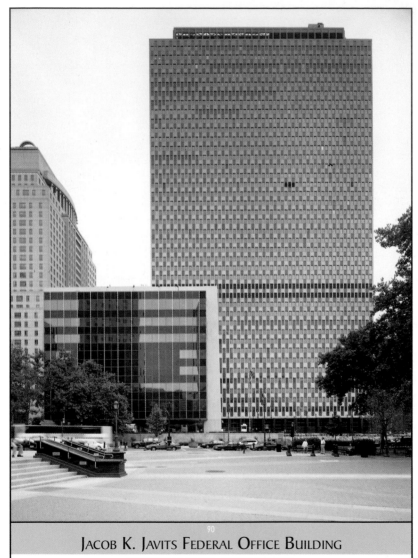

JACOB K. JAVITS FEDERAL OFFICE BUILDING

26 FEDERAL PLAZA, FOLEY SQUARE,
BETWEEN DUANE AND WORTH STREETS

1969, ALFRED EASTON POOR, KAHN & JACOBS AND EGGERS & HIGGINS

Chinatown and the Lower East Side

After the 1850s, when Chinese men began arriving from San Francisco, Chinatown grew up as an extension of the Lower East Side—the traditional gathering point for newly arrived immigrants of many cultures. Thousands followed, and eventually it became America's largest concentrated Chinese community. While other ethnic groups have moved on to other neighborhoods (these blocks were originally an Irish community), the Chinese have stayed, only beginning to spread out after the relaxation of immigration quotas allowed more people to enter the U.S. from Asia. The Lower East Side reflects the influences—and showcases the wonderful cuisines—of dozens of ethnic groups, including Italians and Eastern European Jews, and is still the first stop for many on their way to realizing the American Dream.

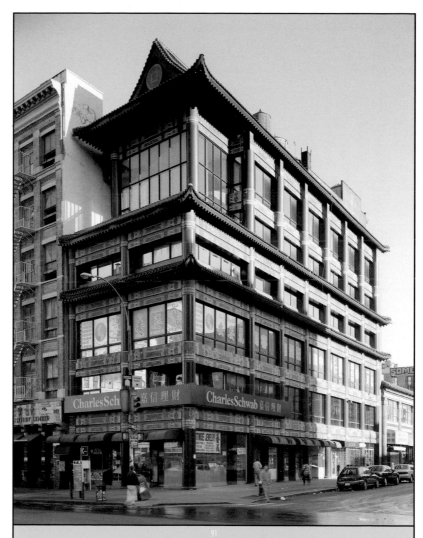

91
Hong Kong Bank Building
241 CANAL STREET AT CENTRE STREET
1983

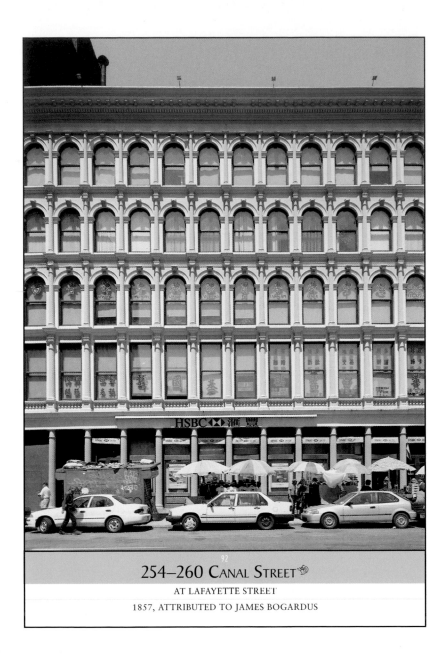

254–260 CANAL STREET

AT LAFAYETTE STREET

1857, ATTRIBUTED TO JAMES BOGARDUS

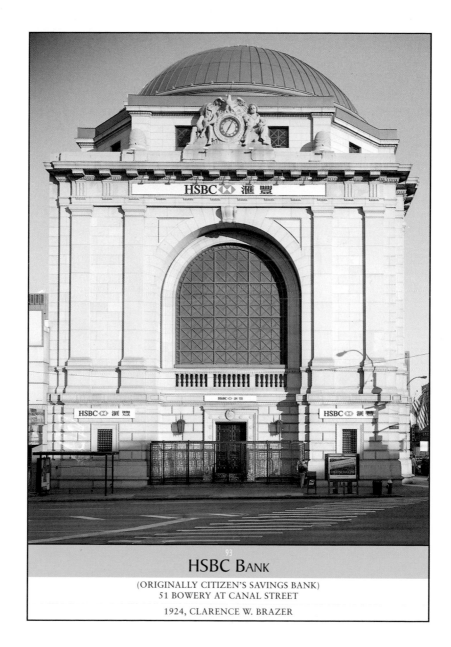

⁹³

HSBC BANK

(ORIGINALLY CITIZEN'S SAVINGS BANK)
51 BOWERY AT CANAL STREET

1924, CLARENCE W. BRAZER

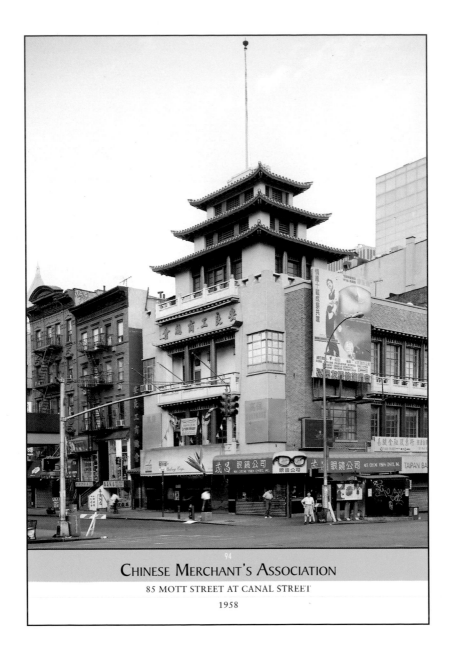

94

Chinese Merchant's Association

85 MOTT STREET AT CANAL STREET

1958

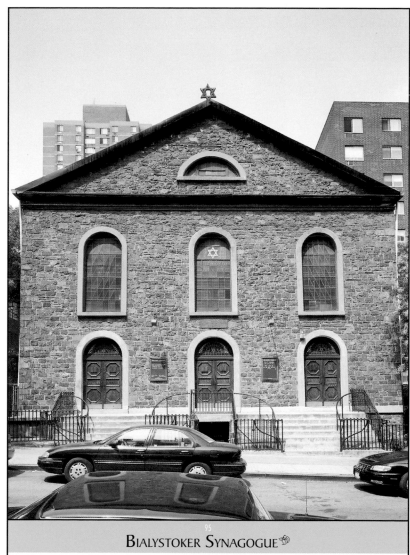

95

BIALYSTOKER SYNAGOGUE

7–13 BIALYSTOKER PLACE
BETWEEN GRAND AND BROOME STREETS

1826

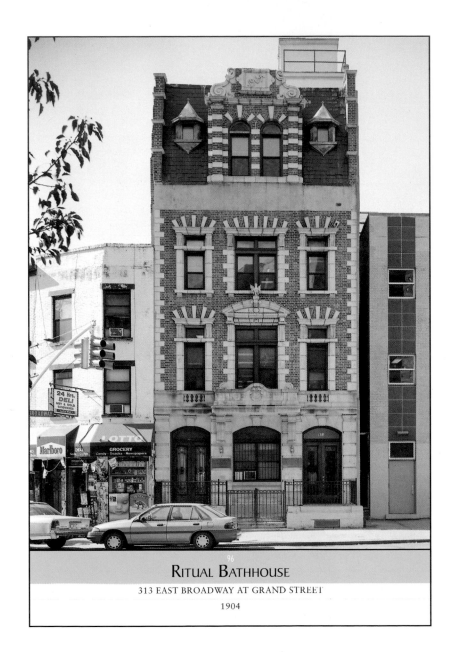

96

RITUAL BATHHOUSE

313 EAST BROADWAY AT GRAND STREET

1904

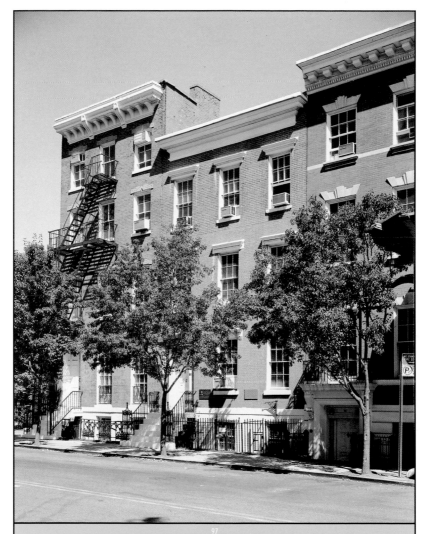

HENRY STREET SETTLEMENT

263, 265, AND 267 HENRY STREET, BETWEEN MONTGOMERY AND GOUVERNEUR

1827 AND 1834. NUMBER 267'S NEW FAÇADE, 1910, BUCHMAN AND FOX.
RESTORATION, 1996, J. LAWRENCE JONES ASSOCIATES

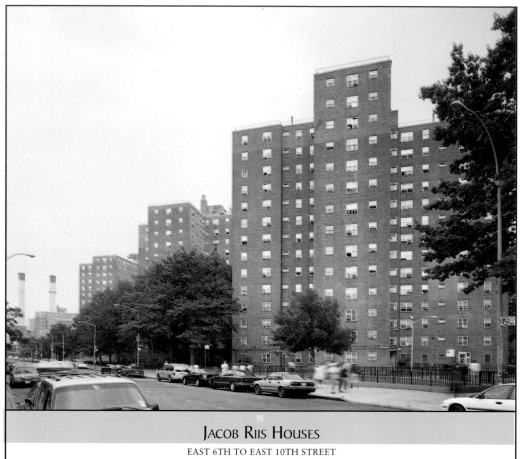

98
Jacob Riis Houses

EAST 6TH TO EAST 10TH STREET
EAST OF AVENUE D

1949, JAMES MACKENZIE, SIDNEY STRAUSS AND WALKER & GILLETTE

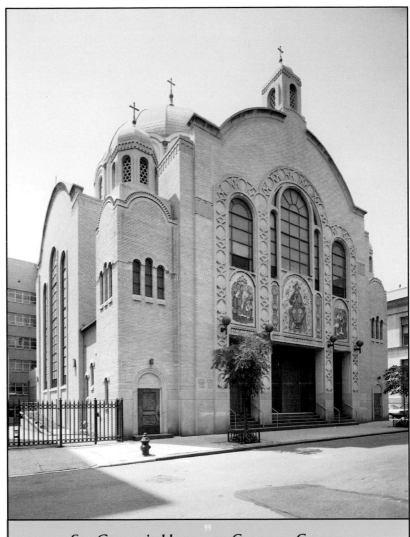

99

St. George's Ukrainian Catholic Church

16–20 EAST 7TH STREET
BETWEEN COOPER SQUARE AND SECOND AVENUE

1977, APOLLINAIRE OSADACA

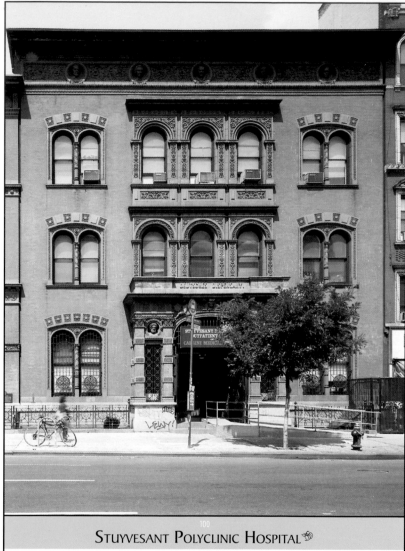

STUYVESANT POLYCLINIC HOSPITAL

137 SECOND AVENUE
BETWEEN ST. MARK'S PLACE AND EAST 9TH STREET

1884, WILLIAM SCHICKEL

◆ CHINATOWN AND THE LOWER EAST SIDE ◆

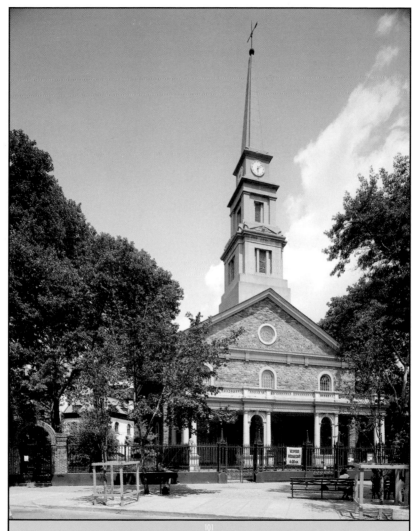

101

ST. MARK'S-IN-THE-BOWERY CHURCH

EAST 10TH STREET AT SECOND AVENUE

1828, ITHIEL TOWN

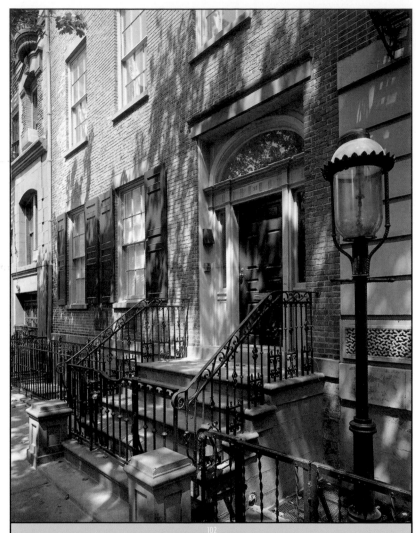

STUYVESANT-FISH HOUSE

21 STUYVESANT STREET
BETWEEN SECOND AND THIRD AVENUES

1804

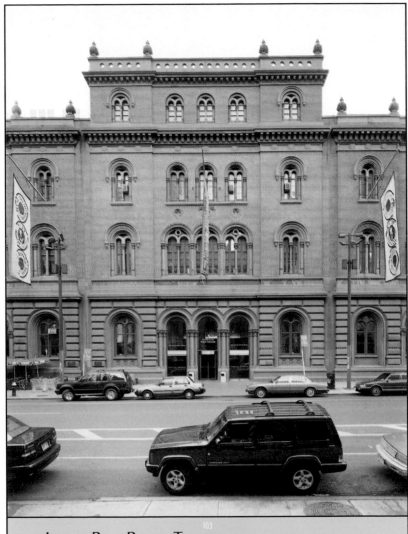

103

JOSEPH PAPP PUBLIC THEATER (ORIGINALLY ASTOR LIBRARY)

425 LAFAYETTE STREET; BETWEEN EAST 4TH STREET AND ASTOR PLACE

1853, ALEXANDER SAELTZER. ADDITIONS, 1869, GRIFFITH THOMAS
AND 1881, THOMAS STENT. THEATER CONVERSION, 1976, GEORGIO CAVAGLIERI

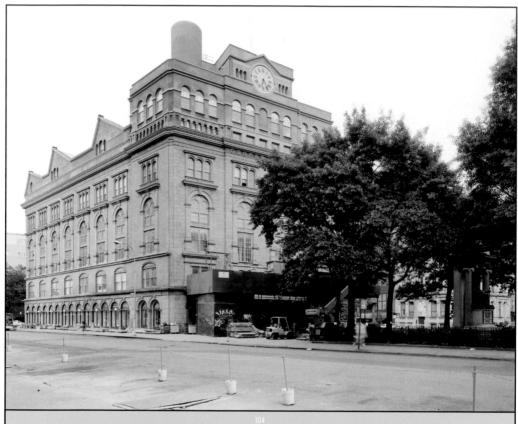

104

Cooper Union Foundation Building 🐦

COOPER SQUARE
EAST 7TH STREET TO ASTOR PLACE; FOURTH AVENUE TO THE BOWERY

1859, FREDERICK A. PETERSON

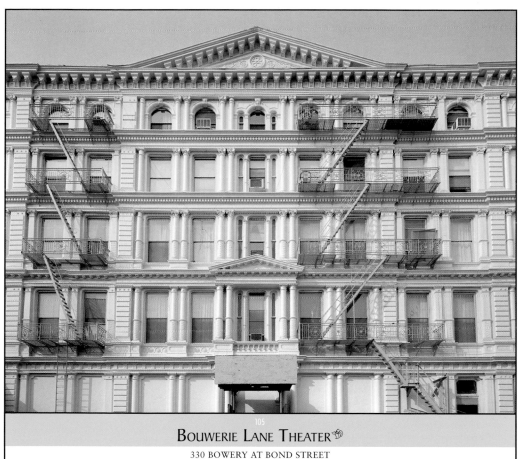

BOUWERIE LANE THEATER

330 BOWERY AT BOND STREET

1874, HENRY ENGLEBERT

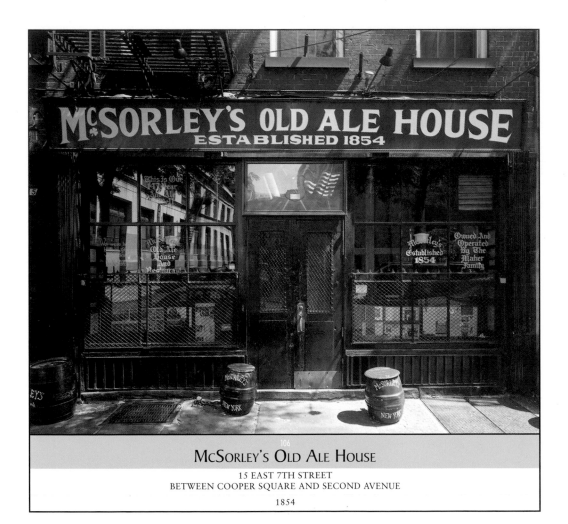

McSorley's Old Ale House

15 EAST 7TH STREET
BETWEEN COOPER SQUARE AND SECOND AVENUE

1854

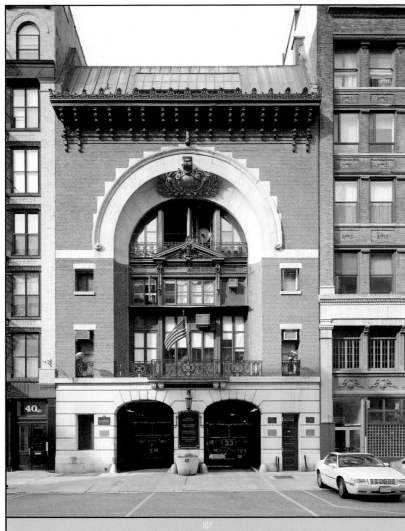

ENGINE COMPANY No. 33

44 GREAT JONES STREET
BETWEEN THE BOWERY AND LAFAYETTE STREET

1899, FLAGG & CHAMBERS

SoHo and Tribeca

These trendy residential enclaves, the area south of Houston Street now called SoHo and the triangle below Canal Street nicknamed Tribeca, were manufacturing districts until recent times. In fact, it was illegal to live in SoHo in the sixties, when artists first began to reclaim the loft buildings there, and city inspectors were dispatched to find and evict them. The squatters were adept at concealing their presence, though, until the authorities began looking for plants in the windows. New Yorkers can't resist bringing the outdoors into their homes, and it proved to be the undoing of many of the illegal tenants. Taking up residence was finally legalized and even encouraged. It worked wonders for the tax base, and now these areas are among the most desireable, the trendiest, and the most expensive in which to live.

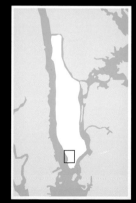

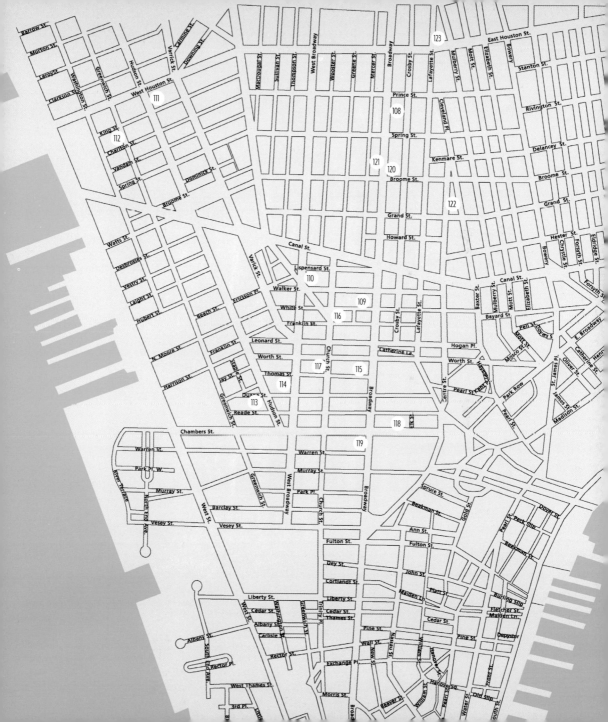

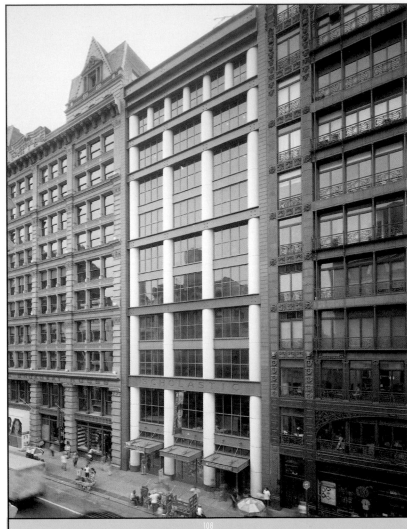

Scholastic Building

557 BROADWAY BETWEEN PRINCE AND SPRING

2001, ALDO ROSSI AND GENSLER ASSOCIATES

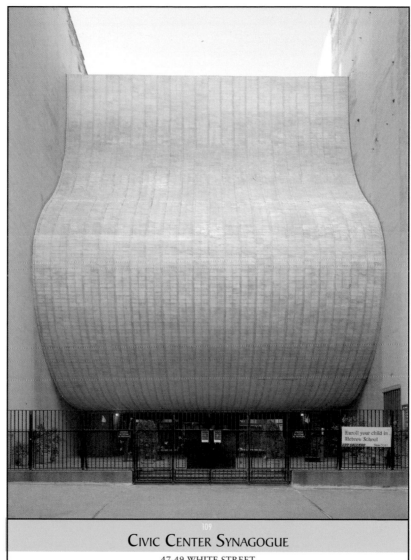

109

Civic Center Synagogue

47-49 WHITE STREET
BETWEEN BROADWAY AND CHURCH STREETS

1967, WILLIAM N. BREGER ASSOCIATES

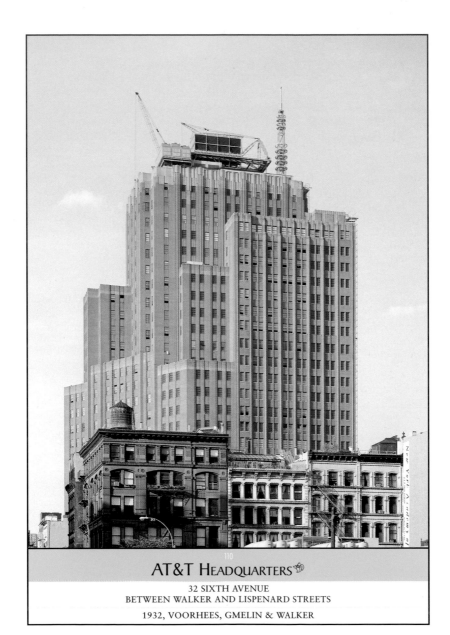

AT&T Headquarters

**32 SIXTH AVENUE
BETWEEN WALKER AND LISPENARD STREETS**

1932, VOORHEES, GMELIN & WALKER

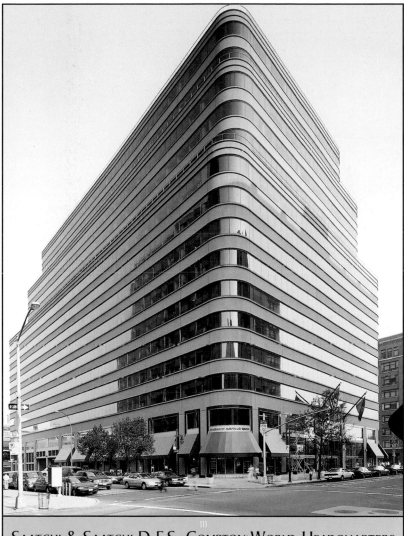

SAATCHI & SAATCHI D.F.S. COMPTON WORLD HEADQUARTERS

375 HUDSON STREET, BETWEEN KING AND WEST HOUSTON STREETS

1987, SKIDMORE, OWINGS & MERRILL, LEE HARRIS POMEROY & ASSOCIATES,
EMERY ROTH & ASSOCIATES

Charlton-King-Vandam Historic District 🍑

King Street Between Sixth Avenue and Varick Street

1820–1849

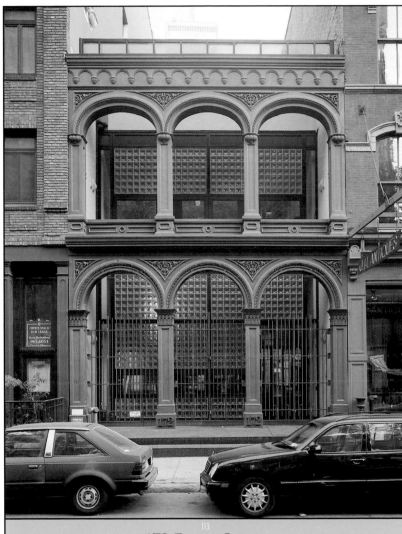

172 DUANE STREET

BETWEEN HUDSON AND GREENWICH STREETS

1872, JACOB WEBER
REMODELED, 1994, V. POLINELLI

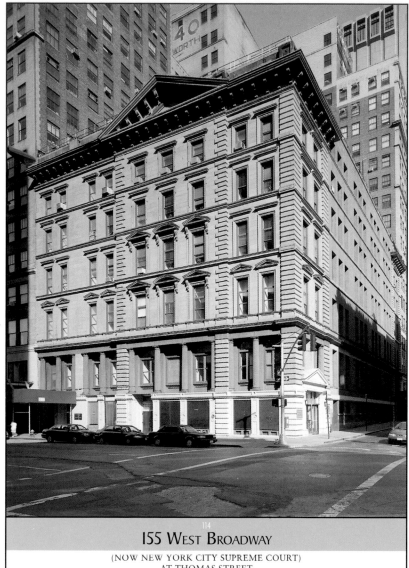

155 West Broadway

(NOW NEW YORK CITY SUPREME COURT)
AT THOMAS STREET

1865, JARDINE, HILL & MURDOCK

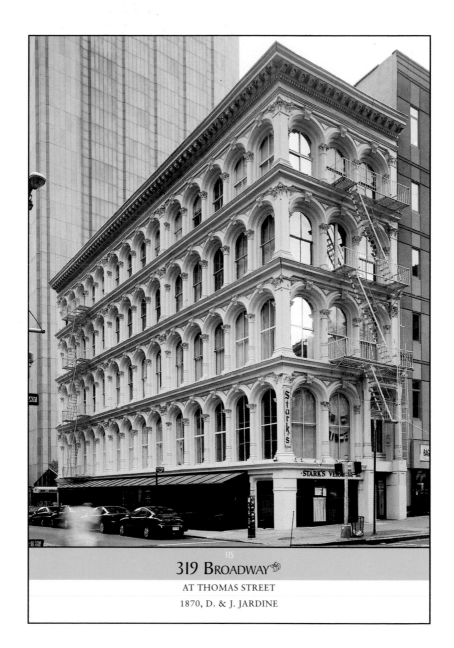

319 Broadway

AT THOMAS STREET

1870, D. & J. JARDINE

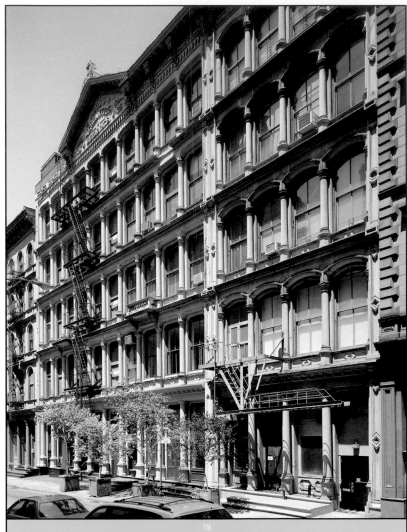

116
36–57 WHITE STREET

BETWEEN CHURCH STREET AND BROADWAY

1861–65, VARIOUS ARCHITECTS,
INCLUDING JOHN KELLUM & SON

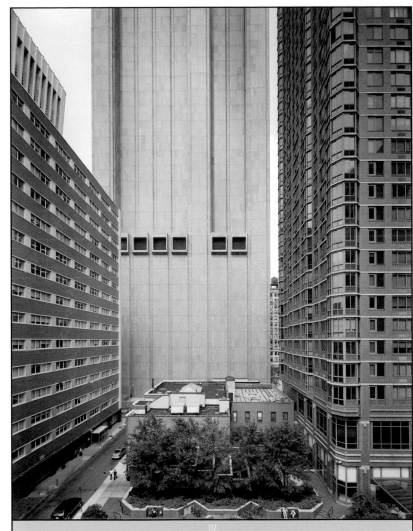

117
AT&T LONG LINES BUILDING

CHURCH STREET
BETWEEN THOMAS AND WORTH STREETS

1974, JOHN CARL WARNECKE & ASSOCIATES

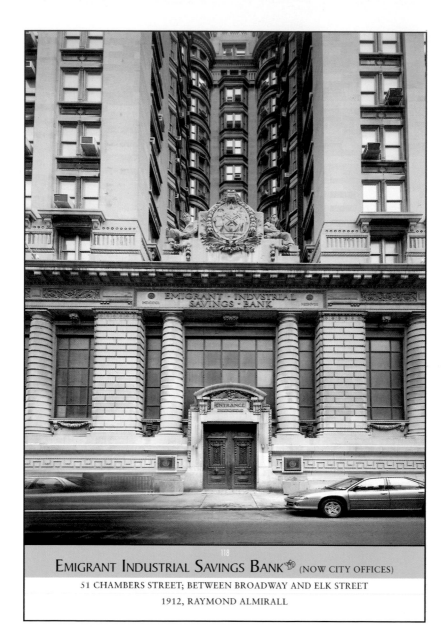

118

EMIGRANT INDUSTRIAL SAVINGS BANK (NOW CITY OFFICES)

51 CHAMBERS STREET; BETWEEN BROADWAY AND ELK STREET

1912, RAYMOND ALMIRALL

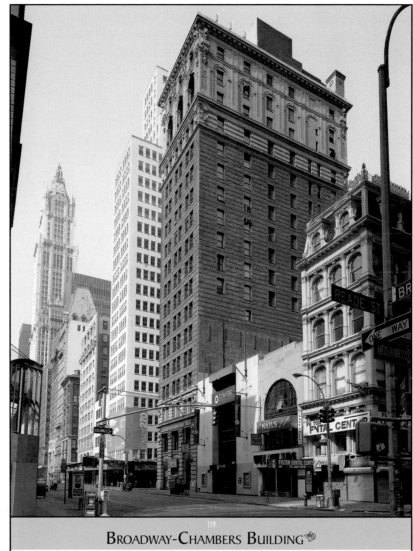

Broadway-Chambers Building

277 BROADWAY AT CHAMBERS STREET

1900, CASS GILBERT

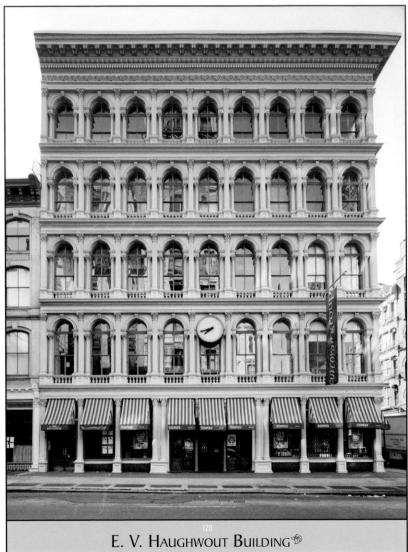

120

E. V. Haughwout Building

488–492 BROADWAY AT BROOME STREET

1857, JOHN GAYNOR
RESTORED, 1999, JOSEPH PELL LOMBARDI

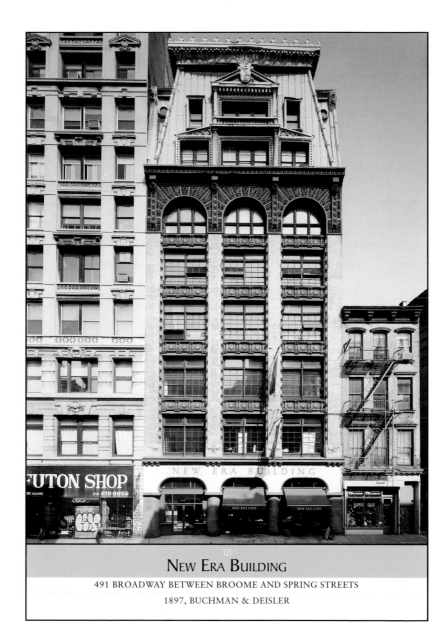

121
New Era Building

491 BROADWAY BETWEEN BROOME AND SPRING STREETS

1897, BUCHMAN & DEISLER

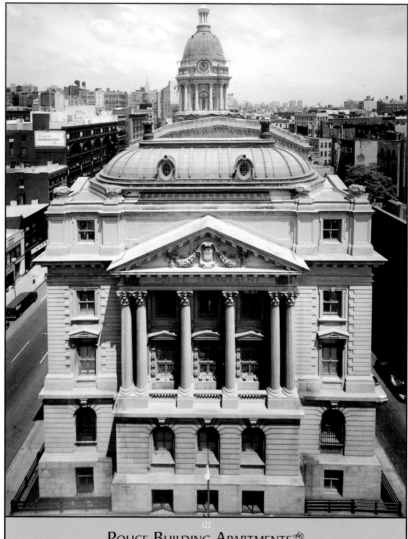

POLICE BUILDING APARTMENTS

240 CENTRE STREET

1909, HOPPIN & KOEN; APARTMENT CONVERSION, 1988, EHRENKRANZ GROUP & ECKSTUT

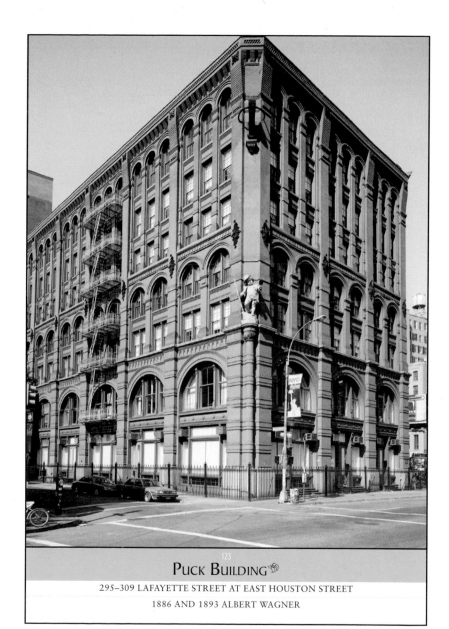

PUCK BUILDING

295–309 LAFAYETTE STREET AT EAST HOUSTON STREET
1886 AND 1893 ALBERT WAGNER

Greenwich Village

On New Year's Eve in 1916, a band of self-styled "Bohemians" climbed to the top of the arch in Washington Square and, after firing cap pistols and releasing balloons, declared the Village a "free republic, independent of uptown." By "uptown," they apparently meant the rest of America, because their proclamation included an appeal to President Wilson for Federal protection as a small country. They needn't have bothered. Greenwich Village has been a place apart since colonial times, a gathering place for free spirits of all kinds, and it still is. Even the streets refuse to follow the rigid grid of the rest of Manhattan. The good news is that you don't need a passport to meander the streets, taking in the diversity of beautiful architecture—including many landmark townhouses—and sampling the restaurants, shops, cafés, and nightlife.

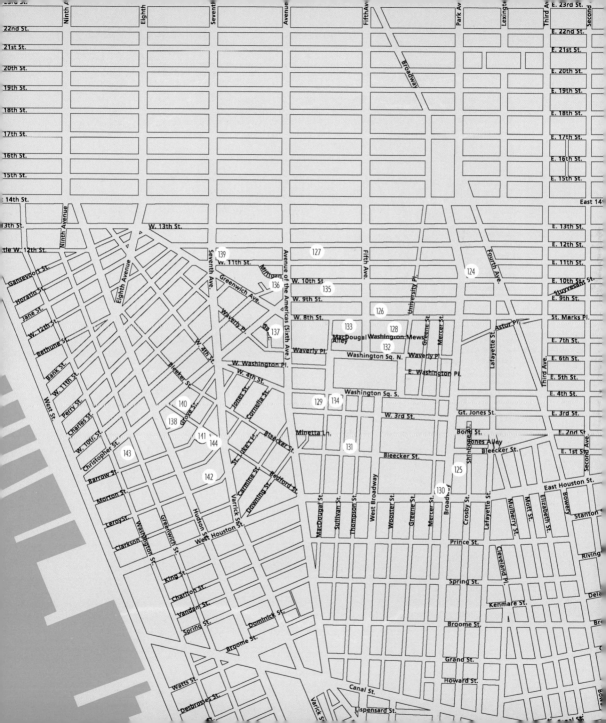

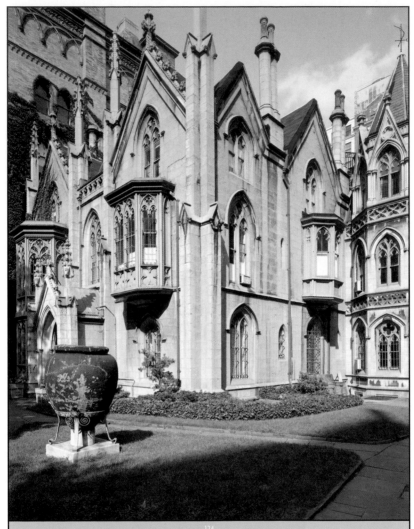

124

GRACE CHURCH

800 BROADWAY AT 10TH STREET

1846, JAMES RENWICK, JR.

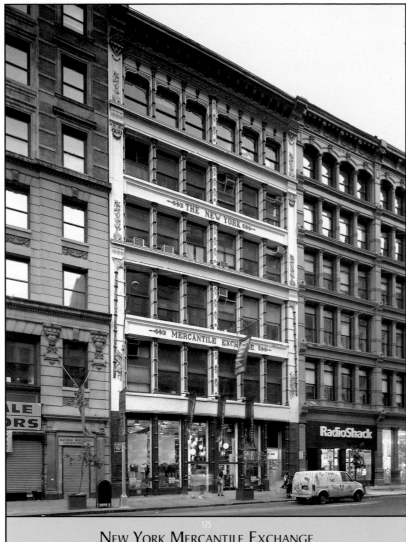

NEW YORK MERCANTILE EXCHANGE

628–639 BROADWAY

1882, HERMAN J. SCHWARZMANN
AND BUCHMAN & DEISLER

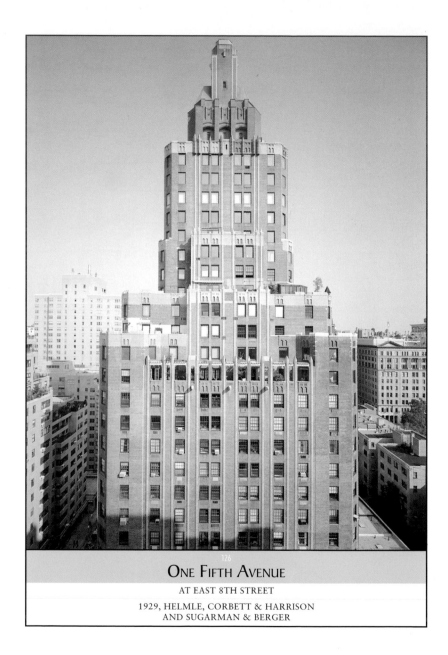

126

One Fifth Avenue

AT EAST 8TH STREET

1929, HELMLE, CORBETT & HARRISON
AND SUGARMAN & BERGER

127

The New School for Social Research

66 WEST 12TH STREET
BETWEEN FIFTH AND SIXTH AVENUES

1930, JOSEPH URBAN

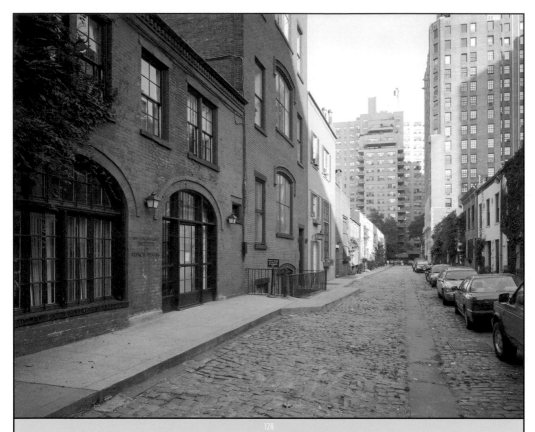

Washington Mews

BEHIND 1–13 WASHINGTON SQUARE NORTH,
BETWEEN FIFTH AVENUE AND UNIVERSITY PLACE

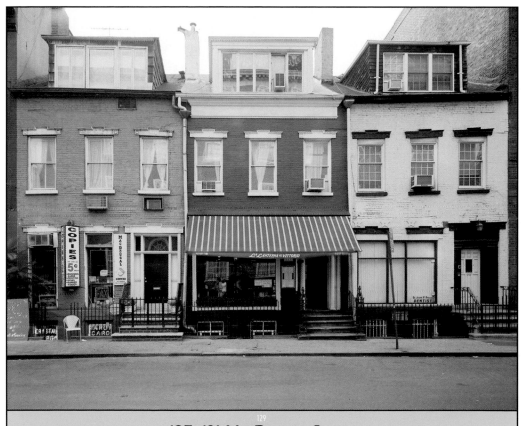

127–131 MacDougal Street

BETWEEN WEST 3RD AND WEST 4TH STREETS

1829

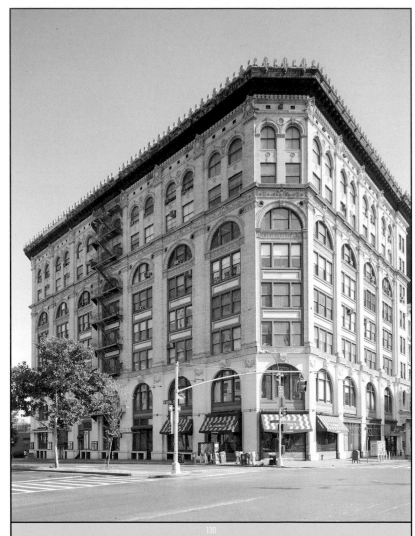

130

CABLE BUILDING

611 BROADWAY AT HOUSTON STREET

1894, MCKIM, MEAD & WHITE

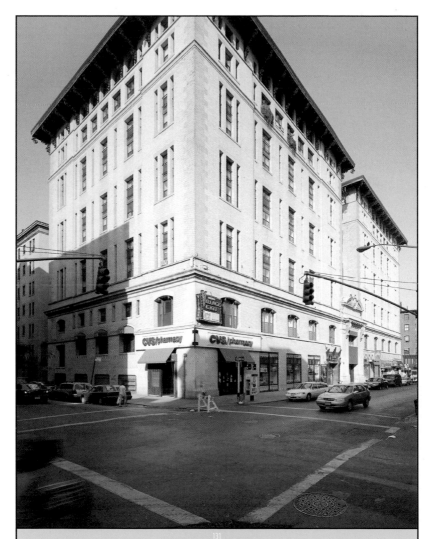

131
THE ATRIUM

160 BLEECKER STREET
BETWEEN SULLIVAN AND THOMPSON STREETS

1896, ERNEST FLAGG

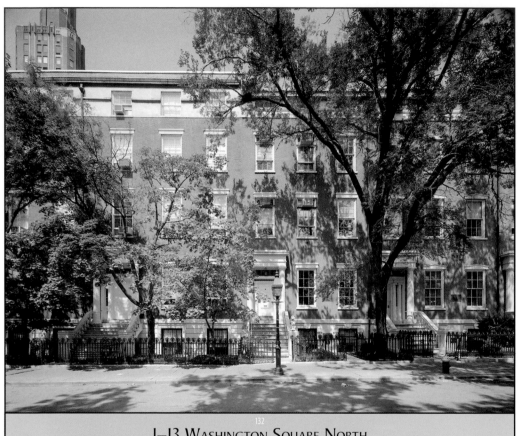

1–13 WASHINGTON SQUARE NORTH

BETWEEN FIFTH AVENUE AND UNIVERSITY PLACE

1833

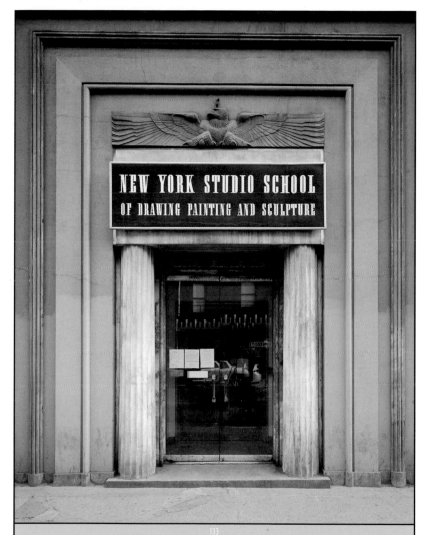

133

New York Studio School of Drawing, Painting and Sculpture

8 WEST 8TH STREET BETWEEN FIFTH AVENUE
AND MACDOUGAL STREET

1838

134

Judson Memorial Church

55 WASHINGTON SQUARE SOUTH

1893, MCKIM, MEAD & WHITE

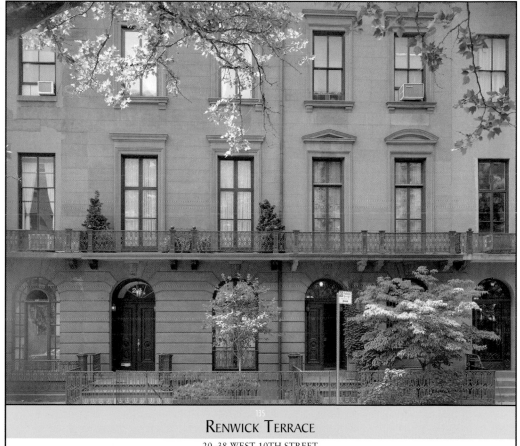

RENWICK TERRACE

20–38 WEST 10TH STREET
BETWEEN FIFTH AND SIXTH AVENUES

1858, ATTRIBUTED TO JAMES RENWICK, JR.

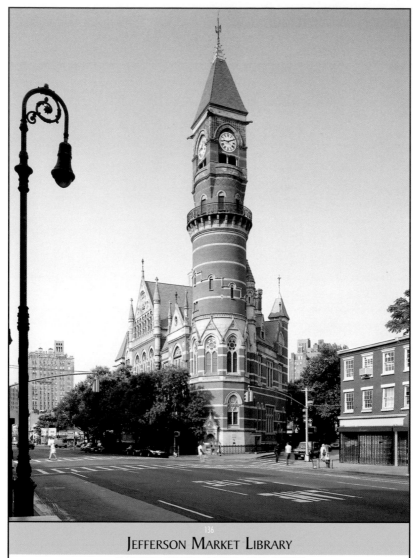

JEFFERSON MARKET LIBRARY

425 SIXTH AVENUE AT WEST 10TH STREET

1877, VAUX & WITHERS
RESTORATION, 1967, GEORGIO CAVAGLIERI

◆ GREENWICH VILLAGE ◆

GAY STREET

BETWEEN CHRISTOPHER STREET AND WAVERLY PLACE

1833–44

4–10 GROVE STREET

BETWEEN BEDFORD AND HUDSON STREETS

1834, JAMES N. WELLS

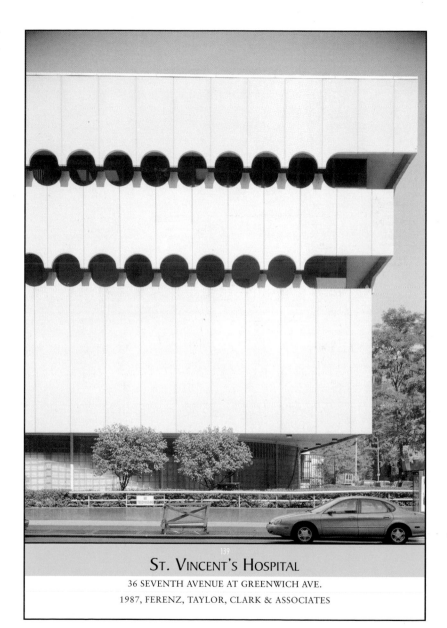

ST. VINCENT'S HOSPITAL

36 SEVENTH AVENUE AT GREENWICH AVE.

1987, FERENZ, TAYLOR, CLARK & ASSOCIATES

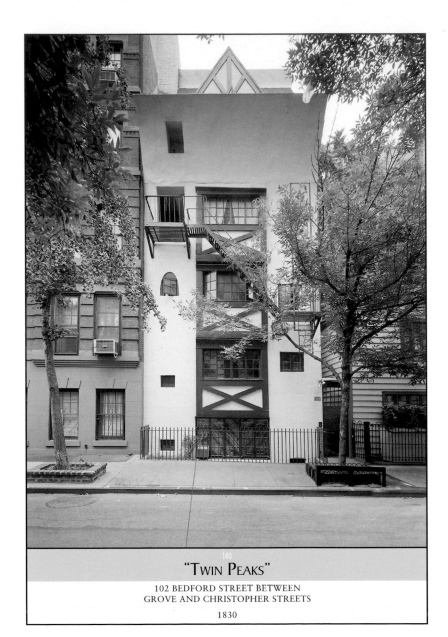

"Twin Peaks"

102 BEDFORD STREET BETWEEN
GROVE AND CHRISTOPHER STREETS

1830

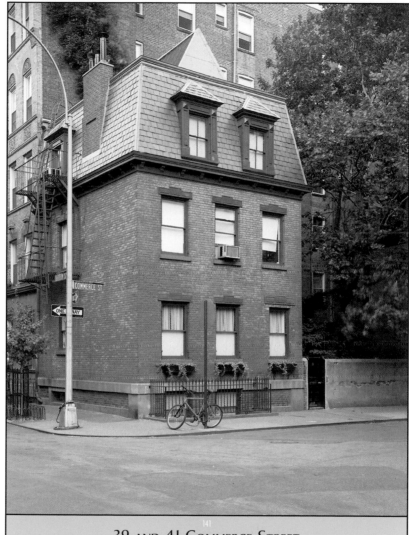

141

39 AND 41 COMMERCE STREET

AT BARROW STREET

1831 AND 1832, D. T. ATWOOD

142

6 St. Luke's Place

LEROY STREET
BETWEEN HUDSON STREET AND SEVENTH AVENUE SOUTH

1880S

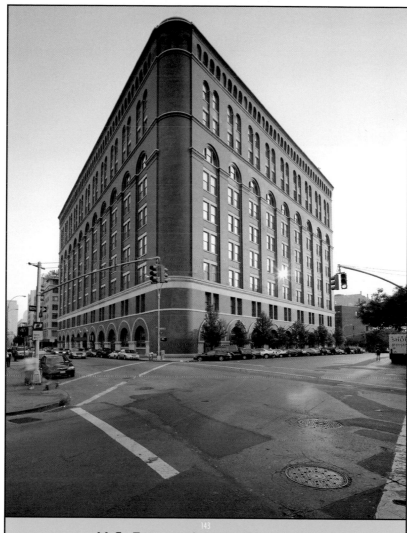

U.S. FEDERAL ARCHIVE BUILDING

666 GREENWICH STREET

1899, WILLOUGHBY J. EDBROOKE,
WILLIAM MARTIN AIKEN, JAMES KNOW TAYLOR

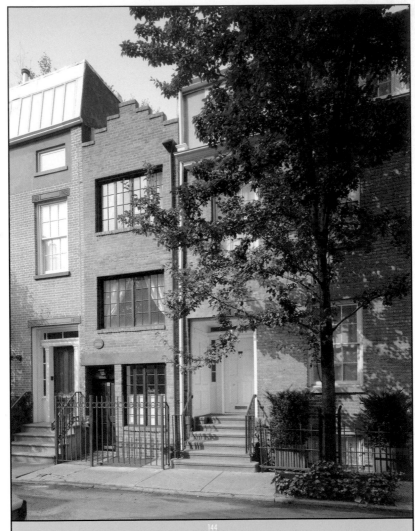

144

"Narrowest House"

75 BEDFORD STREET
BETWEEN MORTON AND COMMERCE STREETS

1873

CHELSEA

Clement Clarke Moore, who wrote the famous poem about the night before Christmas, inherited the estate of his grandfather, Thomas Clarke, and, after expanding it with landfill, divided it into building lots. He sold these with tough stipulations: No alleys or stables were permitted, and all houses had to be built ten feet back from the street. His idyllic dream came crashing down when a railroad, and the attendant warehouses, breweries, and underpaid workers, cut down Eleventh Avenue, and an elevated line cast its shadow along Ninth Avenue. But traces of Clarke's dream still exist here, and both the railroad and the el have passed into history, leaving the neighborhood an interesting mix of residential and industrial properties.

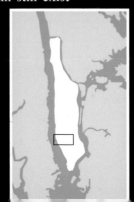

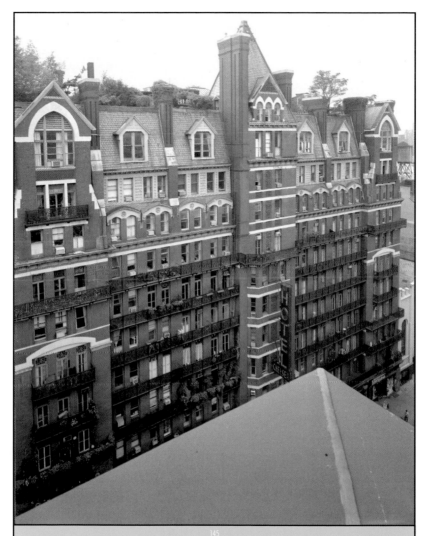

CHELSEA HOTEL

222 WEST 23RD STREET
BETWEEN SEVENTH AND EIGHTH AVENUES,
1885, HUBERT, PIRSSON & CO.

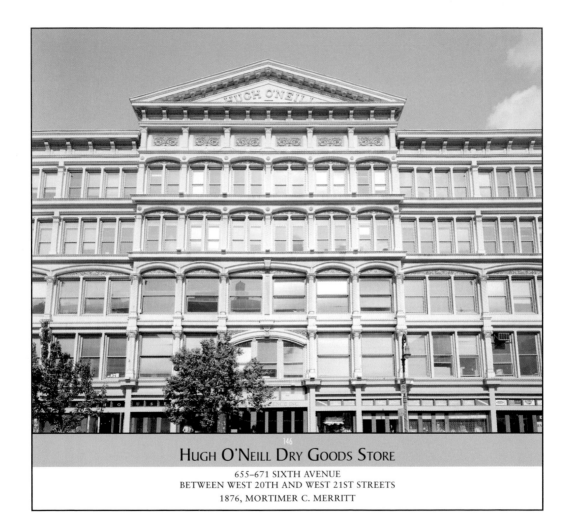

146

Hugh O'Neill Dry Goods Store

655–671 SIXTH AVENUE
BETWEEN WEST 20TH AND WEST 21ST STREETS
1876, MORTIMER C. MERRITT

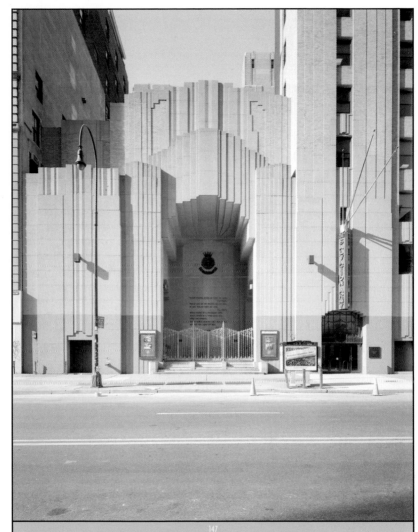

147

Salvation Army Centennial Memorial Temple

120 WEST 14TH STREET
BETWEEN SIXTH AND SEVENTH AVENUES

1930, VOORHEES, GMELIN & WALKER

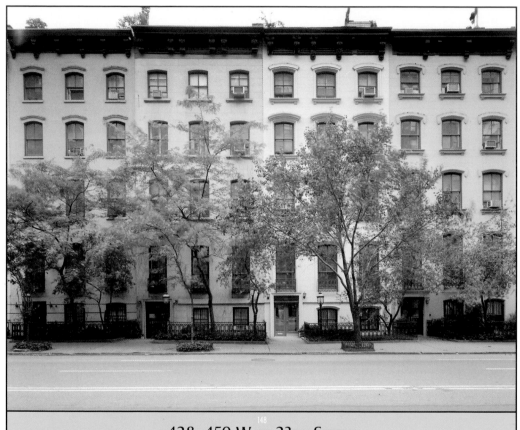

428–450 West 23rd Street

BETWEEN NINTH AND TENTH AVENUES

1860s

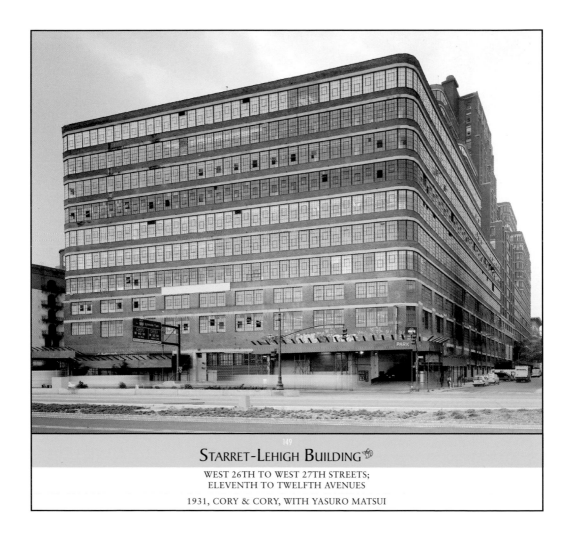

¹⁴⁹

STARRET-LEHIGH BUILDING

WEST 26TH TO WEST 27TH STREETS;
ELEVENTH TO TWELFTH AVENUES

1931, CORY & CORY, WITH YASURO MATSUI

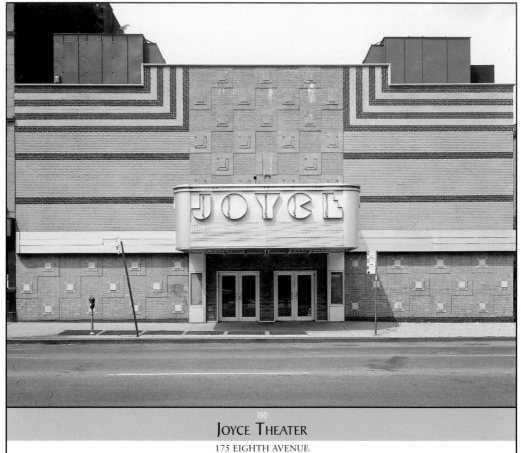

JOYCE THEATER

175 EIGHTH AVENUE
BETWEEN WEST 18TH AND WEST 19TH STREETS

1942, SIMON ZELNIK, (CONVERTED) 1982, HARDY HOLZMAN PFEIFFER ASSOCIATES

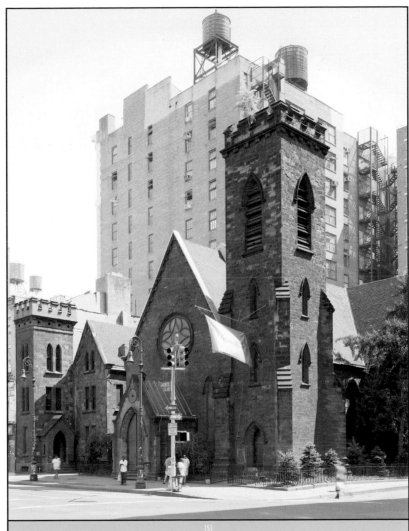

CHURCH OF THE HOLY COMMUNION

49 WEST 20TH STREET AT SIXTH AVENUE

1846, RICHARD UPJOHN

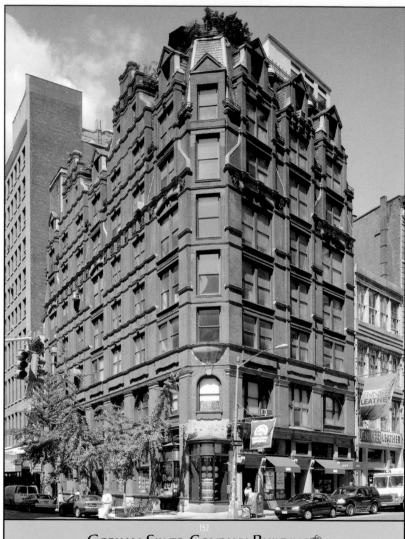

152

GORHAM SILVER COMPANY BUILDING

889–891 BROADWAY AT WEST 19TH STREET

1884, EDWARD H. KENDALL

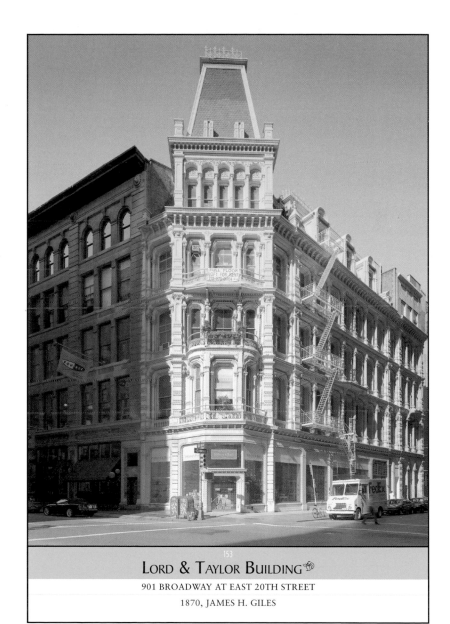

153
LORD & TAYLOR BUILDING 🐚

901 BROADWAY AT EAST 20TH STREET

1870, JAMES H. GILES

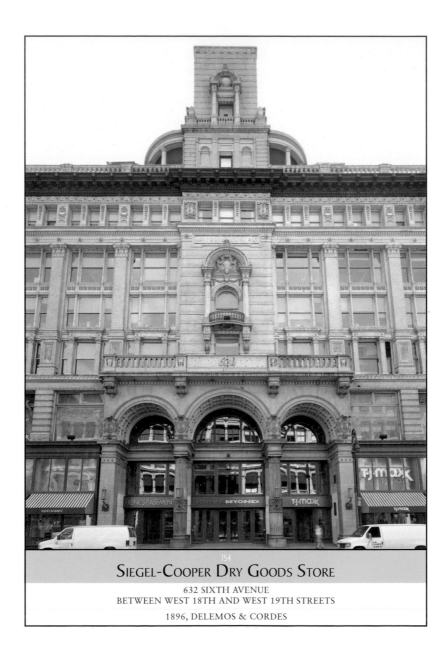

154

Siegel-Cooper Dry Goods Store

632 SIXTH AVENUE
BETWEEN WEST 18TH AND WEST 19TH STREETS

1896, DELEMOS & CORDES

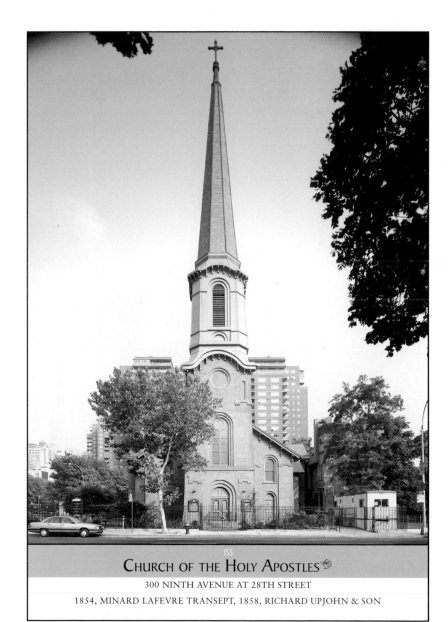

155
Church of the Holy Apostles

300 NINTH AVENUE AT 28TH STREET

1854, MINARD LAFEVRE TRANSEPT, 1858, RICHARD UPJOHN & SON

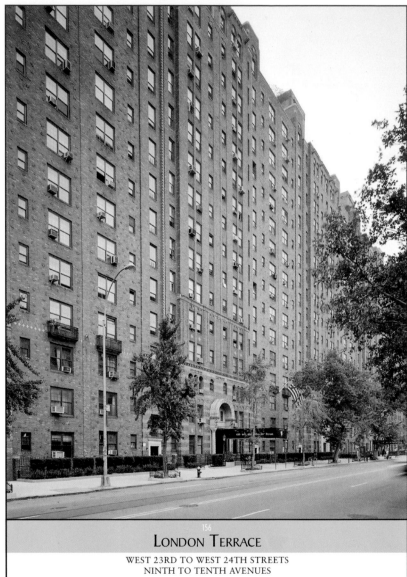

LONDON TERRACE

WEST 23RD TO WEST 24TH STREETS
NINTH TO TENTH AVENUES

1930, FARRAR & WATMAUGH

◆ CHELSEA ◆

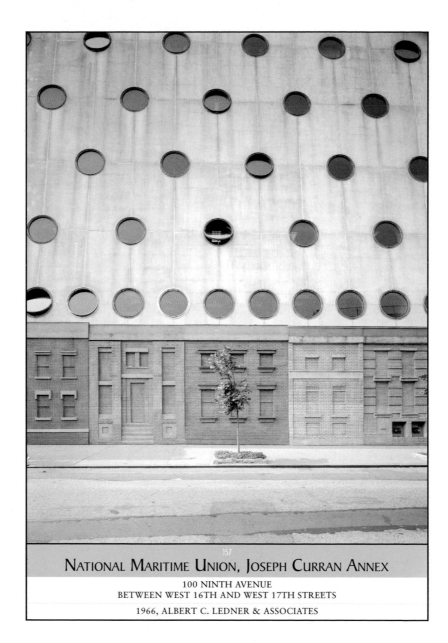

157
NATIONAL MARITIME UNION, JOSEPH CURRAN ANNEX

100 NINTH AVENUE
BETWEEN WEST 16TH AND WEST 17TH STREETS

1966, ALBERT C. LEDNER & ASSOCIATES

GRAMERCY PARK AND KIPS BAY

Gramercy Park was built in the 1830s by real estate developer Samuel Ruggles, who turned a former swamp into one of Manhattan's most exclusive addresses. When he sold sixty-six building lots around the park, the deeds stipulated that only the lot owners could have access to it, and the rule is still in effect. Kips Bay, to Gramercy's northeast, was originally the farm of Jacobus Kip, on the shores of a wide bay in the East River which was used as the beachhead for British troops invading Manhattan during the Revolutionary War. It remained relatively untouched as farmland until after the Civil War, when the bay was filled in and the neighborhood subdivided into building lots.

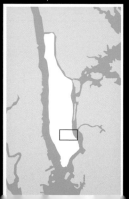

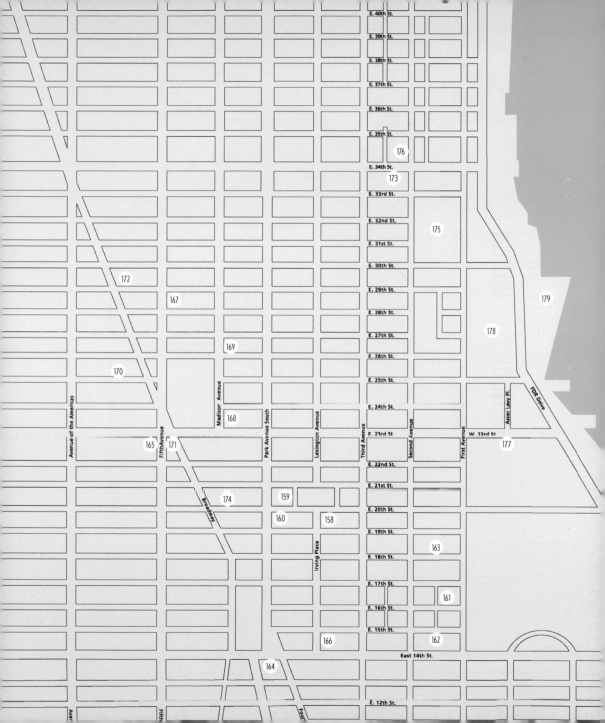

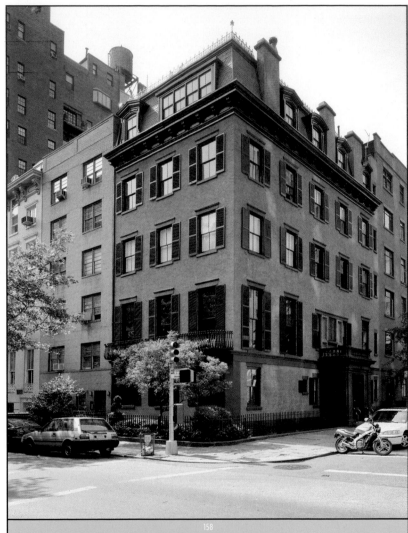

STUYVESANT FISH HOUSE

19 GRAMERCY PARK AT IRVING PLACE

1845

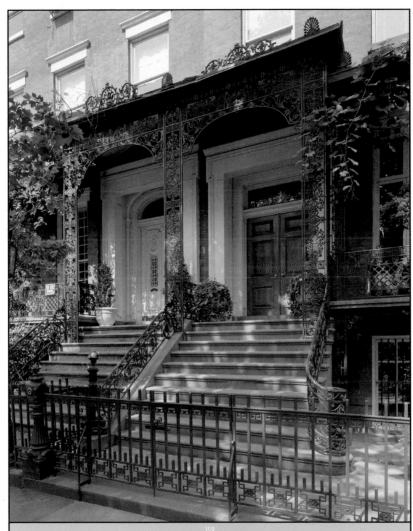

159

3 AND 4 GRAMERCY PARK WEST

BETWEEN EAST 20TH AND EAST 21ST STREETS

1846

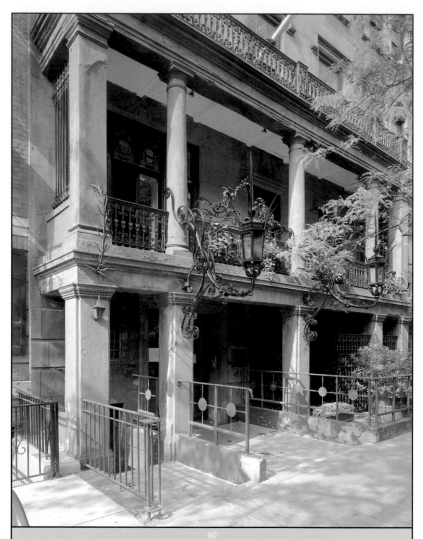

THE PLAYERS

16 GRAMERCY PARK SOUTH
BETWEEN PARK AVENUE SOUTH AND IRVING PLACE
1845, (REMODELED) 1889, STANFORD WHITE

◆ GRAMERCY / KIPS BAY ◆

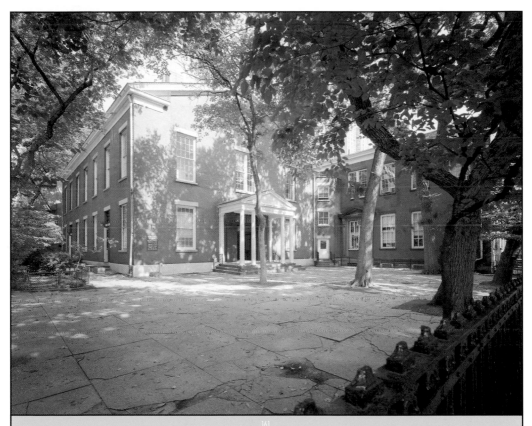

161
FRIENDS MEETING HOUSE AND SEMINARY

226 EAST 16TH STREET AT STUYVESANT SQUARE

1860, CHARLES T. BUNTING

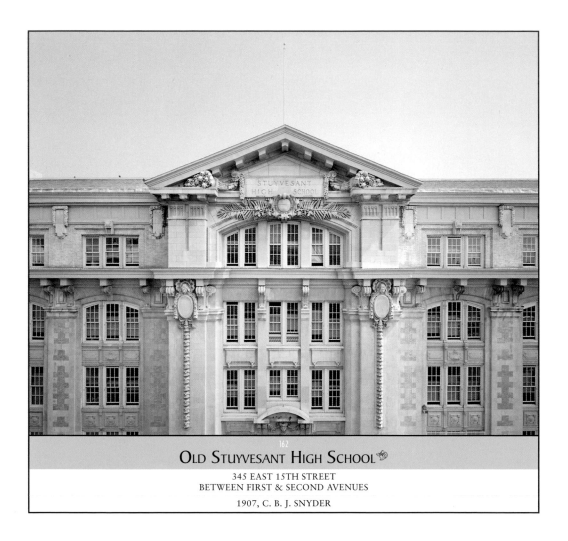

Old Stuyvesant High School 🐝

345 EAST 15TH STREET
BETWEEN FIRST & SECOND AVENUES

1907, C. B. J. SNYDER

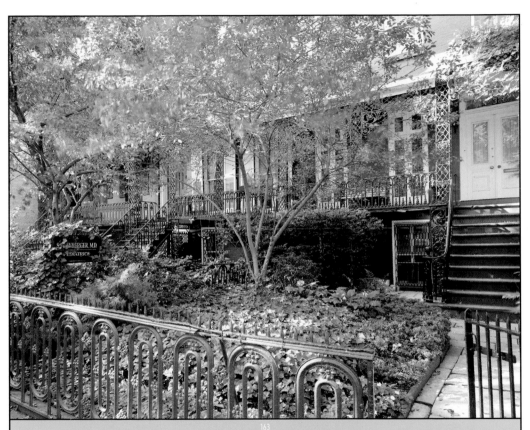

163

326, 328, AND 330 EAST 18TH STREET

BETWEEN FIRST AND SECOND AVENUES

1853

ONE UNION SQUARE SOUTH

14TH STREET BETWEEN FOURTH AVENUE AND BROADWAY

1999, DAVIS BRODY BOND AND SCHUMAN LICHTENSTEIN CLAMAN & EFRON
ARTWALL, KRISTIN JONES AND ANDRE AND ANDREW GINZEL

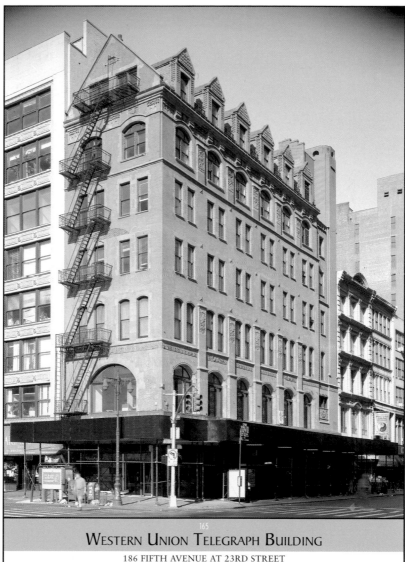

165
WESTERN UNION TELEGRAPH BUILDING

186 FIFTH AVENUE AT 23RD STREET

1884, HENRY J. HARDENBERGH

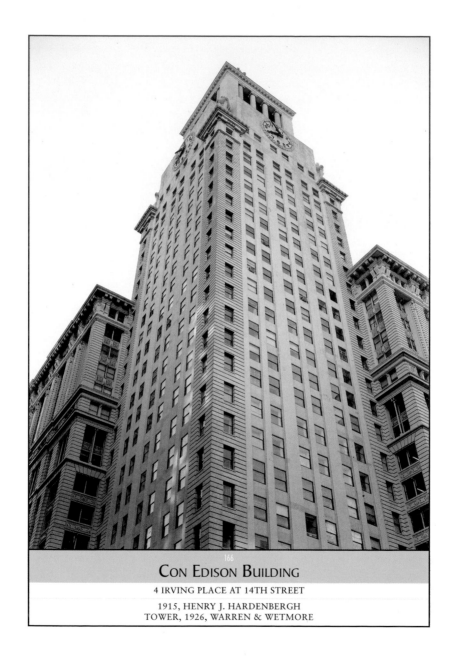

Con Edison Building

4 IRVING PLACE AT 14TH STREET

1915, HENRY J. HARDENBERGH
TOWER, 1926, WARREN & WETMORE

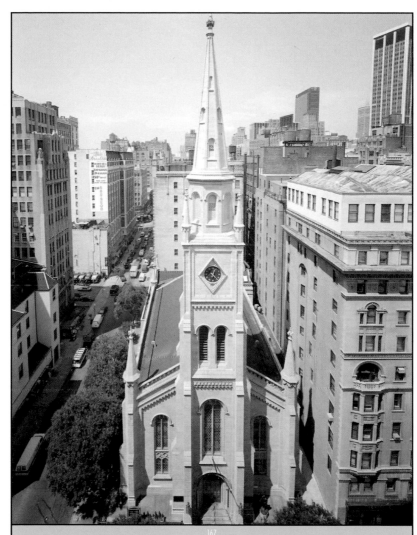

167

MARBLE COLLEGIATE CHURCH

FIFTH AVENUE AT 29TH STREET

1854, SAMUEL A. WARNER

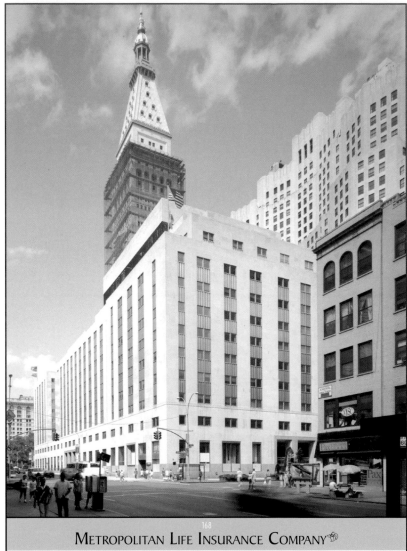

168
Metropolitan Life Insurance Company

ONE MADISON AVENUE AT 23RD STREET

1909, NAPOLEON LEBRUN & SONS

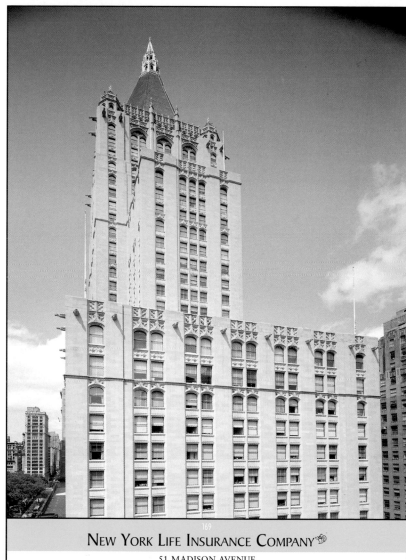

169

NEW YORK LIFE INSURANCE COMPANY

51 MADISON AVENUE
EAST 26TH TO EAST 27TH STREET

1928, CASS GILBERT

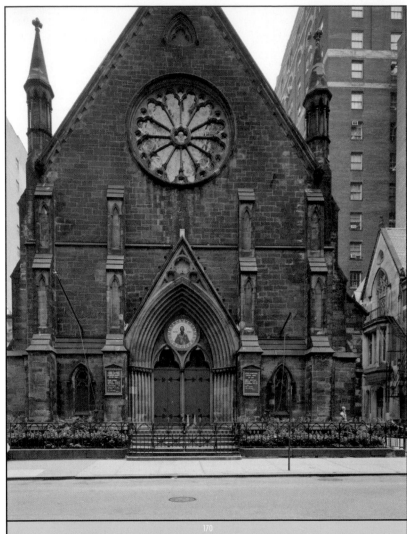

SERBIAN ORTHODOX CATHEDRAL OF ST. SAVA

15 WEST 25TH STREET
BETWEEN FIFTH AND SIXTH AVENUES

1855, RICHARD UPJOHN

◆ GRAMERCY / KIPS BAY ◆

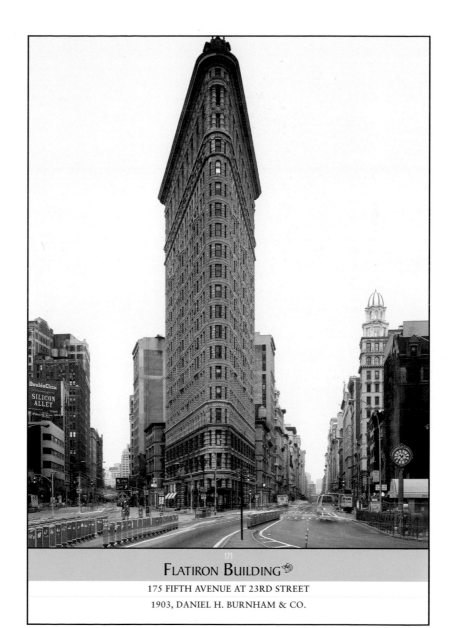

171

FLATIRON BUILDING

175 FIFTH AVENUE AT 23RD STREET

1903, DANIEL H. BURNHAM & CO.

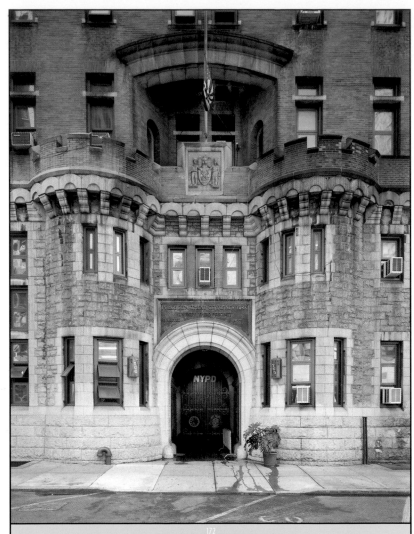

172

GILSEY HOUSE

1200 BROADWAY AT 29TH STREET

1871, STEPHEN D. HATCH

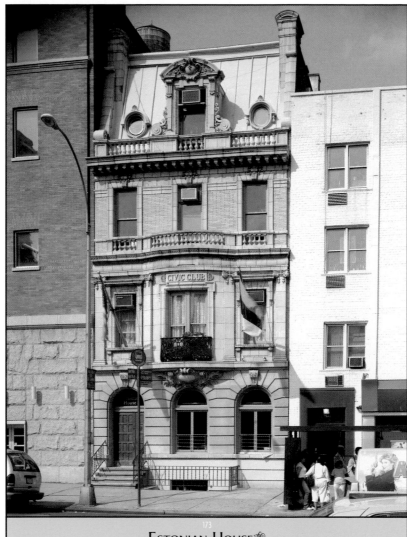

173
Estonian House

243 EAST 34TH STREET
BETWEEN SECOND AND THIRD AVENUES

1899, THOMAS A. GRAY

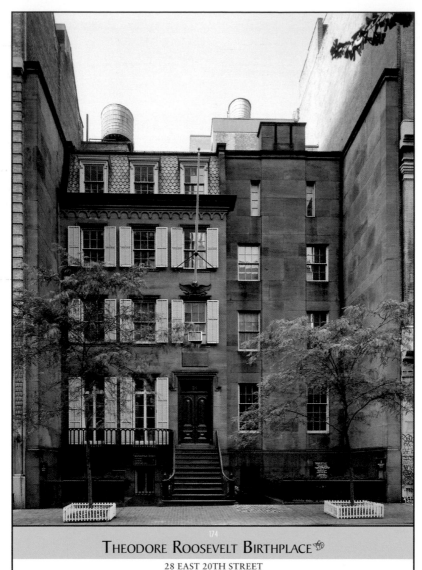

174

THEODORE ROOSEVELT BIRTHPLACE

28 EAST 20TH STREET
BETWEEN BROADWAY AND PARK AVENUE SOUTH

REPLICATED 1923, THEODATE POPE RIDDLE

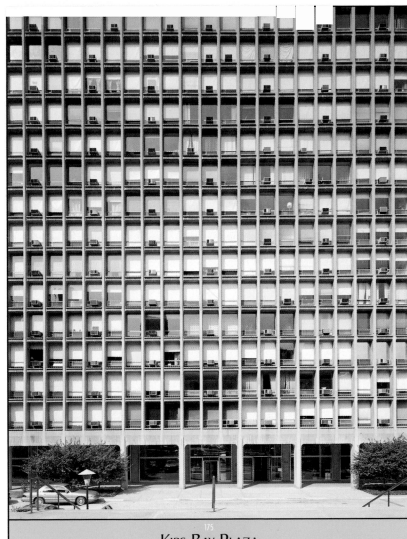

175

KIPS BAY PLAZA

EAST 30TH TO EAST 33RD STREETS
FIRST TO SECOND AVENUES

1963, I. M. PEI & ASSOCIATES

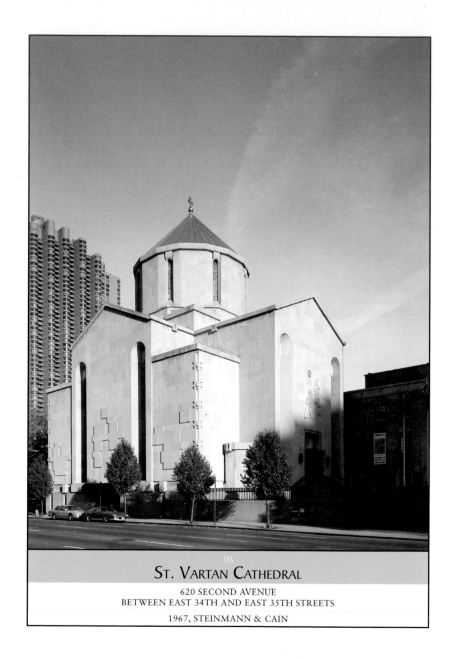

176

St. Vartan Cathedral

620 SECOND AVENUE
BETWEEN EAST 34TH AND EAST 35TH STREETS

1967, STEINMANN & CAIN

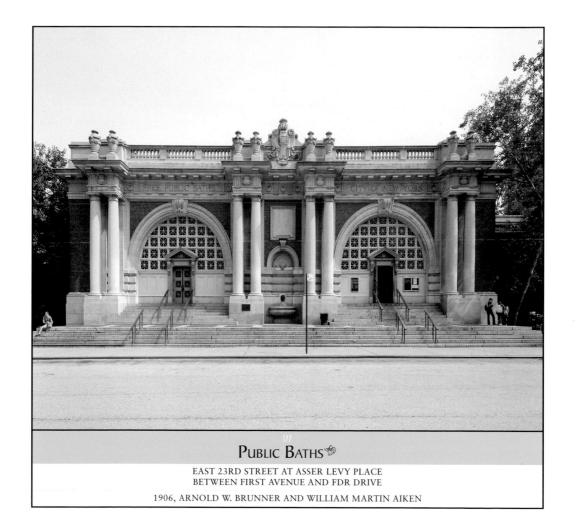

PUBLIC BATHS

EAST 23RD STREET AT ASSER LEVY PLACE
BETWEEN FIRST AVENUE AND FDR DRIVE

1906, ARNOLD W. BRUNNER AND WILLIAM MARTIN AIKEN

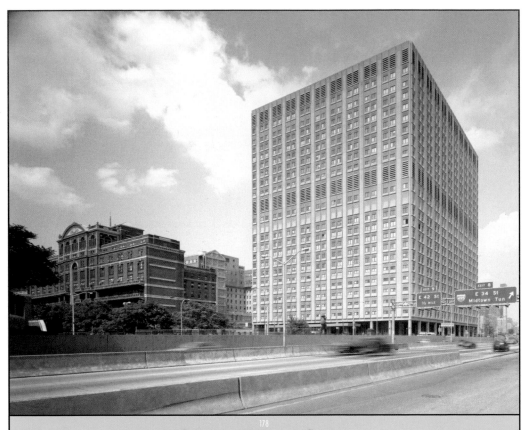

BELLEVUE HOSPITAL CENTER

462 FIRST AVENUE AT 27TH STREET

1908–39, MCKIM, MEAD & WHITE

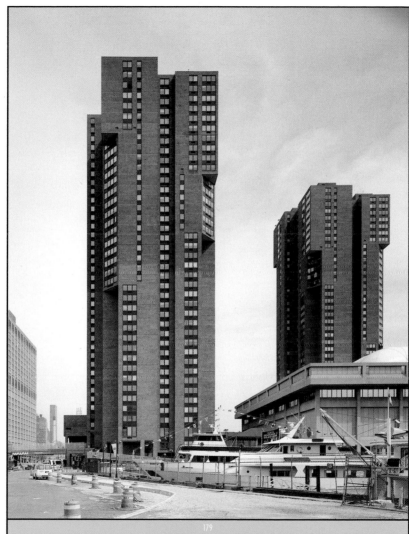

179

Waterside

FDR DRIVE
BETWEEN EAST 25TH AND EAST 30TH STREETS

1974, DAVIS, BRODY & ASSOCIATES

to the United Nations, from Rockefeller Center to the exclusive Fifth-Avenue boutiques. This is the beaten path for a very good reason. If you haven't seen Midtown Manhattan, you haven't seen the world. But it isn't just a mecca for tourists. It is a working, teeming business district, and most of the interesting faces that compete with the buildings for your attention belong to native New Yorkers hurrying to work. Even the most jaded local can't resist looking up at the marvelous surroundings once in awhile.

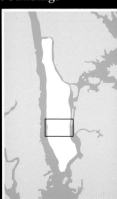

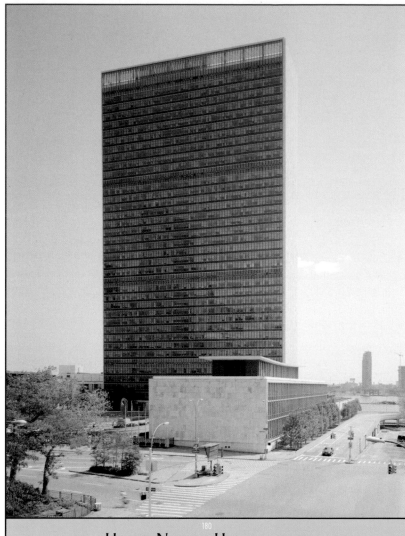

180

United Nations Headquarters

UNITED NATIONS PLAZA (FIRST AVENUE)
BETWEEN EAST 42ND AND EAST 48TH STREETS

1953, INTERNATIONAL ARCHITECTS, WALLACE K. HARRISON, CHAIRMAN

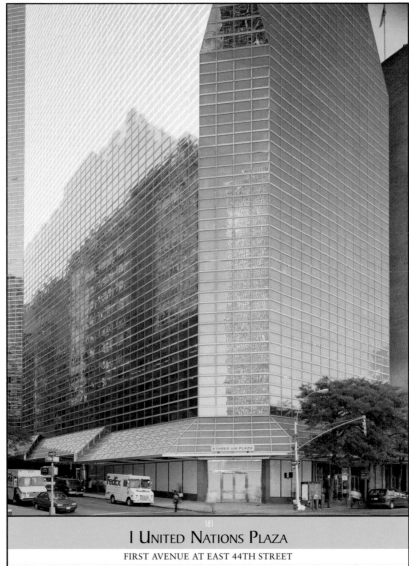

181

1 UNITED NATIONS PLAZA

FIRST AVENUE AT EAST 44TH STREET

1976 AND 1983, KEVIN ROCHE
JOHN DINKELOO & ASSOCIATES

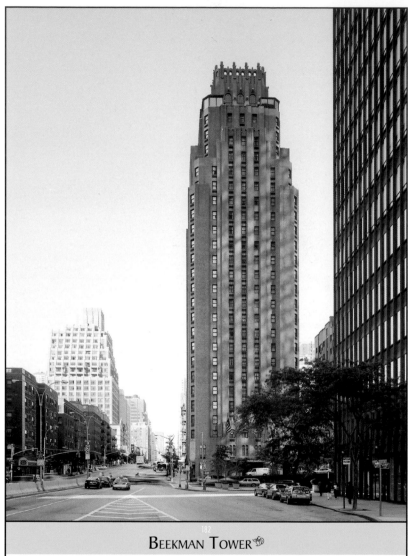

182
Beekman Tower

FIRST AVENUE AT EAST 49TH STREET

1928, JOHN MEAD HOWELLS

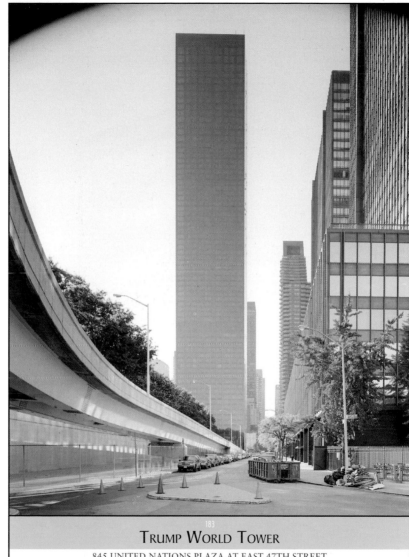

TRUMP WORLD TOWER

845 UNITED NATIONS PLAZA AT EAST 47TH STREET

2001, COSTAS KONDYLIS

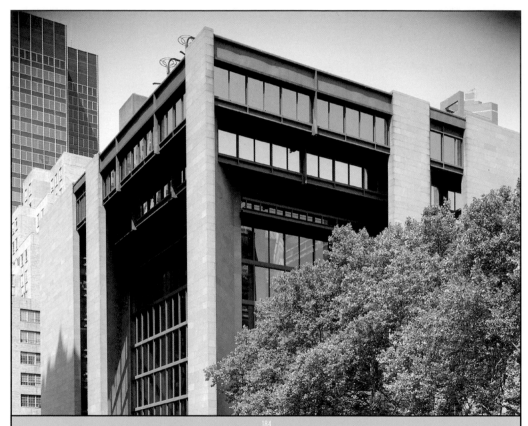

184

Ford Foundation Building ✦

321 EAST 42ND STREET
BETWEEN FIRST AND SECOND AVENUES

1967, KEVIN ROCHE JOHN DINKELOO & ASSOCIATES

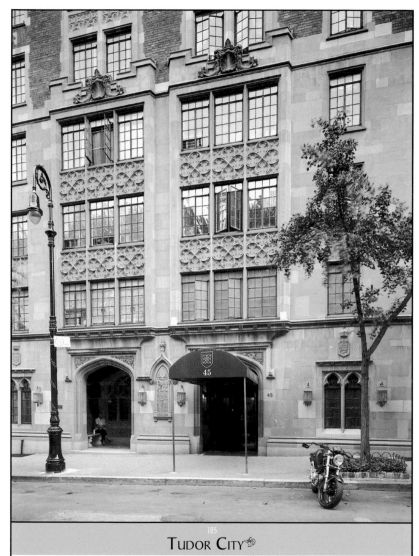

TUDOR CITY

**EAST 40TH TO EAST 43RD STREETS
BETWEEN FIRST AND SECOND AVENUES**

1928, FRED F. FRENCH

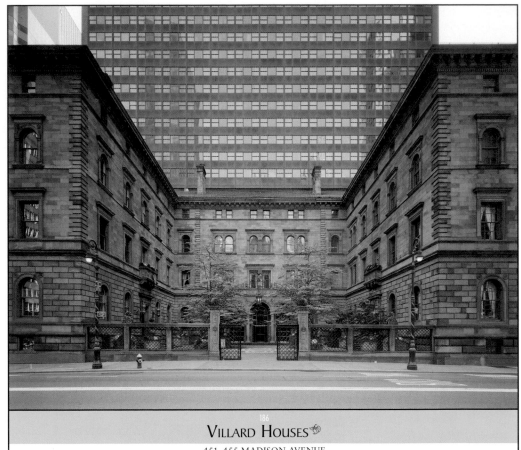

186
VILLARD HOUSES

451–455 MADISON AVENUE
BETWEEN EAST 50TH AND EAST 51ST STREETS

1884, FAÇADE, JOSEPH WELLS, INTERIOR, STANFORD WHITE

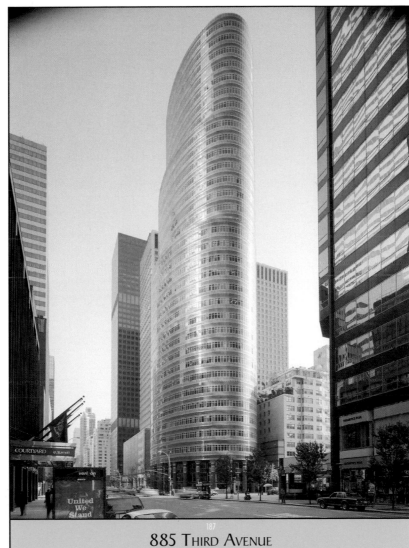

885 THIRD AVENUE

BETWEEN EAST 53RD AND EAST 54TH STREETS

1986, JOHN BURGEE AND PHILIP JOHNSON

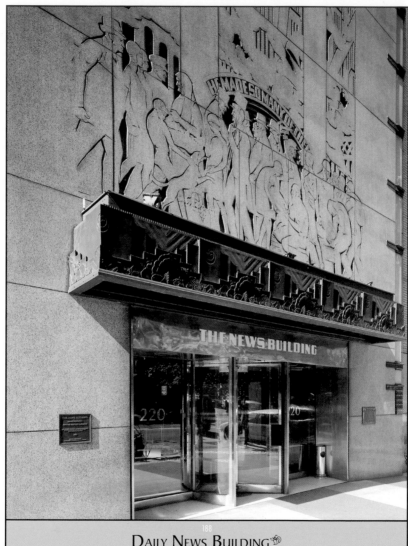

DAILY NEWS BUILDING

220 EAST 42ND STREET
BETWEEN SECOND AND THIRD AVENUES

1930, HOWELLS & HOOD

J. P. MORGAN CHASE BUILDING

410 PARK AVENUE
BETWEEN EAST 47TH AND EAST 48TH STREETS

1960, SKIDMORE, OWINGS & MERRILL

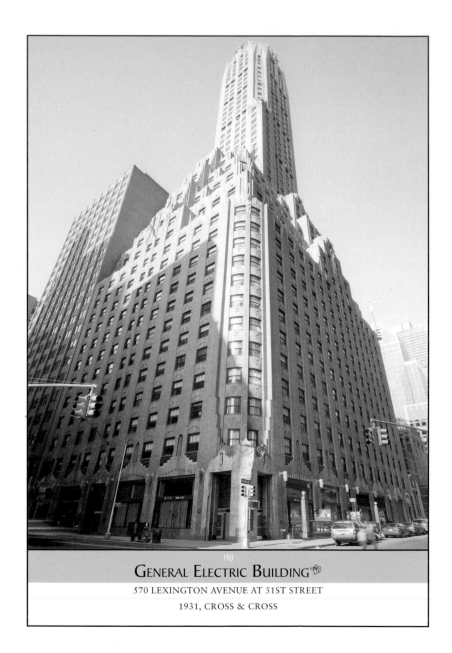

190

GENERAL ELECTRIC BUILDING

570 LEXINGTON AVENUE AT 51ST STREET

1931, CROSS & CROSS

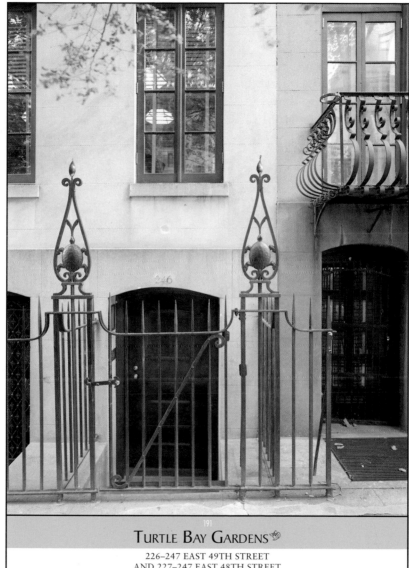

TURTLE BAY GARDENS

226–247 EAST 49TH STREET
AND 227–247 EAST 48TH STREET

REMODELED, 1920, EDWARD C. DEAN AND LAWRENCE BOTTOMLEY

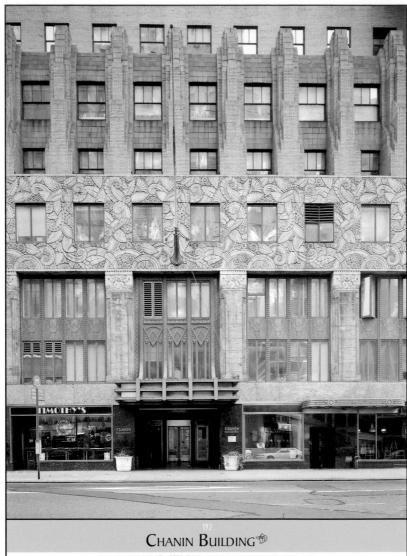

192
CHANIN BUILDING
122 EAST 42ND STREET AT LEXINGTON AVENUE
1929, SLOAN & ROBERTSON

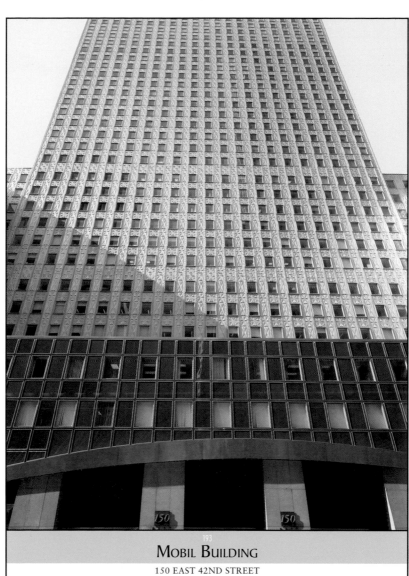

193

MOBIL BUILDING

150 EAST 42ND STREET
BETWEEN LEXINGTON AND THIRD AVENUES

1955, HARRISON & ABRAMOVITZ

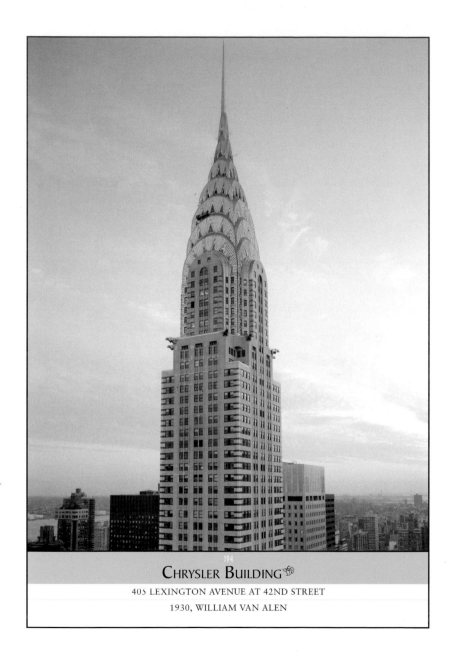

194
Chrysler Building

405 LEXINGTON AVENUE AT 42ND STREET

1930, WILLIAM VAN ALEN

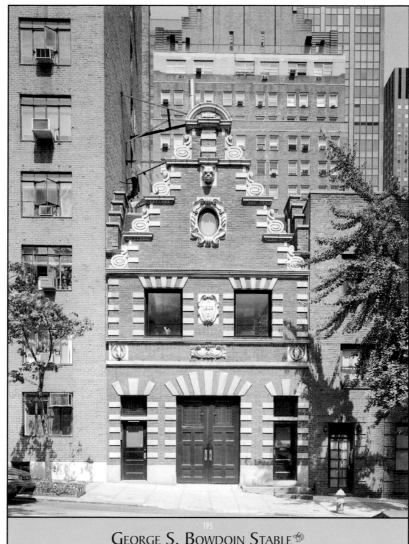

195

GEORGE S. BOWDOIN STABLE

149 EAST 38TH STREET
BETWEEN LEXINGTON AND THIRD AVENUES

1902, RALPH S. TOWNSEND

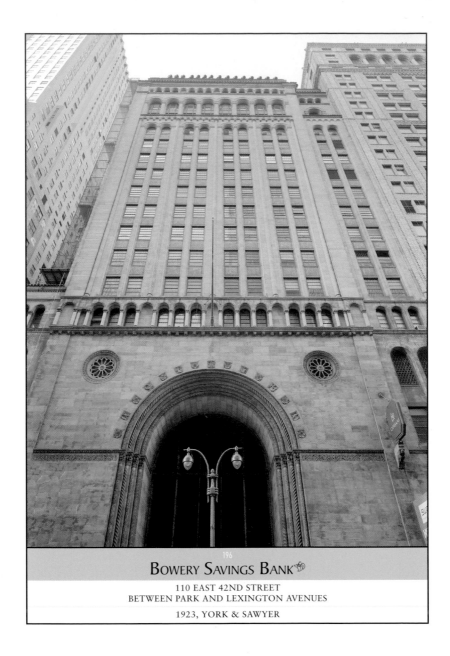

196

BOWERY SAVINGS BANK

110 EAST 42ND STREET
BETWEEN PARK AND LEXINGTON AVENUES

1923, YORK & SAWYER

197

ANDY WARHOL'S "FACTORY"

19 EAST 32ND STREET AND 22 EAST 33RD STREET
BETWEEN PARK AND MADISON AVENUES

REMODELED 1983

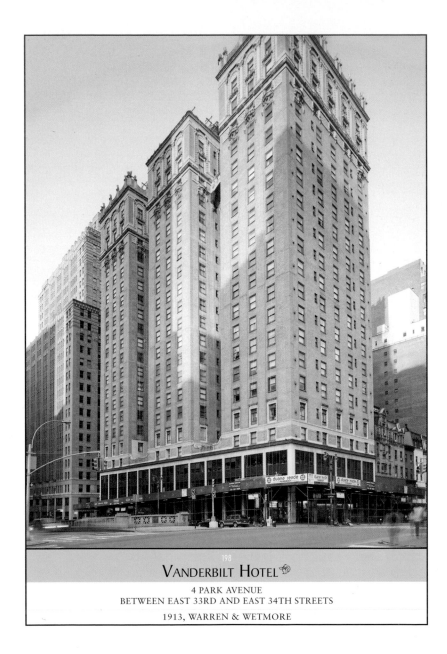

VANDERBILT HOTEL

4 PARK AVENUE
BETWEEN EAST 33RD AND EAST 34TH STREETS

1913, WARREN & WETMORE

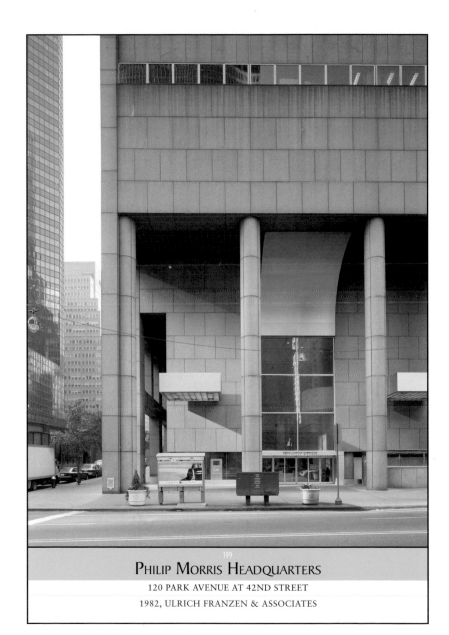

199
Philip Morris Headquarters

120 PARK AVENUE AT 42ND STREET

1982, ULRICH FRANZEN & ASSOCIATES

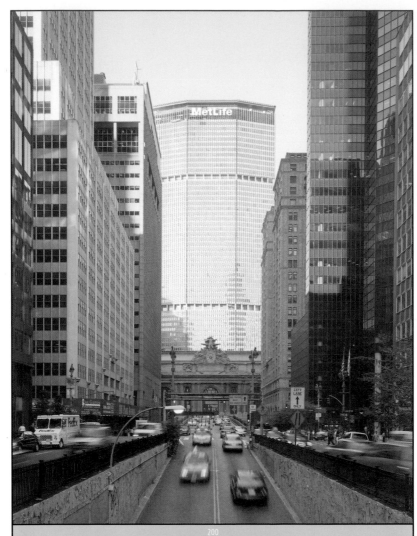

MET LIFE BUILDING

200 PARK AVENUE

1963, EMERY ROTH & SONS
WITH PIETRO BELLUSCHI AND WALTER GROPIUS

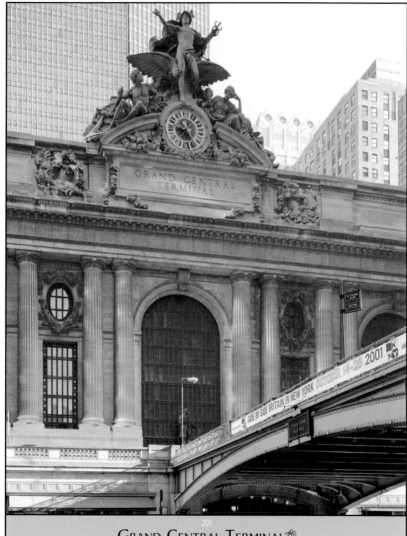

201

GRAND CENTRAL TERMINAL

1913, REED & STEM AND WARREN & WETMORE
INTERIOR RESTORATION, 1998, BEYER BLINDER BELLE

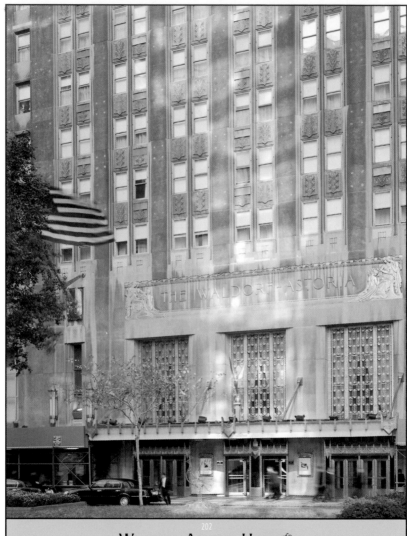

202

WALDORF-ASTORIA HOTEL

301 PARK AVENUE
BETWEEN EAST 49TH AND EAST 50TH STREETS

1931, SCHULTZE & WEAVER

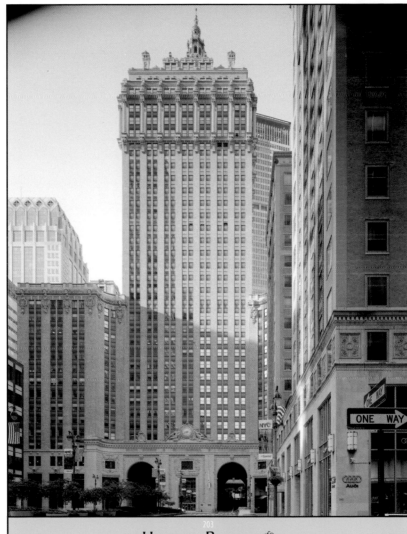

HELMSLEY BUILDING

230 PARK AVENUE
BETWEEN EAST 45TH AND EAST 46TH STREETS

1929, WARREN & WETMORE

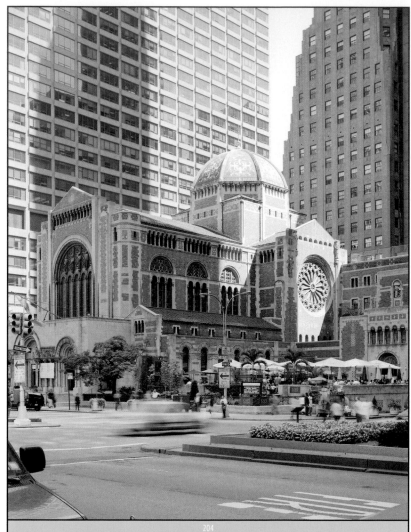

St. Bartholomew's Church

PARK AVENUE
BETWEEN EAST 50TH AND EAST 51ST STREETS

1919, BERTRAM G. GOODHUE

◆ MIDTOWN ◆

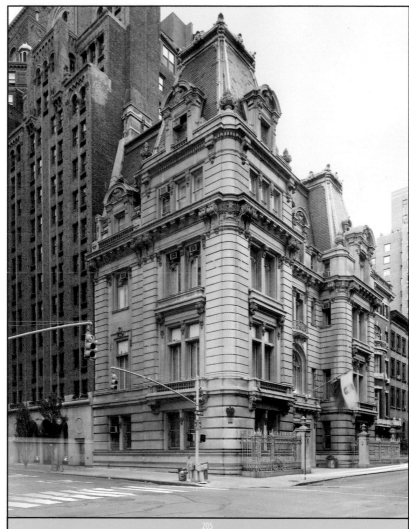

205
Consulate General of Poland

233 MADISON AVENUE AT EAST 37TH STREET

1906, C. P. H. GILBERT

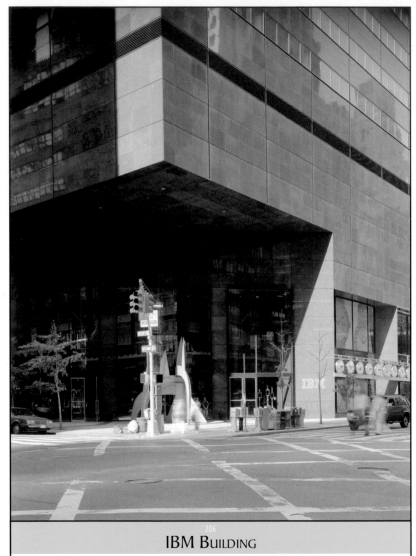

IBM Building

590 MADISON AVENUE AT EAST 57TH STREET

1983, EDWARD LARRABEE BARNES ASSOCIATES

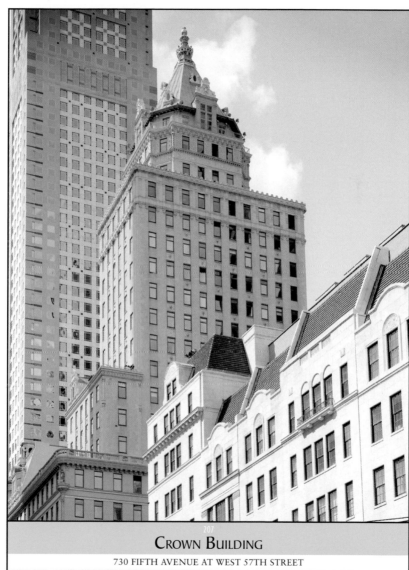

CROWN BUILDING

730 FIFTH AVENUE AT WEST 57TH STREET

1921, WARREN & WETMORE

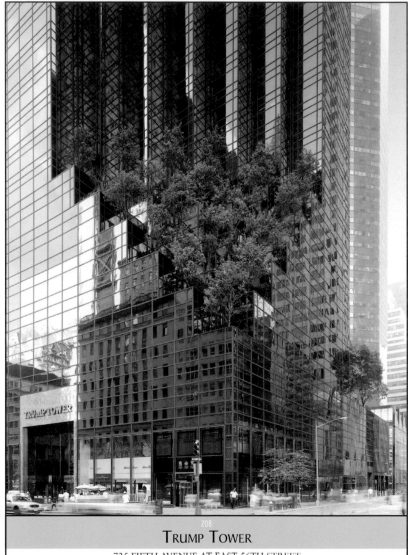

208

Trump Tower

725 FIFTH AVENUE AT EAST 56TH STREET

1983, DER SCUTT, WITH SWANKE, HADEN CONNELL

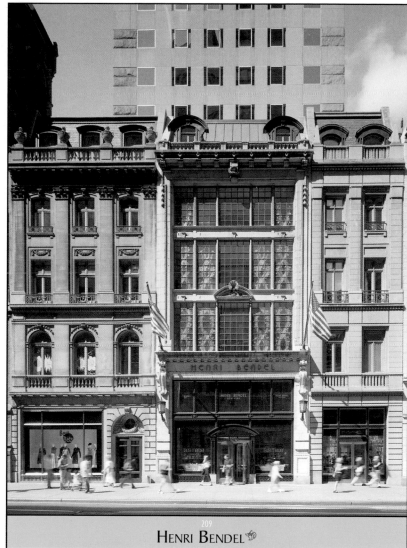

209
Henri Bendel

712 FIFTH AVENUE AND 714 FIFTH AVENUE

1908, ADOLF S. GOTTLIEB, 1909, WOODRUFF LEEMING
COMBINED AND REDESIGNED, 1991, BEYER BLINDER BELLE

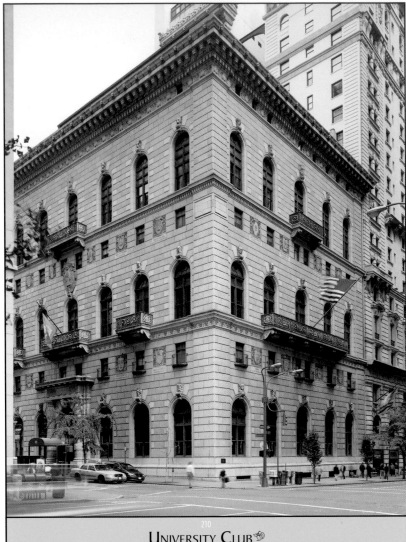

UNIVERSITY CLUB

ONE WEST 54TH STREET AT FIFTH AVENUE

1899, CHARLES MCKIM OF MCKIM, MEAD & WHITE

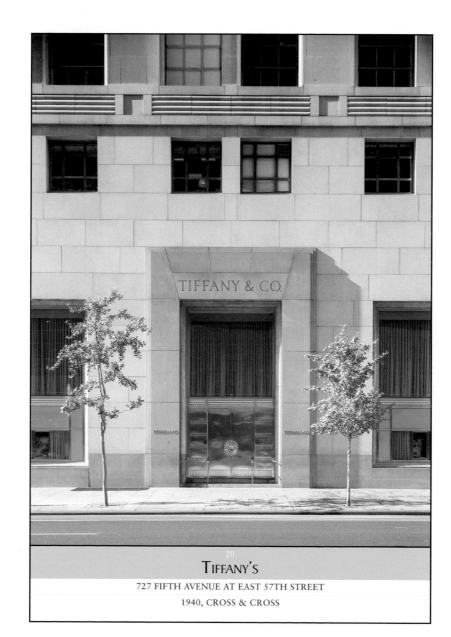

Tiffany's

727 FIFTH AVENUE AT EAST 57TH STREET
1940, CROSS & CROSS

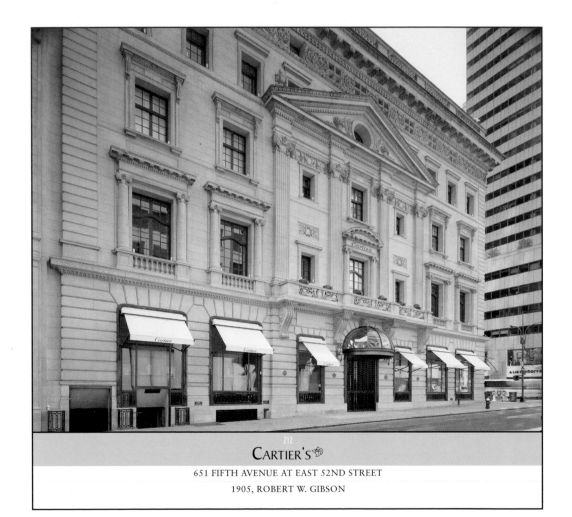

CARTIER'S

651 FIFTH AVENUE AT EAST 52ND STREET

1905, ROBERT W. GIBSON

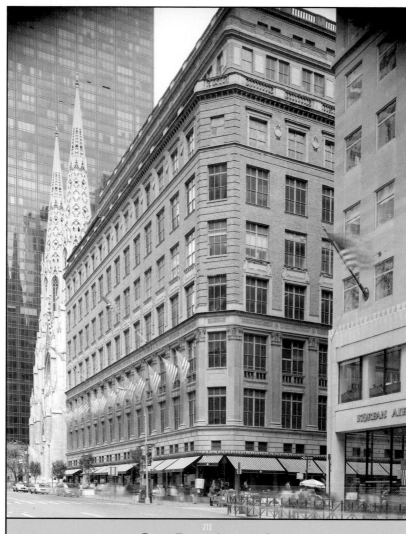

Saks Fifth Avenue

611 FIFTH AVENUE
BETWEEN EAST 49TH AND EAST 50TH STREETS

1924, STARRET & VAN VLECK

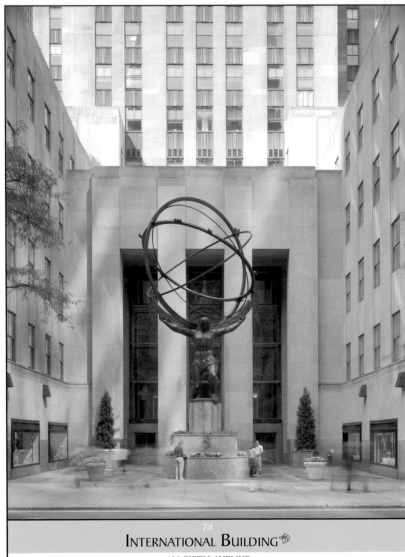

INTERNATIONAL BUILDING

630 FIFTH AVENUE
BETWEEN WEST 50TH AND WEST 51ST STREETS

1934, ASSOCIATED ARCHITECTS

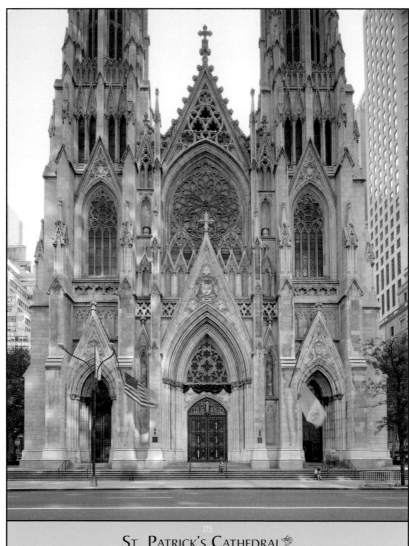

215
St. Patrick's Cathedral

FIFTH AVENUE
BETWEEN EAST 50TH AND EAST 51ST STREETS

1878, JAMES RENWICK, JR.

216

ASSOCIATED PRESS BUILDING

50 ROCKEFELLER PLAZA
BETWEEN WEST 50TH AND WEST 51ST STREETS

1938, ASSOCIATED ARCHITECTS

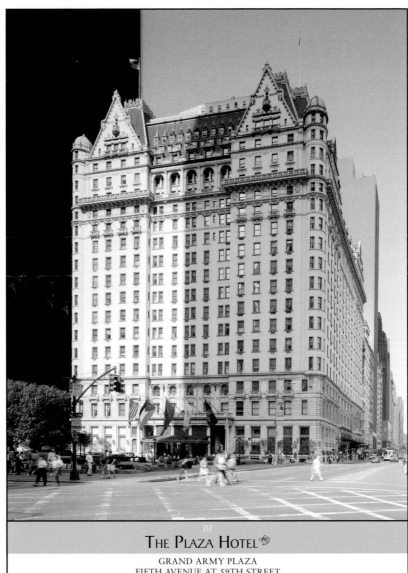

217

THE PLAZA HOTEL

GRAND ARMY PLAZA
FIFTH AVENUE AT 59TH STREET

1907, HENRY J. HARDENBERGH

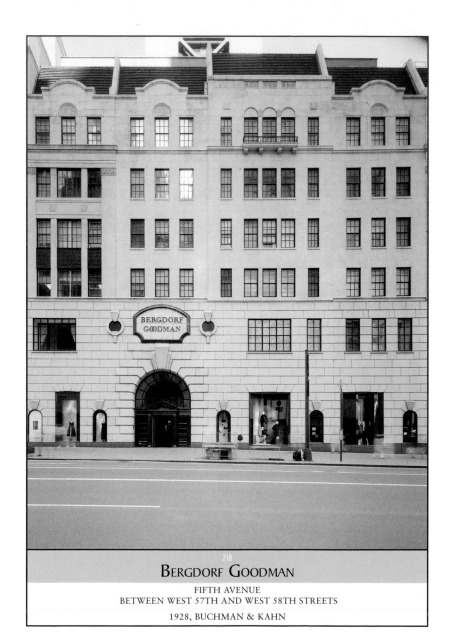

218
BERGDORF GOODMAN

FIFTH AVENUE
BETWEEN WEST 57TH AND WEST 58TH STREETS

1928, BUCHMAN & KAHN

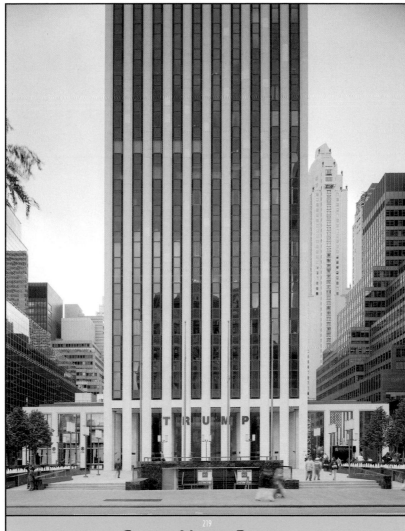

219

GENERAL MOTORS BUILDING

767 FIFTH AVENUE
BETWEEN EAST 58TH AND EAST 59TH STREETS

1968, EDWARD DURRELL STONE

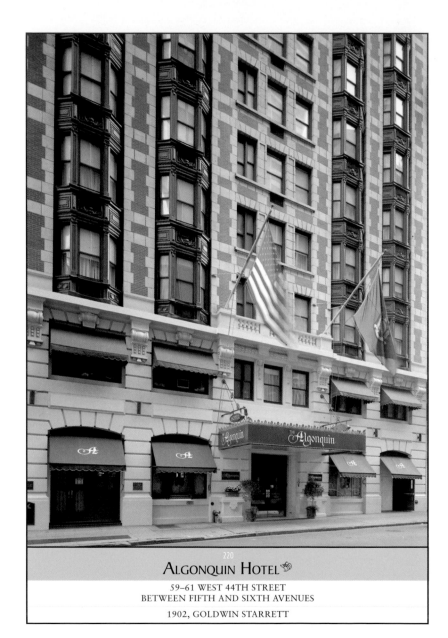

220

ALGONQUIN HOTEL 🐝

59–61 WEST 44TH STREET
BETWEEN FIFTH AND SIXTH AVENUES

1902, GOLDWIN STARRETT

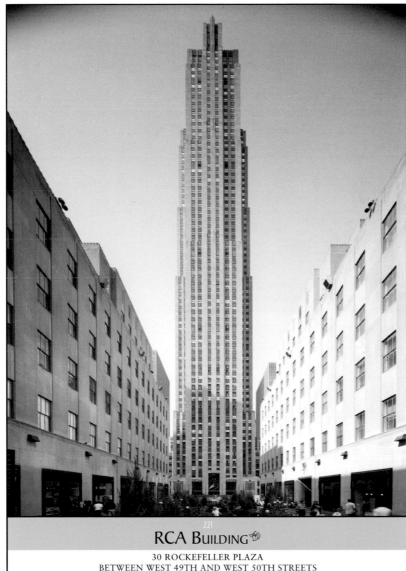

RCA BUILDING

30 ROCKEFELLER PLAZA
BETWEEN WEST 49TH AND WEST 50TH STREETS

1933, ASSOCIATED ARCHITECTS

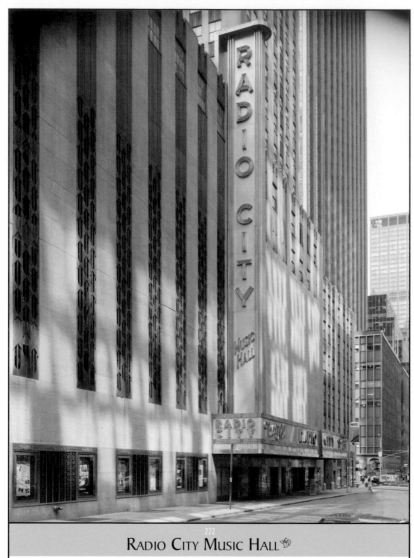

Radio City Music Hall 🐫

SIXTH AVENUE AT 50TH STREET

1932, SAMUEL ("ROXY") ROTHAFEL

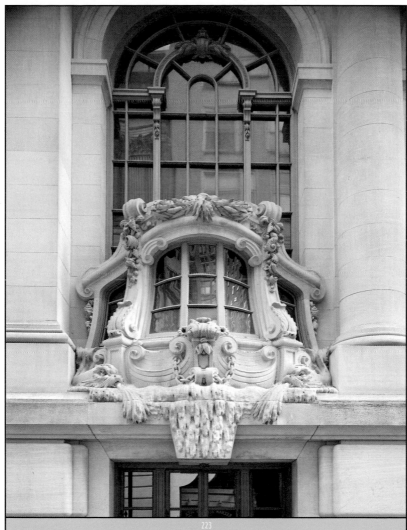

223

New York Yacht Club

37 WEST 44TH STREET
BETWEEN FIFTH AND SIXTH AVENUES

1900, WARREN & WETMORE

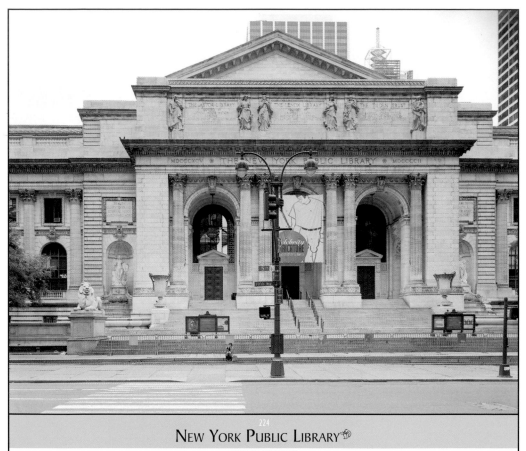

New York Public Library

FIFTH AVENUE
BETWEEN WEST 40TH AND WEST 42ND STREETS

1911, CARRÈRE & HASTINGS

♦ MIDTOWN ♦

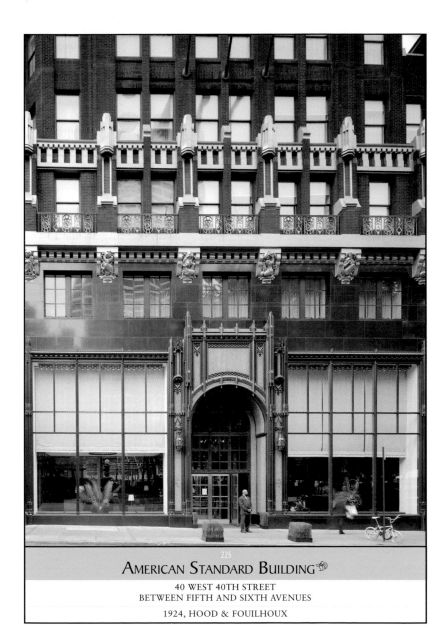

225

AMERICAN STANDARD BUILDING

40 WEST 40TH STREET
BETWEEN FIFTH AND SIXTH AVENUES

1924, HOOD & FOUILHOUX

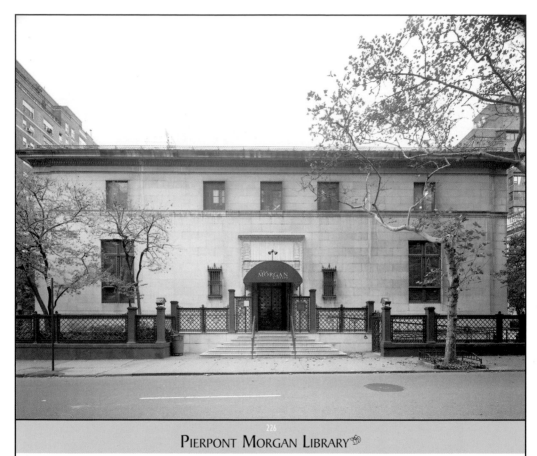

PIERPONT MORGAN LIBRARY

33 EAST 36TH STREET
BETWEEN PARK AND MADISON AVENUES

1906, MCKIM, MEAD & WHITE

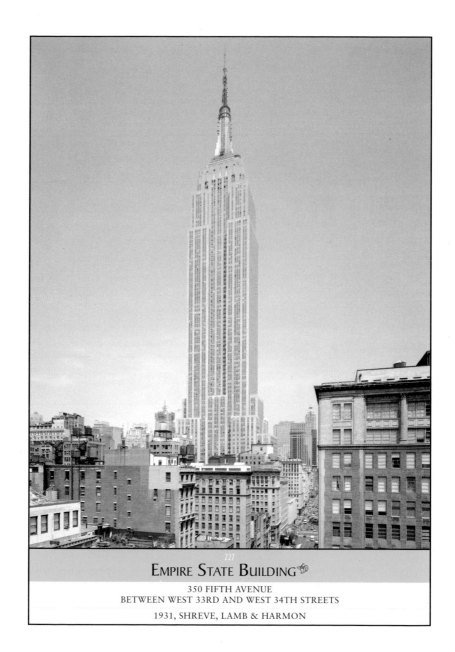

227

EMPIRE STATE BUILDING

350 FIFTH AVENUE
BETWEEN WEST 33RD AND WEST 34TH STREETS

1931, SHREVE, LAMB & HARMON

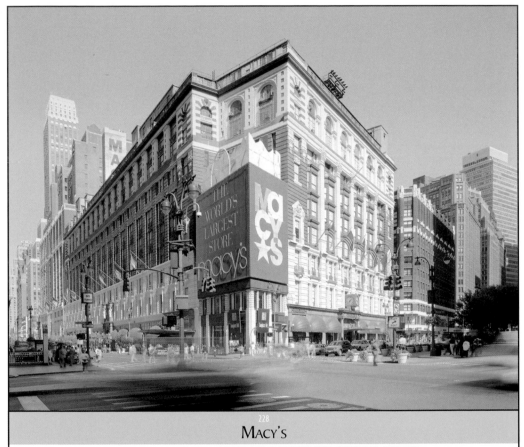

MACY'S

34TH–35TH STREETS, BETWEEN BROADWAY AND SEVENTH AVENUE

BROADWAY BUILDING, 1902, DE LEMOS & CORDES
ADDITIONS, 1924–31, ROBERT D. KOHN

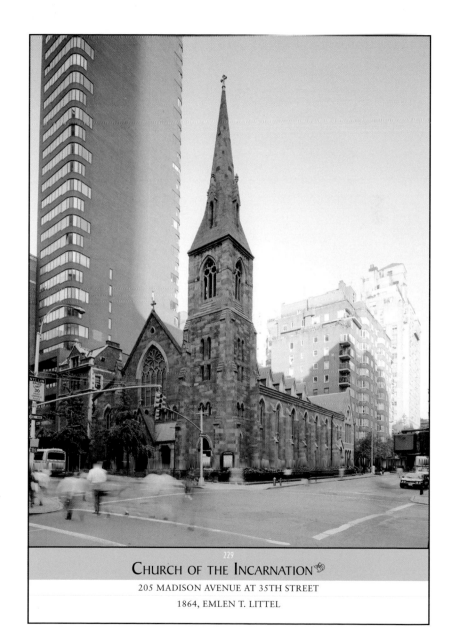

229

CHURCH OF THE INCARNATION

205 MADISON AVENUE AT 35TH STREET

1864, EMLEN T. LITTEL

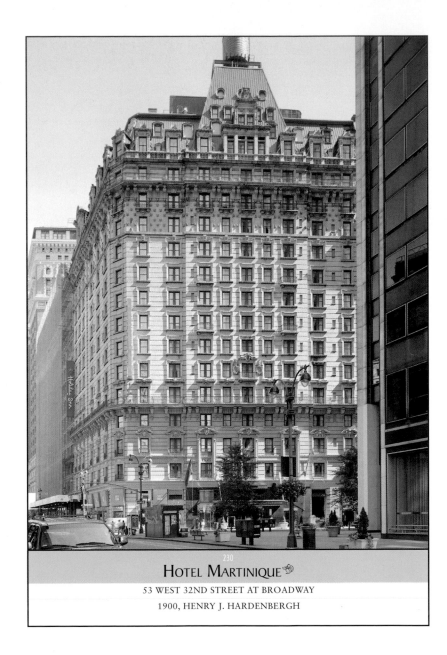

230
Hotel Martinique

53 WEST 32ND STREET AT BROADWAY
1900, HENRY J. HARDENBERGH

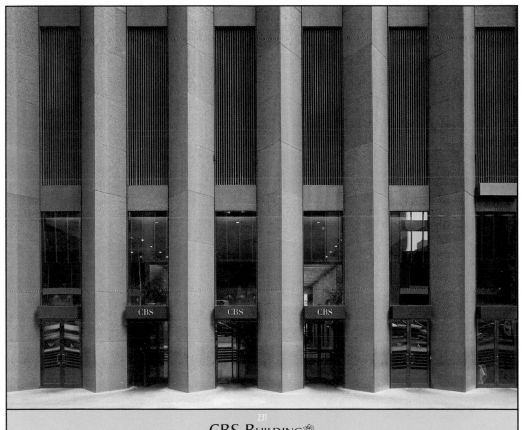

CBS Building

51 WEST 52ND STREET AT SIXTH AVENUE

1965, EERO SAARINEN & ASSOCIATES

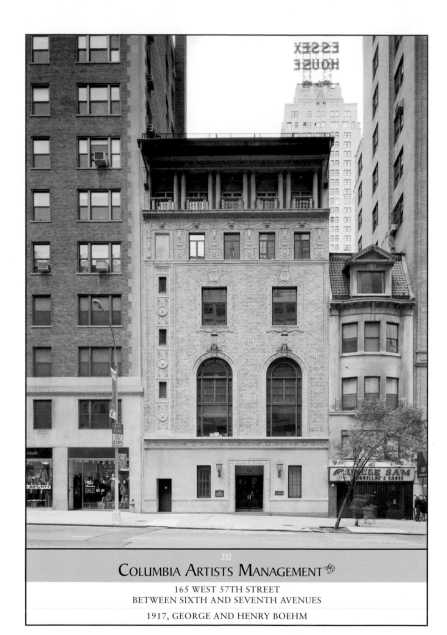

Columbia Artists Management

165 WEST 57TH STREET
BETWEEN SIXTH AND SEVENTH AVENUES

1917, GEORGE AND HENRY BOEHM

◆ MIDTOWN ◆

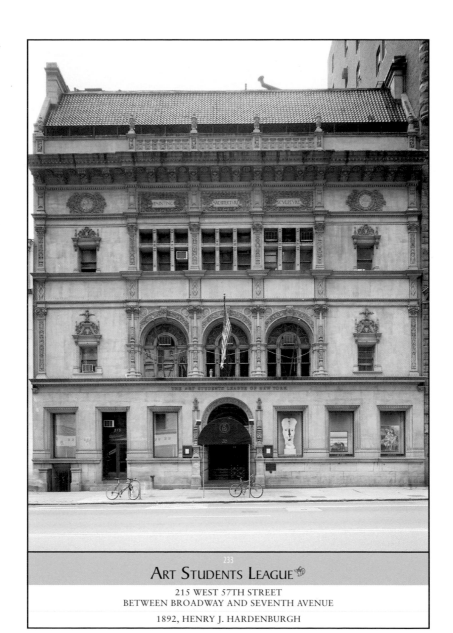

233

ART STUDENTS LEAGUE

215 WEST 57TH STREET
BETWEEN BROADWAY AND SEVENTH AVENUE

1892, HENRY J. HARDENBURGH

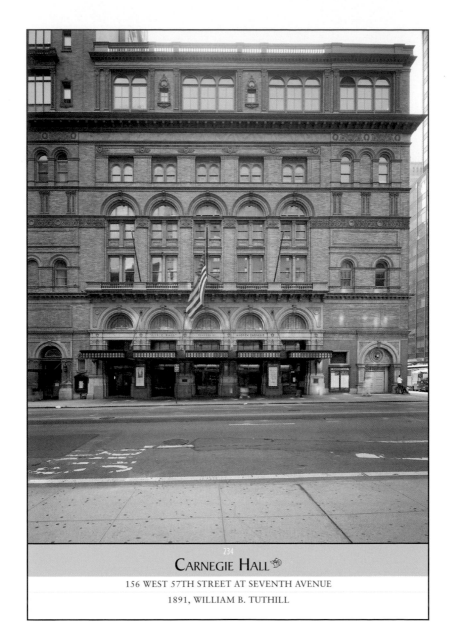

234

CARNEGIE HALL

156 WEST 57TH STREET AT SEVENTH AVENUE

1891, WILLIAM B. TUTHILL

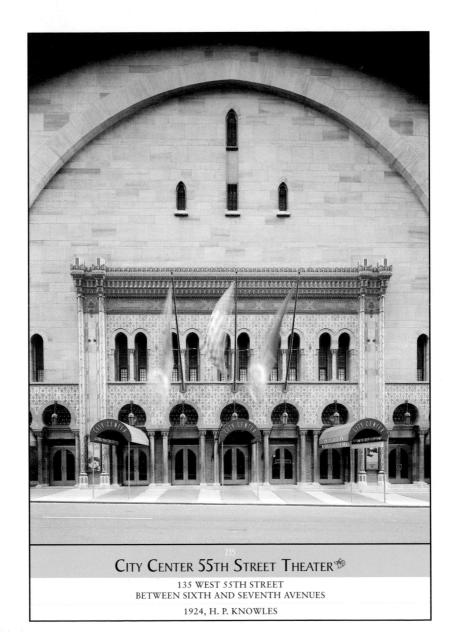

City Center 55th Street Theater

135 WEST 55TH STREET
BETWEEN SIXTH AND SEVENTH AVENUES

1924, H. P. KNOWLES

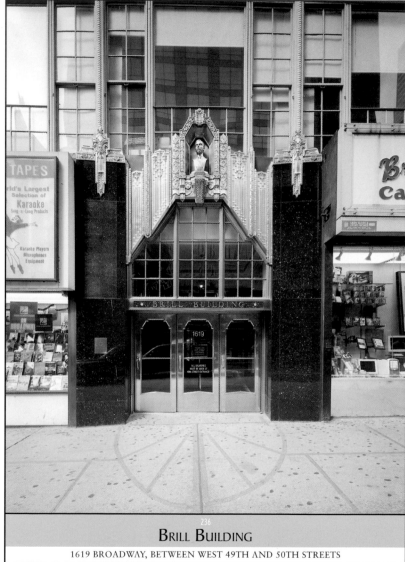

236

BRILL BUILDING

1619 BROADWAY, BETWEEN WEST 49TH AND 50TH STREETS

1931

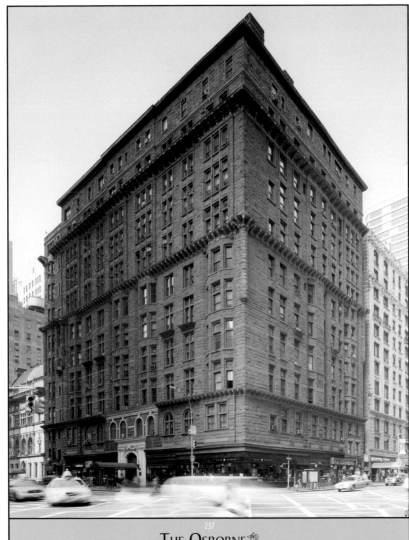

THE OSBORNE

205 WEST 57TH STREET AT SEVENTH AVENUE

1899, JAMES E. WARE

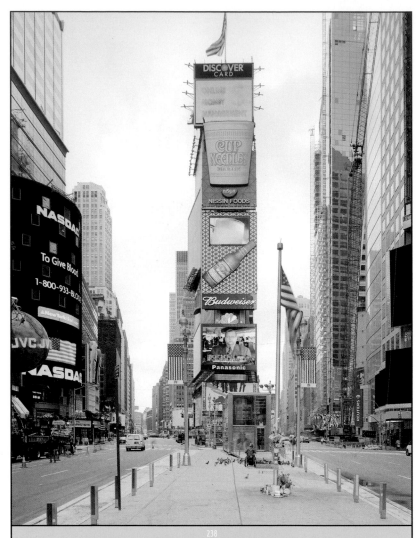

ONE TIMES SQUARE

WEST 42ND STREET
BETWEEN BROADWAY AND SEVENTH AVENUE

1905, CYRUS L. W. EIDLITZ

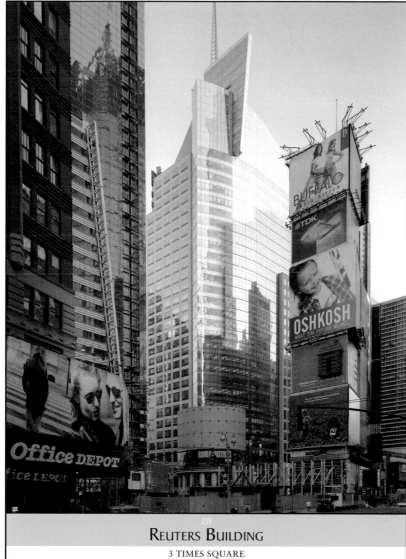

REUTERS BUILDING

3 TIMES SQUARE
BETWEEN WEST 42ND AND WEST 43RD STREETS

2001, FOX & FOWLE

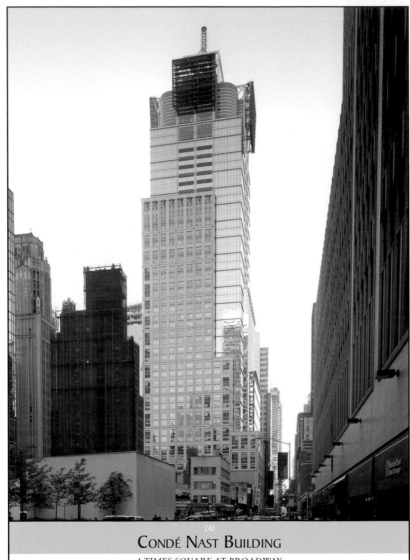

240

Condé Nast Building

4 TIMES SQUARE AT BROADWAY

1999, FOX & FOWLE

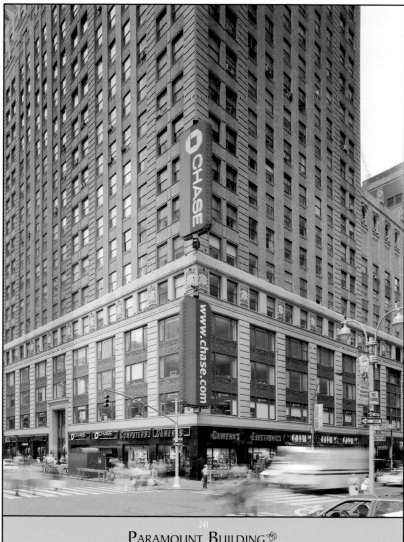

241
PARAMOUNT BUILDING

1501 BROADWAY
BETWEEN WEST 43RD AND WEST 44TH STREETS

1927, RAPP & RAPP

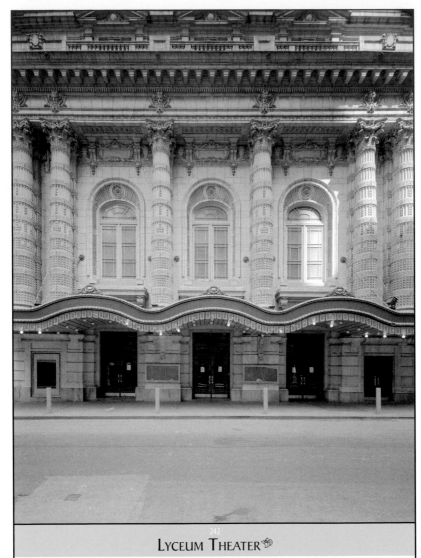

242

LYCEUM THEATER

149–157 WEST 45TH STREET
BETWEEN SIXTH AVENUE AND BROADWAY

1903, HERTS & TALLANT

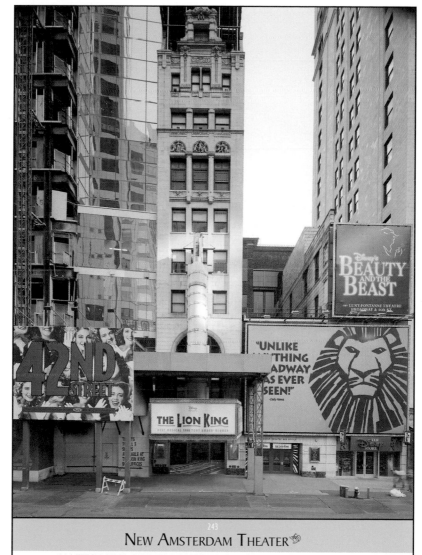

243

New Amsterdam Theater

214 WEST 42ND STREET, BETWEEN SEVENTH AND EIGHTH AVENUES

1903, HERTS & TALLANT
RESTORATION, 1997, HARDY HOLTZMAN PFEIFFER AND WALT DISNEY IMAGINEERING

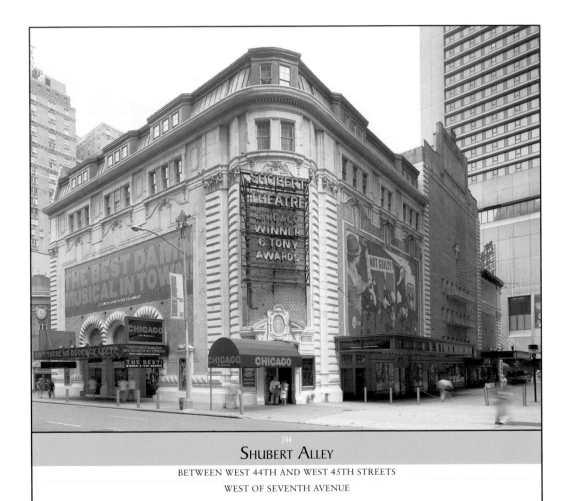

244

SHUBERT ALLEY

BETWEEN WEST 44TH AND WEST 45TH STREETS

WEST OF SEVENTH AVENUE

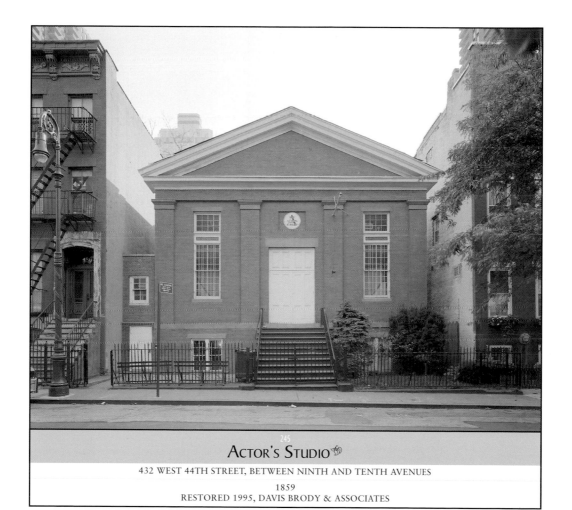

ACTOR'S STUDIO

432 WEST 44TH STREET, BETWEEN NINTH AND TENTH AVENUES

1859
RESTORED 1995, DAVIS BRODY & ASSOCIATES

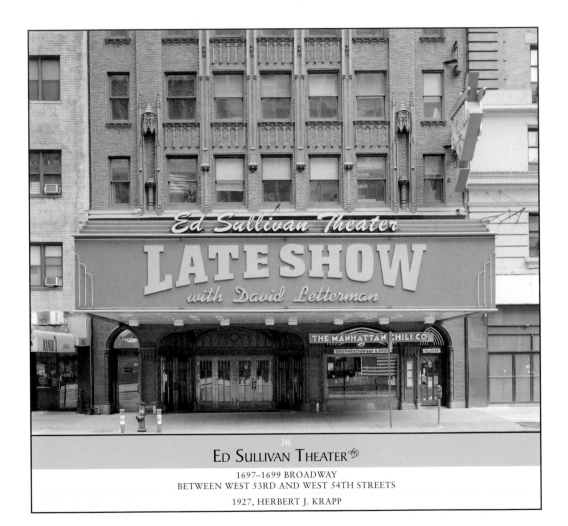

Ed Sullivan Theater 🏛️

1697–1699 BROADWAY
BETWEEN WEST 53RD AND WEST 54TH STREETS

1927, HERBERT J. KRAPP

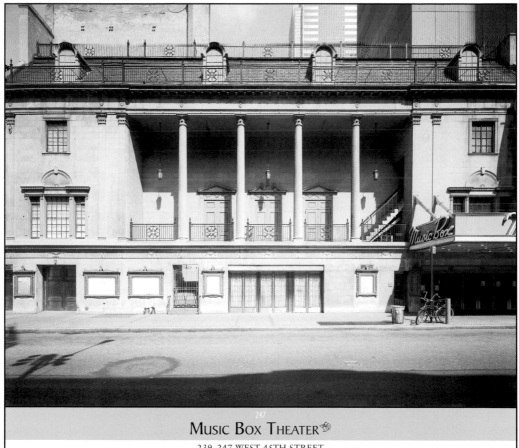

247
MUSIC BOX THEATER

239–247 WEST 45TH STREET
BETWEEN BROADWAY AND EIGHTH AVENUE

1920, C. HOWARD CRANE AND GEORGE KIEHLER

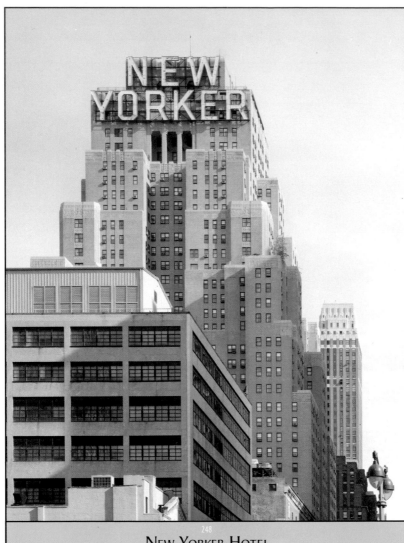

248

New Yorker Hotel

481 EIGHTH AVENUE
BETWEEN WEST 34TH AND WEST 35TH STREETS

1930, SUGARMAN & BERGER

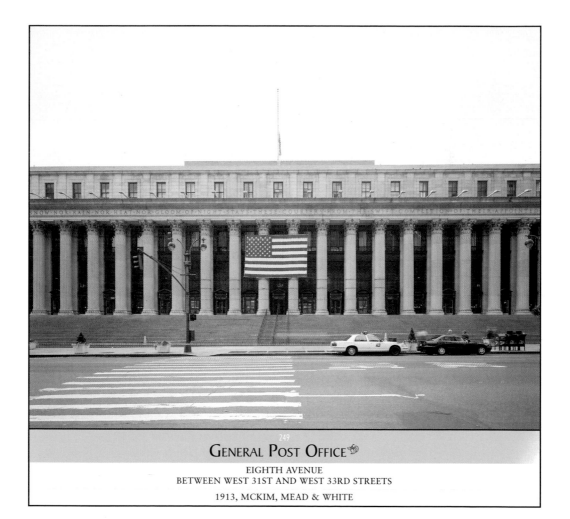

249

GENERAL POST OFFICE

EIGHTH AVENUE
BETWEEN WEST 31ST AND WEST 33RD STREETS

1913, MCKIM, MEAD & WHITE

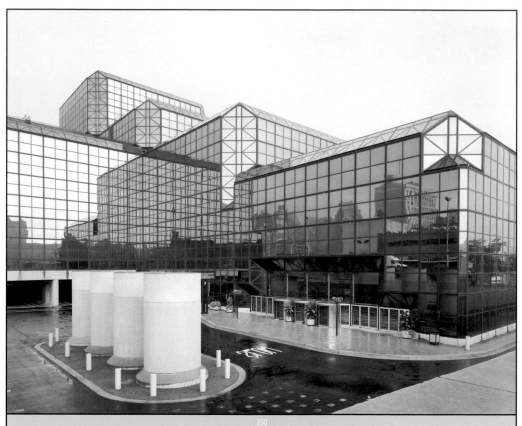

250

Jacob K. Javits Convention Center

ELEVENTH TO TWELFTH AVENUES
BETWEEN WEST 34TH AND WEST 37TH STREETS

1986, I. M. PEI & PARTNERS

ROOSEVELT ISLAND

More than 8,000 people live on Roosevelt Island, an 800-foot-wide sliver of land less than two miles long, located in the East River under the Queensboro Bridge. It was known as Blackwell's Island, for the farming family that owned it, from the 1660s until the city acquired it in 1828 to use as a penal colony. Other public institutions were added over the years for the city's poor, and its name was changed to Welfare Island in 1921. Its image was changed in 1973 by renaming it Roosevelt Island, and two years later, people began moving into its brand-new residential community.

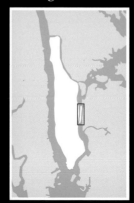

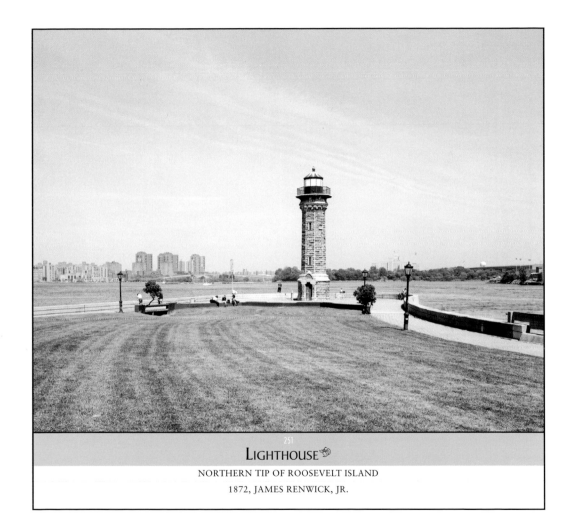

251
LIGHTHOUSE

NORTHERN TIP OF ROOSEVELT ISLAND

1872, JAMES RENWICK, JR.

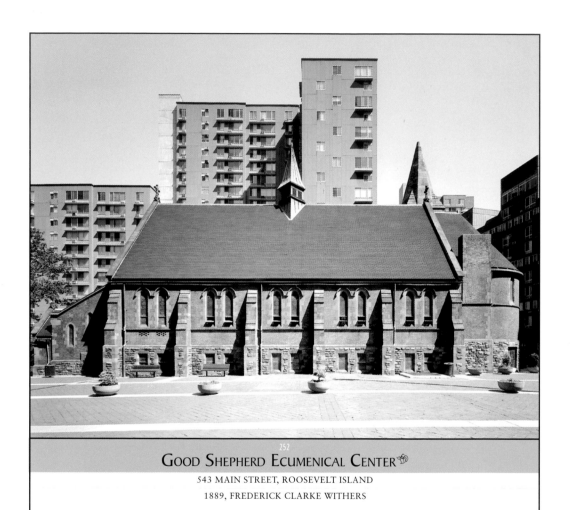

GOOD SHEPHERD ECUMENICAL CENTER

543 MAIN STREET, ROOSEVELT ISLAND

1889, FREDERICK CLARKE WITHERS

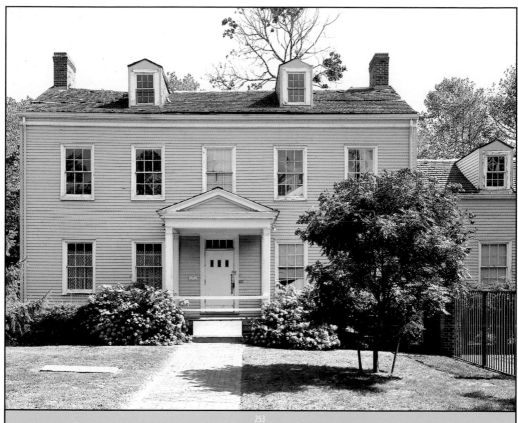

253

JAMES BLACKWELL FARMHOUSE

BLACKWELL PARK, MAIN STREET, ROOSEVELT ISLAND

1804
RESTORED 1973, GEORGIO CAVAGLIERI

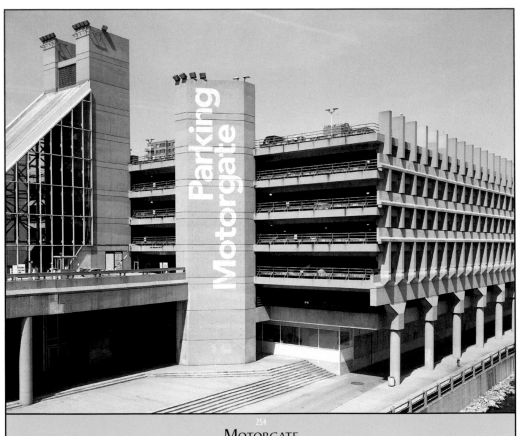

MOTORGATE

EAST SIDE OF ROOSEVELT ISLAND

1974, KALLMANN & MCKINNELL

Upper East Side

New York above 59th Street is like two different cities, the Upper East and Upper West Sides. The eastern half, long known as the Gold Coast, is a bit more elegant and a lot more self-conscious, its avenues lined with designer shops and elegant hotels and apartment buildings. Beekman Place and Sutton Place feature formidably gracious homes set off by gates, featuring breathtaking river views. Still, the neighborhood does have enclaves —particularly north and east—where anyone can feel right at home. Central Park is a formidable dividing line, and for years the twain refused to meet. About a century ago, a lifelong Eastsider confessed to a friend that she actually did travel over to the West Side every once in awhile. "It's where you board the ship for Europe,"she said. That's all changed, of course...or has it?

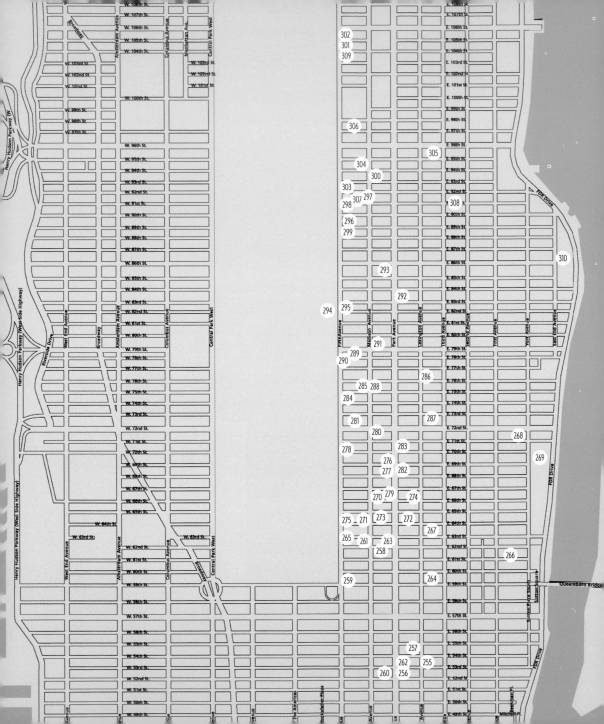

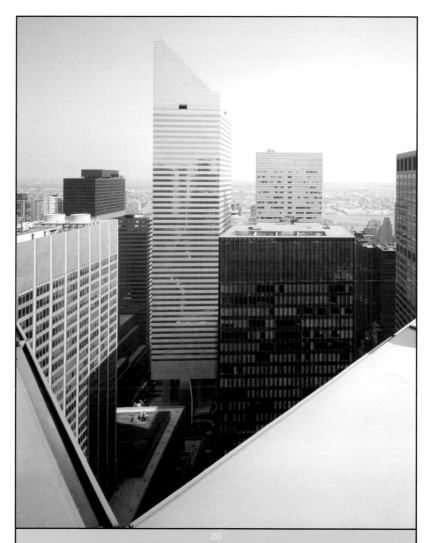

CITICORP CENTER

LEXINGTON AVENUE,
BETWEEN EAST 53RD AND EAST 54TH STREETS

1978, HUGH STUBBINS & ASSOCIATES

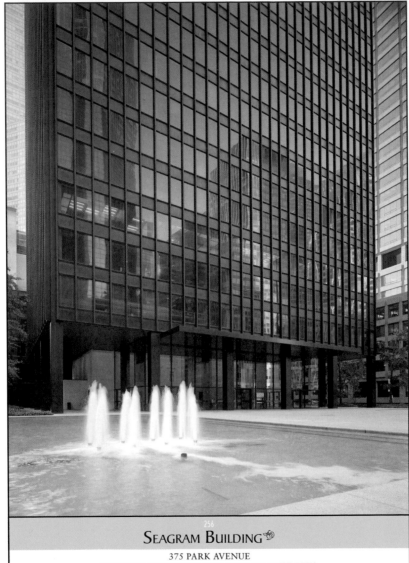

SEAGRAM BUILDING

375 PARK AVENUE
BETWEEN EAST 52ND AND EAST 53RD STREETS

1958, LUDWIG MIES VAN DER ROHE WITH PHILIP JOHNSON

257
CENTRAL SYNAGOGUE

652 LEXINGTON AVENUE AT EAST 55TH STREET

1872, HENRY FERNBACH

40 EAST 62ND STREET

BETWEEN MADISON AND PARK AVENUES

1910, ALBERT JOSEPH BODKER

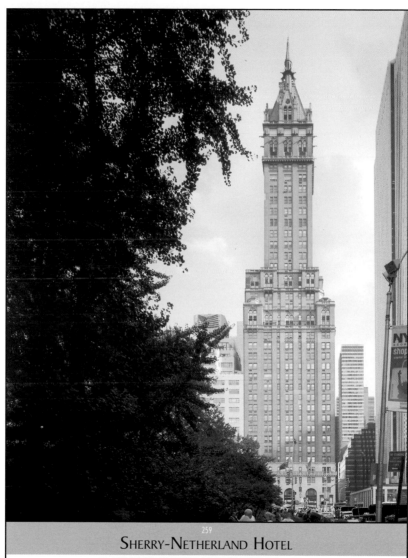

259

SHERRY-NETHERLAND HOTEL

781 FIFTH AVENUE AT EAST 59TH STREET

1927, SCHULTZE & WEAVER, BUCHMAN & KAHN

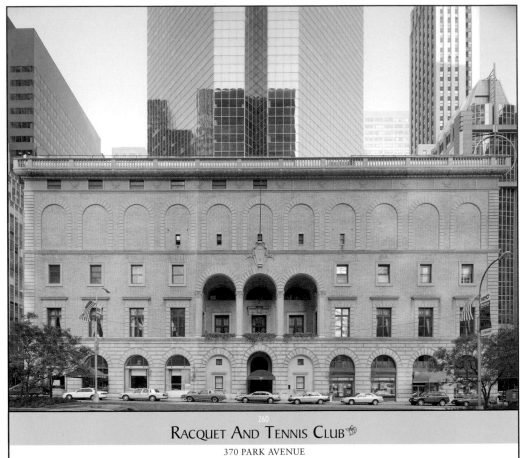

RACQUET AND TENNIS CLUB

370 PARK AVENUE
BETWEEN EAST 52ND AND EAST 53RD STREETS

1918, MCKIM, MEAD & WHITE

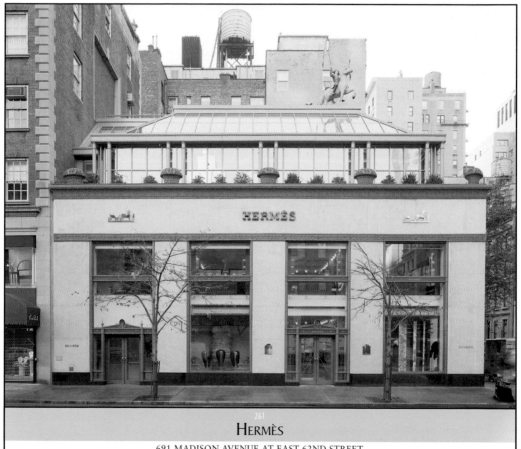

261
HERMÈS

691 MADISON AVENUE AT EAST 62ND STREET
1928, MCKIM, MEAD & WHITE

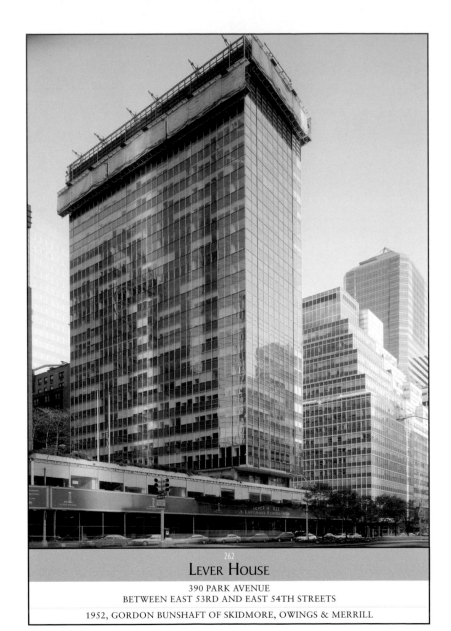

LEVER HOUSE

390 PARK AVENUE
BETWEEN EAST 53RD AND EAST 54TH STREETS

1952, GORDON BUNSHAFT OF SKIDMORE, OWINGS & MERRILL

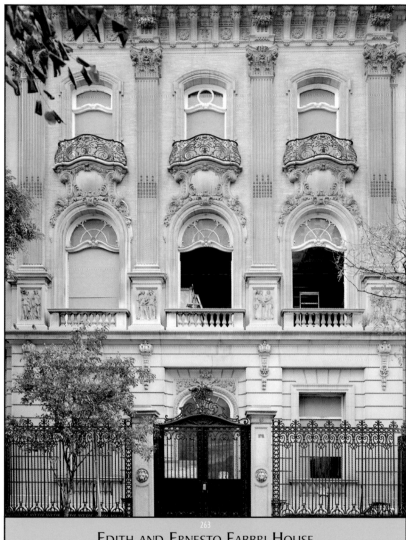

EDITH AND ERNESTO FABBRI HOUSE

11 EAST 62ND STREET
BETWEEN FIFTH AND MADISON AVENUES

1900, HAYDEL & SHEPARD

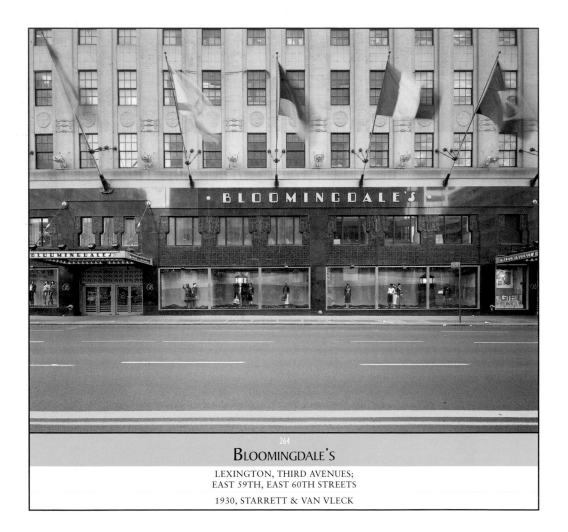

264

BLOOMINGDALE'S

LEXINGTON, THIRD AVENUES;
EAST 59TH, EAST 60TH STREETS

1930, STARRETT & VAN VLECK

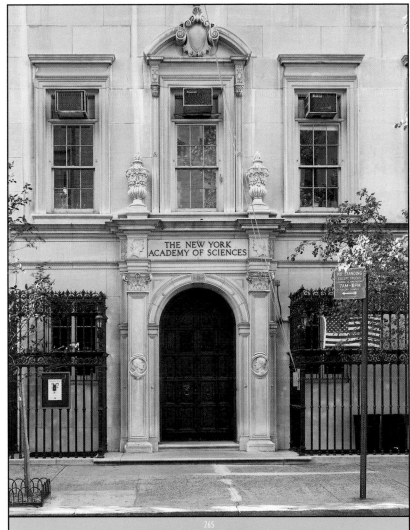

265

NEW YORK ACADEMY OF SCIENCES

2 EAST 63RD STREET
BETWEEN FIFTH AND MADISON AVENUES

1920, STERNER & WOLFE

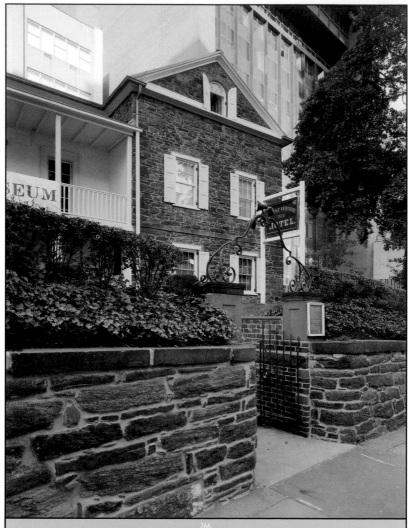

Abigail Adams Smith Museum

421 EAST 61ST STREET, BETWEEN FIRST AND YORK AVENUES

1799

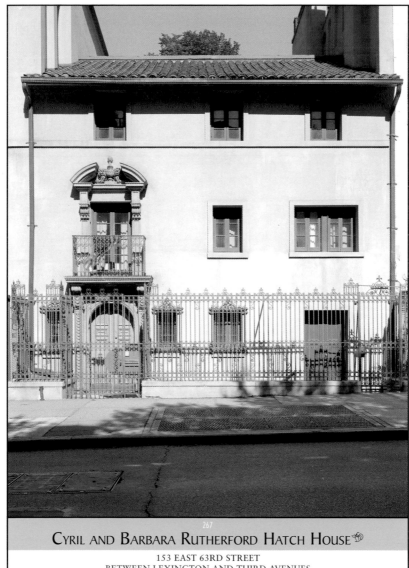

267
CYRIL AND BARBARA RUTHERFORD HATCH HOUSE

153 EAST 63RD STREET
BETWEEN LEXINGTON AND THIRD AVENUES

1919, FREDERICK J. STERNER

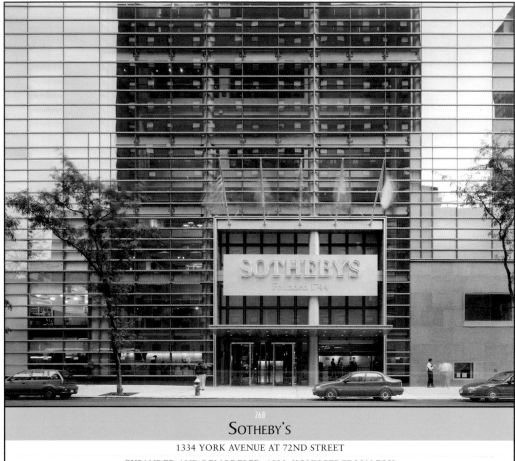

268
SOTHEBY'S
1334 YORK AVENUE AT 72ND STREET
EXPANDED AND REMODELED, 1999, KOHN PEDERSON FOX

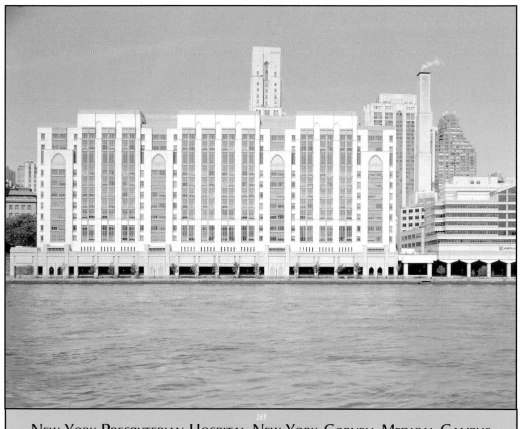

269

NEW YORK PRESBYTERIAN HOSPITAL-NEW YORK-CORNELL MEDICAL CAMPUS

YORK AVENUE
BETWEEN EAST 68TH AND EAST 71ST STREETS

1932, SHEPLEY, BULLFINCH & ABBOTT

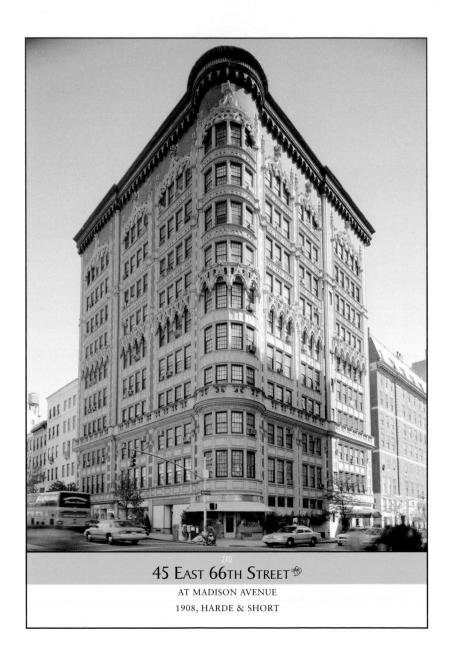

270

45 EAST 66TH STREET 🐎

AT MADISON AVENUE

1908, HARDE & SHORT

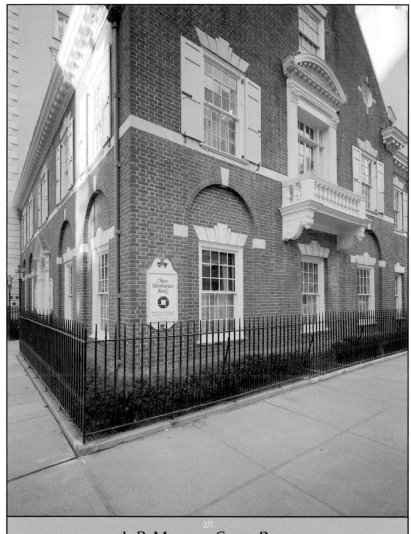

271

J. P. Morgan-Chase Bank

726 MADISON AVENUE AT EAST 64TH STREET

1933, MORRELL SMITH

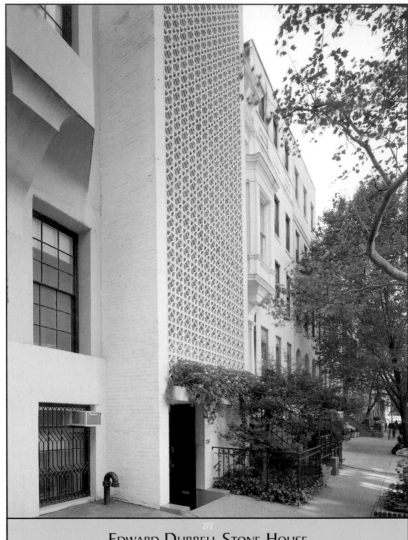

272

Edward Durrell Stone House

130 EAST 64TH STREET
BETWEEN PARK AND LEXINGTON AVENUES

1878, JAMES E. WARE

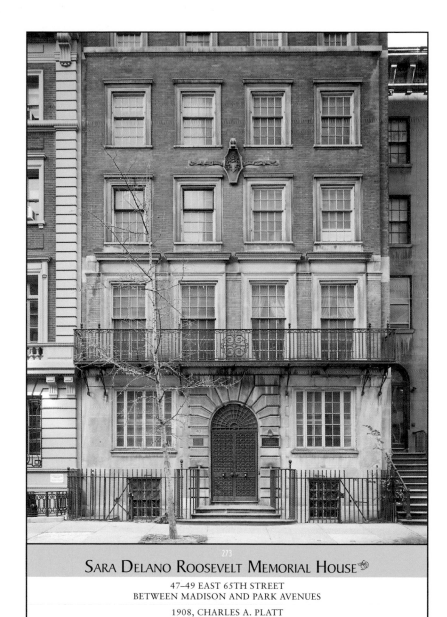

SARA DELANO ROOSEVELT MEMORIAL HOUSE

47–49 EAST 65TH STREET
BETWEEN MADISON AND PARK AVENUES

1908, CHARLES A. PLATT

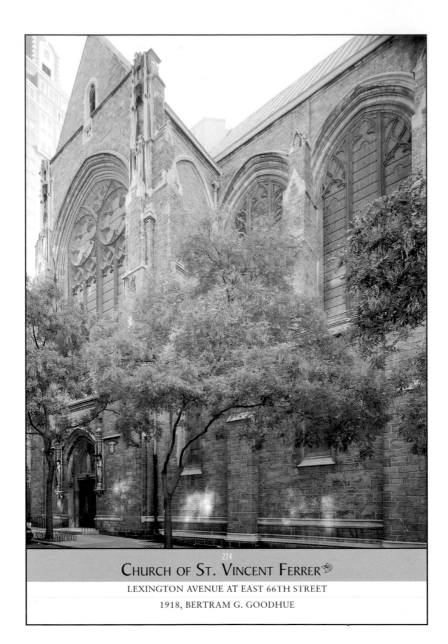

274
CHURCH OF ST. VINCENT FERRER

LEXINGTON AVENUE AT EAST 66TH STREET

1918, BERTRAM G. GOODHUE

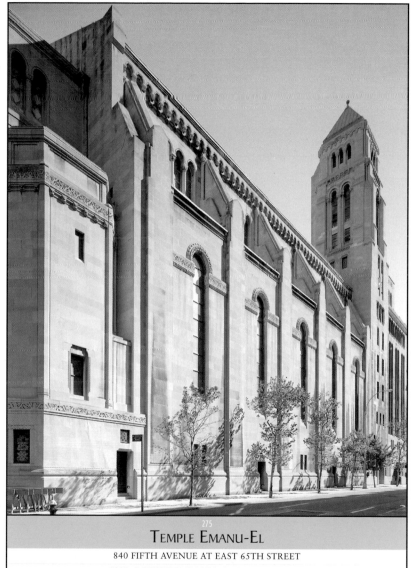

275

TEMPLE EMANU-EL

840 FIFTH AVENUE AT EAST 65TH STREET

1929, ROBERT D. KOHN, CHARLES BUTLER,
CLARENCE STEIN, AND MAYERS, MURRAY & PHILIP

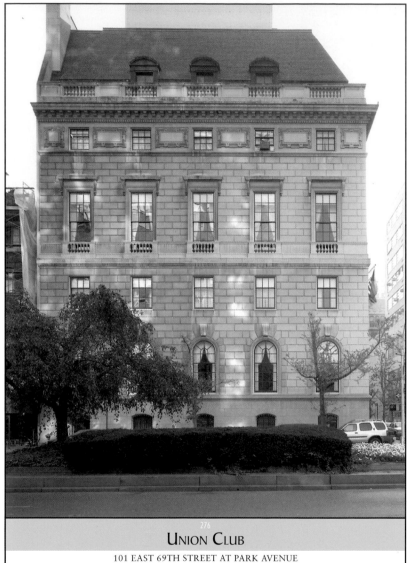

UNION CLUB

101 EAST 69TH STREET AT PARK AVENUE

1932, DELANO & ALDRICH

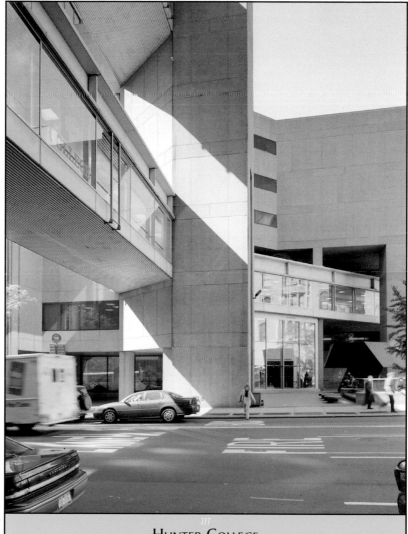

HUNTER COLLEGE

695 PARK AVENUE, BETWEEN EAST 68TH
AND EAST 69TH STREETS AND LEXINGTON AVENUE

1913, C. B. J. SNYDER

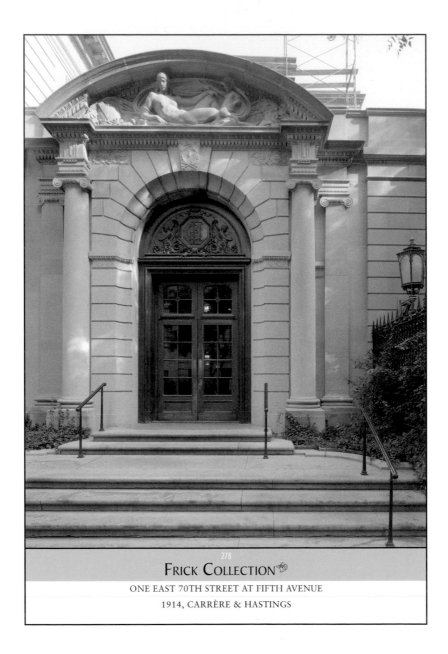

278
FRICK COLLECTION

ONE EAST 70TH STREET AT FIFTH AVENUE

1914, CARRÈRE & HASTINGS

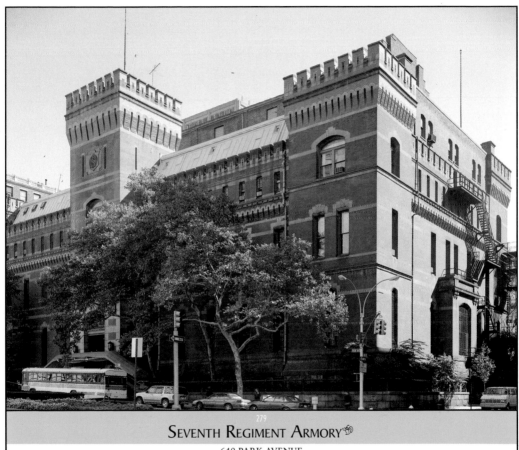

279

SEVENTH REGIMENT ARMORY

640 PARK AVENUE
BETWEEN EAST 66TH AND EAST 67TH STREETS

1879, CHARLES W. CLINTON

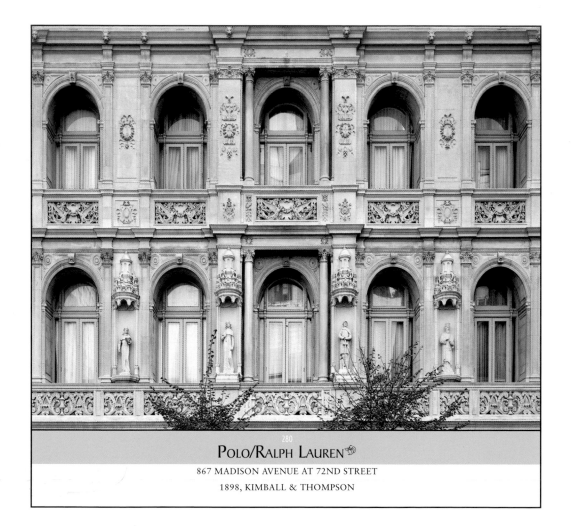

280

Polo/Ralph Lauren

867 MADISON AVENUE AT 72ND STREET

1898, KIMBALL & THOMPSON

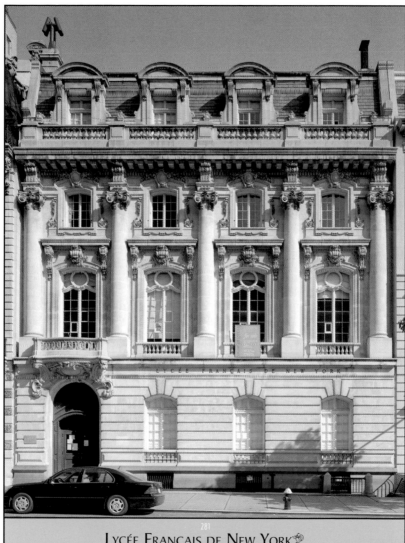

Lycée Français de New York

9 EAST 72ND STREET
BETWEEN FIFTH AND MADISON AVENUES

1899, FLAGG & CHAMBERS, 1896, CARRÈRE & HASTINGS

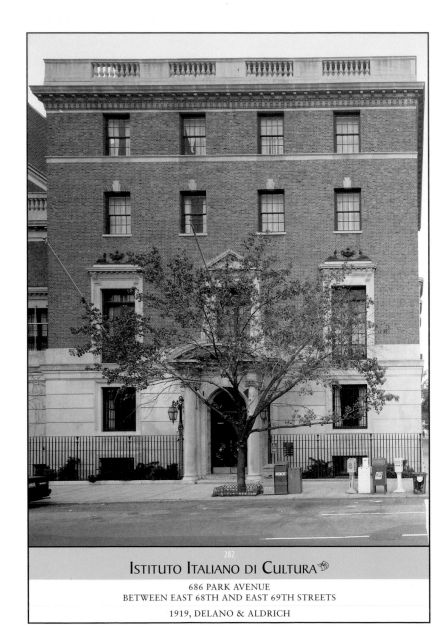

282

Istituto Italiano di Cultura

686 PARK AVENUE
BETWEEN EAST 68TH AND EAST 69TH STREETS

1919, DELANO & ALDRICH

283
ASIA SOCIETY

725 PARK AVENUE AT EAST 70TH STREET

1981, EDWARD LARRABEE BARNES ASSOCIATES

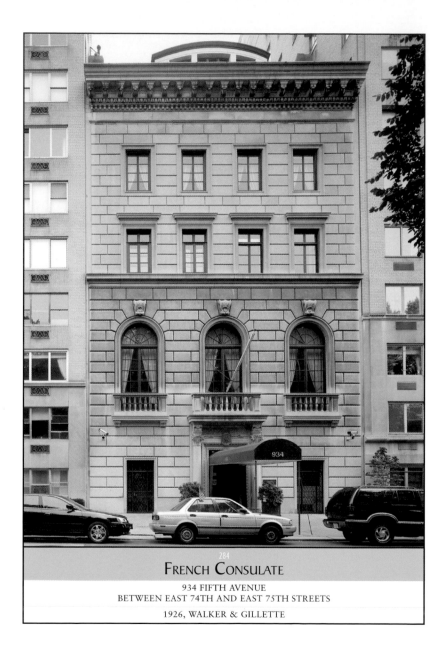

284

FRENCH CONSULATE

934 FIFTH AVENUE
BETWEEN EAST 74TH AND EAST 75TH STREETS

1926, WALKER & GILLETTE

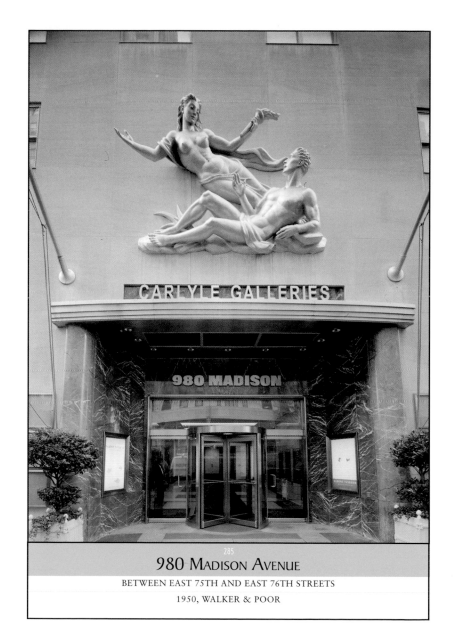

285

980 MADISON AVENUE

BETWEEN EAST 75TH AND EAST 76TH STREETS

1950, WALKER & POOR

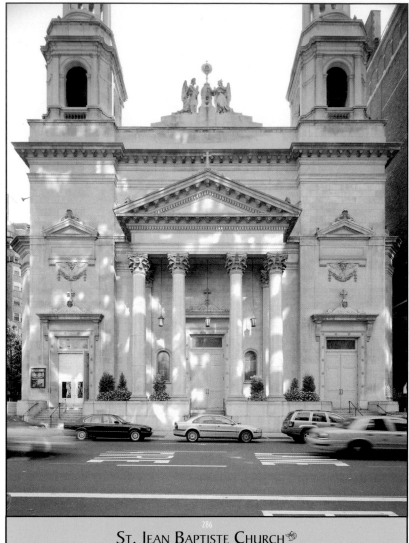

St. Jean Baptiste Church

1067–1071 LEXINGTON AVENUE AT EAST 76TH STREET

1914, NICHOLAS SERRACINO

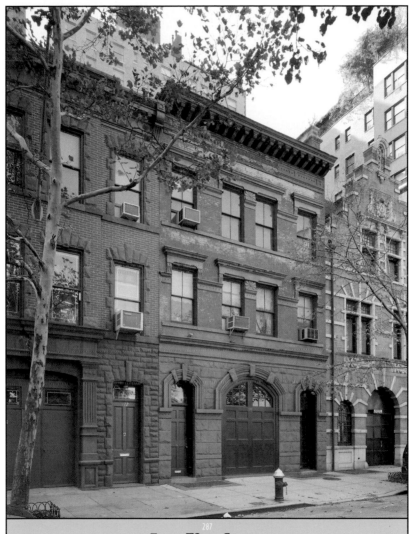

EAST 73RD STREET
BETWEEN LEXINGTON AND THIRD AVENUES

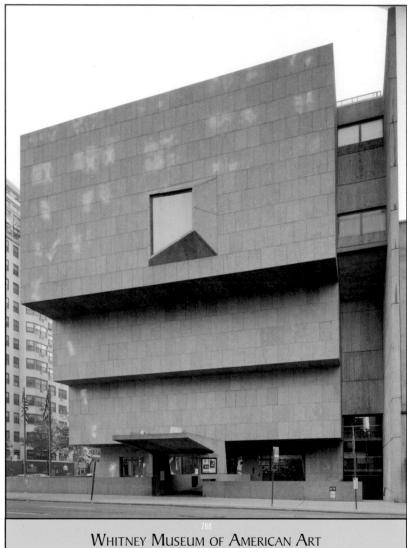

WHITNEY MUSEUM OF AMERICAN ART

945 MADISON AVENUE AT EAST 75TH STREET

1966, MARCEL BREUER & ASSOCIATES

◆ UPPER EAST SIDE ◆

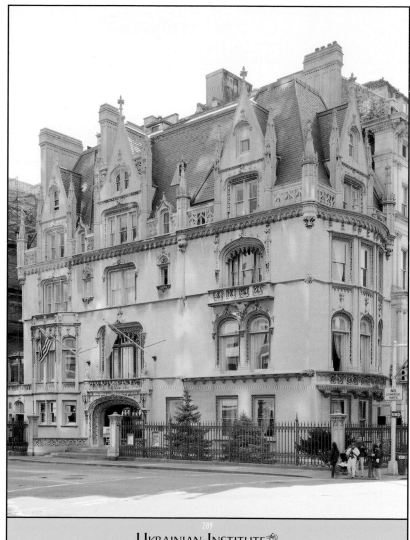

Ukrainian Institute 🦑

2 EAST 79TH STREET

1899, C. P. H. GILBERT

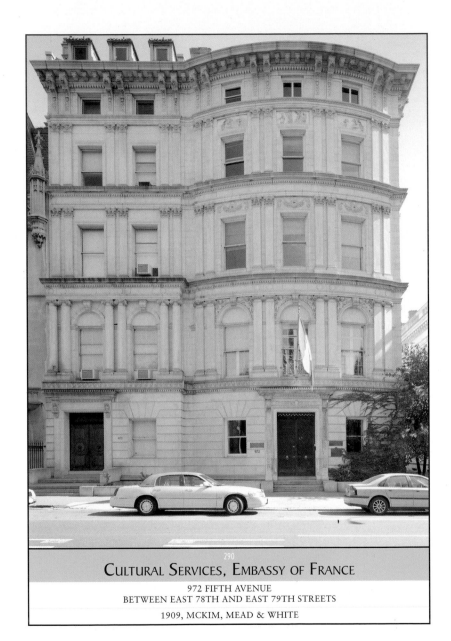

CULTURAL SERVICES, EMBASSY OF FRANCE

972 FIFTH AVENUE
BETWEEN EAST 78TH AND EAST 79TH STREETS

1909, MCKIM, MEAD & WHITE

◆ UPPER EAST SIDE ◆

ISELIN HOUSE

59 EAST 79TH STREET
BETWEEN MADISON AND PARK AVENUES

1909, FOSTER, GADE & GRAHAM

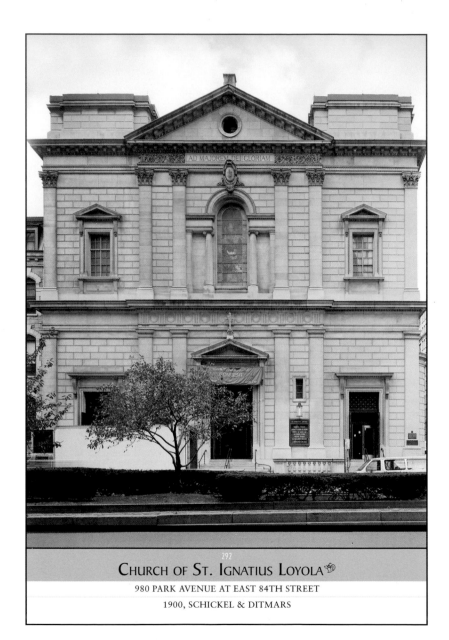

292

CHURCH OF ST. IGNATIUS LOYOLA

980 PARK AVENUE AT EAST 84TH STREET

1900, SCHICKEL & DITMARS

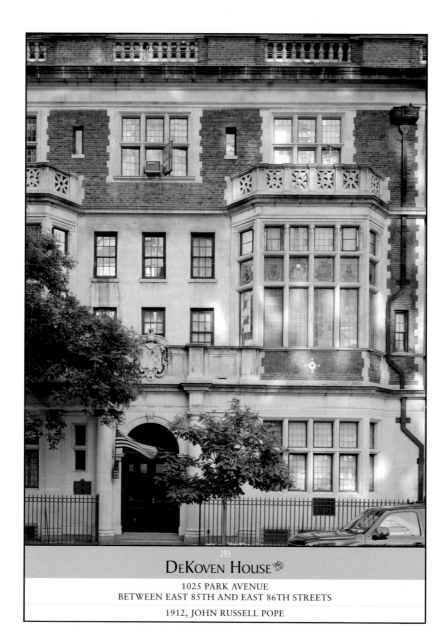

293

DeKoven House

1025 PARK AVENUE
BETWEEN EAST 85TH AND EAST 86TH STREETS

1912, JOHN RUSSELL POPE

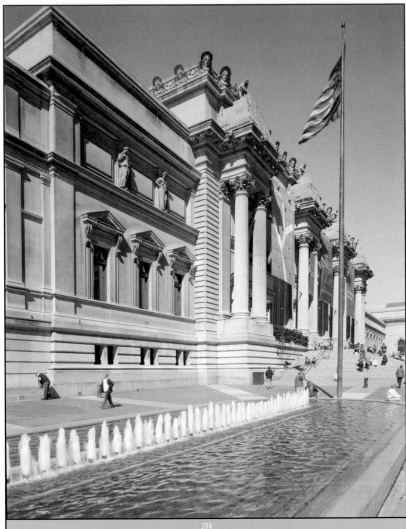

METROPOLITAN MUSEUM OF ART

FIFTH AVENUE, BETWEEN EAST 80TH AND EAST 84TH STREETS

1870, CALVERT VAUX AND JOSEPH WREY MOULD,
RICHARD MORRIS HUNT

◆ UPPER EAST SIDE ◆

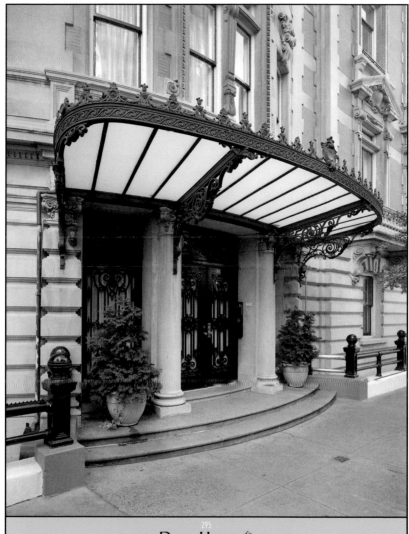

295

Duke House

1009 FIFTH AVENUE AT 82ND STREET

1901, WELCH, SMITH & PROVOT

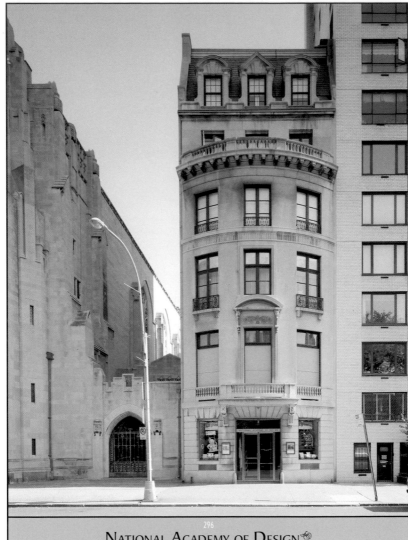

NATIONAL ACADEMY OF DESIGN

1083 FIFTH AVENUE
BETWEEN EAST 89TH AND EAST 90TH STREETS

1915, TURNER & KILIAN AND OGDEN CODMAN, JR.

◆ UPPER EAST SIDE ◆

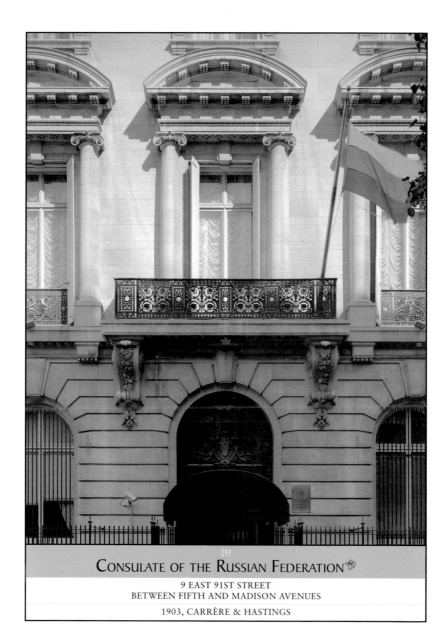

297

CONSULATE OF THE RUSSIAN FEDERATION ❧

9 EAST 91ST STREET
BETWEEN FIFTH AND MADISON AVENUES

1903, CARRÈRE & HASTINGS

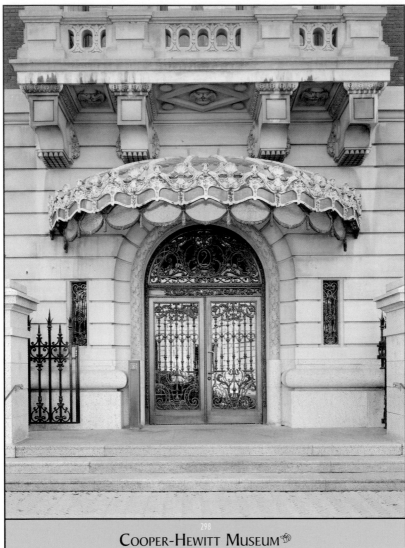

COOPER-HEWITT MUSEUM

2 EAST 91ST STREET AT FIFTH AVENUE

1903, BABB, COOK & WILLARD

◆ UPPER EAST SIDE ◆

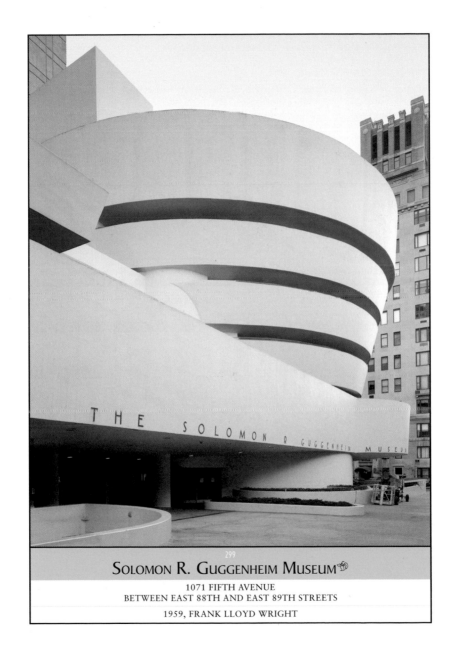

SOLOMON R. GUGGENHEIM MUSEUM

1071 FIFTH AVENUE
BETWEEN EAST 88TH AND EAST 89TH STREETS

1959, FRANK LLOYD WRIGHT

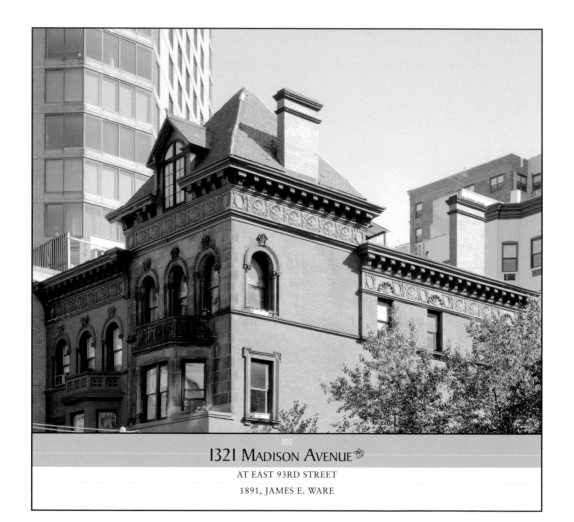

300

1321 Madison Avenue ❦

AT EAST 93RD STREET

1891, JAMES E. WARE

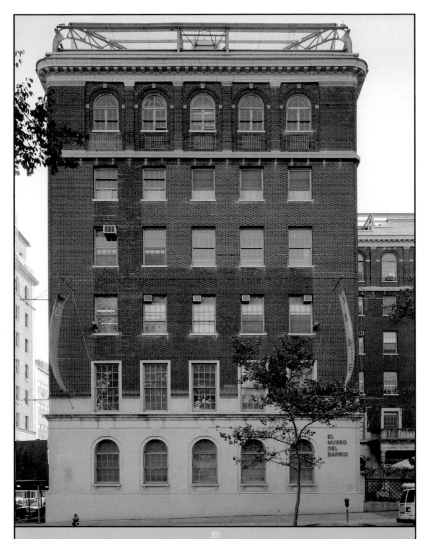

301

EL MUSEO DEL BARRIO

1230 FIFTH AVENUE
BETWEEN EAST 104TH AND EAST 105TH STREETS

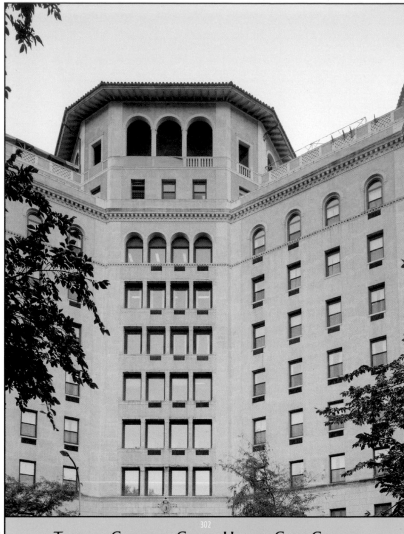

TERENCE CARDINAL COOKE HEALTH CARE CENTER

1240–1248 FIFTH AVENUE
BETWEEN EAST 105TH AND EAST 106TH STREETS

1921, YORK & SAWYER

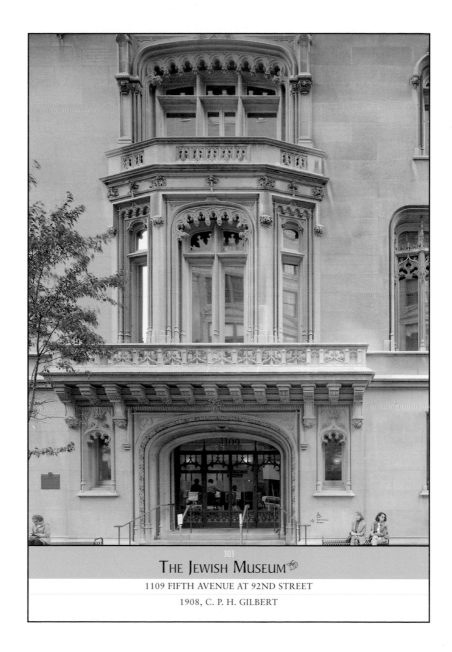

THE JEWISH MUSEUM

1109 FIFTH AVENUE AT 92ND STREET

1908, C. P. H. GILBERT

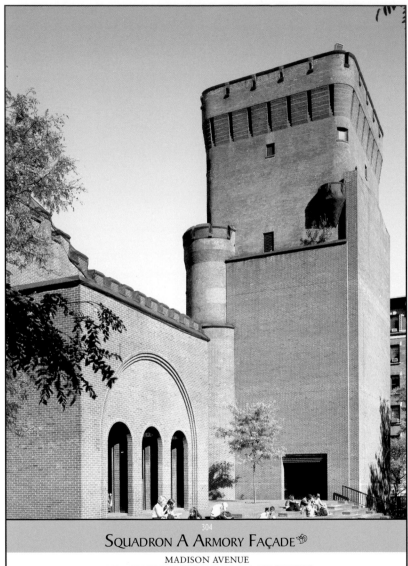

SQUADRON A ARMORY FAÇADE

MADISON AVENUE
BETWEEN EAST 94TH AND EAST 95TH STREETS

1895, JOHN ROCHESTER THOMAS

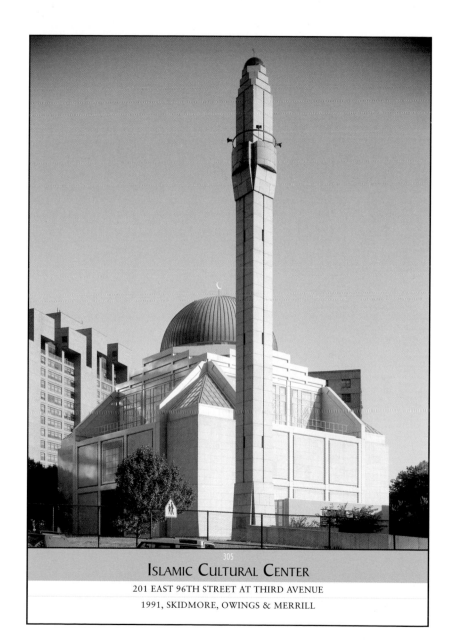

305

Islamic Cultural Center

201 EAST 96TH STREET AT THIRD AVENUE

1991, SKIDMORE, OWINGS & MERRILL

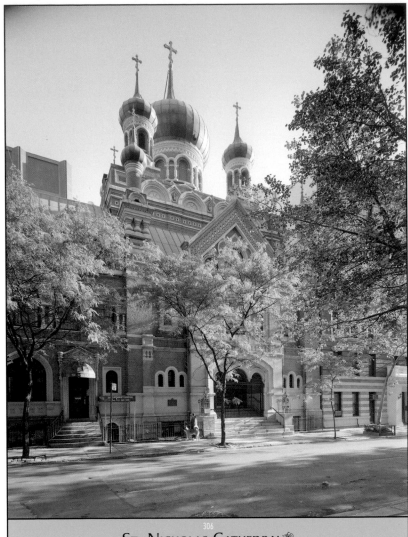

306
St. Nicholas Cathedral

15 EAST 97TH STREET
BETWEEN FIFTH AND MADISON AVENUES

1902, JOHN BERGENSEN

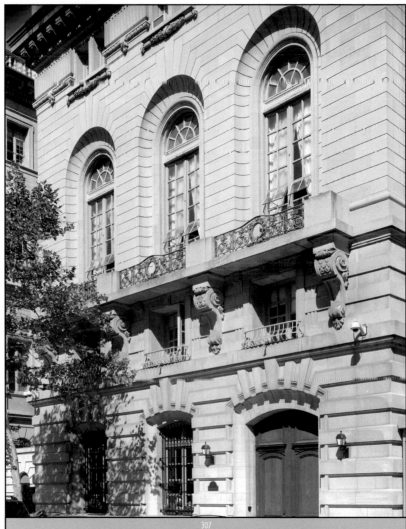

307

Duchene Residence School

7 EAST 91ST STREET
BETWEEN FIFTH AND MADISON AVENUES

1902, WARREN, WETMORE & MORGAN

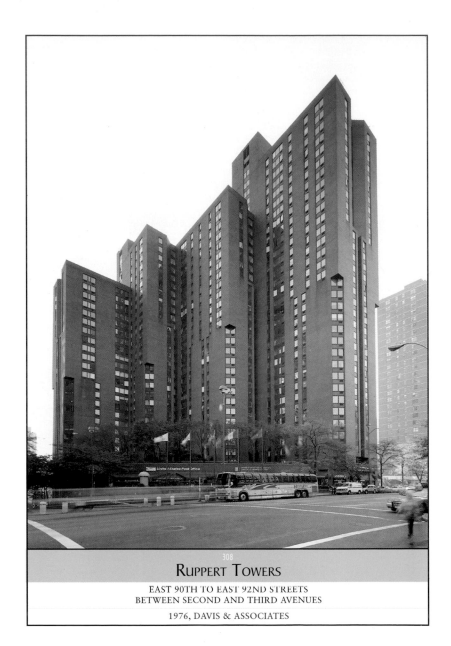

308

Ruppert Towers

EAST 90TH TO EAST 92ND STREETS
BETWEEN SECOND AND THIRD AVENUES

1976, DAVIS & ASSOCIATES

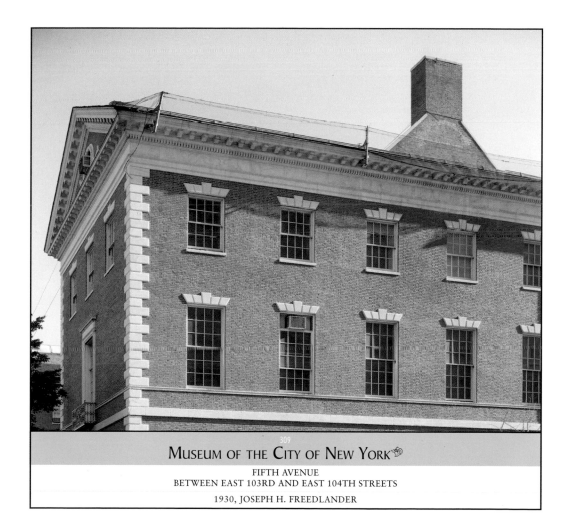

MUSEUM OF THE CITY OF NEW YORK

FIFTH AVENUE
BETWEEN EAST 103RD AND EAST 104TH STREETS

1930, JOSEPH H. FREEDLANDER

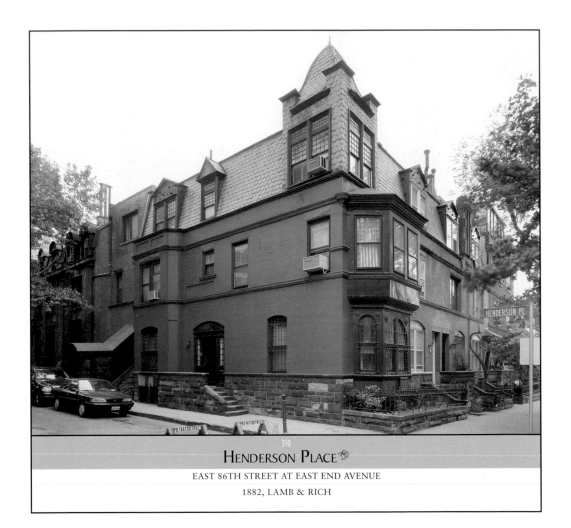

310

HENDERSON PLACE

EAST 86TH STREET AT EAST END AVENUE

1882, LAMB & RICH

Central Park

All the buildings, bridges, boulevards, and highways that make New York unique stand as testaments to what the hand of man can accomplish. But nothing else stands out as an example of human accomplishment quite like Central Park. Built on a master plan by Frederick Law Olmstead and Calvert Vaux, it was opened in 1859 after twenty years of construction. Over those years, 10 million wagonloads of dirt were rearranged, five million trees were planted, and 500,000 cubic yards of topsoil hauled in. Streams, ponds, and a lake were created, and even glacial rocks were moved to more picturesque places than the spots Mother Nature had chosen. At 840 acres, it is Manhattan's biggest park, but the record-holder in the five boroughs is Jamaica Bay Park in Queens, with 2,868 acres. America's largest urban park is Fairmount Park in Philadelphia, at 3,845 acres.

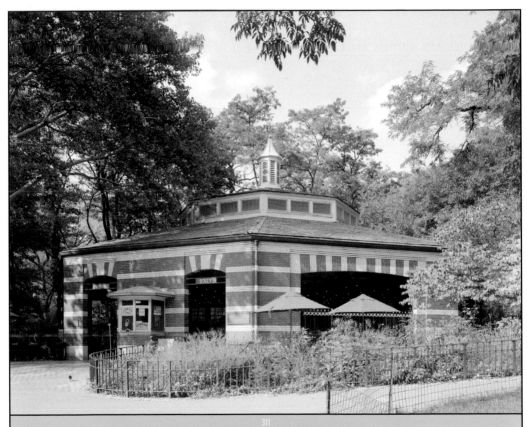

311

Friedsam Memorial Carousel

SOUTHEAST CENTRAL PARK
NEAR THE 65TH STREET TRANSVERSE AND CENTER DRIVE

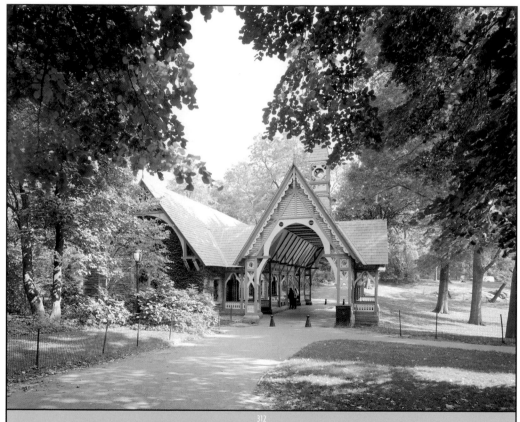

312

THE DAIRY

SOUTHEAST CENTRAL PARK AT 65TH STREET

1870, CALVERT VAUX

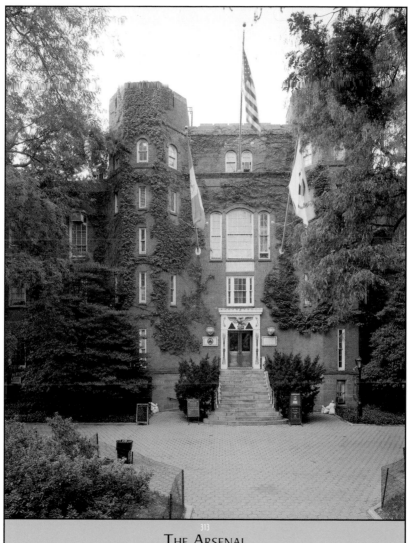

313

THE ARSENAL

FIFTH AVENUE AT EAST 64TH STREET

1848, MARTIN E. THOMPSON

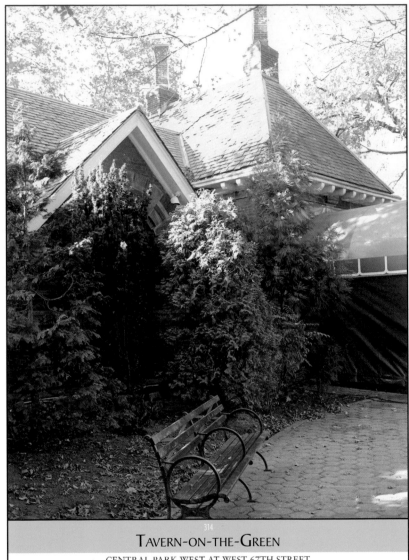

314
Tavern-on-the-Green
CENTRAL PARK WEST AT WEST 67TH STREET
1870

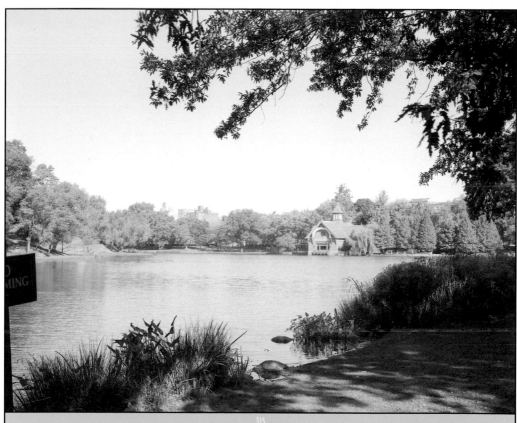

315

HARLEM MEER BOATHOUSE

CENTRAL PARK NORTH AT 110TH STREET

1947

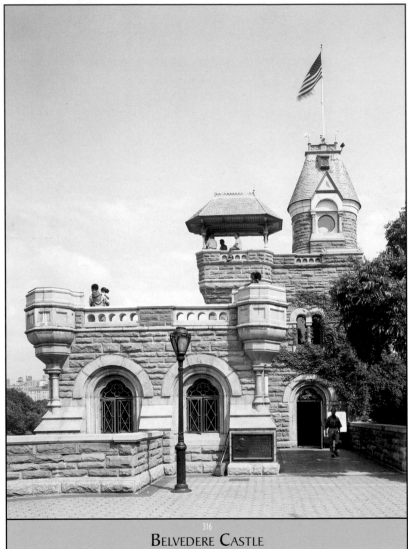

BELVEDERE CASTLE

VISTA ROCK, CENTER OF CENTRAL PARK AT 81ST STREET

1869, CALVERT VAUX

Upper West Side

From Columbus Circle to 110th Street, Central Park to the Hudson River, this is one of the most diverse areas in Manhattan, filled with young mothers pushing baby strollers, college students on their way to classes at Columbia and Barnard, retirees sunning on the benches along the Broadway malls, and a wide array of immigrant populations. It is inhabited by everyone from affluent bankers on Riverside Drive and celebrities on Central Park West to Dominican hairdressers on Amsterdam Avenue and budget-minded young European tourists at the hostels that seem to have sprung up everywhere. The area once consisted of country estates, and was called Bloemendaal, "flowering valley," by the Dutch—although in reality it was mainly rocky outcroppings, most of which have been blasted away to make room for today's buildings.

Henry Hu

Henry Hudson Parkw

Henry Hudson Parkwy

Henry Hudson Parkway (West Side Highway)

Henry Hudson Parkway (West Side Highway)

Riverside Dr.

West End Avenue

West End Avenue

West End Avenue

Broadway

Broadway

Amsterdam Avenue

Amsterdam Avenue

Amsterdam Avenue

Columbus Avenue

Columbus Avenue

Manhattan Ave.

Central Park West

Central Park West

Central Park West

Fifth Avenue

Madison Avenue

Park Avenue

Lexington Avenue

Third Avenue

W. 111th St.

E. 111th St.

W. 110th St. (Cathedral Parkway)

W. 109th St.

W. 108th St.

W. 107th St.

W. 106th St.

W. 105th St.

W. 104th St.

W. 103rd St.

W. 103rd St.

W. 102nd St.

W. 102nd St.

W. 101st St.

W. 101st St.

W. 100th St.

W. 99th St.

W. 98th St.

W. 97th St.

W. 96th St.

W. 95th St.

W. 94th St.

W. 93rd St.

W. 92nd St.

W. 91st St.

W. 90th St.

W. 89th St.

W. 88th St.

W. 87th St.

W. 86th St.

W. 85th St.

W. 84th St.

W. 83rd St.

W. 82nd St.

W. 81st St.

W. 80th St.

W. 79th St.

W. 78th St.

W. 77th St.

W. 76th St.

W. 75th St.

W. 74th St.

W. 73rd St.

W. 72nd St.

W. 71

W. 70th

W. 69th St.

W. 68th St.

W. 67th St.

W. 66th St.

W. 65th St.

W. 64th St.

W. 63rd St.

W. 63rd St.

W. 62nd St.

W. 61st St.

W. 60th St.

W. 59th St.

W. 58th St.

E. 1
E. 1
E. 1
E. 1
E. 1
E. 1
E. 10
E. 1
E. 1
E. 9
E. 9
E. 9
E. 9
E. 9
E. 9
E. 9
E. 9
E. 8
E. 8
E. 8
E. 8
E. 8
E. 8
E. 8
E. 8
E. 7
E. 7
E. 7
E. 7
E. 7
E. 7
E. 7
E. 6
E. 6
E. 6
E. 6
E. 6
E. 6
E. 6
E. 5

345
346
348
344
347
343
342
341
338
339
333
349
335
336
340
332
331
330
337 334
326
327
329
323
328
325
324
320
322
318
321
317
319

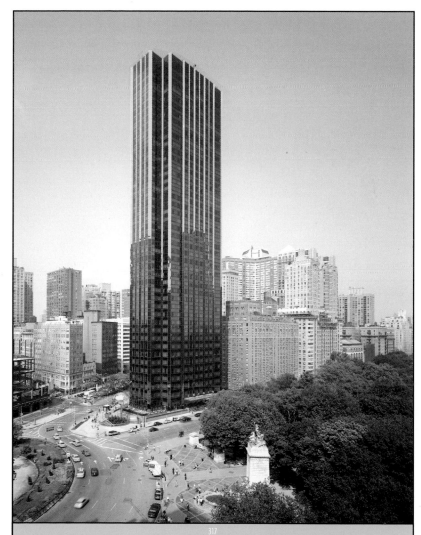

317

TRUMP INTERNATIONAL HOTEL AND TOWER

ONE CENTRAL PARK WEST AT COLUMBUS CIRCLE

1970, THOMAS E. STANLEY
REDESIGNED, MID-1990S, PHILIP JOHNSON AND ALAN RITCHIE

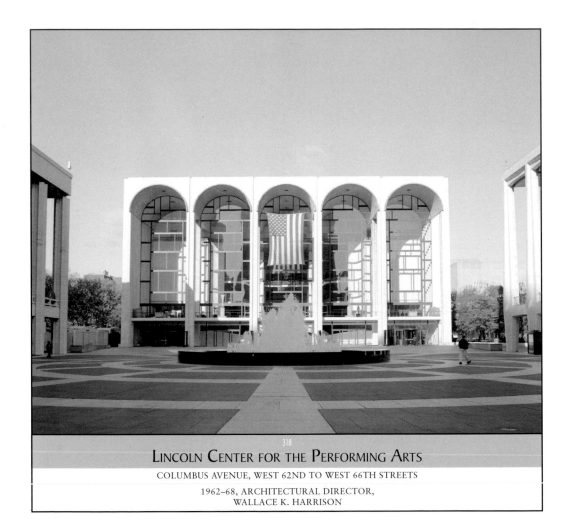

318

Lincoln Center for the Performing Arts

COLUMBUS AVENUE, WEST 62ND TO WEST 66TH STREETS

1962–68, ARCHITECTURAL DIRECTOR,
WALLACE K. HARRISON

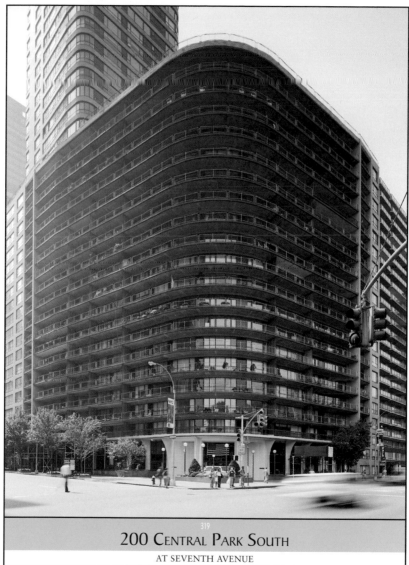

319

200 CENTRAL PARK SOUTH
AT SEVENTH AVENUE
1964, WECHSLER & SCHIMENTI

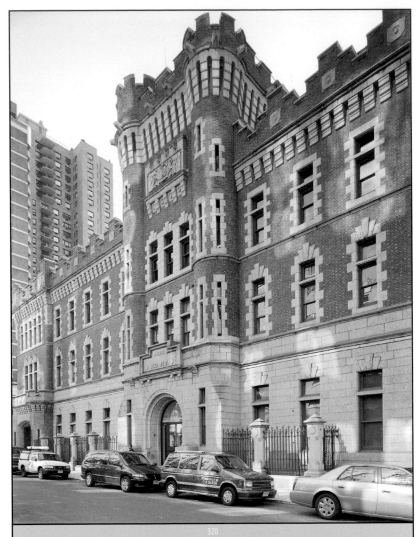

First Battery Armory

56 WEST 66TH STREET, BETWEEN COLUMBUS AVENUE AND CENTRAL PARK WEST

1901, HORGAN & SLATTERY
ALTERED, 1978, KOHN PEDERSON FOX ASSOCIATES

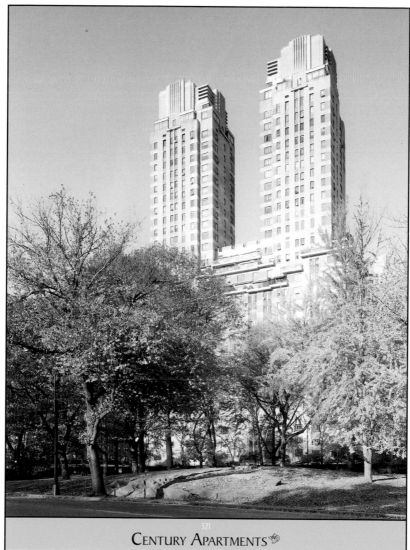

CENTURY APARTMENTS

25 CENTRAL PARK WEST
BETWEEN WEST 63RD AND WEST 64TH STREETS

1931, IRWIN S. CHANIN

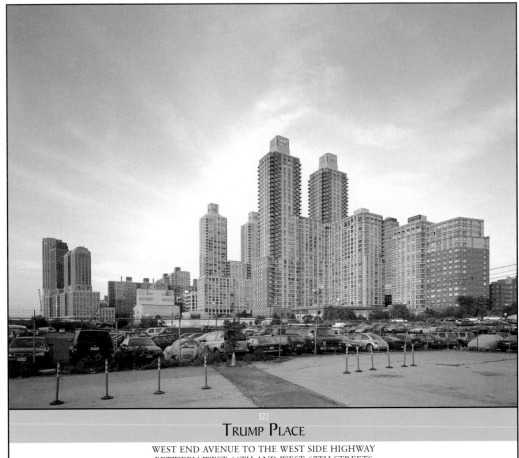

322
TRUMP PLACE

WEST END AVENUE TO THE WEST SIDE HIGHWAY
BETWEEN WEST 66TH AND WEST 67TH STREETS

1999, PHILIP JOHNSON & ALAN RITCHIE WITH COSTAS KONDYLIS

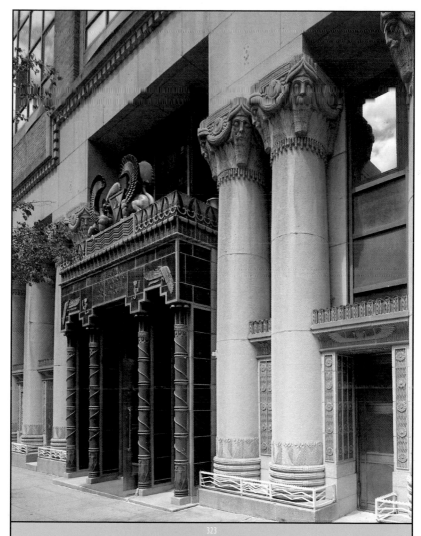

323

Pythian Temple

135 WEST 70TH STREET, BETWEEN BROADWAY AND COLUMBUS AVENUE

1927, THOMAS W. LAMB
ALTERED, 1986, DAVID GURA

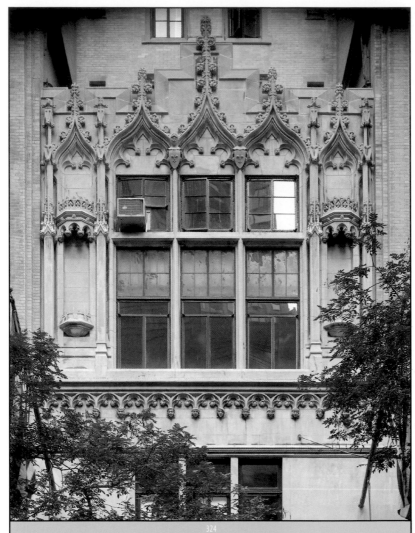

HOTEL DES ARTISTES

ONE WEST 67TH STREET
BETWEEN CENTRAL PARK WEST AND COLUMBUS AVENUE

1918, GEORGE MORT POLLARD

◆ UPPER WEST SIDE ◆

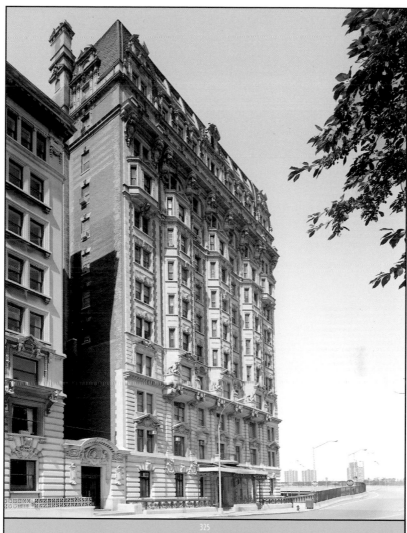

THE CHATSWORTH

344 WEST 72ND STREET AT THE WEST SIDE HIGHWAY

1902–06, JOHN E. SCHARSMITH

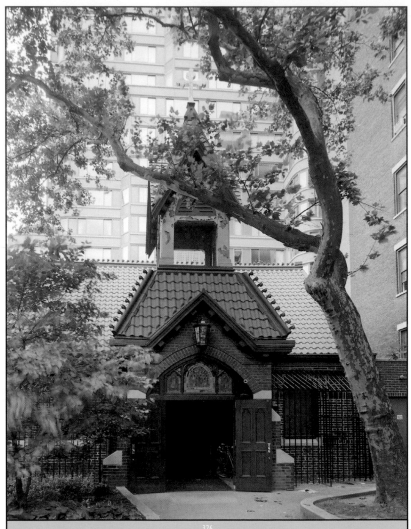

CHRIST AND ST. STEPHEN'S CHURCH

129 WEST 69TH STREET
BETWEEN BROADWAY AND COLUMBUS AVENUE

1880, WILLIAM H. DAY

◆ UPPER WEST SIDE ◆

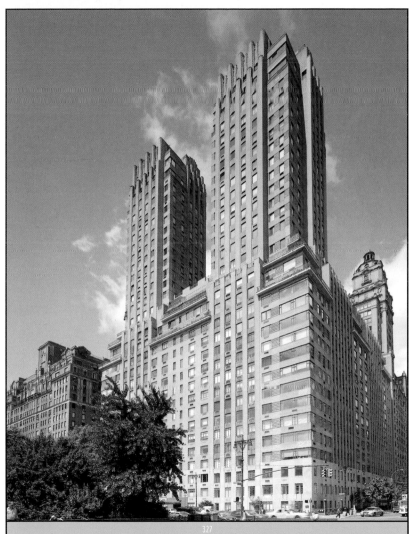

327
MAJESTIC APARTMENTS

115 CENTRAL PARK WEST
BETWEEN WEST 71ST AND WEST 72ND STREET

1931, IRWIN S. CHANIN

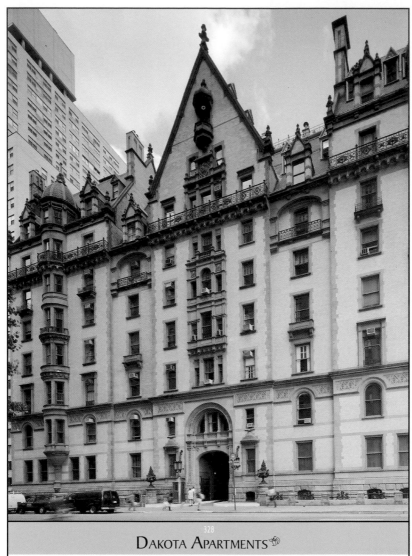

DAKOTA APARTMENTS

ONE WEST 72ND STREET AT CENTRAL PARK WEST

1884, HENRY J. HARDENBERGH

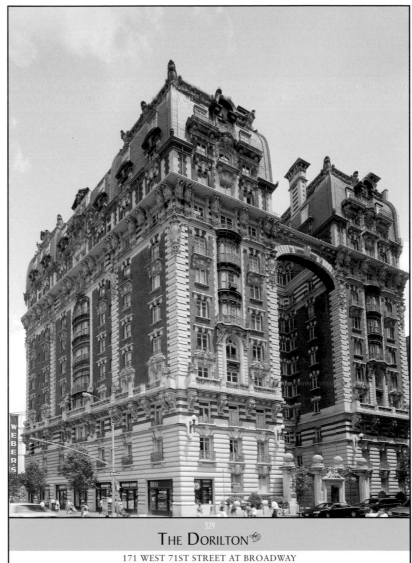

329
THE DORILTON
171 WEST 71ST STREET AT BROADWAY
1902, JANES & LEO

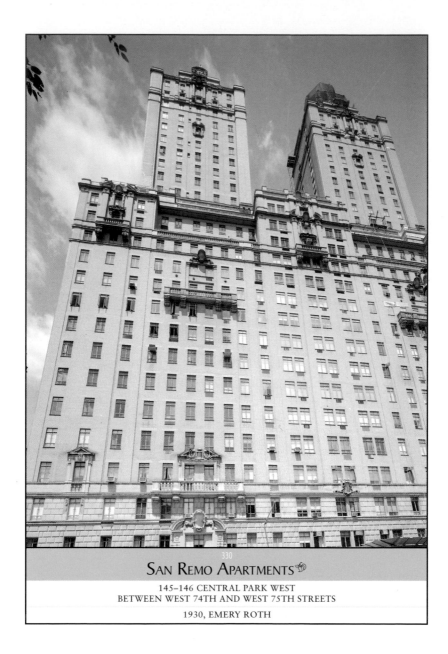

330

SAN REMO APARTMENTS

145–146 CENTRAL PARK WEST
BETWEEN WEST 74TH AND WEST 75TH STREETS

1930, EMERY ROTH

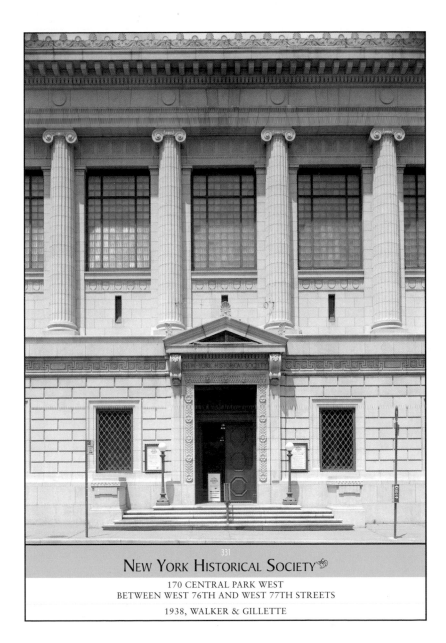

331

NEW YORK HISTORICAL SOCIETY

170 CENTRAL PARK WEST
BETWEEN WEST 76TH AND WEST 77TH STREETS

1938, WALKER & GILLETTE

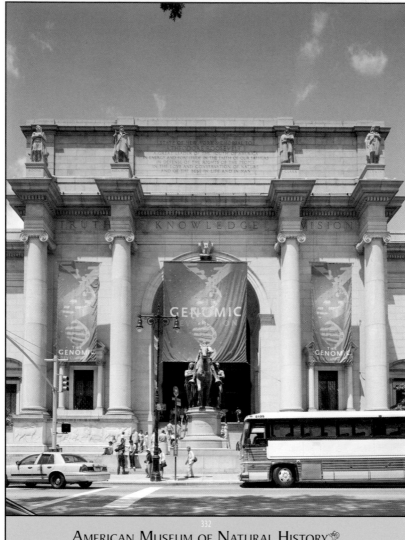

AMERICAN MUSEUM OF NATURAL HISTORY

CENTRAL PARK WEST TO COLUMBUS AVENUE, WEST 77TH TO WEST 81ST STREETS

1877, CALVERT VAUX AND JACOB WREY MOULD, 1901, J.C. CADY & CO
1908, CHARLES VOLZ, 1924, TROWBRIDGE & LIVINGSTON

◆ UPPER WEST SIDE ◆

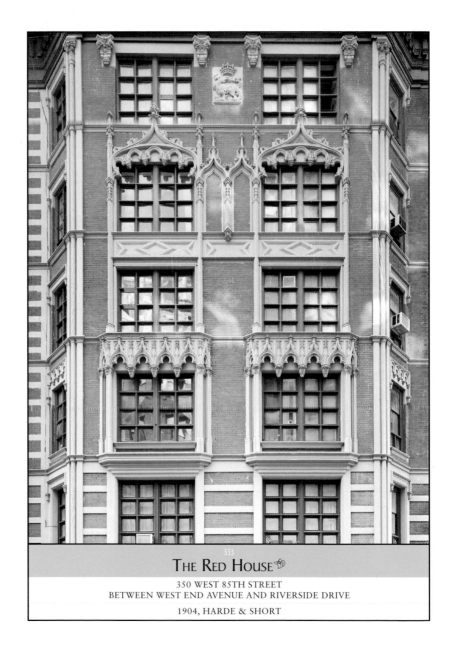

THE RED HOUSE

350 WEST 85TH STREET
BETWEEN WEST END AVENUE AND RIVERSIDE DRIVE

1904, HARDE & SHORT

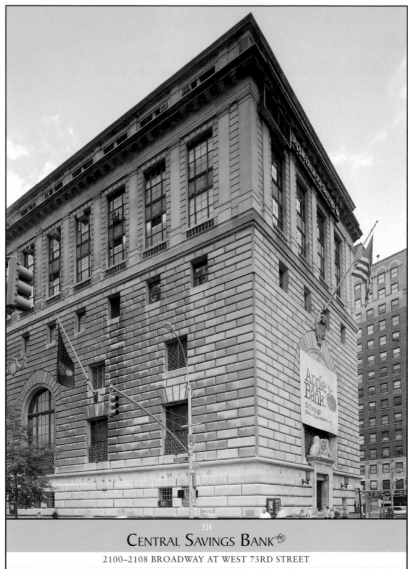

334

CENTRAL SAVINGS BANK

2100–2108 BROADWAY AT WEST 73RD STREET

1928, YORK & SAWYER

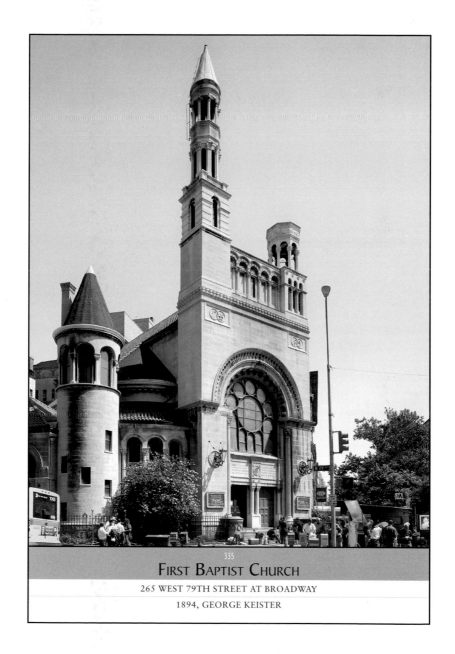

335

First Baptist Church

265 WEST 79TH STREET AT BROADWAY

1894, GEORGE KEISTER

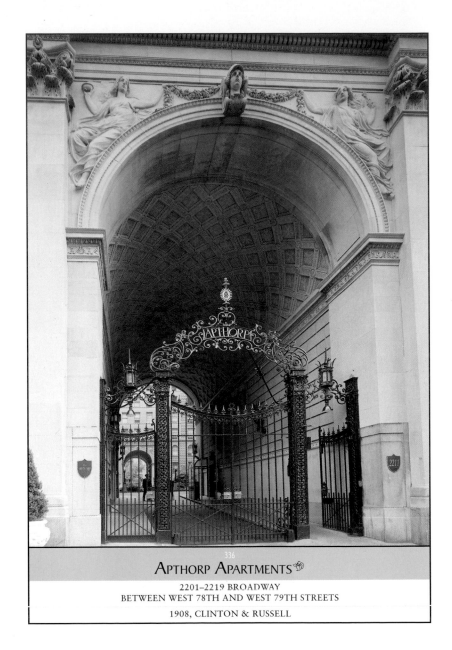

APTHORP APARTMENTS

2201–2219 BROADWAY
BETWEEN WEST 78TH AND WEST 79TH STREETS

1908, CLINTON & RUSSELL

◆ UPPER WEST SIDE ◆

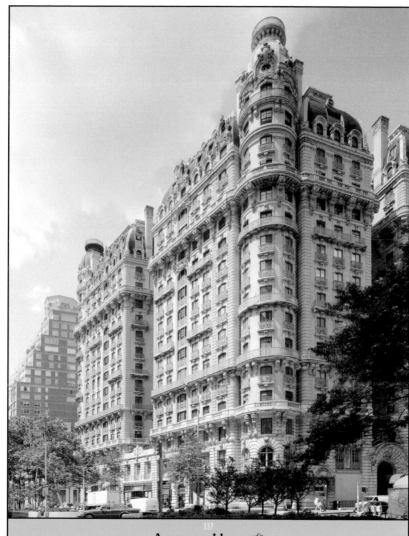

ANSONIA HOTEL

2109 BROADWAY
BETWEEN WEST 73RD AND WEST 74TH STREETS

1904, PAUL E. M. DUBOY

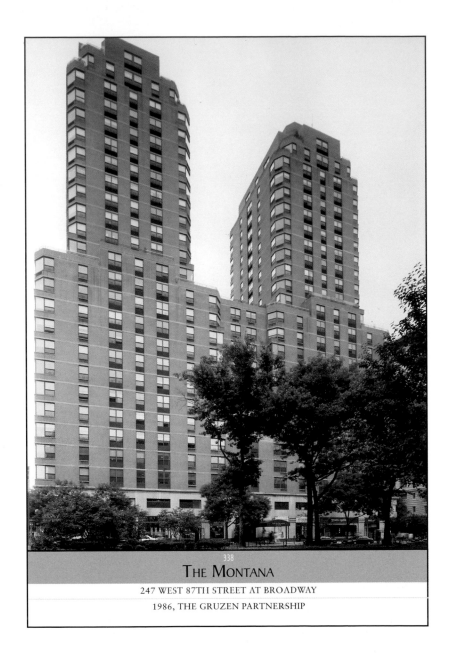

THE MONTANA

247 WEST 87TH STREET AT BROADWAY

1986, THE GRUZEN PARTNERSHIP

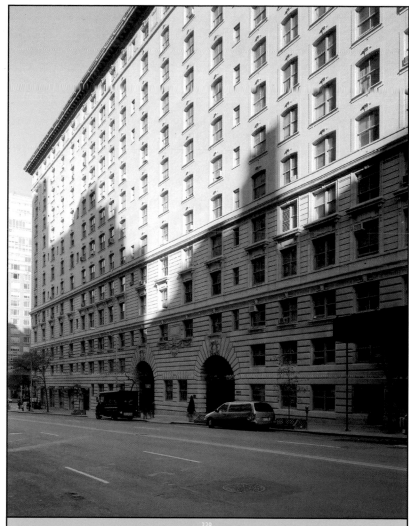

Belnord Apartments

225 WEST 86TH STREET
BETWEEN AMSTERDAM AVENUE AND BROADWAY

H. HOBART WEEKES

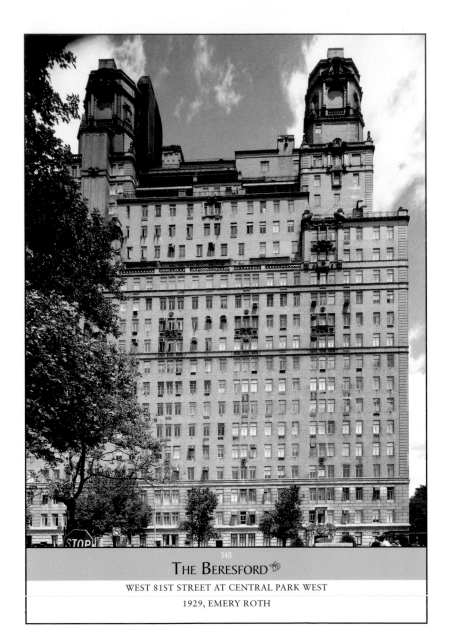

340

THE BERESFORD ❧

WEST 81ST STREET AT CENTRAL PARK WEST

1929, EMERY ROTH

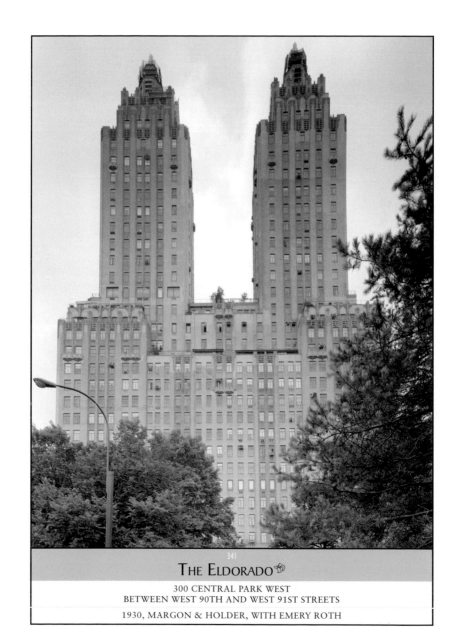

341

The Eldorado

300 CENTRAL PARK WEST
BETWEEN WEST 90TH AND WEST 91ST STREETS

1930, MARGON & HOLDER, WITH EMERY ROTH

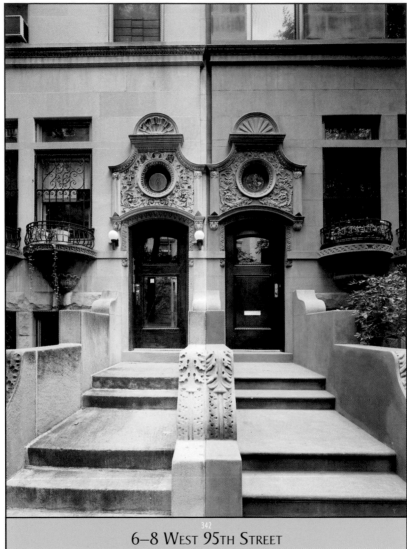

6–8 WEST 95TH STREET

BETWEEN CENTRAL PARK WEST AND COLUMBUS AVENUE

◆ UPPER WEST SIDE ◆

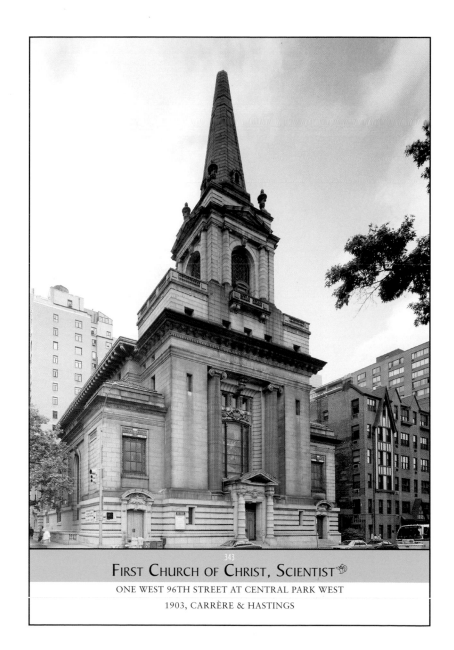

343

First Church of Christ, Scientist

ONE WEST 96TH STREET AT CENTRAL PARK WEST

1903, CARRÈRE & HASTINGS

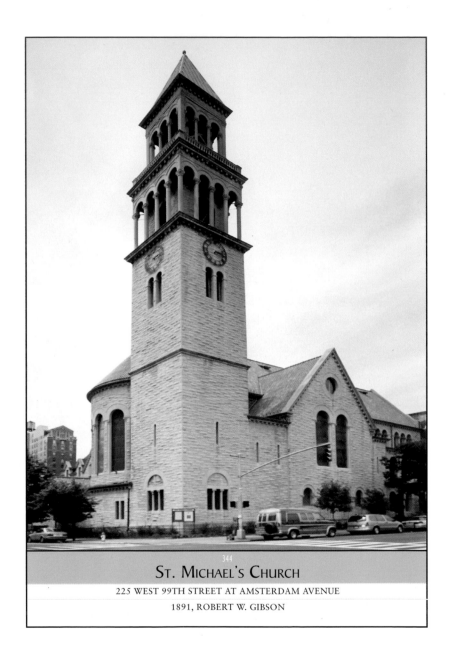

344

St. Michael's Church

225 WEST 99TH STREET AT AMSTERDAM AVENUE

1891, ROBERT W. GIBSON

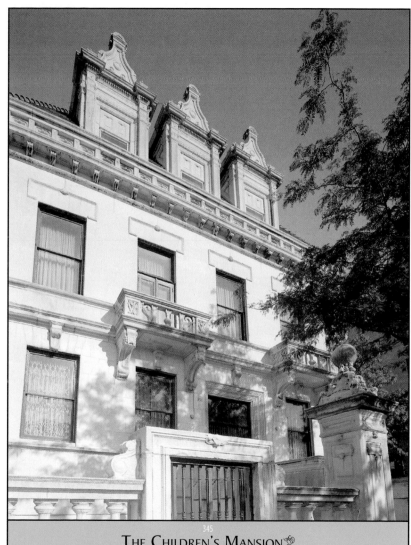

345

THE CHILDREN'S MANSION

351 RIVERSIDE DRIVE AT 107TH STREET

1909, WILLIAM B. TUTHILL

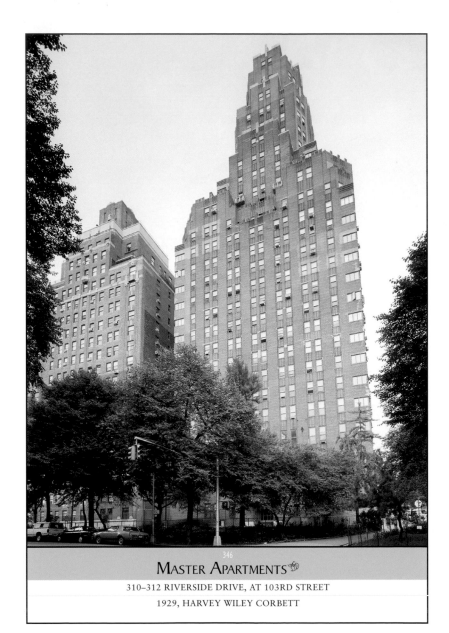

346

MASTER APARTMENTS

310–312 RIVERSIDE DRIVE, AT 103RD STREET

1929, HARVEY WILEY CORBETT

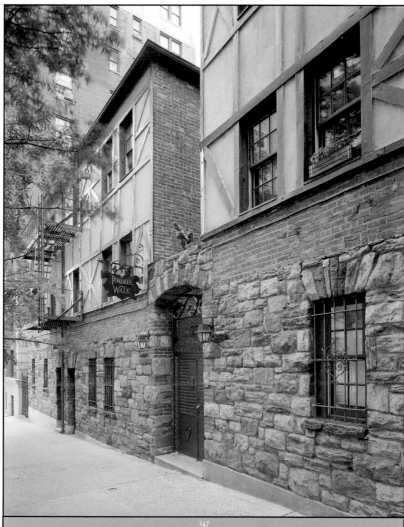

347

POMANDER WALK

BETWEEN WEST 95TH AND WEST 96TH STREETS
BROADWAY AND WEST END AVENUES

1921, KING & CAMPBELL

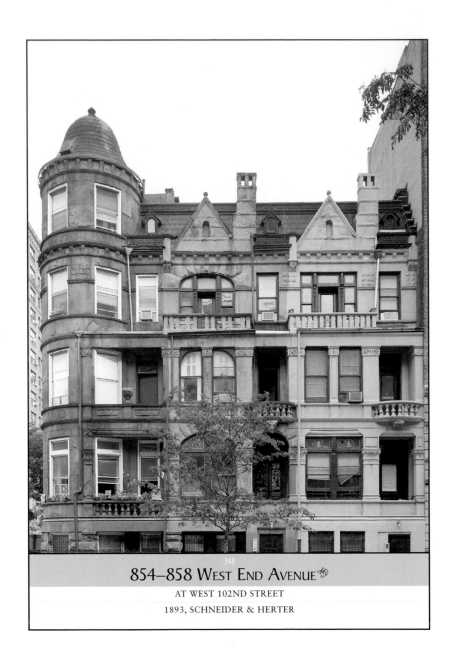

854–858 WEST END AVENUE

AT WEST 102ND STREET

1893, SCHNEIDER & HERTER

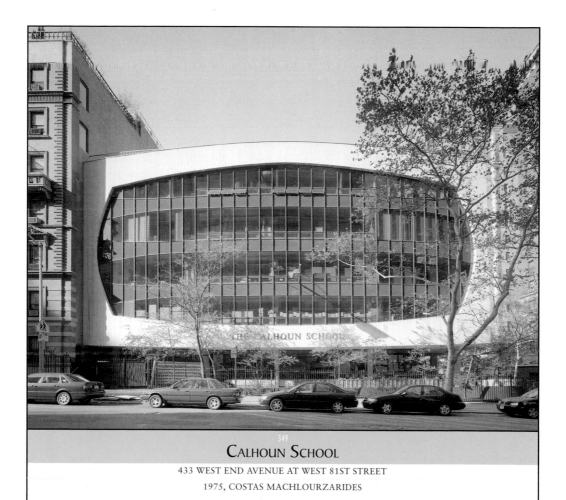

349
Calhoun School
433 WEST END AVENUE AT WEST 81ST STREET
1975, COSTAS MACHLOURZARIDES

Harlem and the Heights

Beginning with Morningside Heights at 110th Street, the rocky highlands along the Hudson River extend up toward the tip of the island, through Hamilton and Washington Heights to Inwood Hill Park, the only place in Manhattan that hasn't changed since Henry Hudson anchored there in 1609. Inland to the east is Harlem, the vibrant center of African-American culture. It was first settled by the Dutch in 1658 as the village of Nieuw Haarlem, and was transformed from farmland when the elevated railroads arrived in 1880, growing up even more after the subway reached it in 1901. It developed into a center of African-American life, with the encouragment of its churches, after a real estate panic hit the area at the beginning of the twentieth century.

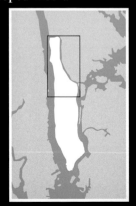

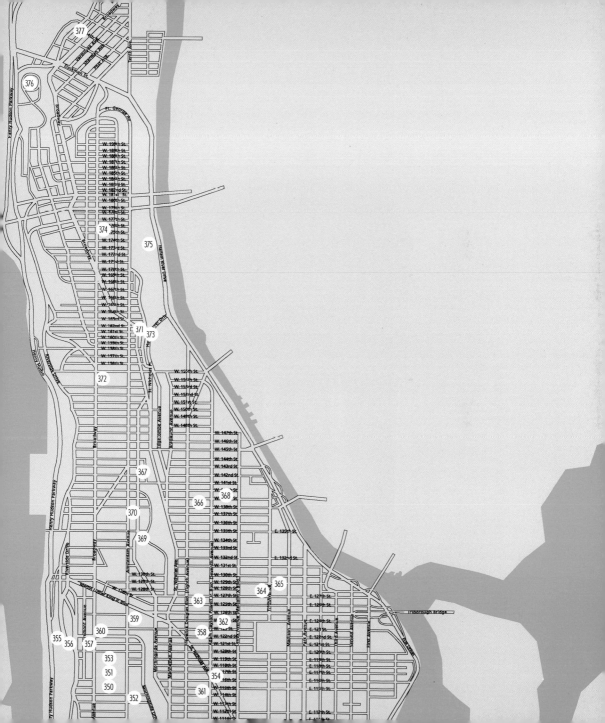

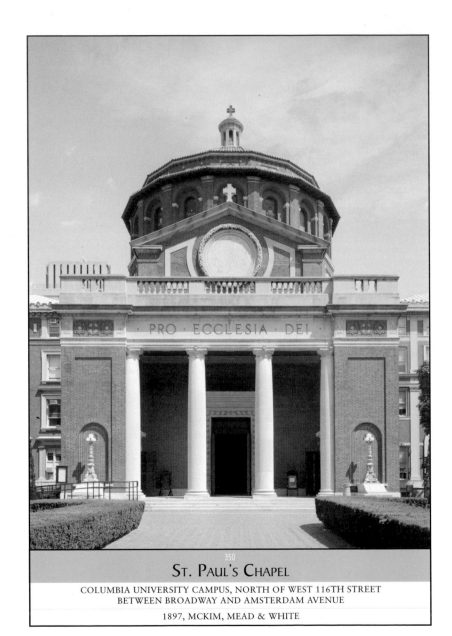

350

St. Paul's Chapel

COLUMBIA UNIVERSITY CAMPUS, NORTH OF WEST 116TH STREET
BETWEEN BROADWAY AND AMSTERDAM AVENUE

1897, MCKIM, MEAD & WHITE

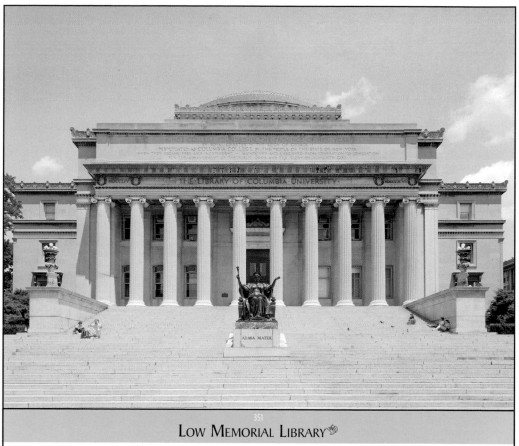

Low Memorial Library

COLUMBIA UNIVERSITY CAMPUS, NORTH OF WEST 116TH STREET
BETWEEN BROADWAY AND AMSTERDAM AVENUE

1907, HOWELLS & STOKES

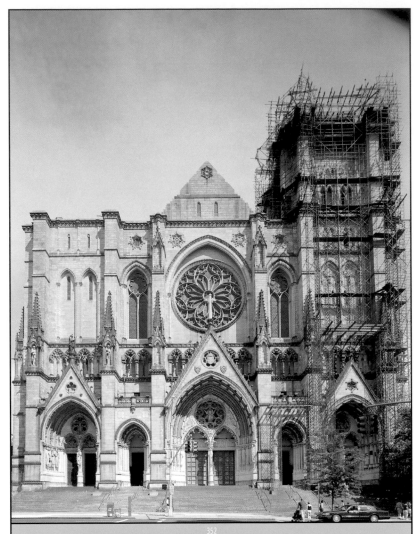

352

CATHEDRAL CHURCH OF ST. JOHN THE DIVINE

AMSTERDAM AVENUE AT WEST 112TH STREET

1892–1911, HEINS & LA FARGE
1911–42, CRAM & FERGUSON

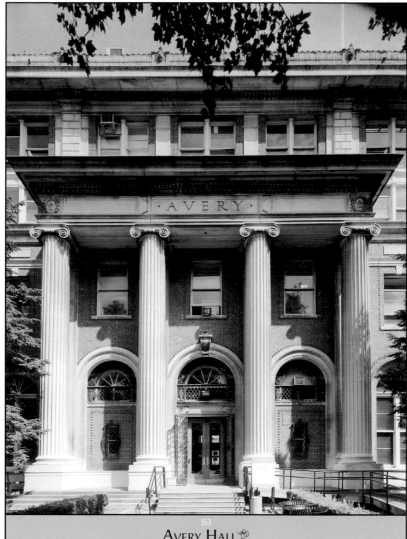

353
AVERY HALL

COLUMBIA UNIVERSITY CAMPUS, WEST 116TH STREET
BETWEEN BROADWAY AND AMSTERDAM AVENUE

1912, MCKIM, MEAD & WHITE

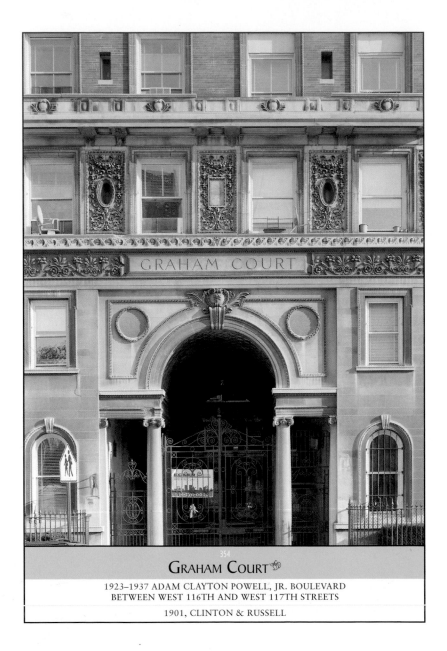

GRAHAM COURT

1923–1937 ADAM CLAYTON POWELL, JR. BOULEVARD
BETWEEN WEST 116TH AND WEST 117TH STREETS

1901, CLINTON & RUSSELL

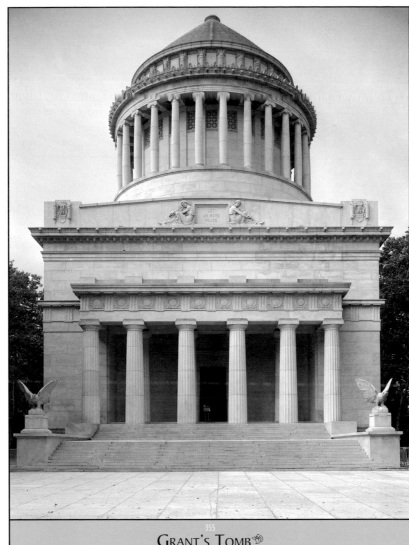

355

GRANT'S TOMB

RIVERSIDE DRIVE AT 122ND STREET

1897, JOHN H. DUNCAN

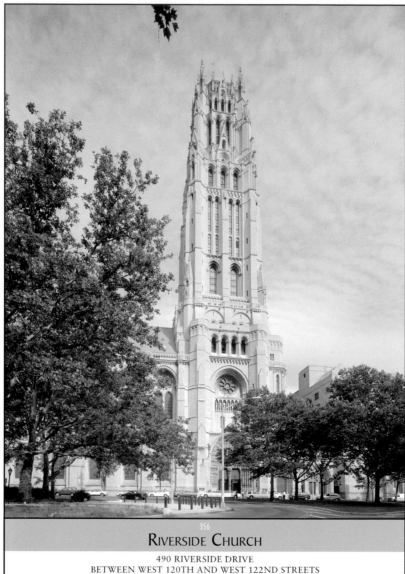

Riverside Church

490 RIVERSIDE DRIVE
BETWEEN WEST 120TH AND WEST 122ND STREETS

1930, ALLEN & COLLINS

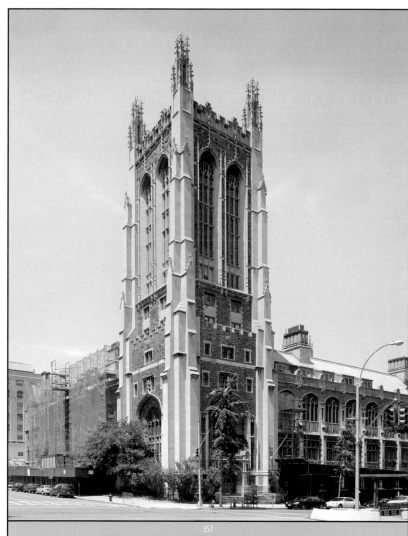

357

UNION THEOLOGICAL SEMINARY

BROADWAY, BETWEEN WEST 120TH
AND WEST 122ND STREETS

1910, ALLEN & COLLINS

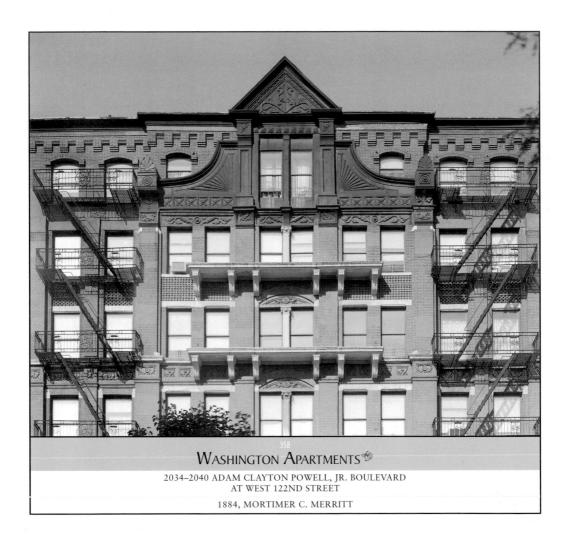

358
Washington Apartments

2034–2040 ADAM CLAYTON POWELL, JR. BOULEVARD
AT WEST 122ND STREET

1884, MORTIMER C. MERRITT

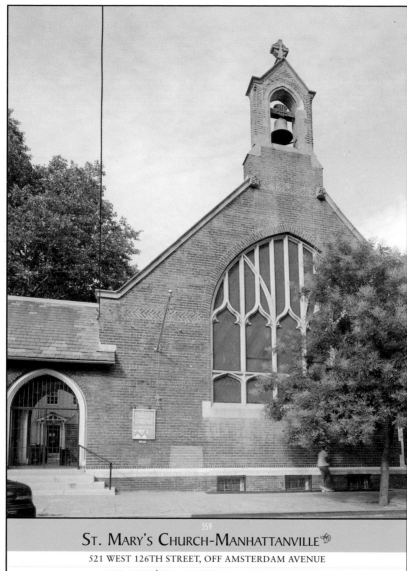

St. Mary's Church-Manhattanville

521 WEST 126TH STREET, OFF AMSTERDAM AVENUE

1909, CARRÈRE & HASTINGS AND T. E. BLAKE

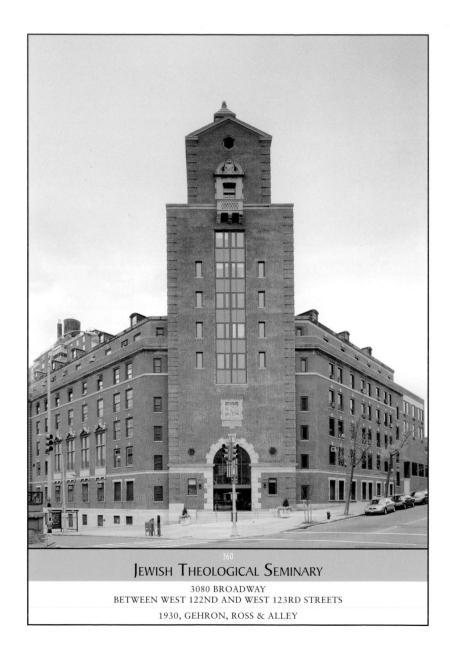

360
JEWISH THEOLOGICAL SEMINARY

3080 BROADWAY
BETWEEN WEST 122ND AND WEST 123RD STREETS

1930, GEHRON, ROSS & ALLEY

WADLEIGH HIGH SCHOOL

215 WEST 114TH STREET, BETWEEN ADAM CLAYTON POWELL, JR. AND
FREDERICK DOUGLASS BOULEVARDS

1902, C. B. J. SNYDER

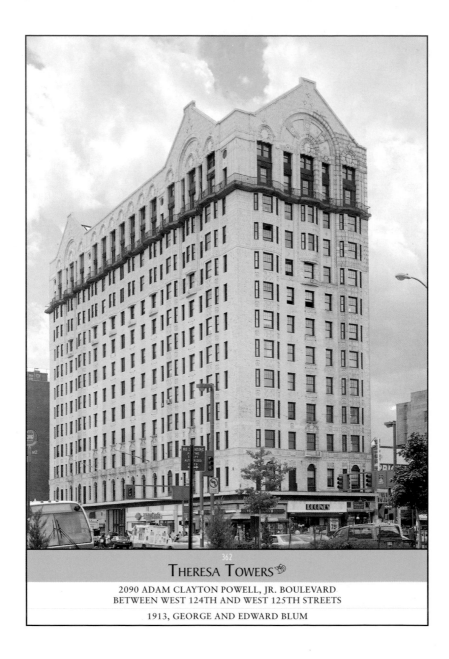

362

THERESA TOWERS

2090 ADAM CLAYTON POWELL, JR. BOULEVARD
BETWEEN WEST 124TH AND WEST 125TH STREETS

1913, GEORGE AND EDWARD BLUM

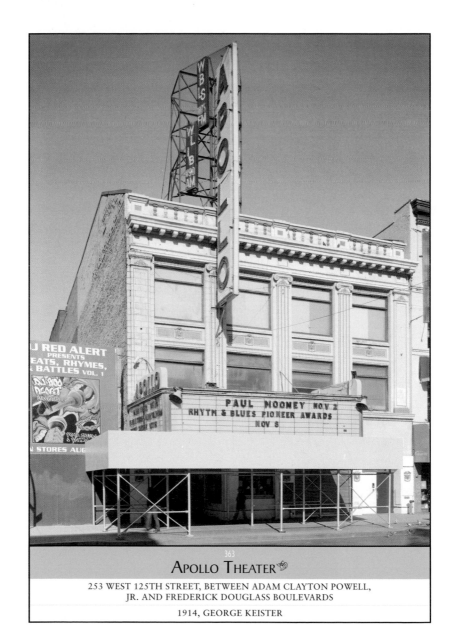

363

APOLLO THEATER

253 WEST 125TH STREET, BETWEEN ADAM CLAYTON POWELL,
JR. AND FREDERICK DOUGLASS BOULEVARDS

1914, GEORGE KEISTER

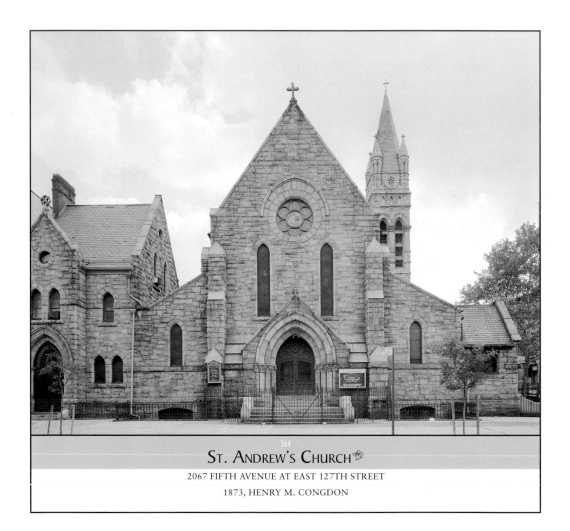

ST. ANDREW'S CHURCH

2067 FIFTH AVENUE AT EAST 127TH STREET

1873, HENRY M. CONGDON

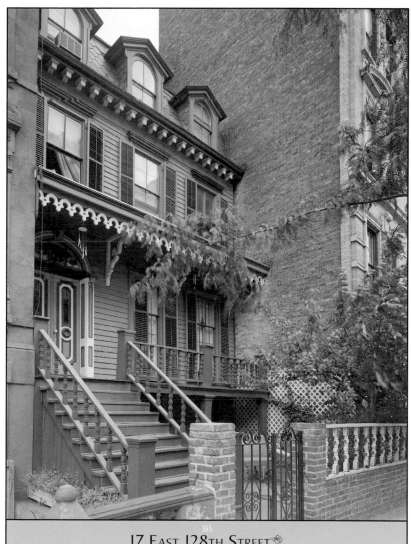

365

17 East 128th Street

BETWEEN FIFTH AND MADISON AVENUE

C. 1864

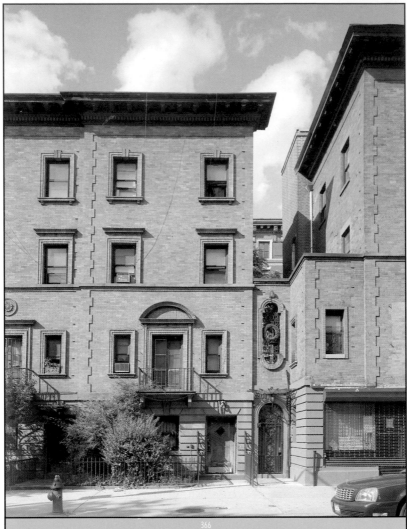

STRIVER'S ROW

WEST 138TH TO WEST 139TH STREETS, BETWEEN ADAM CLAYTON POWELL,
JR. AND FREDERICK DOUGLASS BOULEVARDS

1893, JAMES BROWN LORD, BRUCE PRICE, AND STANFORD WHITE

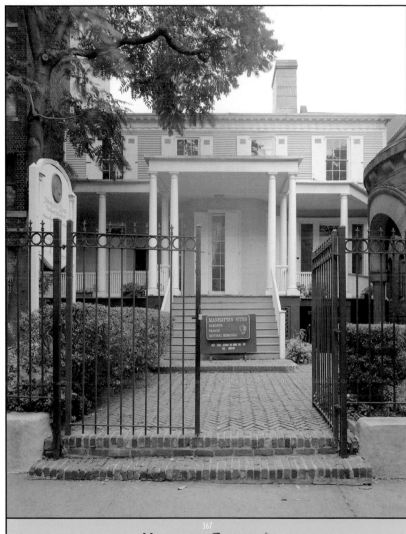

367

HAMILTON GRANGE

287 CONVENT AVENUE
BETWEEN WEST 141ST AND WEST 142ND STREETS

1802, JOHN MCCOMB, JR.

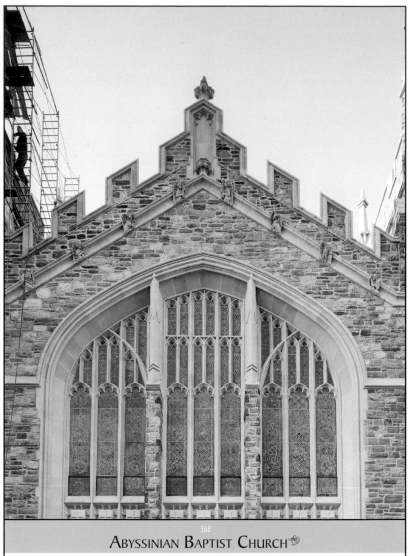

368

Abyssinian Baptist Church

132 WEST 138TH STREET BETWEEN MALCOLM X
AND ADAM CLAYTON POWELL, JR. BOULEVARDS

1923, CHARLES W. BOLTON & SONS

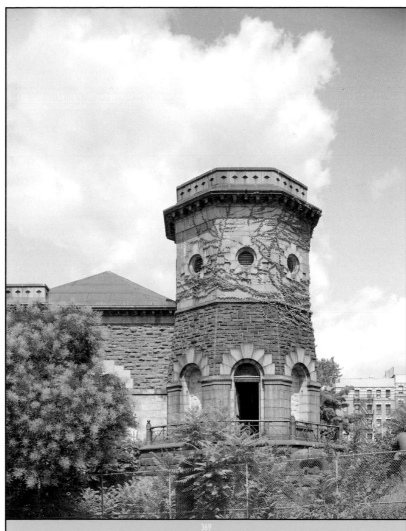

135TH STREET GATEHOUSE

CROTON AQUEDUCT
CONVENT AVENUE AT WEST 135TH STREET

1890, FREDERICK S. COOK

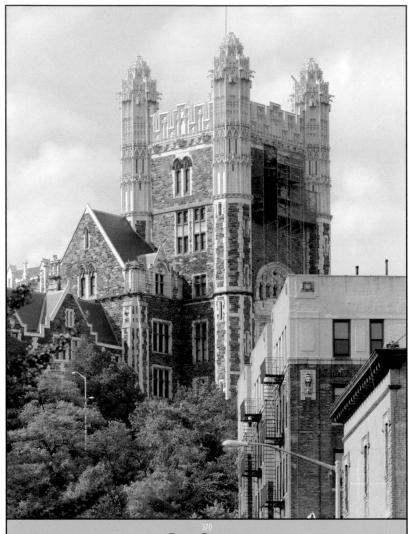

370

CITY COLLEGE

WEST 138TH TO WEST 141ST STREETS
AMSTERDAM AVENUE TO ST. NICHOLAS TERRACE

1907

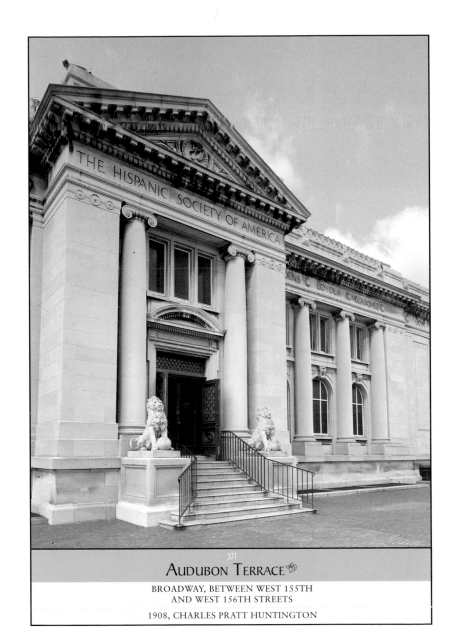

AUDUBON TERRACE

BROADWAY, BETWEEN WEST 155TH
AND WEST 156TH STREETS

1908, CHARLES PRATT HUNTINGTON

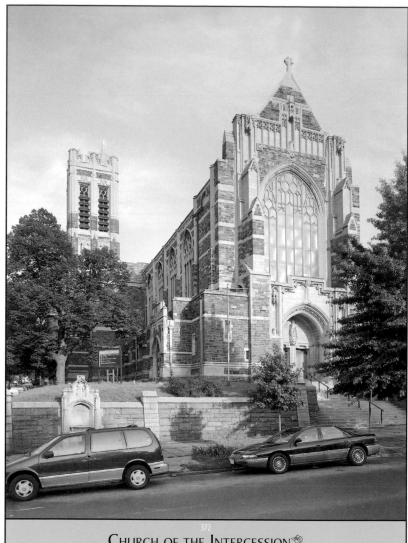

372

Church of the Intercession

550 WEST 155TH STREET AT BROADWAY

1914, CRAM, GOODHUE & FERGUSON

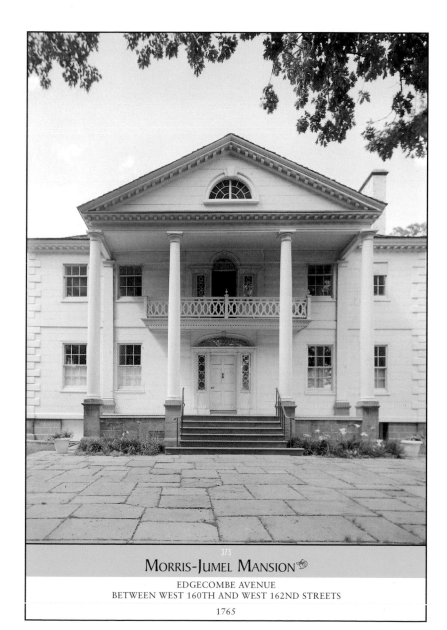

373

MORRIS-JUMEL MANSION

EDGECOMBE AVENUE
BETWEEN WEST 160TH AND WEST 162ND STREETS

1765

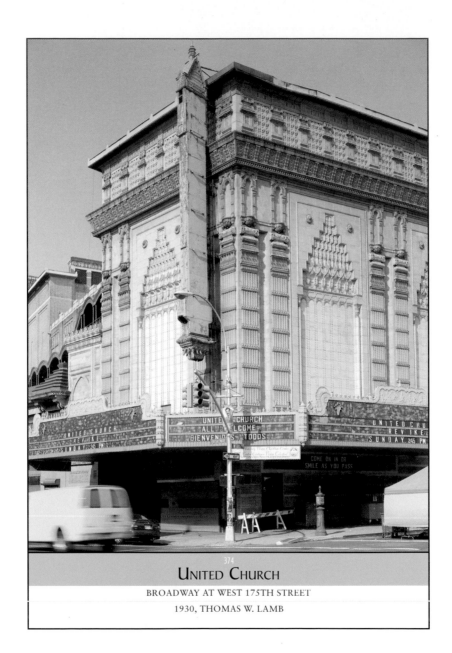

374

United Church

BROADWAY AT WEST 175TH STREET

1930, THOMAS W. LAMB

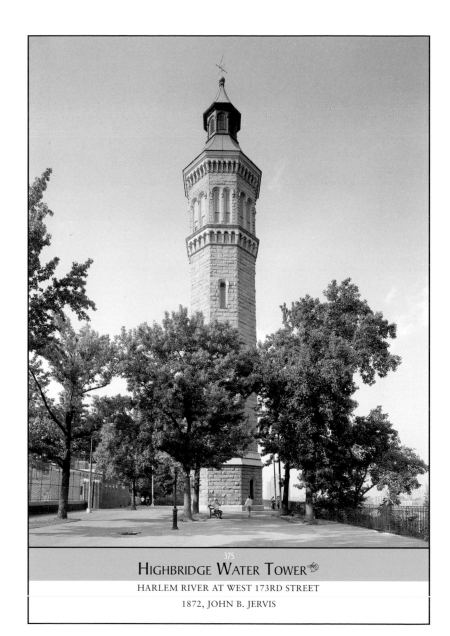

375
HIGHBRIDGE WATER TOWER

HARLEM RIVER AT WEST 173RD STREET

1872, JOHN B. JERVIS

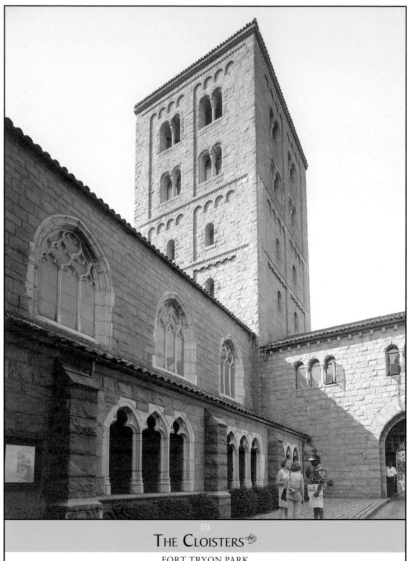

THE CLOISTERS

FORT TRYON PARK

1939, ALLEN, COLLINS & WILLIS

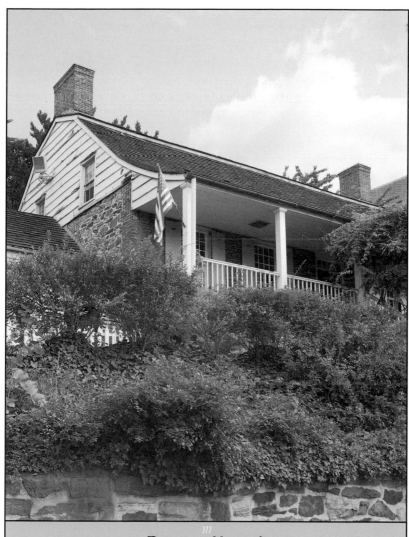

Dyckman House

4881 BROADWAY AT WEST 204TH STREET

1785

THE BRONX

Except for the Bronx River, which gives the borough its name, the Bronx didn't appear on any maps until after it became part of Greater New York in 1898. Up until then, it was part of Westchester County. Even after joining up, the Bronx was a stepchild among the boroughs, officially a part of Manhattan County. Its citizens had to travel all the way to lower Manhattan to settle their differences in court until 1914, when the state legislature finally got around to declaring it a county all by itself. The Bronx is the answer to the trivia question asking for the identity of the only borough not on an island, but it is surrounded by water on three sides and it does take full advantage of its shoreline.

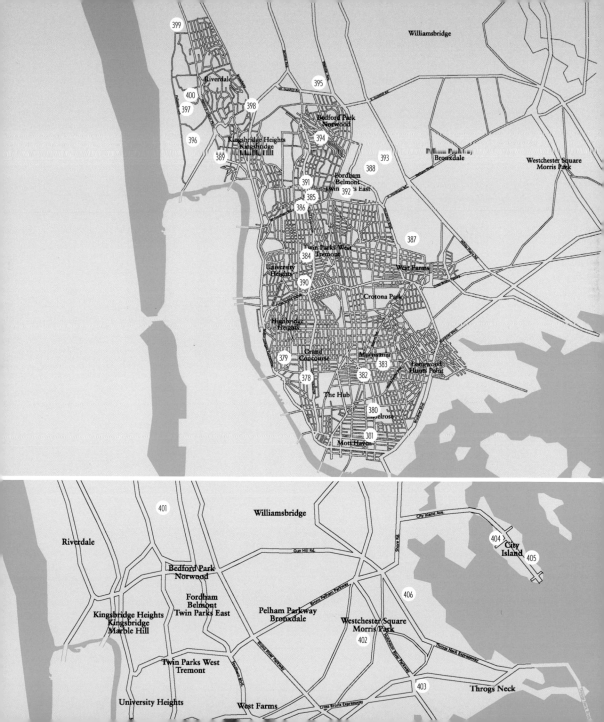

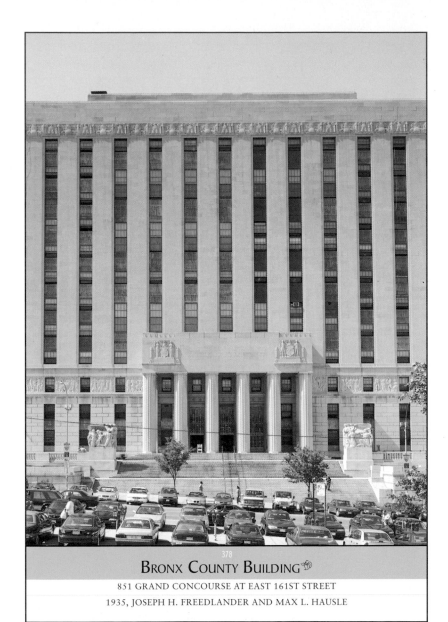

378
Bronx County Building

851 GRAND CONCOURSE AT EAST 161ST STREET

1935, JOSEPH H. FREEDLANDER AND MAX L. HAUSLE

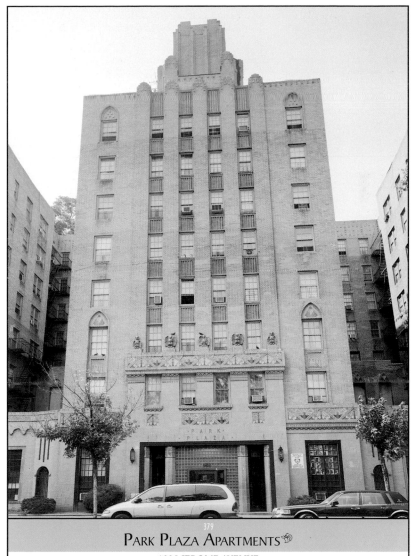

PARK PLAZA APARTMENTS

379

1005 JEROME AVENUE
BETWEEN ANDERSON AVENUE AND EAST 165TH STREET

1931, HORACE GINSBERG AND MARVIN FINE

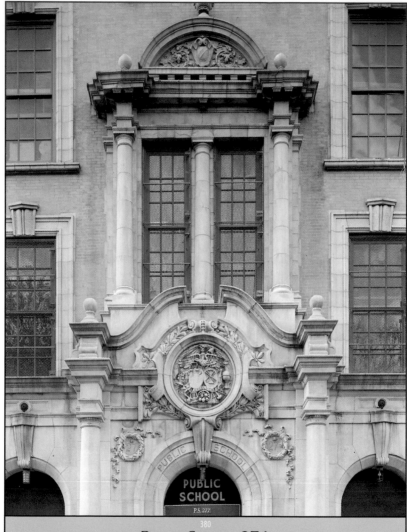

Public School 27

519 ST. ANN'S AVENUE
BETWEEN EAST 147TH AND EAST 148TH STREETS

1897, C. B. J. SNYDER

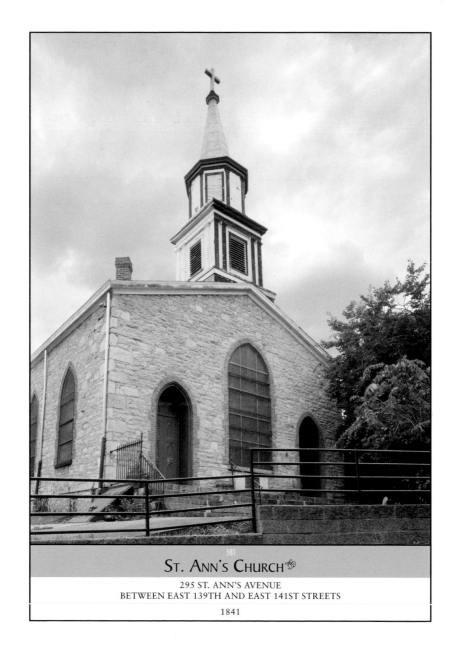

381

St. Ann's Church ✦

295 ST. ANN'S AVENUE
BETWEEN EAST 139TH AND EAST 141ST STREETS

1841

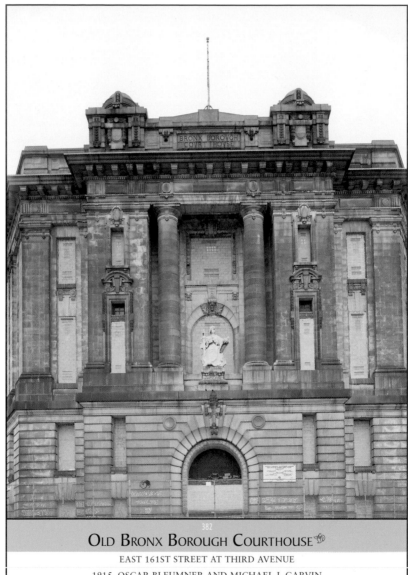

382

Old Bronx Borough Courthouse 🎗

EAST 161ST STREET AT THIRD AVENUE

1915, OSCAR BLEUMNER AND MICHAEL J. GARVIN

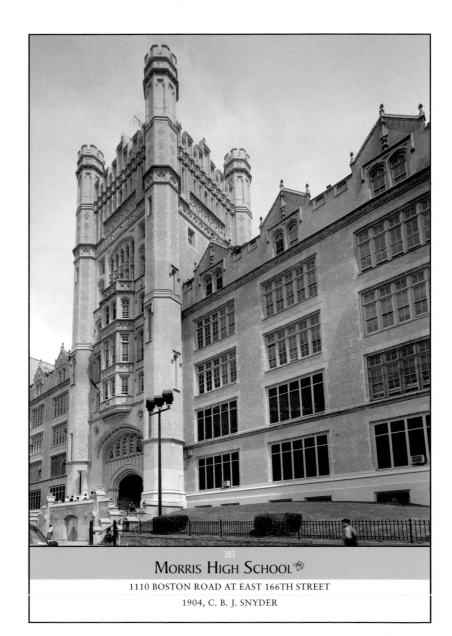

MORRIS HIGH SCHOOL

1110 BOSTON ROAD AT EAST 166TH STREET

1904, C. B. J. SNYDER

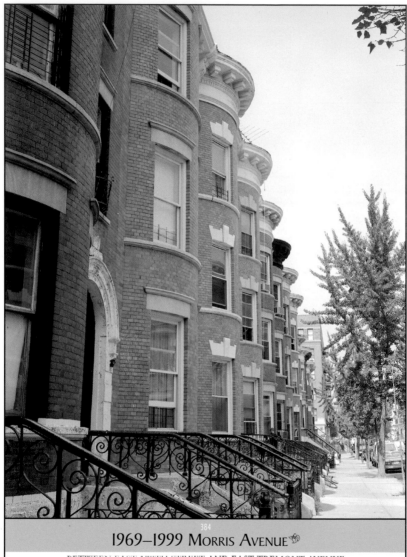

1969–1999 MORRIS AVENUE

BETWEEN EAST 179TH STREET AND EAST TREMONT AVENUE

1910, JOHN HAUSER

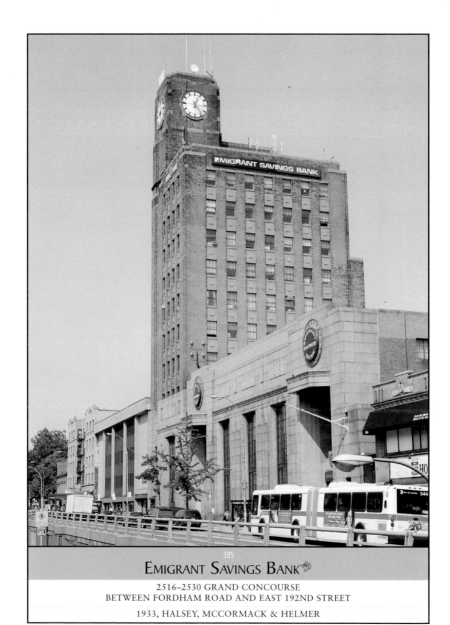

385

EMIGRANT SAVINGS BANK

2516–2530 GRAND CONCOURSE
BETWEEN FORDHAM ROAD AND EAST 192ND STREET

1933, HALSEY, MCCORMACK & HELMER

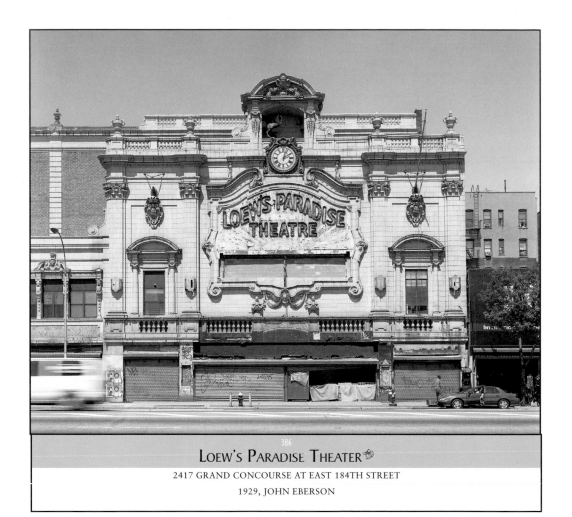

LOEW'S PARADISE THEATER

2417 GRAND CONCOURSE AT EAST 184TH STREET

1929, JOHN EBERSON

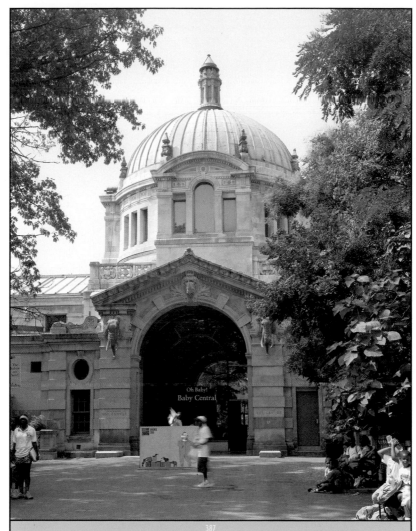

387

Bronx Zoo/Wildlife Conservation Park

Bronx Park, East of Fordham Road

1899, Heins & La Farge

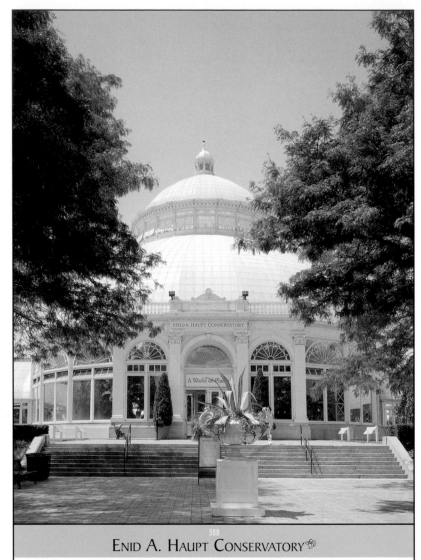

388

ENID A. HAUPT CONSERVATORY

NEW YORK BOTANICAL GARDEN, BRONX PARK NORTH AT FORDHAM ROAD

1902, LORD & BURNHAM
RECONSTRUCTED, 1997, BEYER BLINDER BELLE

◆ THE BRONX ◆

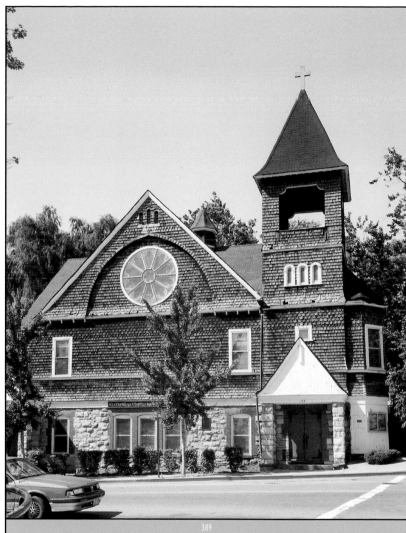

389

ST. STEPHEN'S UNITED METHODIST CHURCH

146 WEST 228TH STREET AT MARBLE HILL AVENUE

1897

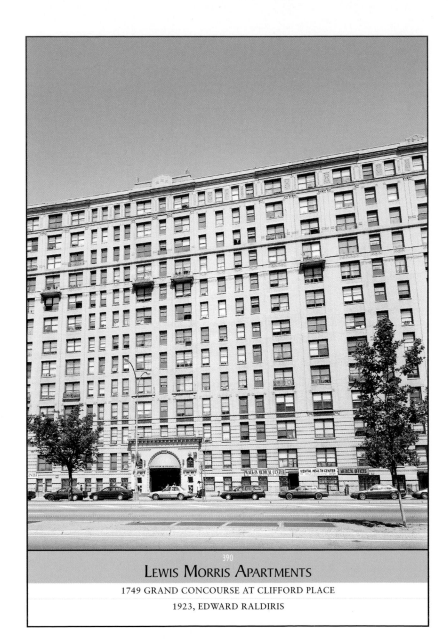

390

Lewis Morris Apartments

1749 GRAND CONCOURSE AT CLIFFORD PLACE

1923, EDWARD RALDIRIS

POE COTTAGE

GRAND CONCOURSE AT EAST KINGSBRIDGE ROAD

C. 1812

392

FORDHAM UNIVERSITY

ROSE HILL CAMPUS
FORDHAM ROAD AT WEBSTER AVENUE

1838–86

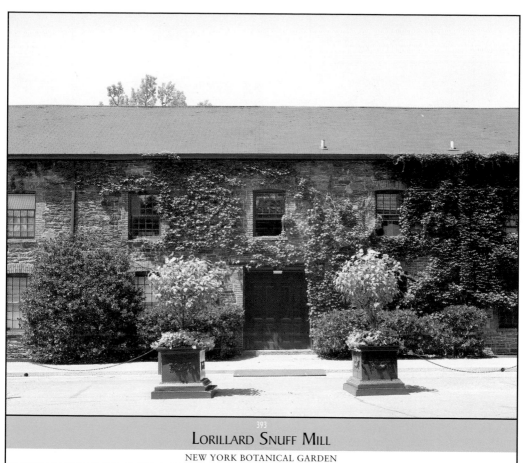

393
LORILLARD SNUFF MILL
NEW YORK BOTANICAL GARDEN
C. 1840

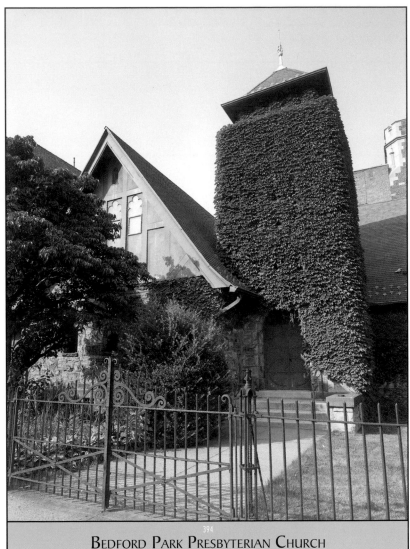

394

Bedford Park Presbyterian Church

2933 BAINBRIDGE AVENUE AT BEDFORD PARK BLVD.

1900, R. H. ROBERTSON

395

Montefiore Apartments II

450 WAYNE AVENUE
BETWEEN EAST GUN HILL ROAD AND EAST 210TH STREET

1972, SCHUMAN, LICHTENSTEIN & CLAMAN

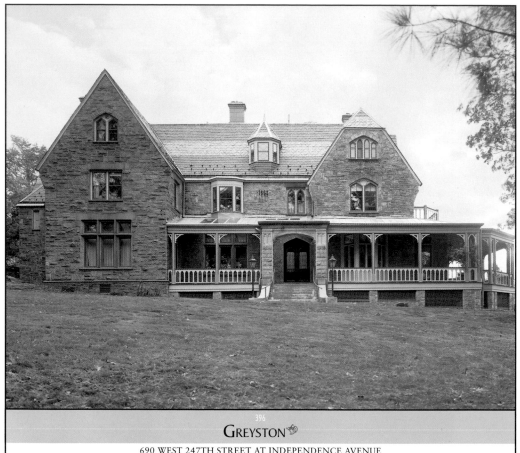

GREYSTON

690 WEST 247TH STREET AT INDEPENDENCE AVENUE

1864, JAMES RENWICK, JR.

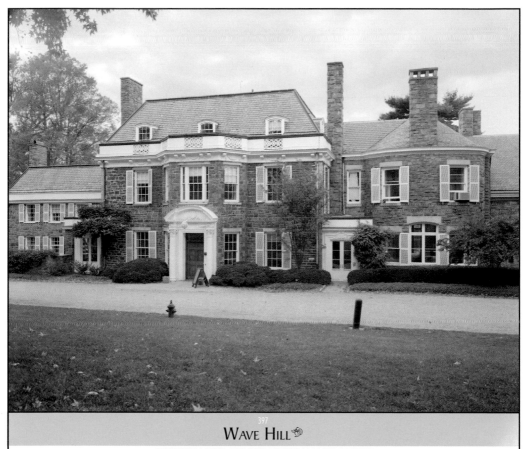

WAVE HILL 🐝

675 WEST 252ND STREET AT SYCAMORE AVENUE

1843

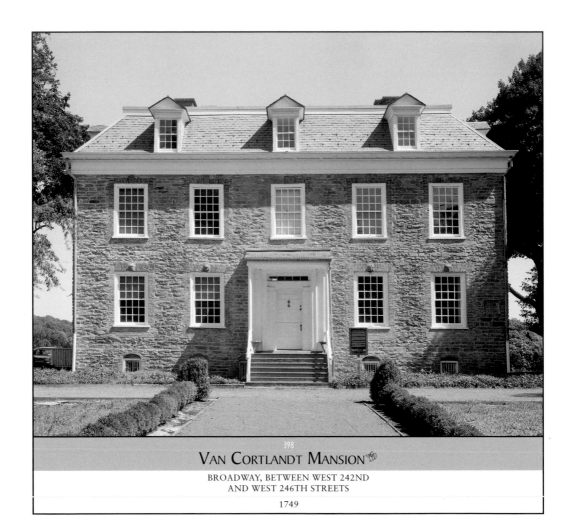

398

VAN CORTLANDT MANSION

BROADWAY, BETWEEN WEST 242ND
AND WEST 246TH STREETS

1749

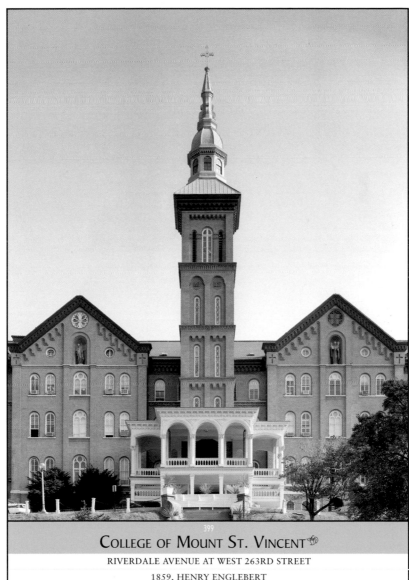

COLLEGE OF MOUNT ST. VINCENT

RIVERDALE AVENUE AT WEST 263RD STREET

1859, HENRY ENGLEBERT

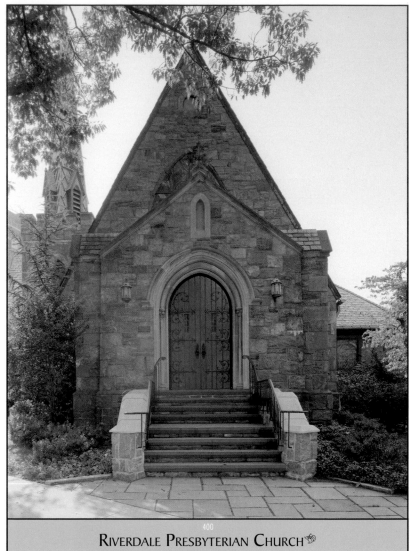

400

RIVERDALE PRESBYTERIAN CHURCH

4765 HENRY HUDSON PARKWAY W., AT W. 249TH STREET

1864, JAMES RENWICK, JR.

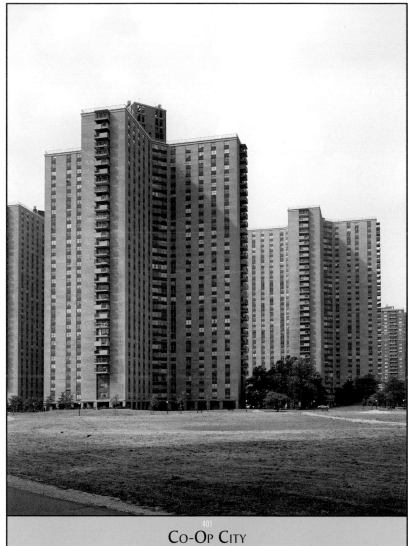

401

CO-OP CITY

NORTHERN SECTION: EAST OF NEW ENGLAND THRUWAY, BAYCHESTER AVE.
BETWEEN CO-OP CITY BLVD. AND BARTOW AVE; SOUTHERN SECTION: EAST OF
HUTCHINSON RIVER PARKWAY EAST, BETWEEN BARTOW AND BOLLER AVENUES

1968–1970, HERMAN J. JESSOR

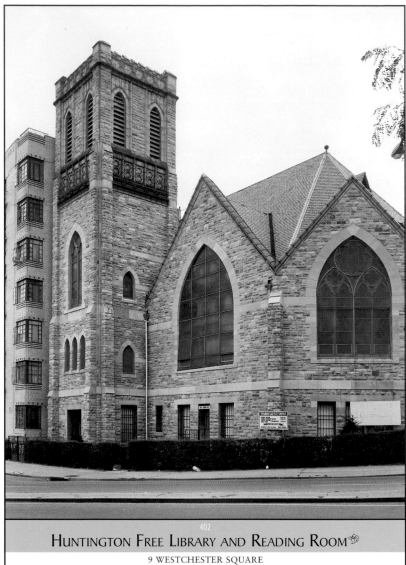

Huntington Free Library and Reading Room

9 WESTCHESTER SQUARE

1883, FREDERICK CLARKE WITHERS

◆ THE BRONX ◆

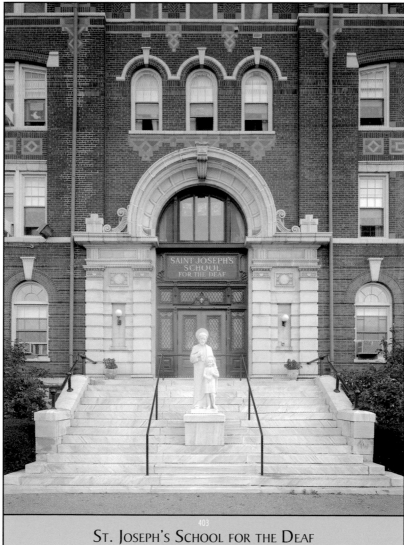

403

St. Joseph's School for the Deaf

1000 HUTCHINSON RIVER PARKWAY
AT BRUCKNER BOULEVARD

1898, SCHICKEL & DITMARS

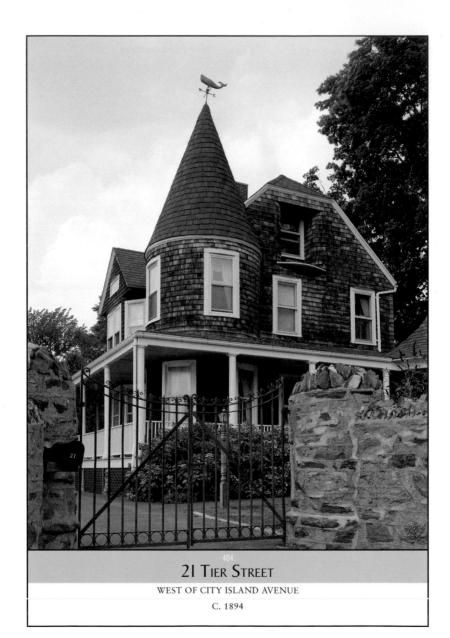

21 TIER STREET

WEST OF CITY ISLAND AVENUE

C. 1894

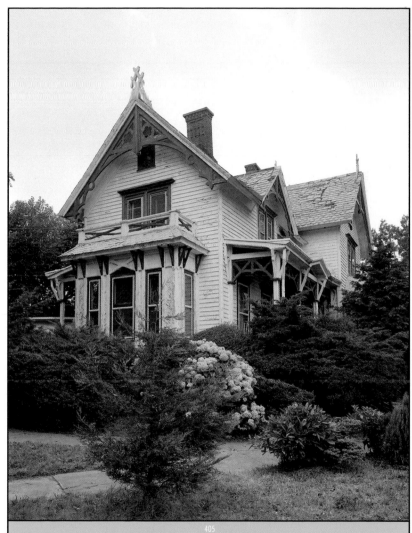

405
173 Belden Street

EAST OF CITY ISLAND AVENUE

C. 1880

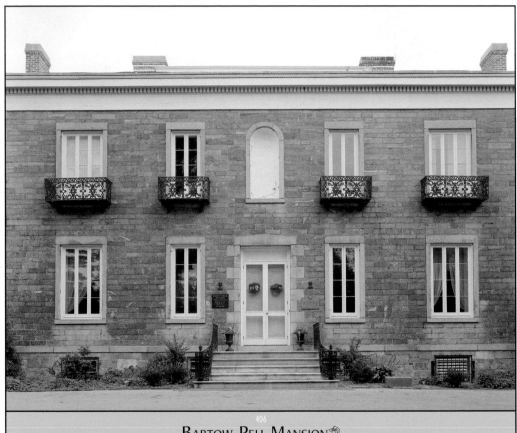

406
Bartow-Pell Mansion

PELHAM BAY PARK, SHORE RD. NEAR PELHAM SPLIT GOLF COURSE

1842, MINARD LAFEVER
RESTORED, 1914, DELANO & ALDRICH

QUEENS

At 120 square miles, this is the largest of the city's five boroughs. It's bigger, in fact, than Manhattan, the Bronx, and Staten Island put together. When the English took over in 1664, they divided the colony into ten counties, naming this one for Queen Catherine of Braganza, the wife of King Charles II. Until it became part of Greater New York, its territory extended out to the eastern end of Long Island, which broke away to form Nassau and Suffolk Counties, rejecting the opportunity to become part of the city in a special election held in 1897. Even today, many Queensites, who still cling to the names of the old villages, have their mail addressed to such places as Elmhurst, Long Island.

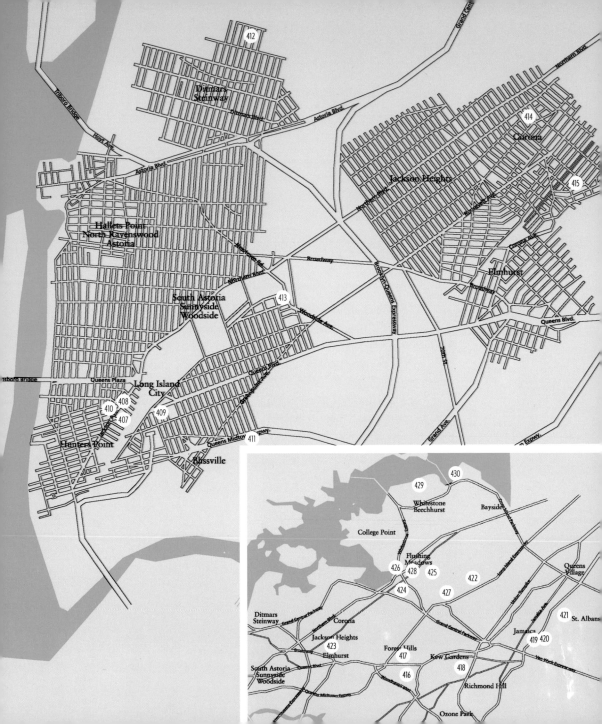

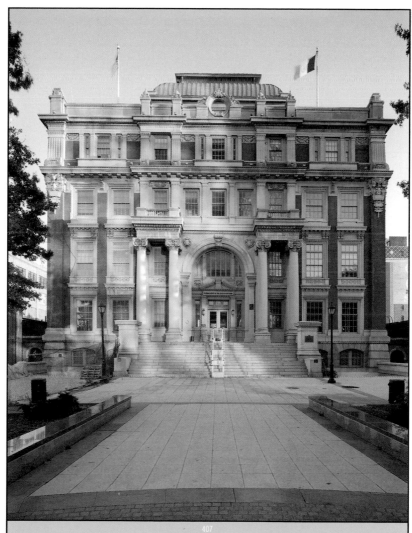

407
NEW YORK STATE SUPREME COURT

LONG ISLAND CITY BRANCH, JACKSON AND THOMPSON AVENUES

1876, GEORGE HATHORN
REBUILT, 1908, PETER M. COCO

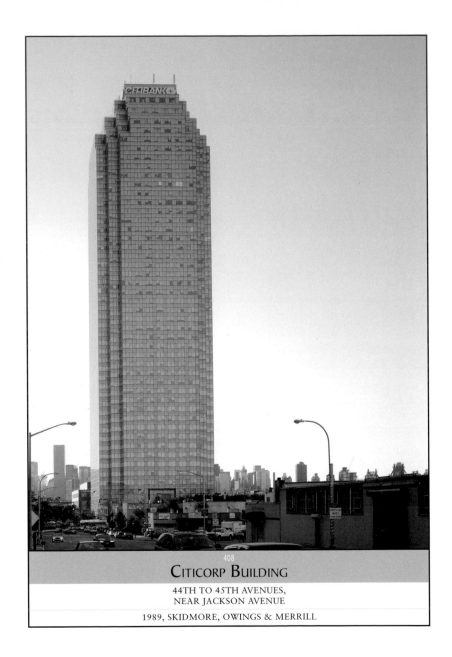

408
CITICORP BUILDING

44TH TO 45TH AVENUES,
NEAR JACKSON AVENUE

1989, SKIDMORE, OWINGS & MERRILL

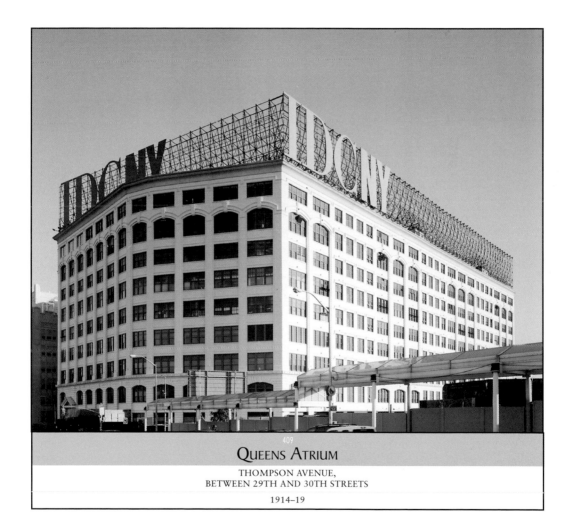

409

QUEENS ATRIUM

THOMPSON AVENUE,
BETWEEN 29TH AND 30TH STREETS

1914–19

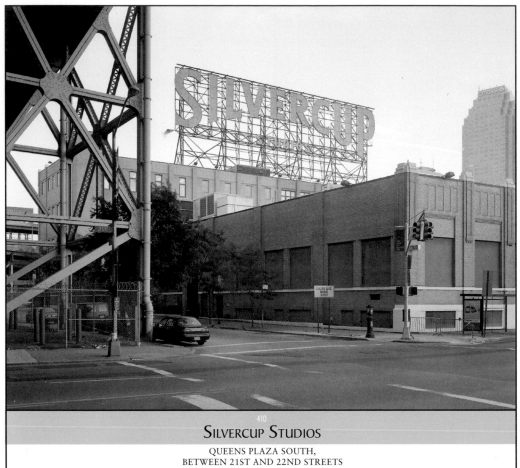

410

SILVERCUP STUDIOS

QUEENS PLAZA SOUTH,
BETWEEN 21ST AND 22ND STREETS

1939

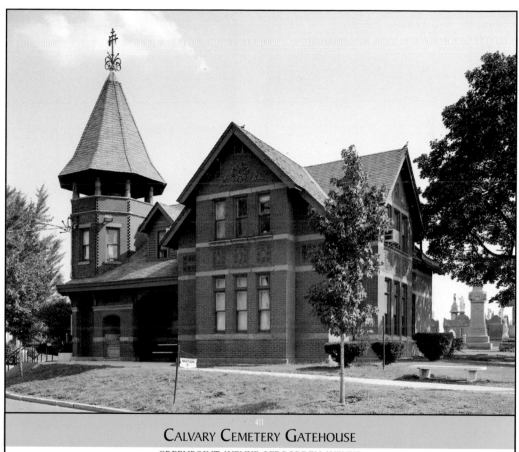

411

CALVARY CEMETERY GATEHOUSE

GREENPOINT AVENUE OFF BORDEN AVENUE

1892

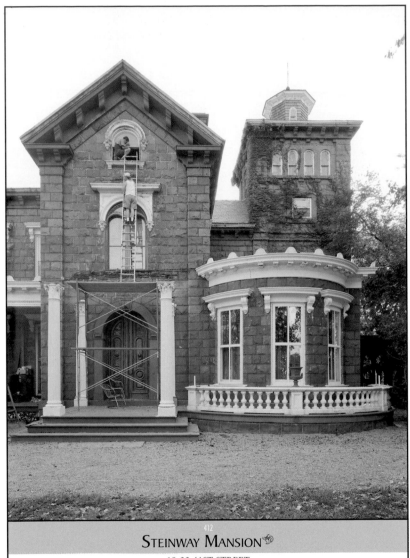

STEINWAY MANSION

18-33 41ST STREET
BETWEEN BERRIAN BOULEVARD AND 19TH AVENUE

1858

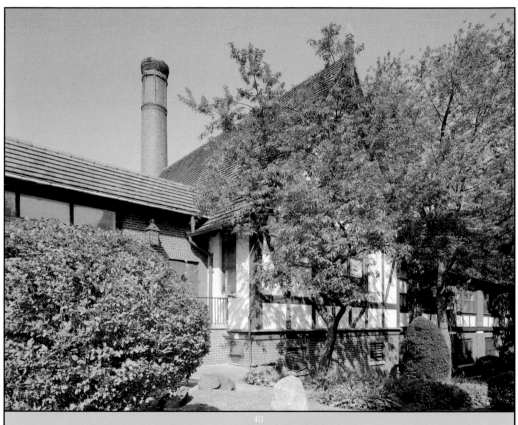

413

Lathan Lithography Company

3804 WOODSIDE AVENUE
BETWEEN BARNETT AND 39TH AVENUES

1923, MCDONNELL & PEARL

414
Louis Armstrong House

34-56 107TH STREET
BETWEEN 34TH AND 37TH AVENUES

1910, ROBERT W. JOHNSON

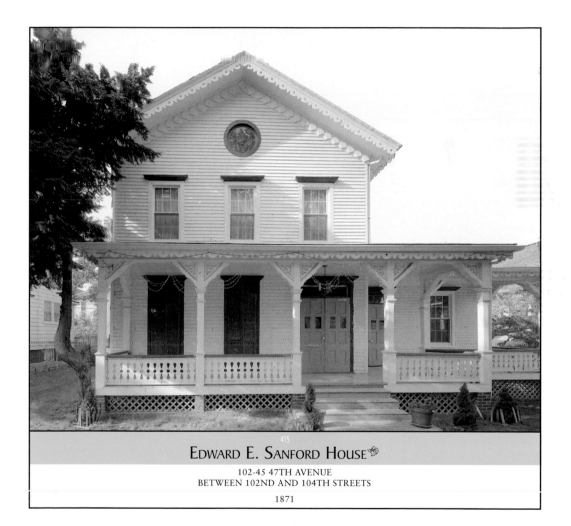

Edward E. Sanford House

102-45 47TH AVENUE
BETWEEN 102ND AND 104TH STREETS

1871

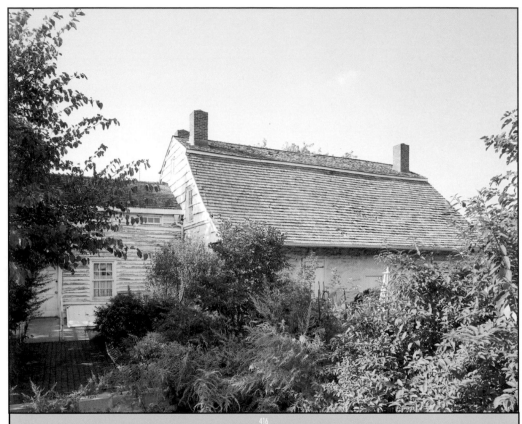

416

ADRIAN ONDERDONK HOUSE

18-20 FLUSHING AVENUE
BETWEEN CYPRUS AND ONDERDONK AVENUES

1731

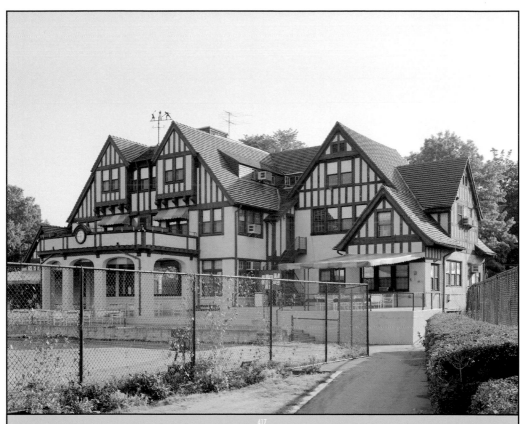

417

WEST SIDE TENNIS CLUB

FOREST HILLS GARDENS

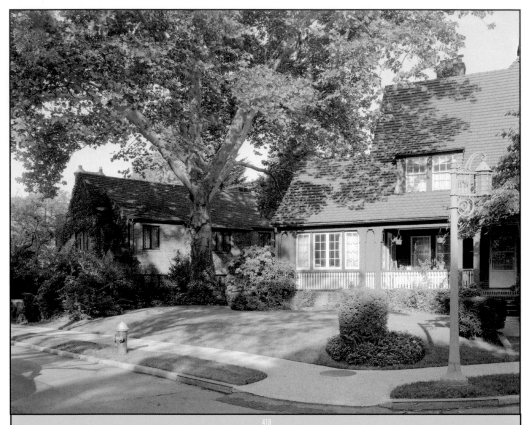

FOREST HILLS GARDENS

CONTINENTAL AVENUE TO UNION TURNPIKE

1913, GROSVENOR ATTERBURY

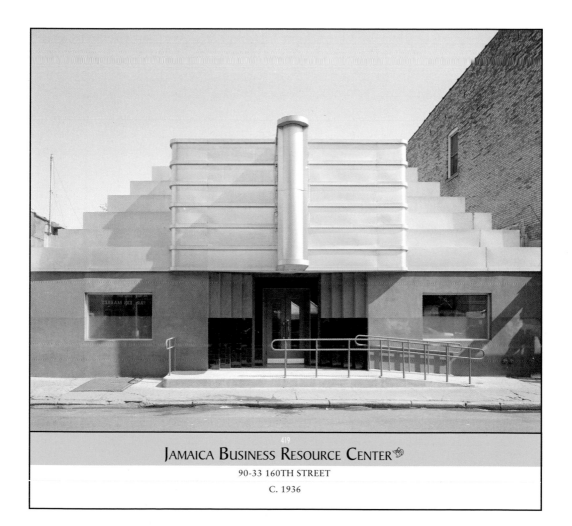

JAMAICA BUSINESS RESOURCE CENTER

90-33 160TH STREET

C. 1936

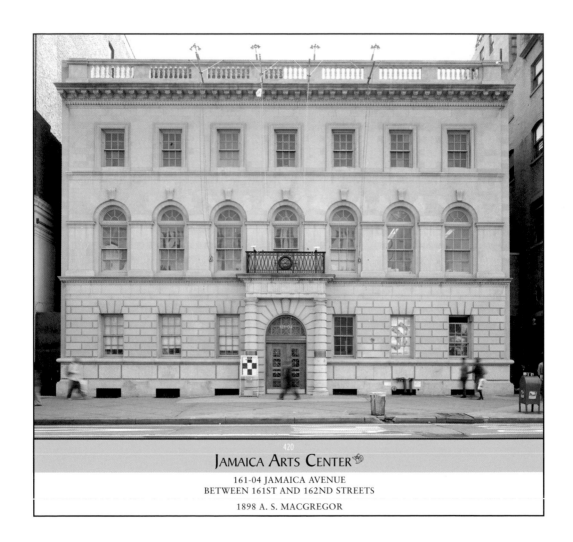

420

JAMAICA ARTS CENTER

161-04 JAMAICA AVENUE
BETWEEN 161ST AND 162ND STREETS

1898 A. S. MACGREGOR

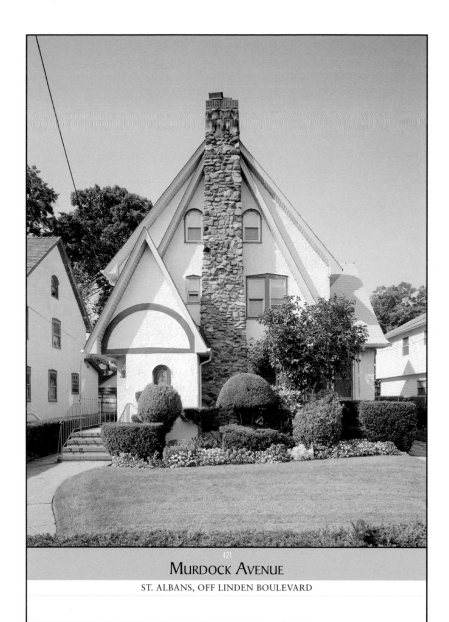

421
MURDOCK AVENUE
ST. ALBANS, OFF LINDEN BOULEVARD

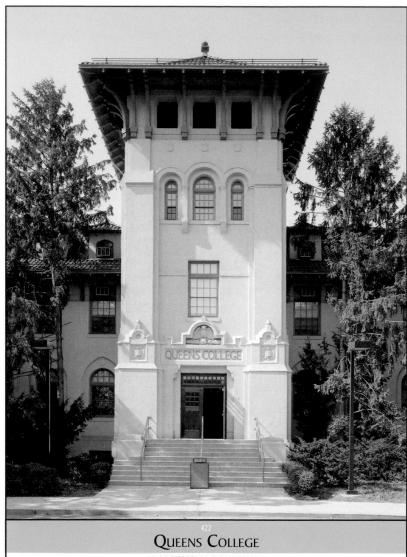

QUEENS COLLEGE

65-30 KISSENA BOULEVARD
AT THE LONG ISLAND EXPRESSWAY

MAIN BUILDING, 1908

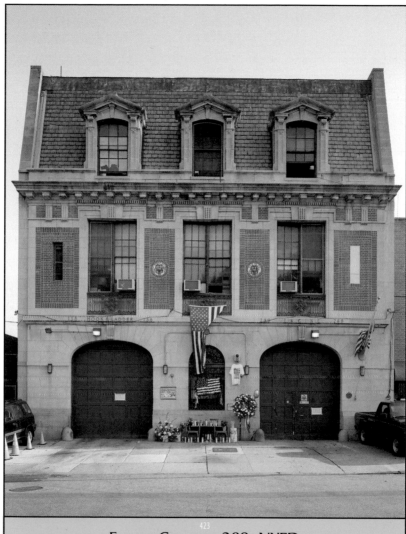

423
ENGINE COMPANY 289, NYFD

97-28 43RD AVENUE
BETWEEN 97TH PLACE AND 99TH STREET

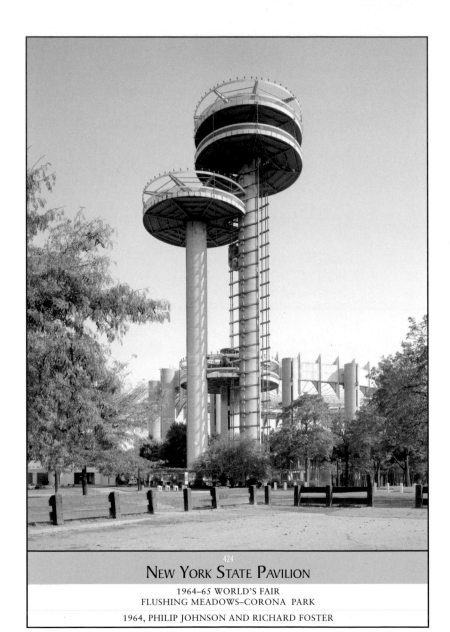

NEW YORK STATE PAVILION

1964–65 WORLD'S FAIR
FLUSHING MEADOWS–CORONA PARK

1964, PHILIP JOHNSON AND RICHARD FOSTER

◆ QUEENS ◆

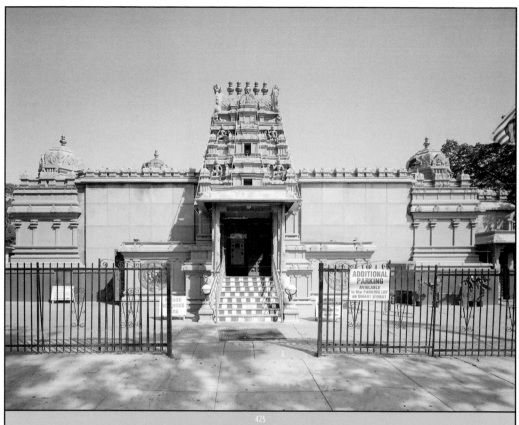

425

HINDU TEMPLE SOCIETY OF NORTH AMERICA

45-57 BOWNE STREET AT 45TH AVENUE

1977, BARYN BASU ASSOCIATES

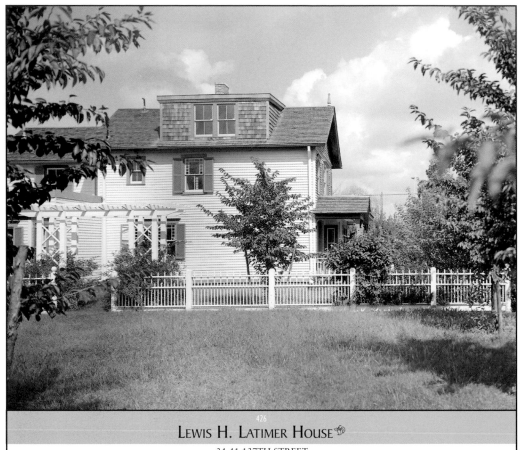

426
Lewis H. Latimer House

34-41 137TH STREET
BETWEEN LEAVITT STREET AND 32ND AVENUE

C. 1889

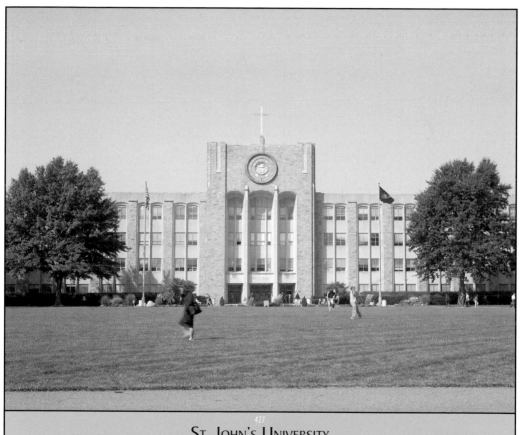

427

St. John's University

UNION TURNPIKE AT UTOPIA PARKWAY

1955–73

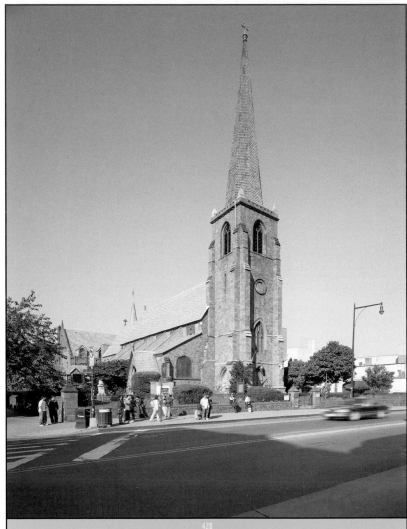

428

St. George's Church

MAIN STREET, BETWEEN 38TH AND 39TH STREETS

1854, WILLS & DUDLEY
1968–1970, HERMAN J. JESSOR

429

WILDFLOWER

168-11 POWELLS COVE BOULEVARD
AT 166TH STREET

1924, DWIGHT JAMES BAUM

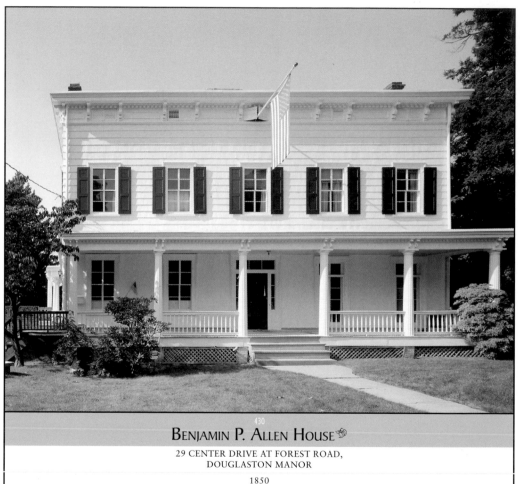

430
Benjamin P. Allen House

29 CENTER DRIVE AT FOREST ROAD, DOUGLASTON MANOR

1850

Downtown Brooklyn

At the time Brooklyn was dragged kicking and screaming into the family of the five boroughs, a little more than a century ago, it was already the third largest city in America, after Philadelphia and New York itself—it was the center of the action. Originally one of five tiny Dutch settlements across the East River from Nieuw Amsterdam, it was named Breuckelen for a suburb of old Amsterdam. Among its notable buildings is Borough Hall, which was originally called City Hall. On the night Brooklyn joined the rest of New York, a poet wrote, "This is not death; though a life link is broken. Still shall your sweet name forever be spoken." Its former mayor called it "the passing of a great city."

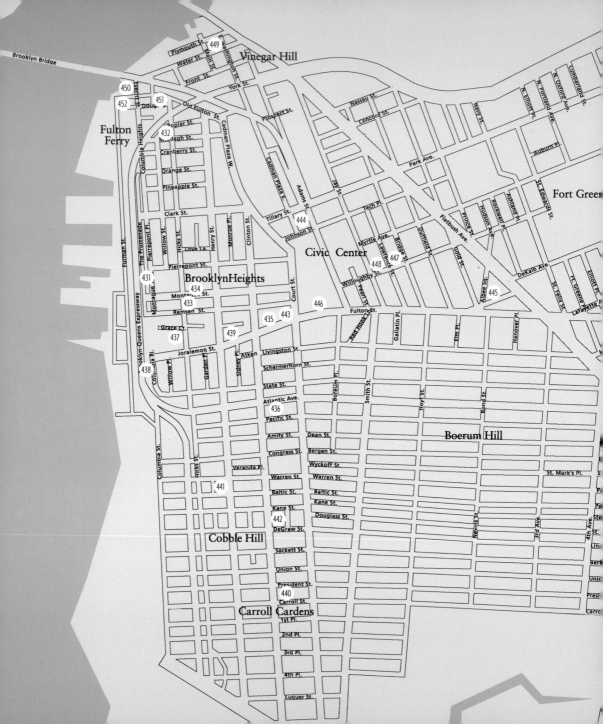

Brooklyn Bridge

Vinegar Hill

Plymouth St.
Water St.
Front St.
York St.

E. Washington St.
Washington St.
Main St.
449

450
452 451 Doug
Old Fulton St.

Poplar St.
Middagh St.
Cranberry St.
Orange St.
Pineapple St.

432

Fulton
Ferry

Columbia Heights

Cadman Plaza W.

Prospect St.

Nassau St.
Concord St.

Navy St.

N. Elliott Pl.
N. Portland Ave.
N. Oxford St.
Cumberland St.

Auburn Pl.

Park Ave.

Adams St.

Fort Gree

Clark St.

Tillary St.

Jay St.

Tech Pl.

Flatbush Ave.

Prince St.
Hudson Ave.
Rockwell Pl.
Ashland Pl.
St. Edward St.

Furman St.

The Promenade
Pierrepont Pl.
Willow St.
Hicks St.
Love La.
Henry St.
Monroe Pl.
Clinton St.

Johnson St.

444

Civic Center

Myrtle Ave.

Bridge St.
Duffield St.
Gold St.

DeKalb Ave.

St. Felix St.
Ft. Greene
Elliott Pl.
Lafayette
431

Pierrepont St.

BrooklynHeights

434
433

Montague St.
Remsen St.

Court St.

Willoughby St.

448 447

Pearl St.

446

Albee Sq.

445

435 443

Grace Ct.
437

439

Fulton St.

Red Hook St.

Gallatin Pl.

Elm Pl.

Hanover Pl.

438

Brooklyn-Queens Expressway

Montague St.

Columbia Pl.

Joralemon St.

Garden Pl.

Sidney Pl.

Aitken
Livingston St.

Schermerhorn St.

State St.

Atlantic Ave.
436
Pacific St.

Boerum Pl.

Smith St.

Hoyt St.

Bond St.

Boerum Hill

Amity St.

Congress St.

Warren St.

Baltic St.

441

Kane St.

442

DeGraw St.

Sackett St.

Union St.

President St.
440
Carroll St.

Cobble Hill

Dean St.

Bergen St.

Wyckoff St.

Warren St.

Baltic St.

Kane St.

Douglass St.

St. Mark's Pl.

Nevins St.

Pacific St.

4th Ave.

Columbia St.

Hicks St.

Veranda Pl.

Carroll Cardens

1st Pl.

2nd Pl.

3rd Pl.

4th Pl.

Luquer St.

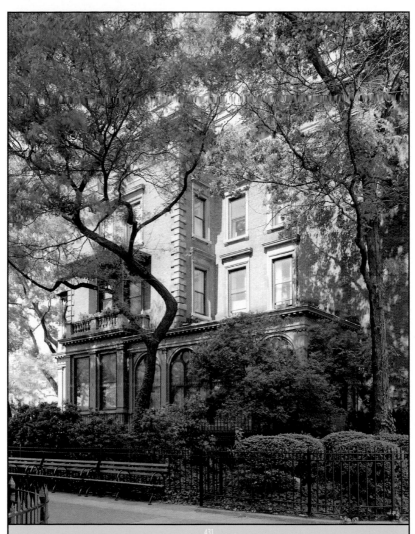

2 AND 3 PIERREPONT PLACE

BETWEEN PIERREPONT AND MONTAGUE STREETS

1857, FREDERICK A. PETERSON

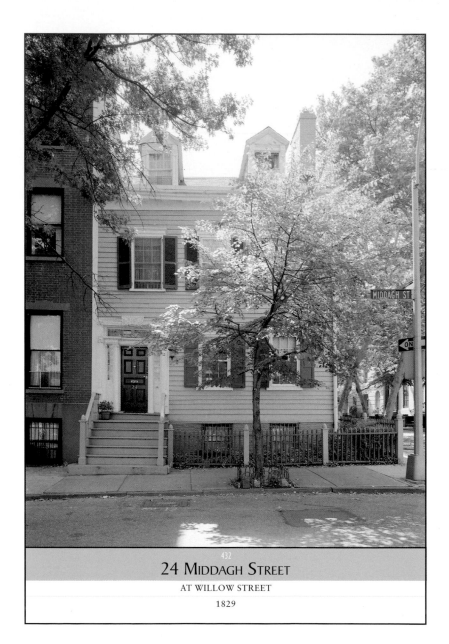

432

24 MIDDAGH STREET

AT WILLOW STREET

1829

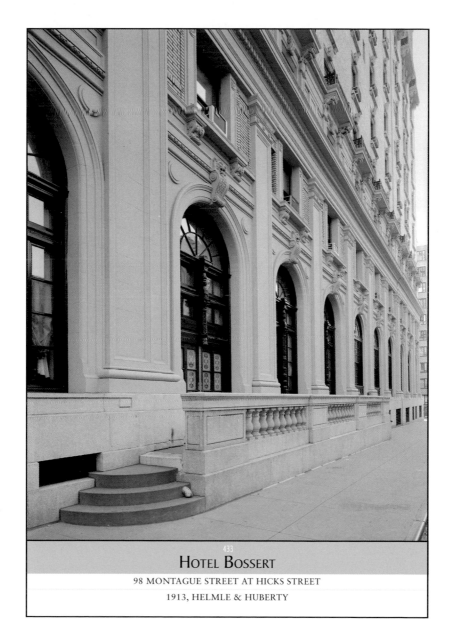

433

HOTEL BOSSERT

98 MONTAGUE STREET AT HICKS STREET

1913, HELMLE & HUBERTY

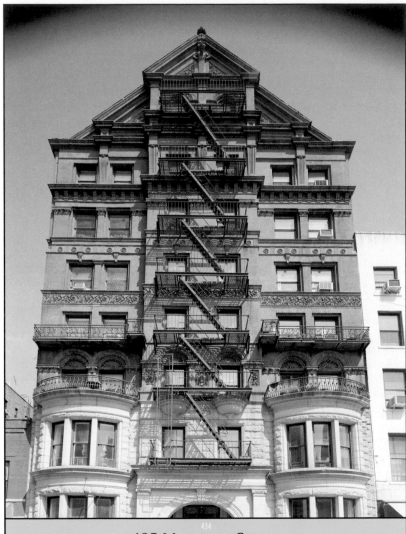

105 Montague Street

BETWEEN HENRY AND HICKS STREETS

1885, PARFITT BROS.

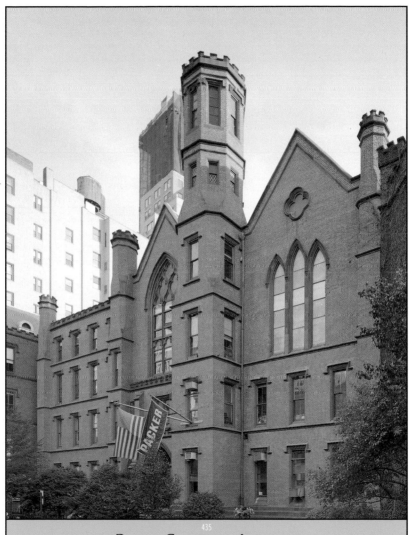

435
Packer Collegiate Institute

170 JORALEMON STREET
BETWEEN COURT AND CLINTON STREETS

1856, MINARD LAFEVER

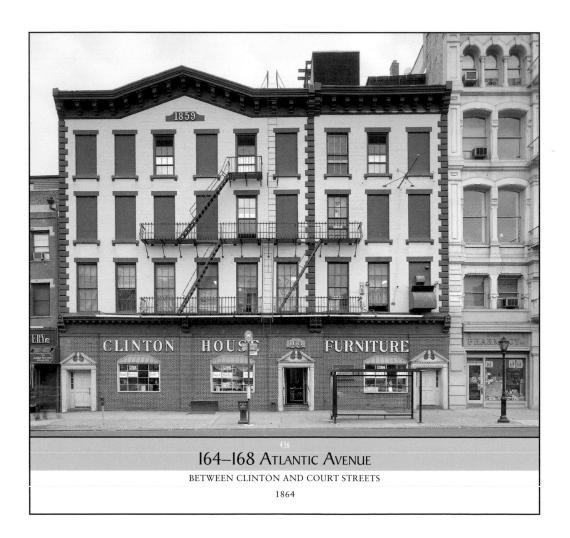

164–168 ATLANTIC AVENUE

BETWEEN CLINTON AND COURT STREETS

1864

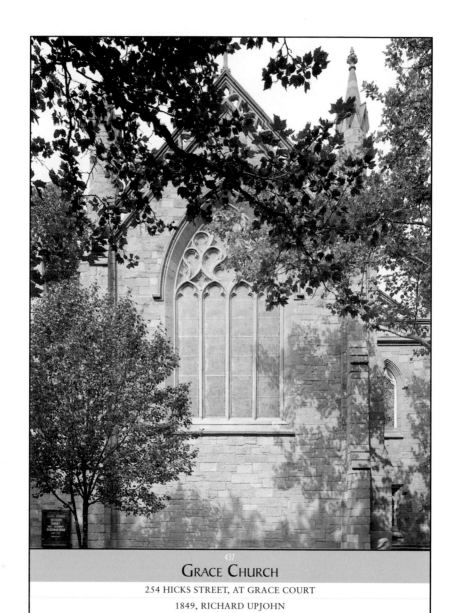

437

GRACE CHURCH

254 HICKS STREET, AT GRACE COURT

1849, RICHARD UPJOHN

Riverside Apartments

4–30 COLUMBIA PLACE AT JORALEMON STREET

1890, WILLIAM FIELD & SON

129 JORALEMON STREET

BETWEEN HENRY AND CLINTON STREETS

1891, C. P. H. GILBERT

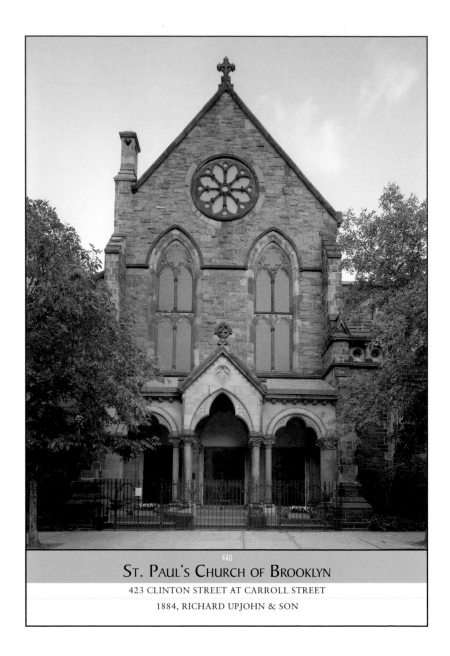

440
ST. PAUL'S CHURCH OF BROOKLYN

423 CLINTON STREET AT CARROLL STREET

1884, RICHARD UPJOHN & SON

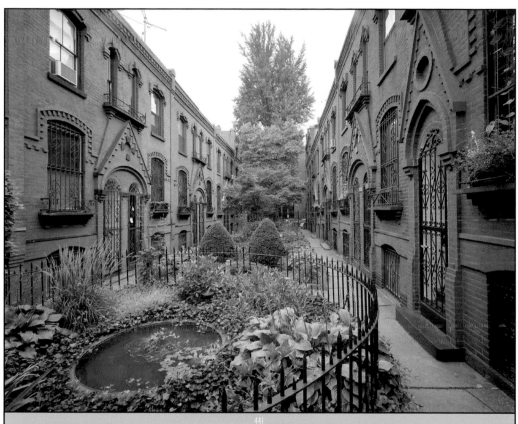

441
WORKINGMEN'S COTTAGES
WARREN PLACE, BETWEEN HICKS AND HENRY STREETS

1879

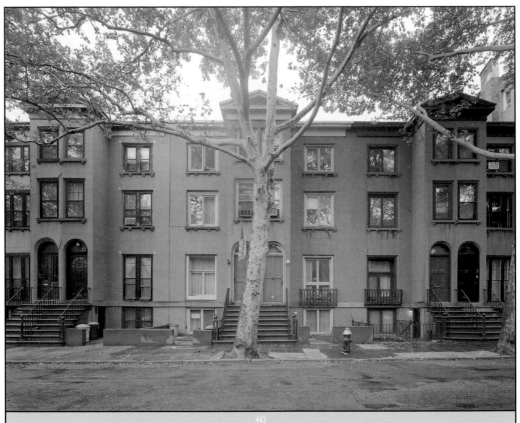

442
301–311 CLINTON STREET
AT KANE STREET
1849–54

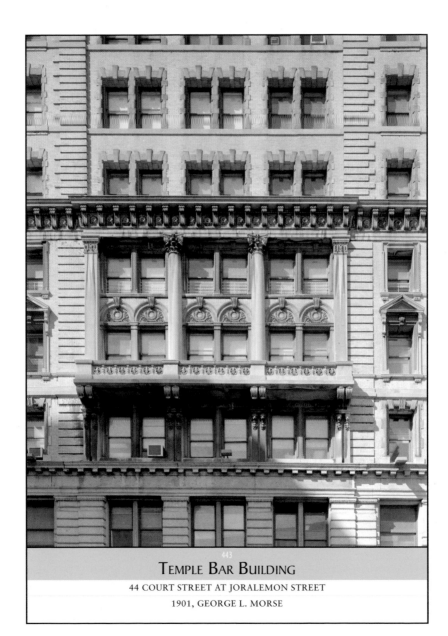

443

TEMPLE BAR BUILDING

44 COURT STREET AT JORALEMON STREET

1901, GEORGE L. MORSE

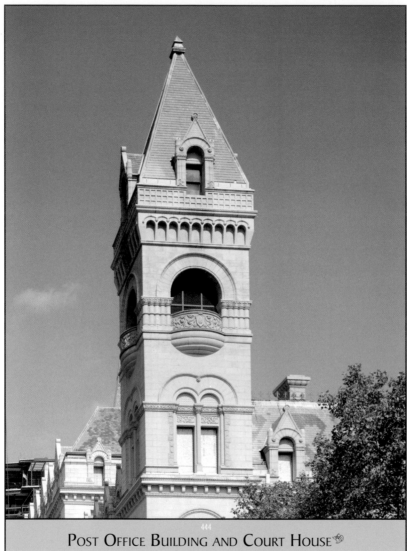

444

Post Office Building and Court House 🐚

271–301 CADMAN PLAZA AT JOHNSON STREET

1891, MIFFLIN E. BELL

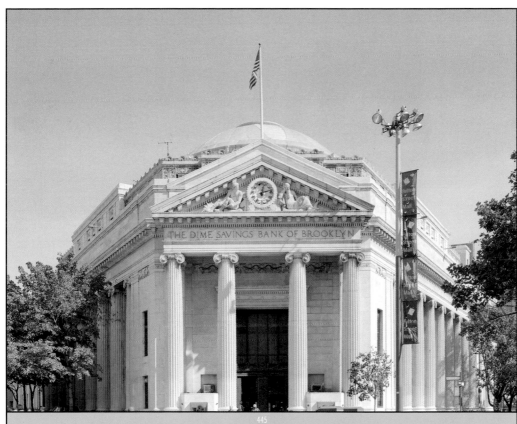

445
DIME SAVINGS BANK

9 DEKALB AVENUE, OFF FULTON STREET

1908, MOBRAY & UFFINGER
EXPANDED, 1932, HALSEY, MCCORMACK & HELMLER

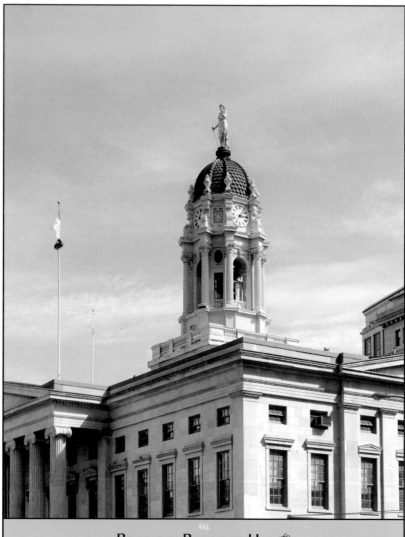

446

BROOKLYN BOROUGH HALL

209 JORALEMON STREET AT CADMAN PLAZA

1848, GAMALIEL KING
CUPOLA, 1898, VINCENT C. GRIFFITH AND STOUGHTON & STOUGHTON

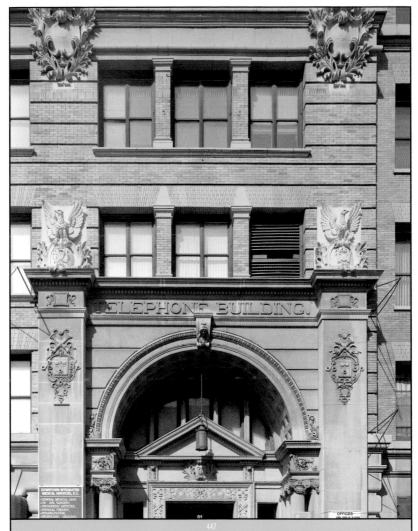

447

New York & New Jersey Telephone Company Building

81 WILLOUGHBY STREET AT LAWRENCE STREET

1898, R. L. DAUS

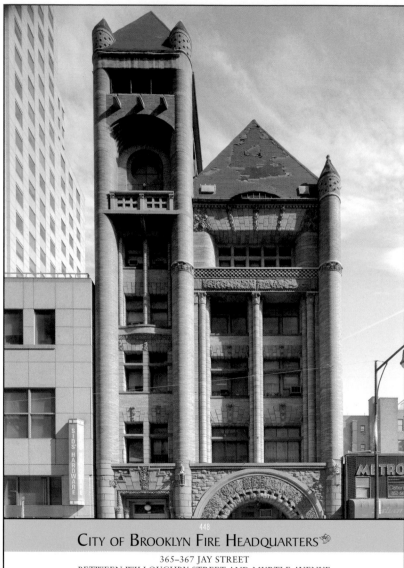

448
City of Brooklyn Fire Headquarters ❧

365–367 JAY STREET
BETWEEN WILLOUGHBY STREET AND MYRTLE AVENUE

1892, FRANK FREEMAN

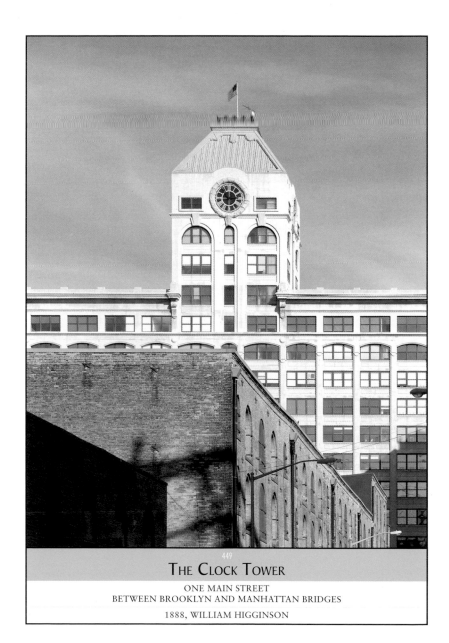

449
THE CLOCK TOWER

ONE MAIN STREET
BETWEEN BROOKLYN AND MANHATTAN BRIDGES

1888, WILLIAM HIGGINSON

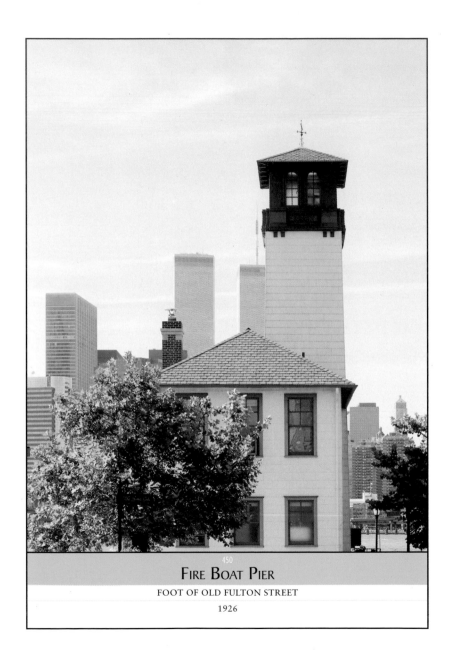

450

FIRE BOAT PIER

FOOT OF OLD FULTON STREET

1926

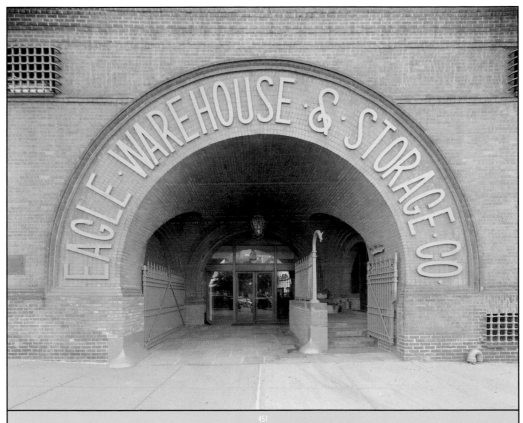

451
Eagle Warehouse

8 OLD FULTON STREET AT ELIZABETH STREET

1893, FRANK FREEMAN

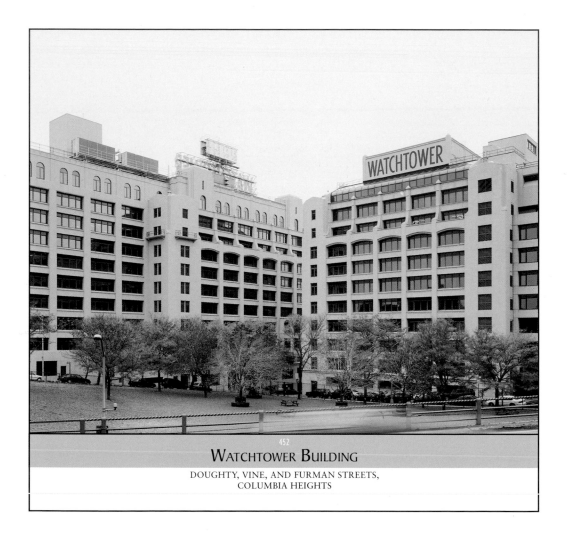

452

WATCHTOWER BUILDING

DOUGHTY, VINE, AND FURMAN STREETS,
COLUMBIA HEIGHTS

BROOKLYN

Within three years after Brooklyn became a New York City borough in 1898, its population topped the million mark and by 1920, it had more than doubled. The city's tax laws forced farmers to sell out, and developers were more than happy to sell their land to new Brooklynites. New neighborhoods were created and the older ones changed, too, as Brooklyn became the place to live. One could live in relatively bucolic surroundings and, thanks to the subway, be whisked off to jobs in downtown Brooklyn, or even Manhattan, for a nickel. It may not be as rural as it was back then, and the trip to work may be a bit pricier, but Brooklyn's diverse neighborhoods remain enticing for young people and families alike.

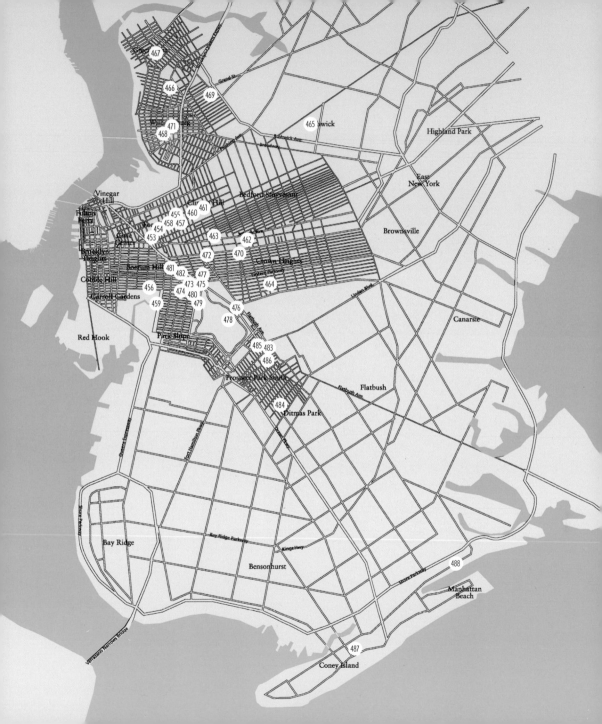

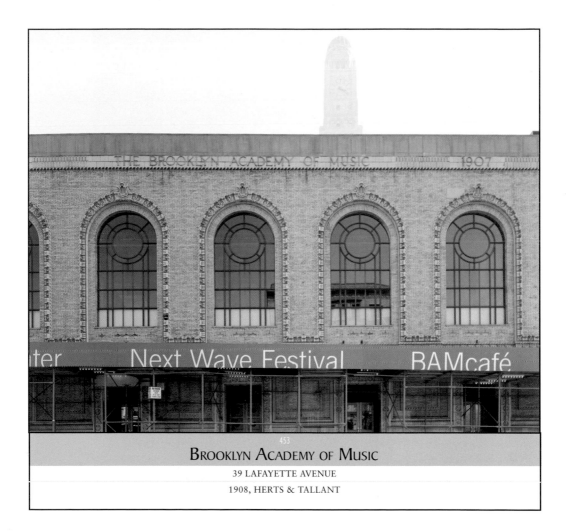

453

BROOKLYN ACADEMY OF MUSIC

39 LAFAYETTE AVENUE

1908, HERTS & TALLANT

179–186 WASHINGTON PARK

BETWEN WILLOUGHBY AND DEKALB AVENUES

1886, JOSEPH H. TOWNSENS

455
ST. JOSEPH'S COLLEGE

232 CLINTON AVENUE
BETWEEN DEKALB AND WILLOUGHBY AVENUES

1875, EBENEZER L. ROBERTS

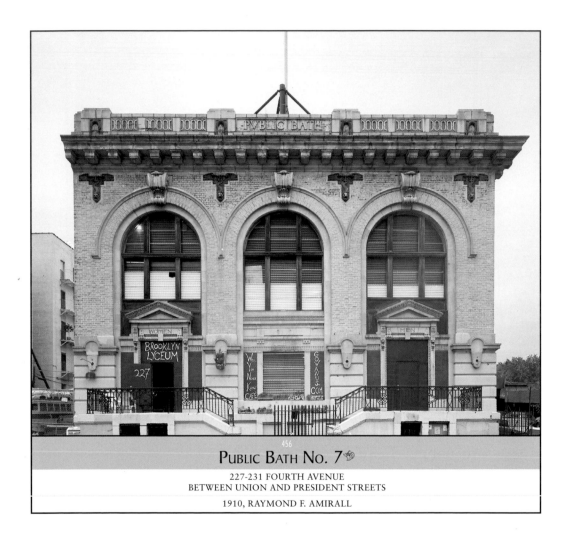

PUBLIC BATH No. 7

227-231 FOURTH AVENUE
BETWEEN UNION AND PRESIDENT STREETS

1910, RAYMOND F. AMIRALL

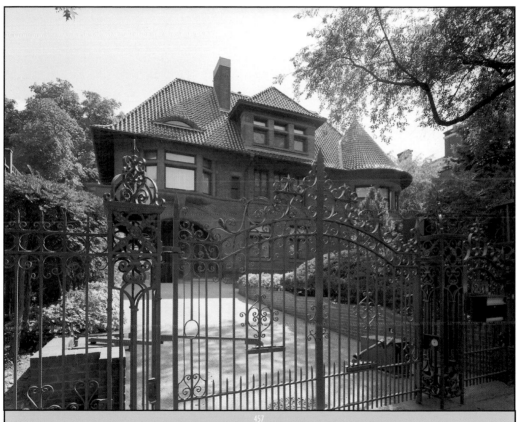

457

Residence, Bishop of Brooklyn

241 CLINTON AVENUE
BETWEEN DEKALB AND WILLOUGHBY AVENUES

1890, WILLIAM E. TUBBY

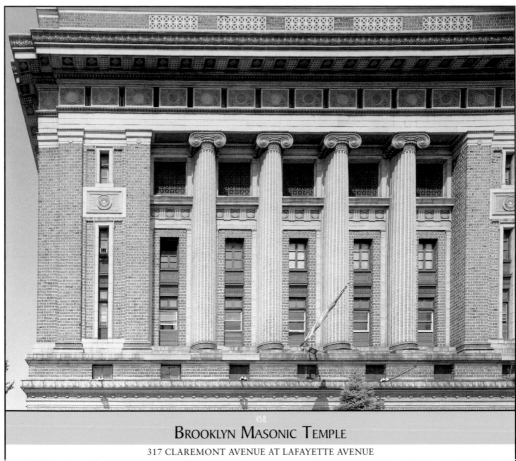

458

Brooklyn Masonic Temple

317 CLAREMONT AVENUE AT LAFAYETTE AVENUE

1906, LORD & HEWLETT AND PELL & CORBETT

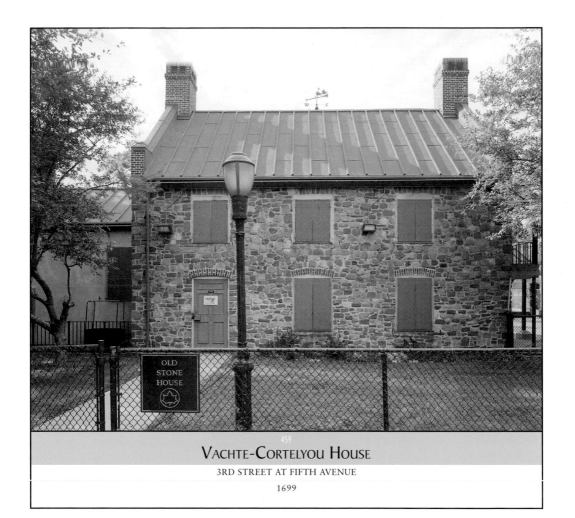

459

VACHTE-CORTELYOU HOUSE

3RD STREET AT FIFTH AVENUE

1699

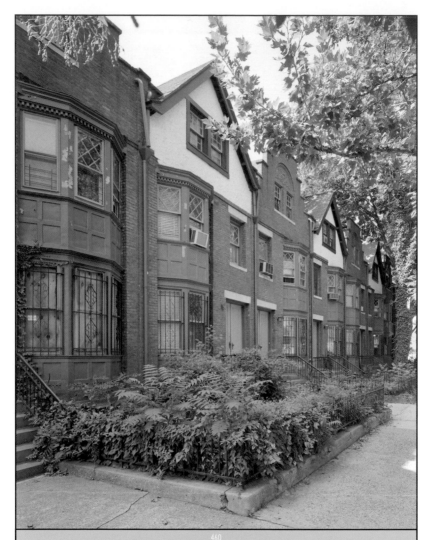

PRATT ROW

220–234 WILLOUGHBY AVENUE

1907, HOBART WALKER

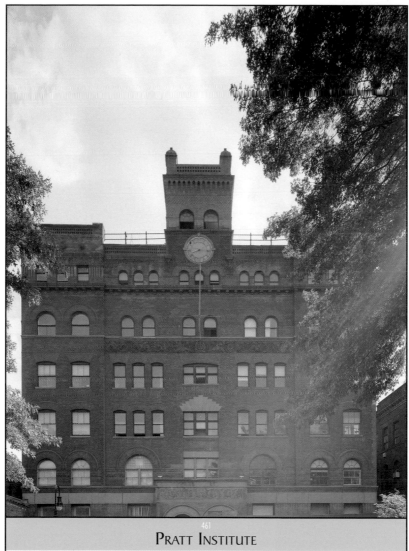

461

Pratt Institute

SOUTH OF WILLOUGHBY AVENUE NEAR DEKALB AVENUE

1887–2000

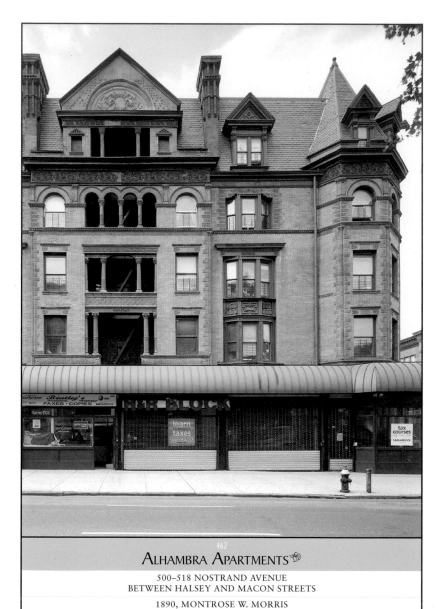

ALHAMBRA APARTMENTS

500–518 NOSTRAND AVENUE
BETWEEN HALSEY AND MACON STREETS

1890, MONTROSE W. MORRIS

◆ BROOKLYN ◆

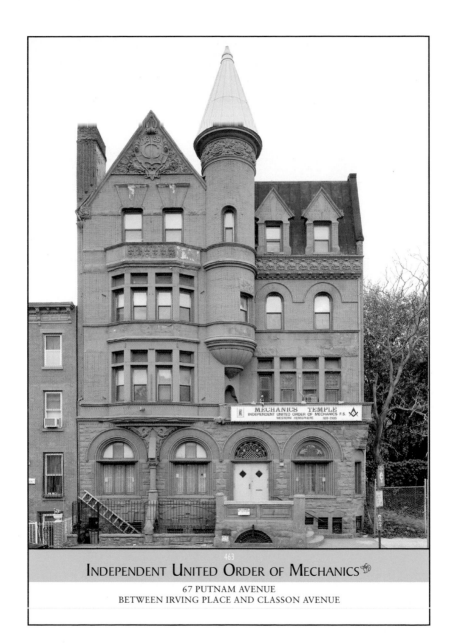

463
INDEPENDENT UNITED ORDER OF MECHANICS

67 PUTNAM AVENUE
BETWEEN IRVING PLACE AND CLASSON AVENUE

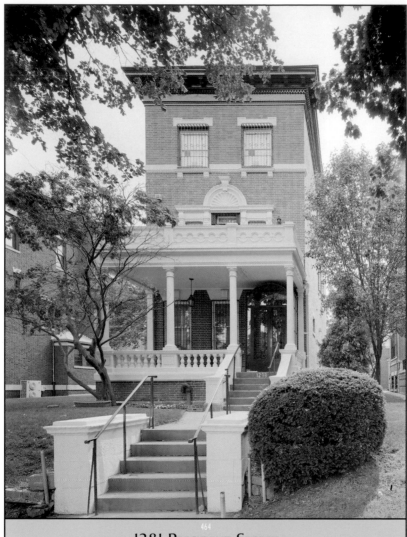

464

1281 PRESIDENT STREET

BETWEEN BROOKLYN AND NEW YORK AVENUES

1911, WILLIAM DEBUS

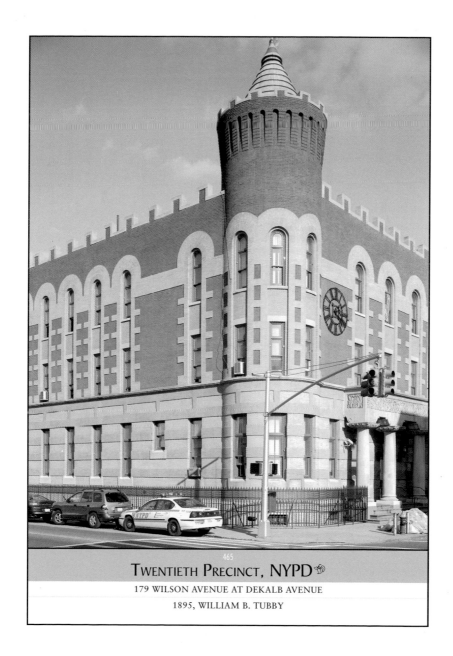

465

Twentieth Precinct, NYPD

179 WILSON AVENUE AT DEKALB AVENUE

1895, WILLIAM B. TUBBY

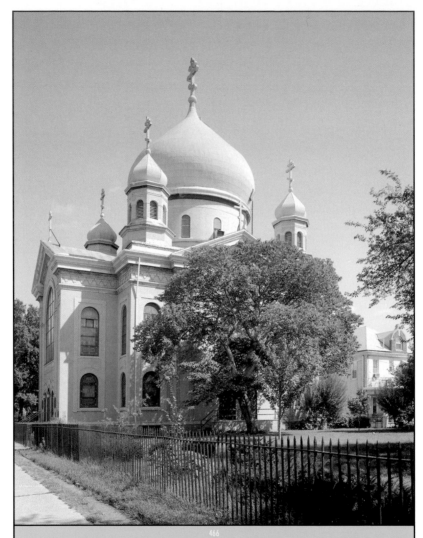

466
Russian Orthodox Cathedral of the Transfiguration of Our Lord

228 NORTH 12TH STREET AT DRIGGS AVENUE

1921, LOUIS ALLMENDINGER

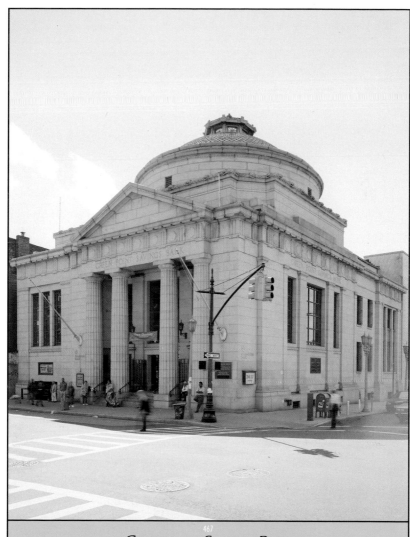

467

GREENPOINT SAVINGS BANK

807 MANHATTAN AVENUE AT CALYER STREET

1908, HELMLE & HUBERTY

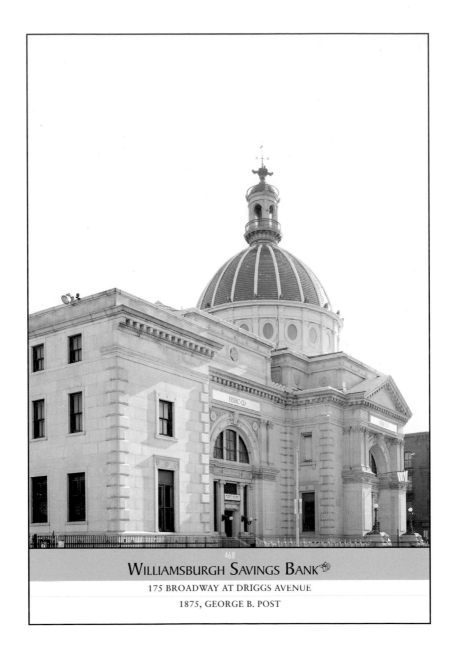

468
WILLIAMSBURGH SAVINGS BANK

175 BROADWAY AT DRIGGS AVENUE

1875, GEORGE B. POST

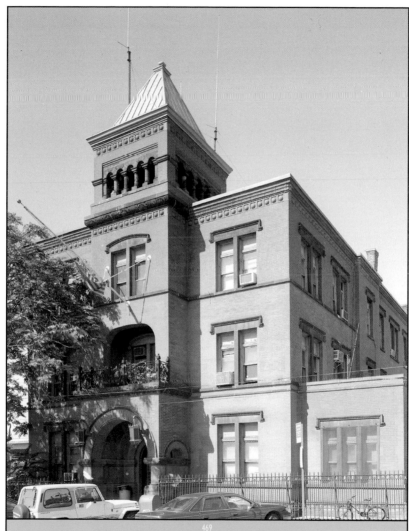

19TH PRECINCT STATION HOUSE

43 HERBERT STREET AT HUMBOLDT STREET

1892, GEORGE INGRAHAM

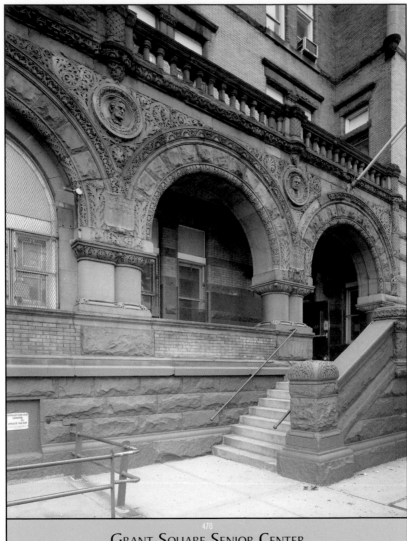

470

GRANT SQUARE SENIOR CENTER

BEDFORD AVENUE AT DEAN STREET

1890, P. J. LAURITZEN

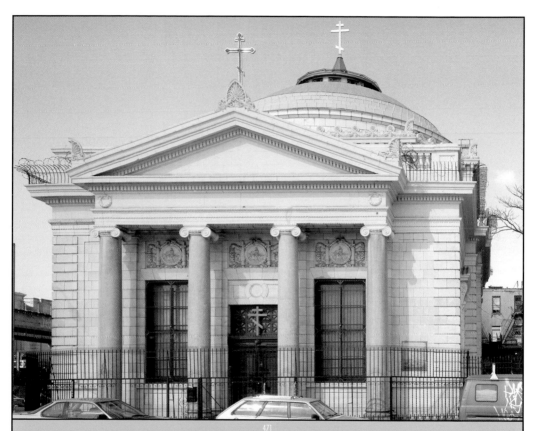

471

Holy Trinity Church of Ukranian Autocaphalic Orthodox Church in Exile

117–185 SOUTH 5TH STREET AT NEW STREET

1906, HELMLE & HUBERTY

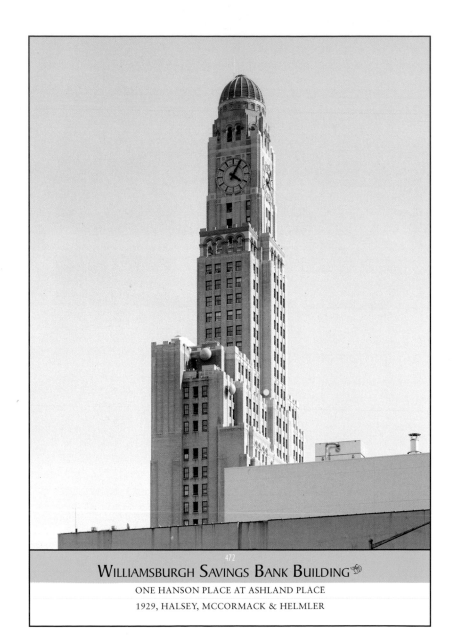

472
WILLIAMSBURGH SAVINGS BANK BUILDING
ONE HANSON PLACE AT ASHLAND PLACE
1929, HALSEY, MCCORMACK & HELMLER

◆ BROOKLYN ◆

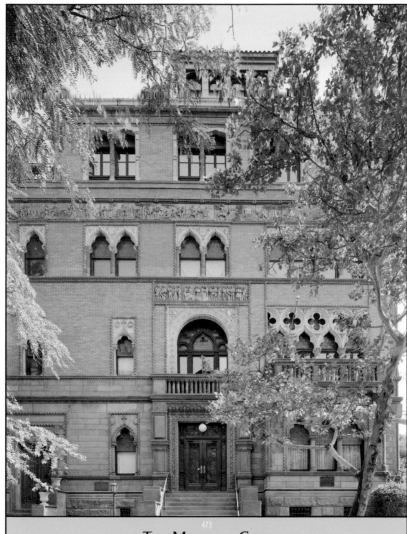

473

THE MONTAUK CLUB

25 EIGHTH AVENUE AT LINCOLN PLACE

1891, FRANCIS H. KIMBALL

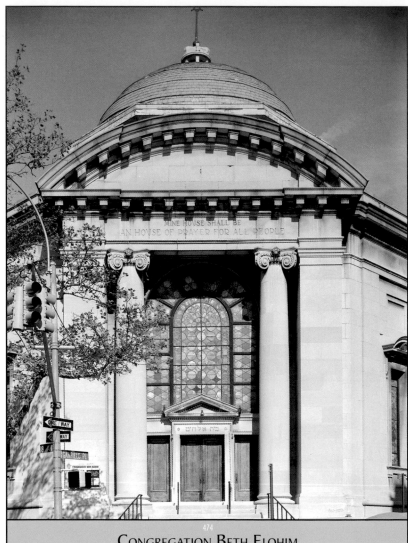

Congregation Beth Elohim

EIGHTH AVENUE AT GARFIELD PLACE

1910, SIMON EISENDRATH AND B. HOROWITZ

◆ BROOKLYN ◆

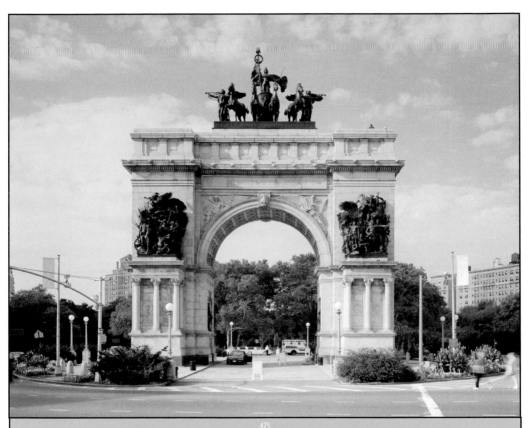

475

Soldiers' and Sailors' Memorial Arch

GRAND ARMY PLAZA
FLATBUSH AVENUE, EASTERN PARKWAY

1892, JOHN H. DUNCAN

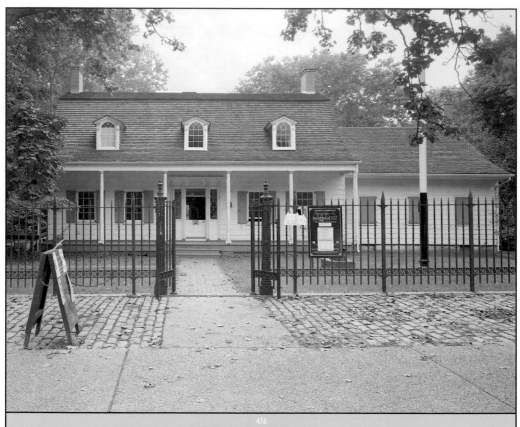

LEFFERTS HOMESTEAD

FLATBUSH AVENUE
NEAR EMPIRE BOULEVARD IN PROSPECT PARK

1783

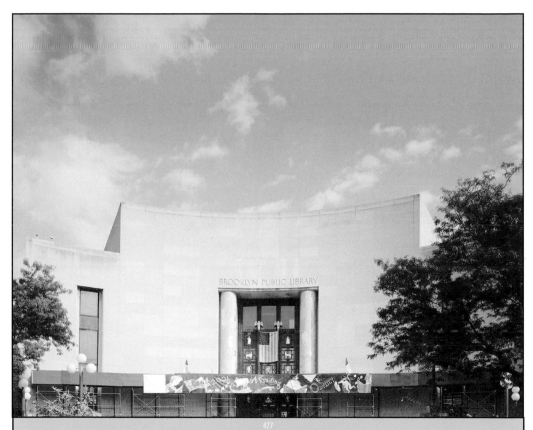

477

Brooklyn Public Library

GRAND ARMY PLAZA
AT FLATBUSH AVENUE AND EASTERN PARKWAY

1941, ALFRED MORTON GITHENS AND FRANCIS KEALLY

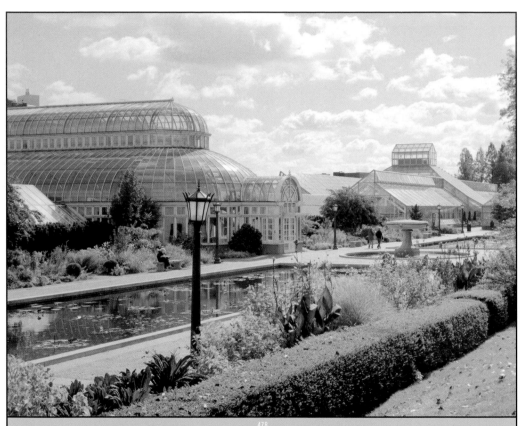

478
BROOKLYN BOTANIC GARDEN GREENHOUSES

1987, DAVIS, BRODY & ASSOCIATES

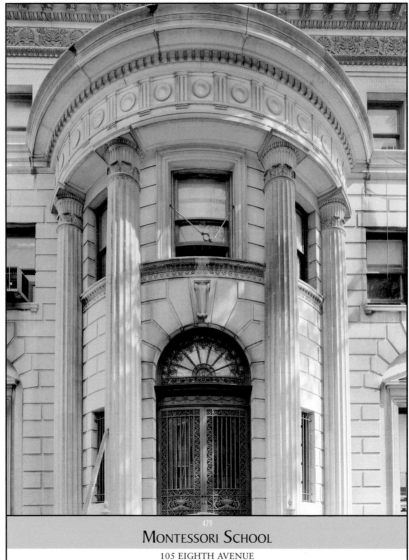

Montessori School

105 EIGHTH AVENUE
BETWEEN PRESIDENT AND CARROLL STREETS

1916, HELMLE & HUBERTY

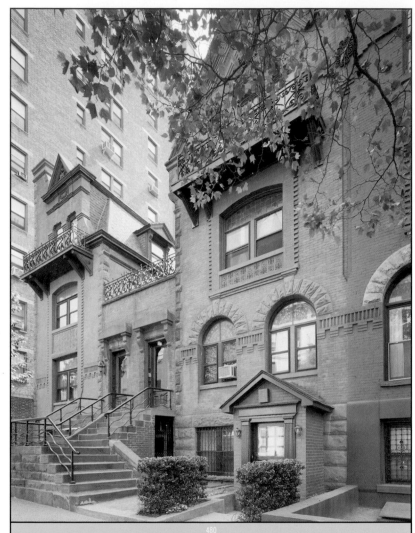

480

944–946 PRESIDENT STREET

BETWEEN PROSPECT PARK WEST AND EIGHTH AVENUE

1885, CHARLES T. MOTT

182 SIXTH AVENUE

AT ST. MARK'S PLACE

1880s

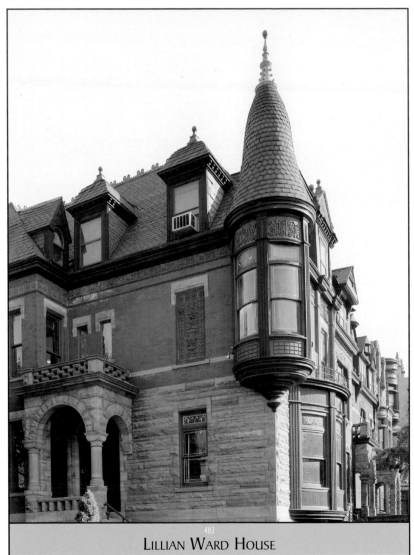

482

LILLIAN WARD HOUSE

21 SEVENTH AVENUE AT STERLING PLACE

1887, LAWRENCE B. VALK

483
ALBEMARLE TERRACE

EAST 21ST STREET
BETWEEN CHURCH AVENUE AND ALBEMARLE ROAD

1917, SLEE & BRYSON

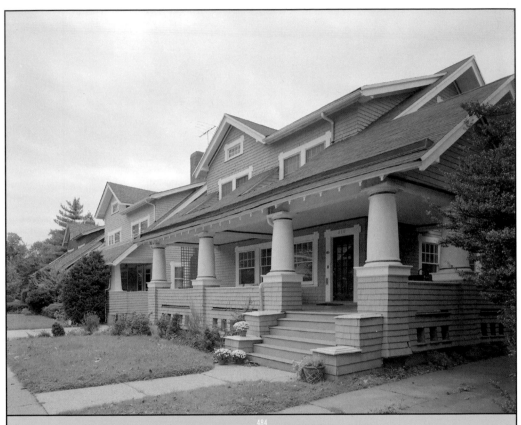

EAST 16TH STREET

BETWEEN NEWKIRK AND DITMAS AVENUES

1909, ARLINGTON ISHAM

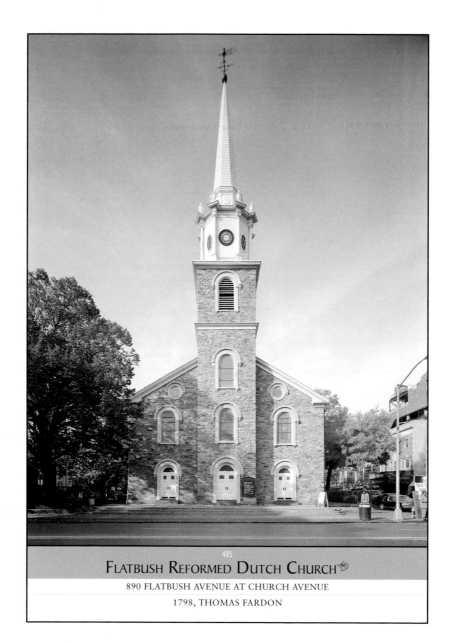

485
FLATBUSH REFORMED DUTCH CHURCH

890 FLATBUSH AVENUE AT CHURCH AVENUE

1798, THOMAS FARDON

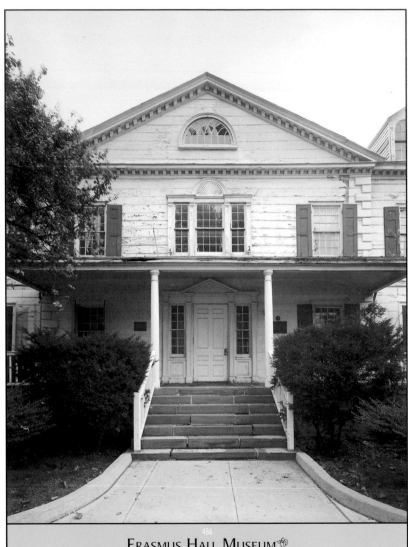

Erasmus Hall Museum

911 FLATBUSH AVENUE
BETWEEN CHURCH AND SNYDER AVENUES

1786

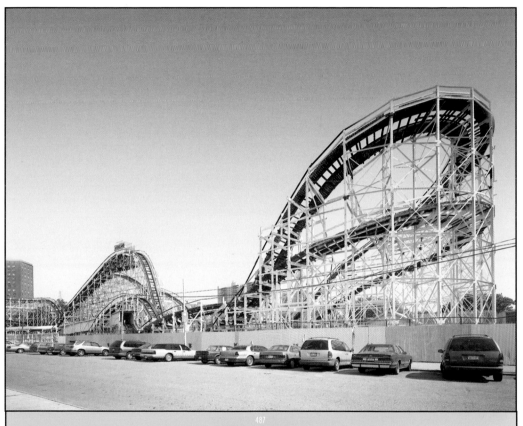

487
CYCLONE

CONEY ISLAND BOARDWALK AT WEST 10TH STREET

1927, HARRY C. BAKER
INVENTOR, VERNON KEENAN, ENGINEER

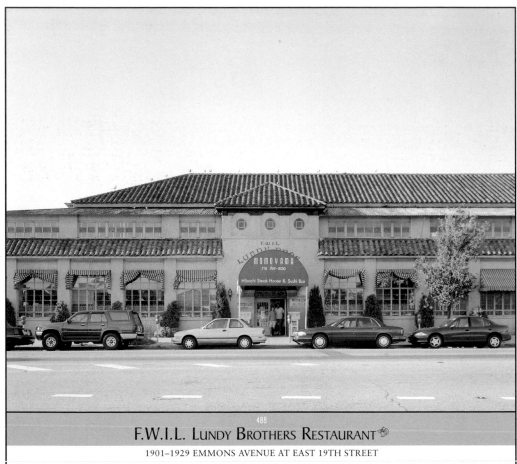

488

F.W.I.L. LUNDY BROTHERS RESTAURANT

1901–1929 EMMONS AVENUE AT EAST 19TH STREET

1934, BLOCH & HESSE

STATEN ISLAND

When Giovanni da Verazzano sailed into New York Bay in 1524, he found a treasure in the form of the sweetest water he had ever tasted. The island where it bubbled up to the surface was called "the watering place" until Henry Hudson arrived eighty-five years later and named it Staten Island for his benefactors, the Netherlands States General. Its name was changed again to Richmond after the consolidation of the five boroughs, and that was its official name for more than seventy-five years, until it was changed back to Staten Island in 1975 during the administration of Mayor Abraham Beame. When the Verazzano Bridge opened in 1964, the island's population was less than 225,000. It has since nearly doubled.

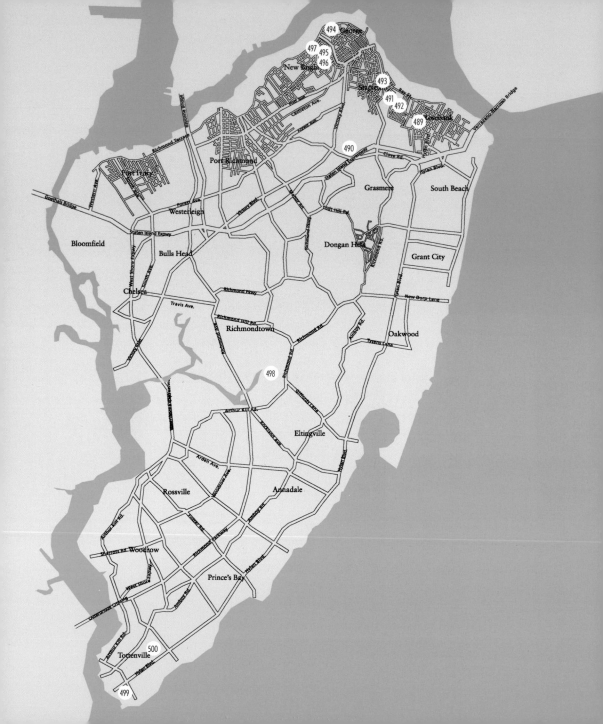

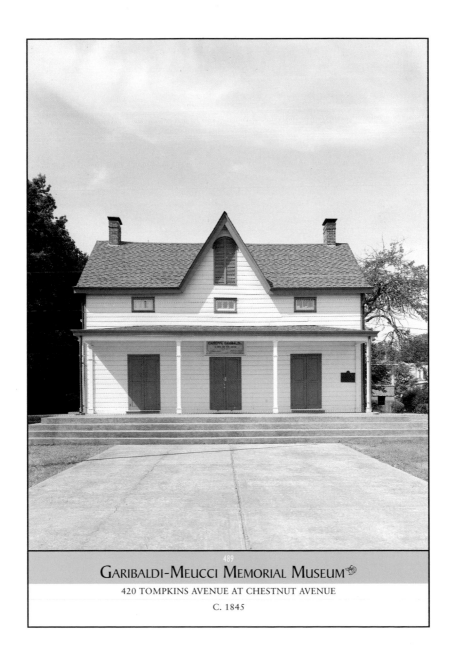

489
GARIBALDI-MEUCCI MEMORIAL MUSEUM

420 TOMPKINS AVENUE AT CHESTNUT AVENUE

C. 1845

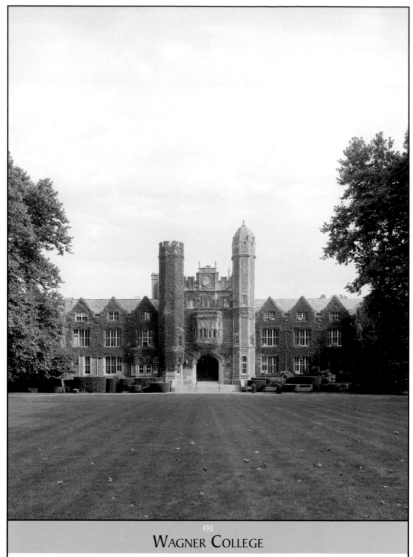

490

WAGNER COLLEGE

HOWARD AVENUE
BETWEEN CAMPUS AND STRATFORD ROADS

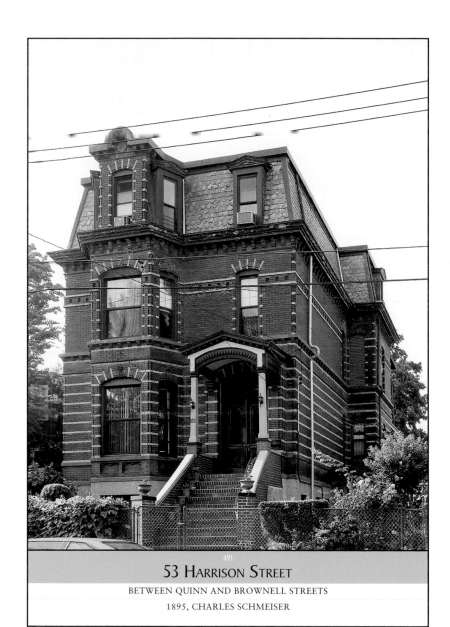

491

53 HARRISON STREET

BETWEEN QUINN AND BROWNELL STREETS

1895, CHARLES SCHMEISER

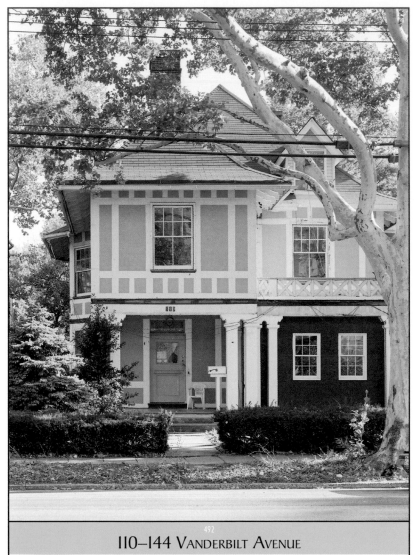

110–144 VANDERBILT AVENUE

BETWEEN TALBOT PLACE AND TOMPKINS AVENUE

1900, CARRÈRE & HASTINGS

◆ STATEN ISLAND ◆

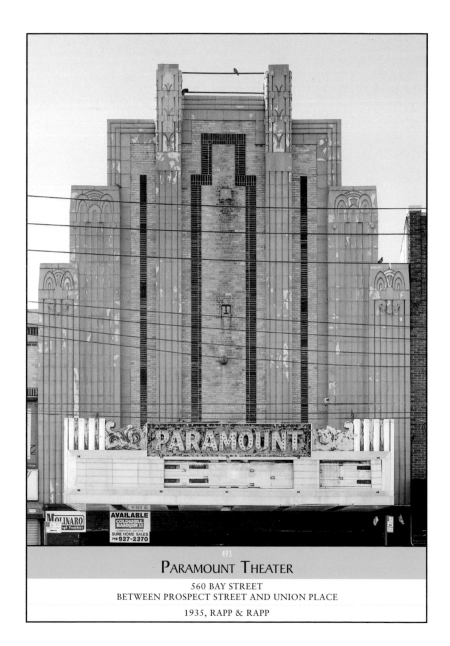

493

PARAMOUNT THEATER

560 BAY STREET
BETWEEN PROSPECT STREET AND UNION PLACE

1935, RAPP & RAPP

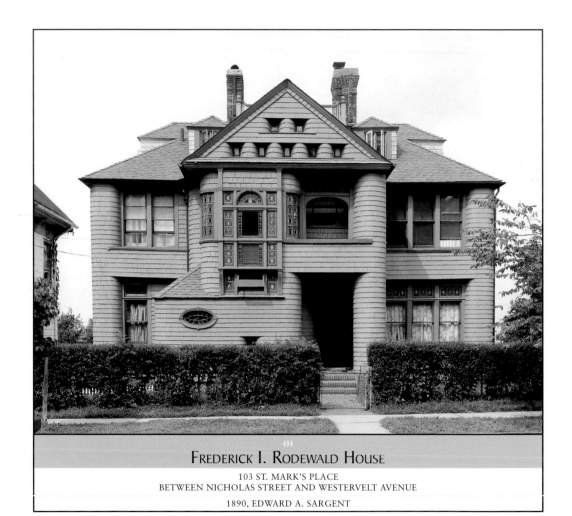

494

Frederick I. Rodewald House

103 ST. MARK'S PLACE
BETWEEN NICHOLAS STREET AND WESTERVELT AVENUE

1890, EDWARD A. SARGENT

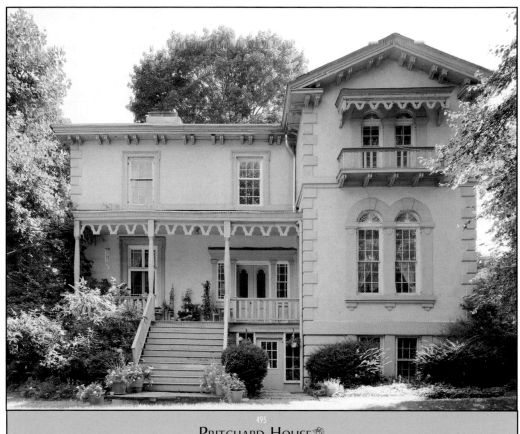

⁴⁹⁵
Pritchard House

66 HARVARD AVENUE AT PARK PLACE

1853

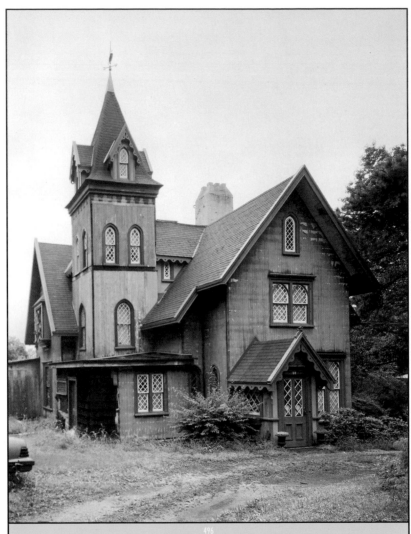

W. S. Pendleton House 🐿

22 PENDLETON PLACE
BETWEEN FRANKLIN AND PROSPECT AVENEUES

1855, CHARLES DUGGIN

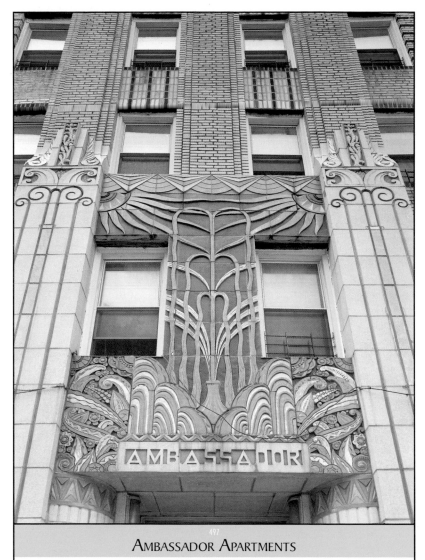

Ambassador Apartments

30 DANIEL LOW TERRACE
BETWEEN CRESCENT AVENUE AND FORT HILL CIRCLE

1932, LUCIAN PISCIATTA

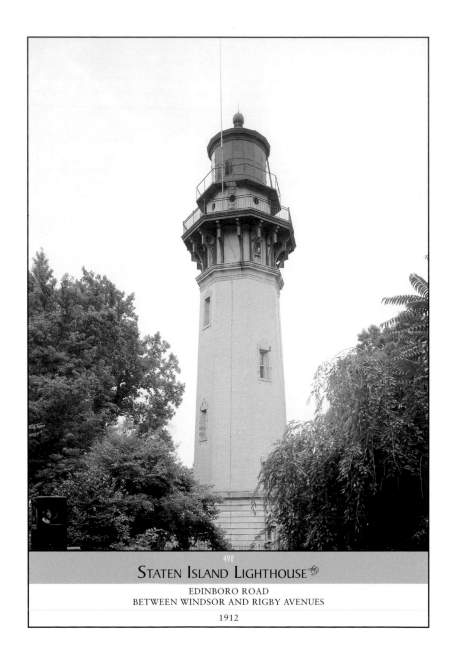

498
STATEN ISLAND LIGHTHOUSE

EDINBORO ROAD
BETWEEN WINDSOR AND RIGBY AVENUES

1912

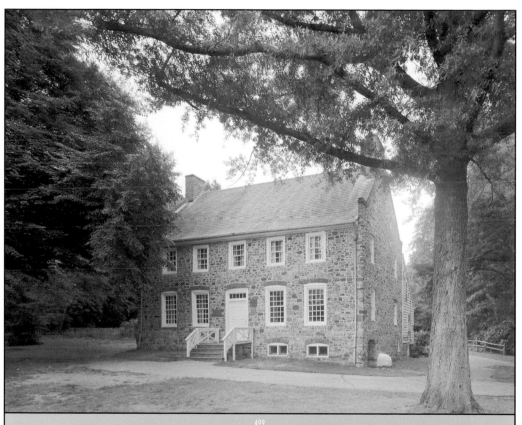

THE CONFERENCE HOUSE

HYLAN BOULEVARD

C. 1675

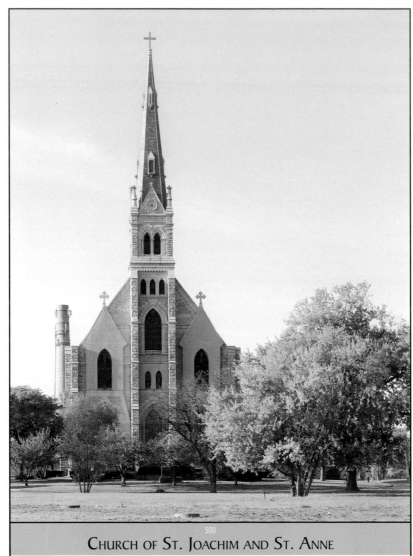

500

Church of St. Joachim and St. Anne

HYLAN BLVD.,
BETWEEN SHARROTT AND RICHARD AVENUES

1891, REBUILT, 1974

STATUE OF LIBERTY [1]

When the French government offered Miss Liberty as a gift, the U.S. government turned a cold shoulder to the idea. The official United States position was that the Statue of Liberty was only going to benefit New York City. The New York State legislature refused to open its purse strings to get the statue erected on what was then called Bedloe's Island and, predictably, money ran out before the pedestal was finished. Joseph Pulitzer's newspaper, New York World, raised the needed $100,000 from more than 121,000 individuals. For the statue's centennial in 1986, the Statue of Liberty–Ellis Island Foundation spent more than $425 million to restore it and the former immigration station, all of it from donations made by people in every part of the United States who knew all along that the Statue of Liberty belonged to them all.

ELLIS ISLAND NATIONAL MONUMENT [2]

This was the gateway to America for more than 16 million immigrants who arrived here between 1892 and 1954. The last arrival was a Norwegian sailor who had jumped ship to find his way in the new country. The names of most of them are inscribed on the Wall of Honor outside the Main Building, now the National Museum of Immigration. President Lyndon Johnson declared the island a National Monument in 1965, but Congress refused to appropriate the money it would take to restore it. The "private sector" finally did the job, but the dormitories and hospital buildings on the island's south side are still weed-choked and waiting for somebody to heed their call for help.

STATEN ISLAND FERRY TERMINAL [3]

This structure is functional, but that is about all that can be said for it. It will be replaced one of these days, just as it replaced an ornate, French-inspired building itself. But in the meantime, the free boat ride to Staten Island and back makes it one of the city's top tourist attractions.

ONE BROADWAY [4]

Once the office of the United States Lines, the building's frieze is decorated with symbols of its fleet's ports of call. The doors to the bank that replaced the steamship company's ticket offices are marked with classes of passage on such ocean liners as America, Leviathan, and George Washington.

WHITEHALL BUILDING [5]

Before the bulky addition was built on its north side, Hardenburgh's building was three-sided, with façades on West and Washington Streets and Battery Place. He carefully made it part of the view across Battery Park, and the view from the other direction is just as fabulous. That is why the McAlister Towing Company chose it for their offices: it's the best place in the neighborhood to keep an eye on their tugboats.

STANDARD & POORS BUILDING [6]

Before there were overnight air shipping companies, Railway Express was the fastest,

often the only, way to get packages from here to there. It was a big business and it was run from this unusual H-shaped building until the wave of the future caught up with it.

BOWLING GREEN IRT CONTROL HOUSE

Along with its twin at 72nd Street and Broadway, this is a reminder of the intended glory of New York's first subway, the Interborough Rapid Transit Company. Although most of the original subway's entry points had steel and glass kiosks, important stations like this one were marked with brick and stone structures meant to resemble garden pavilions. "Control house" refers to its function of controlling the comings and goings of passengers in and out of the stations.

STANDARD OIL BUILDING

When John D. Rockefeller arrived in New York in 1886, he commissioned Ebenezer L. Roberts to build a nine-story headquarters building on this site for his Standard Oil Company. Ten years later he hired Kimball & Thompson to add a nineteen-story annex and another six floors on top of the original building. Then in 1922, he called in Carrère & Hastings to make some sense of the resulting mess and add yet another annex. What they gave him was a building that hugs the curve of Broadway, but matches the grid of the skyline in its tower. The chimney at the top is hidden inside a representation of an oil lamp, a nod to Rockefeller's success at marketing kerosene for the lamps of America.

ALEXANDER HAMILTON CUSTOM HOUSE

When he won this commission, architect Cass Gilbert wrote, "while having a practical purpose [the building] should express in its adornment something of the wealth and luxury of the great port of New York." Once the country's biggest collector of import duties, the building became surplus federal property after the Customs Service moved to the World Trade Center in 1977, and has since become home to the Smithsonian's Museum of the American Indian. This is the site of Fort Amsterdam, which the Dutch built to protect their original settlement and where Director General Peter Stuyvesant was forced to surrender it to the British, who renamed it New York. In those days it was the water's edge. Everything west of the Custom House is landfill.

2 BROADWAY

The first building in the financial district to break with the tradition of solid masonry walls, its bland curtain walls didn't do a thing for the banking community's sense of aesthetics. Even its owner, Uris Brothers, seemed to agree and attempted to make it interesting by adding abstract mosaics over the entrances. That didn't work, either. Architectural Forum magazine called it "Off-Tune on Broadway."

BROAD FINANCIAL CENTER

When the Dutch ran this city, the main thoroughfare was a canal called de Heere Gracht, but when the British took over in

1664, they filled it in and called it Broad Street—an appropriate name because, thanks to the size of the canal, it was the widest street in the colony. The name has been considered important ever since, which is why this tower on Whitehall Street pretends it has a Broad Street address.

GOLDMAN-SACHS BUILDING

According to the zoning law, the design of this monster was supposed to be complementary to the landmarked Fraunces Tavern block on the other side of Pearl Street, which provided the air rights necessary to make it as large as it is. But something was obviously lost in the translation. There is a very small nod to history inside, in a pair of glassed-in displays of seventeenth-century artifacts uncovered during the excavation of its foundations.

AMERICAN BANK NOTE COMPANY

Breaking with the tradition of dividing a façade into individual floors, this building is fronted with a monumental order of Corinthian columns. The attic above the cornice contains executive offices and a private dining room.

FRAUNCES TAVERN

The tavern is a faithful recreation of the 1719 Etienne DeLancey house, which became the Queen's Head Tavern in 1762. It was operated by Samuel Fraunces, a West Indian who also served as General George Washington's chief steward, which gave him an inside track as caterer for the gala banquet hosted by Governor Clinton to celebrate the evacuation of British troops from New York in 1783. The guest of honor was General Washington himself, who bade farewell to his officers in the Long Room on the tavern's second floor. The building deteriorated until 1904, when the Sons of the Revolution bought it, meticulously restored it to its former appearance, and in 1907 reopened it as a restaurant. It was refurbished once again, after the restaurant's operator gave up in the face of rising rents, and the lease changed hands in 2001.

SHRINE OF ST. ELIZABETH ANN BAYLEY SETON

Looking around the neighborhood today, it is hard to believe that State Street was once lined with a magnificent row of Federal-style houses that matched this surviving pair. Originally the James Watson House, the shrine is dedicated to the first American-born saint, Mother Seton, the founder of the Sisters of Charity and America's parochial school system. The adjoining Church of Our Lady of the Rosary was once Mother Seton's home, overlooking her native Staten Island.

ONE NEW YORK PLAZA

Architecture critic Paul Goldberger compared this building's façade to "fifty stories of Otis elevator buttons (or blank TV screens)." His colleague, Ada Louis Huxtable, said it reminded her of "stamped barber shop ceilings." The AIA Guide chimed in that "Thousands of interior decorators' picture frames form an unhappy façade on this all too prominent, dark, brooding office tower."

3 NEW YORK PLAZA [17]

A flashpoint for Vietnam War protesters, this former U.S. Army Building was where generations of draftees went for their pre-induction physicals as far back as the Korean War. In the days when the draft was still in effect, any eighteen-year-old who got a letter beginning, " Greetings…" didn't have to read any further. It wasn't even necessary to ask how to get here—every young man in the city knew exactly where it was. "Whitehall Street" said it all. The building, which resembled a castellated fortress, was swallowed up behind the glass walls that now enclose a health club, and offices rise above the original structure, which is still just under the surface.

4 NEW YORK PLAZA [18]

In an unusual attempt to emulate its nineteenth-century neighbors, the architects specified a brick façade here, but they missed the point with larger-than-average bricks and narrow windows that give it a fortress-like appearance. The windows are intentionally small to keep sunlight and heat from the computers inside.

FIRST PRECINCT, NYPD [19]

This precinct was called "the most important police district in the world," by A. E. Costello in his 1885 history of the force, *Our Police Protectors*. He explained: "Treachery on the part of [the] patrolmen for a couple of hours would enable criminals to possess themselves of booty amounting to millions." At the time the precinct was established here in 1884, its officers watched over the assets of thirty-two banks, the Custom House, the Federal Subtreasury, and the New York Stock Exchange. All of these institutions, and others that have since joined them, have their own security departments today, and the precinct was moved to TriBeCa in 1973. The building housed the Landmarks Commission until 2001, whereafter it became the home of the Police Museum.

BATTERY-MARITIME BUILDING [20]

Long after the Brooklyn Bridge was opened in 1883, fourteen different ferry lines still connected lower Manhattan and Brooklyn. The last of them, which wasn't shut down until 1942, was one of several that used this elegant terminal whose sheet metal exterior is painted green to match the weathered copper skin of the Statue of Liberty. It was also at the Manhattan end of the ferry to Governor's Island when it was a Coast Guard base, and is still the only connection to the island for the caretakers stationed there. At the time it was built as the Whitehall Ferry Terminal, it was one of dozens of buildings like it lining the waterfront, but it is the only one that has survived.

CONTINENTAL CENTER [21]

Boston's Fenway Park has its "green monster," and this is New York's. Hitting a baseball in its direction is not recommended, although quite a few architecture critics have hurled brickbats at it.

NATIONAL WESTMINSTER BANK [22]

A pair of mirrored glass cylinders seems to be holding this building together. Workers

excavating its foundations unearthed an eighteenth-century sailing ship buried in the landfill, and when word got out, the builders agreed to allow the public to have a look at it, but only on a single Sunday when the workers had the day off and digging wouldn't be interrupted. Part of the ship was rescued and sent to the Mariners' Museum at Newport News, Virginia.

23 WALL STREET PLAZA

This white aluminum and glass building earned a special award from the American Institute of Architects for its "Classical purity." It isn't actually on Wall Street, but it does have one of the best plazas in the Wall Street neighborhood, containing a two-part stainless steel sculpture by Yu Yu Yang consisting of a L-shaped vertical slab with a circular opening facing a twelve-foot polished disk. It is a memorial to the Cunard liner *Queen Elizabeth I*, which burned in Hong Kong harbor as this building was being built.

24 MORGAN BANK

This massive fifty-two-story tower gets along quite well with its neighbors. It contains an incredible 1.7 million square feet of office space, almost without flaunting its size. The bank is among the many legacies of John Peirpont Morgan, who was born in Connecticut and began his New York career as the American agent of his father's London-based firm, Dabney, Morgan and Company, in 1861.

25 HOME INSURANCE PLAZA

The small plaza in front of the Home Insurance Company is more important than the buildings that surround it. Maiden Lane is among Manhattan's oldest streets, originally a dirt path leading through the woods to a brook where young women (maidens, they say) came out every morning to do their laundry.

26 MORGAN GUARANTY TRUST BUILDING

The simple Classicism of this, his nerve center, was said to have been inspired by the personality of J. P. Morgan, who had been dominating American finance for a quarter-century when it was built. It was also a lightning rod for anti-capitalists, who set off a wagonload of dynamite on the sidewalk outside in 1920, killing 33 and injuring 400 innocent bystanders, and leaving visible scars on the Wall Street façade to this day.

27 55 WATER STREET

With more than 3 million square feet of rentable space, this was the largest commercial office building in the world when it was built. Only the Pentagon had more space. It consumed four small city blocks, in return for which the developer, Uris Brothers, agreed to rebuild Jeanette Park to its east. It is an unremarkable public space with nothing to recommend but the nearly forgotten seventy-foot New York Vietnam Veterans Memorial, designed by M. Paul Friedberg & Associates.

28 INDIA HOUSE

Since 1914, this has been a private club for businessmen dealing in foreign trade. In earlier times it was the headquarters of the Hanover

Bank, then it became the New York Cotton Exchange, and later the home of W. R. Grace & Company. Hanover Square has been a public common since 1637, familiar to Captain William Kidd who, before he was hanged as a pirate in 1699, lived around the corner at 119 Pearl Street.

NEW YORK STOCK EXCHANGE 🕸

Although Wall Street is synonymous with high finance, the real nerve center of the money world is inside this neo-Classical building around the corner, on Broad Street. The busy trading floor is accessible to the public, but only discreetly, through the annex next door at 20 Broad Street. The sculpture above the Corinthian columns, formally called *Integrity Protecting the Works of Man*, is a lead-coated replica of the original marble carving, placed there in 1936. The relief symbolically represents the Exchange as a reflection of national wealth.

CHASE MANHATTAN BANK TOWER

When David Rockefeller announced plans to build a new headquarters for Chase Manhattan Bank, it was taken as a signal that lower Manhattan in general and the financial community in particular had finally turned the corner after the Great Depression. Better buildings would follow, but none as filled with hope for the future as this one. The stage was set by cladding the 800-foot tower with anodized aluminum panels that make it shine and stand out among its masonry neighbors. The plaza at its base is graced by Jean Dubuffet's forty-two-foot abstract sculpture called *Group of Four Trees*, installed in

1972 after a ten-year search for something appropriately monumental.

WILLIAMSBURGH SAVINGS BANK

This ornate building was originally the headquarters of the Seaman's Bank for Savings. The architect made good use of his client's long association with the harbor by commissioning three large murals by Ernest Peixotta to trace the history of the port, then decorated the banking room and the Romanesque façade with representations of ships and mermaids, dolphins, and other iconography of the sea. If it weren't a bank, you might say that the design is playful.

REGENT WALL STREET HOTEL 🕸

Originally the Merchant's Exchange, this structure served as the United States Custom House and for nearly ninety years it was the headquarters of National City Bank, and its successor, Citibank. After a brief stint as a catering hall, it was converted into a 144-room hotel in 1999. The wonderful Great Hall, designed by McKim, Mead & White, now serves as one of the most elegant ballrooms in the world.

TRUMP BUILDING 🕸

Originally the main office of the Bank of the Manhattan Company, which merged with Chase Bank and moved into its building. In his book, *New York: The Wonder City*, W. Parker Chase said of this skyscraper, "no building ever constructed more thoroughly typifies the American spirit of hustle than does this extraordinary structure."

BANCA COMMERCIALE ITALIANA [34]

Originally the Seligman Building, this twelve-story Baroque structure displeased turn-of-the-century architecture critics, but considering the angles of the intersection it fills, it was something of a triumph. The 1986 addition by Gino Valle, Jeremy P. Lang, and Fred Liebman is also a triumph, a rare example of a modern building in harmony with its surroundings.

13–15 SOUTH WILLIAM STREET [35]

All of the buildings of old Nieuw Amsterdam are long gone, but these stepped gables offer an educated guess of what the whole colony probably looked like. The most impressive building the Dutch built was the Stadt Huys, originally built in 1641 as a tavern, on the other side of the square. An imposing five-story building, it was the tallest in town and, as the city hall, the most important.

CHUBB & SONS [36]

This is a modern addition to the city's oldest paved street. Once known as Brouwers Straet because it meandered past Stephanus Van Cortlandt's brewery, it was paved with cobblestones in 1657 in response to complaints by Mrs. Van Cortlandt about the dust raised by her husband's customers.

NEW YORK COCOA EXCHANGE [37]

Originally known as the Beaver Building, the architects solved the problem of designing for an angular site by rounding off the corner. The Cocoa Exchange is a commodities trader, now part of the New York Coffee and Sugar Exchange. It moved from here to the World Trade Center in the 1990s.

DELMONICO'S [38]

New York's oldest restaurant, founded in 1825, Delmonico's has had seven different locations over the years. After its original building on this site was destroyed by fire, it was replaced by this one, as a hotel and restaurant for men only. The hotel now houses condominium apartments and the restaurant is open to all. The marble pillars at the entrance, said to have been excavated at Pompeii, also graced the first building.

CANADIAN IMPERIAL BANK OF COMMERCE [39]

By the time this building was built for the City Bank Farmer's Trust Company, bankers had begun demanding Modern Classicism as their architectural statement. Cross & Cross delivered the goods and pleased the bankers even more with a fifty-seven-story limestone tower that was ready for occupancy just one day short of a year from the time it was begun.

TRINITY CHURCH [40]

This is the third church on the same site, beginning with a 1697 structure that was destroyed by the Great Fire of 1776 and replaced by another that fell victim to snow piled on its roof during a blizzard in 1839. The parish itself was established as the colonial outpost of the Church of England by a 1705 land grant from England's Queen Anne that included all of the territory west of Broadway from Fulton Street

north to Christopher Street. The grant also transferred the rights to the contents of any ships that might run aground there and to all of the whales that washed ashore. But the real riches came in the form of leases for buildings that went up in that area known as "The Queen's Farms." Apart from being the richest and oldest parish in New York, Trinity is also its best-known church, thanks to its setting in a two-and-a-half-acre Colonial graveyard adjoining the canyons of the Financial District.

FEDERAL HALL NATIONAL MEMORIAL 🐚

Less than twenty-five years after George Washington took his oath of office on a balcony at New York's former City Hall, the building was torn down and sold for scrap, netting $425. It was replaced by this Greek Revival temple, which served first as the U.S. Custom House and then as a sub-treasury building. It became a National Historic Site in 1939. J. Q. A. Ward's 1883 statue of President Washington had already been placed on the front steps to mark the important moment.

45 WALL STREET

The dream of being able to walk to work has persisted among New Yorkers for generations, but on Wall Street the dream wasn't realized until the present generation, with buildings like this one. Laundromats and grocery stores may be few and far between, but since the '80s, even these amenities have begun to spring up to service the growing number of residential buildings within walking distance of the world's financial center.

BANKERS TRUST COMPANY BUILDING 🐚

The stepped pyramid that crowns this tower was used for many years as the bank's corporate symbol. The Classical building, which Bankers Trust sold in 1987, was created only partly for its own offices, with a healthy share of its space left over for rental. The 1933 addition contains muted Art Deco touches, which blend perfectly with the Doric-columned main façade of the original structure.

BANK OF NEW YORK

Ralph Walker, who designed this building, wrote that, "the skin [of a building] becomes a matter of whatever ardent experience that man can bring forth to create delight as well strength." One Broadway is proof that he practiced what he preached. The limestone tower appears delightfully rippling. The interior is a tour de force of mosaics that look like fine tapestries.

EQUITABLE BUILDING 🐚

The floor space inside this behemoth works out to 1.2 million square feet, but the lot it stands on is just about an acre. What was called a "wholesale theft of daylight" led to the zoning resolution of 1916. America's first such law, it regulated building heights in relation to the width of the street and set a fixed formula for skyscraper setbacks.

LIBERTY TOWER 🐚

A neo-Gothic freestanding skyscraper with a handsome terra-cotta façade lavishly decorated with representations of birds and animals, this was one of the earlier downtown

buildings to be converted into apartments. The renovation dates back to 1981, and prior to that, Liberty Tower was the headquarters of the Sinclair Oil Company.

FEDERAL RESERVE BANK OF NEW YORK

More pure gold is stored in the five levels under this building, inspired by the Florentine Strozzi Palace, than any other spot on earth. It is the property of a host of different nations who order the ingots moved from one vault to another to satisfy trade debts between them.

TRINITY AND U.S. REALTY BUILDINGS

Designed in a Gothic style to complement Trinity Church on the other side of the graveyard, the twin lots these buildings fill are only 50 feet wide, though 264 feet long. The southernmost Trinity Building is on the site of the first office building ever built in New York.

BANK OF TOKYO

In 1975, the Japanese design firm of Kajima International modernized Bruce Price's rusticated façade, bringing the former American Surety Building squarely into the twentieth century. Happily, they didn't touch the row of eight allegorical stone goddesses created by sculptor J. Massey Rhind. The top of the building has decorated façades on all four sides, uncommon among most corner buildings built in the late nineteenth century. Another unusual innovation is the construction

WORLD FINANCIAL CENTER

These glass and granite office towers house such giants of the financial world as Dow Jones, American Express, Merrill Lynch and Oppenheimer & Company. Although severely damaged in the World Trade Center attack on September 11, 2001, all of them were left virtually intact, as was the Winter Garden, a huge glass-walled interior space featuring rows of ninety-foot palm trees. The open plaza beyond overlooks the river and a cove for the yachting set.

WORLD TRADE CENTER

The now-destroyed 110-story stainless steel Twin Towers were, at 1,350 feet, the tallest buildings in the world for a couple of weeks when they were finished in 1974, until an upstart in Chicago called the Sears Tower topped them by 104 feet. But the World Trade Center was more than just a pair of monoliths, it was seven buildings connected by a vast underground concourse and a wide windswept plaza at ground level. The sixteen-acre site now known as "Ground Zero" is expected to be cleared of debris by the summer of 2002.

MILLENIUM HILTON HOTEL

Before anyone pointed out that they had spelled "millennium" wrong, apparently, all the letterheads and brochures had been printed, and the builders of this 58-story hotel decided to let the mistake go. The 561-room property more than made up for it in its standards of luxury and service, and its location across from the World Trade Center made it a sell-out from the beginning. The collapse of the Twin Towers

resulted in a lot of broken glass in its sleek façade and a good deal of smoke damage, but the Millenium is still standing, still sound, and plans to reopen.

St. Paul's Chapel 🕸
53

Influenced by London's Church of St. Martin's in the Fields, this is the oldest church building in Manhattan. George Washington worshiped here, in fact. Originally built as an outpost of Trinity Parish at the edge of the city, its front door was made to face the churchyard on the east side because no one knew that Broadway would ever amount to anything. The steeple was added in 1796, but beyond that the church is unchanged from the day it opened.

Garrison Building 🕸
54

Built as the headquarters of the *New York Post*, the sculptures here represent the "Four Periods of Publicity," and the colophons of early printers are worked into the spandrels between the windows and the elaborate Art Nouveau top.

Federal Office Building
55

Originally housing the Department of Commerce, the Federal Housing Administration, and the Treasury Department, this monolith represented a shift in official government architecture from historic statements to demonstrations of post-Depression power and strength.

American Telephone and Telegraph Building
56

When AT&T moved from here, they took along Evelyn Beatrice Longman's sculpture, *The Genius of the Telegraph*, after it had spent sixty years on the roof. It is now at the company's headquarters in New Jersey. Its former headquarters here at 195 Broadway, now an office building, has more Classical columns on its façade than any other structure in the world, and the parade continues gloriously inside.

Barclay-Vesey Building 🕸
57

Built as a switching center for the New York Telephone Company, this Art Deco treasure incorporates an innovative seventeen-foot pedestrian arcade that allows its interior space to extend out to the street line. Its ornamentation is exotic and playful, including giant elephants lounging up at the top. The brickwork comes in no less than nineteen different colors, from deep rose at street level to bright orange, tinged with pink, at the roof line.

One Liberty Plaza
58

Built by U.S. Steel as a demonstration of the possibilities of its newly developed Cor-ten steel for building exteriors, the architects got the message and came up with a structure with unusually wide bays spanned by deep girders that are exposed on the outside. The effect is overpowering, but nowhere more so than at the entrance, where the low beams make you instinctively want to duck so that you won't bump your head. This building replaced Ernest Flagg's 1908 Singer Tower, the tallest building ever demolished in the name of progress. During television coverage of the September 11 World Trade Center disaster, One Liberty Plaza was authoritatively pronounced dead all afternoon by reporters who were blocks away. But when the dust cleared, it was still standing.

59
EAST RIVER SAVINGS BANK

If you're a bargain hunter, you've surely been inside this building. Your mother probably remembers the former Art Deco bank with stainless steel eagles over the entrances. Banks have been converted into every conceivable re-use, from churches to discos, but few have, like this one, become department stores.

60
ST. PETER'S CHURCH

The oldest Catholic parish in the city, this building stands on the site of its predecessor, built on land purchased from the Episcopalian Trinity Parish in 1785. There were only about two hundred Catholics in New York at the end of the Revoloutionary War, but in less than a century, it became the city's largest religious denomination and it still is.

61
MUSEUM OF JEWISH HERITAGE

Serving as an anchor to the lower end of the Battery Park City Esplanade, this is a memorial to victims of the Holocaust and also includes artifacts tracing the history of the Jewish people. Although hundreds of New York's Jewish families are Holocaust survivors, their history in New York begins with twenty-three Sephardic refugees from Portuguese Brazil who were given asylum here in 1654. Over the next two centuries, a large majority of Jews who emigrated to the United States went no further than New York, and today there are about 1.1 million Jews living here, more than double the Jewish population of Jerusalem.

62
SCHERMERHORN ROW

This is the last surviving row of Federal-style warehouses in a city that once had hundreds of them. They have their original pitched roofs and dormers that were a later addition, and they still show their original Flemish-bond brickwork and splayed lintels. Peter Schermerhorn, who ran a successful ship chandlery around the corner at 243 Water Street, acquired the property for these buildings in 1800 when the city offered the new landfill as "water lots" to local landowners on the condition that they would be used for buildings and not left vacant. The Schermerhorn family owned the buildings he built until 1939.

63
BOGARDUS BUILDING

The orginal version of South Street Seaport's Bogardus Building was stolen. The current one is based on a cast-iron structure made from elements created by James Bogardus, a pioneer master of the art, that was dismantled and stored in a warehouse for later installation at the restored Seaport. But it was purloined by person or persons unknown and melted down for scrap before anybody knew it was missing. Fortunately, photographs and drawings of it still existed, and this is what the twentieth-century architects saw in them.

64
PIER 17

Not every structure at South Street Seaport is a nineteenth-century original, and Pier 17 is among the new ones, although the pier itself was the busy centerpiece of the

old port. After the fun of exploring the Seaport's fleet of historic ships, including the barque Pekin and the occasional visiting vessels that tie up among them, a visit to this mall-like building across the way that houses stores and restaurants affords the best available views of the Brooklyn Bridge and the traffic on the East River.

ILX SYSTEMS
[65]

Among the last corporate headquarters built before World War II, this compact Modernist structure communicated a special identity for the client, as was expected of pre-war architecture. But it also set the stage for postwar buildings that would make statements of their own.

127 JOHN STREET
[66]

Once past the canvas panels over the entrance, a visitor goes through a neon-lit tunnel leading to the lobby in back, where Oriental rugs and soft light calm the nerves. Service rooms on the tenth floor can be seen through clear glass and at night, flashing lights make the building seem like a living, breathing entity. A digital clock on an adjacent building at the south side will tell you if you're late for an appointment, but it may take you a minute or two to figure out what time it is.

DOWN TOWN ASSOCIATION
[67]

Among the oldest private clubs in the Financial District, this is a quiet retreat where executives and lawyers meet for power lunches. Since its founding in 1860, its membership has included lawyer William M. Evarts, who represented President Andrew Johnson in his 1868 impeachment and became secretary of state in the administration of Rutherford B. Hayes, Henry L. Stimson, who served as secretary of war during all of World War II, and President Franklin D. Roosevelt.

AMERICAN INTERNATIONAL BUILDING
[68]

Because the site was so small, the architects saved space by reducing the number of elevator shafts in this building, making each serve two floors at a time with double-decked cars. That meant the lobby had to be a double-decker, too, but thanks to a natural slope in the lot, both levels are accessible directly from the street on different sides. In order to squeeze in more floor space, the building is in the shape of a cross, intersected by rectangles that give it twenty-eight different sides (and lots of window offices).

POTTER BUILDING
[69]

Developer Orlando B. Potter lost his New York World building on this site to a fire in 1882 (you probably read about it in Jack Finney's book, *Time And Again*), and he was determined not to let that happen again. The result was the city's first fireproof building, which used terra-cotta to protect the steel beams and more of the same to dress up the façade in a masterpiece of ornamental detail. It now contains forty-one spacious loft apartments, the nicest of which feature views of City Hall and its adjoining park just across Park Row. The park's recently restored fountain features original gas lamps.

70
Park Row Building 🐝

When the idea of skyscrapers arrived in New York, most businessmen were dubious. Tall buildings made sense to them as long as they were freestanding and not abutting their neighbors, since the lack of side windows would surely make the space unrentable. As if to prove the theory wrong, this structure, which was the world's tallest building for eight years, went up in mid-block with party walls on both sides. The architect added cupolas above the cornice to give it the illusion of a freestanding tower. This building, familiar to shoppers who frequent J&R's superstore, is among the most recent landmarks to be converted into apartments.

71
Morse Building

A former manufacturing loft building, 12 Beekman Street was converted into spacious and unique apartments in 1980 by Hurley & Farinella. The original architects were Benjamin Silliman, Jr., who designed nearby Temple Court, and James M. Farnsworth, who was responsible for the additions to another neighbor, the Bennett Building. The cast-iron streetlights in this area, known as "bishop's crooks," were once common throughout the city and are enjoying a comeback in some historic neighborhoods.

72
Bennett Building 🐝

This loft building had a mansard roof until 1892, when it was replaced by four more floors of work space, providing more income for its owner, James Gordon Bennett, better known as the owner of the *New York Herald*. It began as a seven-story office building, was enlarged with a four-story addition, and then expanded again two years later with an extension on the Ann Street side. The three stages blend together seamlessly, making it the tallest cast-iron building in the city.

73
Excelsior Power Company

Built to generate electrical power with the steam from coal-burning furnaces, this might have been a place to look for a way to solve New York's present shortage of power plants. But it's too late: The generators are gone and this Romanesque building is now an apartment house.

74
Temple Court 🐝

Although the twin steeples that crown this office building suggest a temple, it was actually named for the London landmark that houses two of the Inns of Court, which was itself named for its site replacing the headquarters of the medieval Templars. Inside, awaiting restoration, is an atrium that soars through nine stories to the roof, with delicate cast-iron balustrades. The building extends to the corner of Theater Alley, which in the first half of the eighteenth century was the site of the city's first major showplace.

75
American Tract Society Building

This Romanesque building, whose original tenants were publishers of religious flyers and newspapers called "tracts," faces Printing House Square, where a statue of Benjamin

Franklin by Ernst Plassman has been standing with a copy of his newspaper, the *Pennsylvania Gazette*, since 1872. The neighborhood was already home to such well-known newspapers as the *New York Times*, the *New York World*, the *Herald*, and the *Daily Graphic*.

76
Woolworth Building

For an idea of what the architect himself looked like, check out a gargoyle he placed in the lobby. He's the one hugging a model of the building, not far from his client, dime-store entrepreneur F. W. Woolworth, who is depicted counting his money. The Woolworth Building's lyrical Gothic style established a new benchmark for skyscraper architecture, replacing French Modern, which before then had been considered the only style appropriate for tall buildings. Much to the despair of New Yorkers looking for little necessities that they once found in Woolworth's stores, the "five-and-tens" have all vanished from the city's neighborhoods. At the time Mr. Woolworth died, six years after this building was finished, his empire extended to more than a thousand stores around the world and his fortune had grown to some $65 million, an impressive number of nickels and dimes in 1919. He was always proud to let it be known that he paid cash for his "Cathedral of Commerce." His rise to the role of merchant prince began in 1878 with a "five-cent" store in Utica, New York. When it failed, he moved to Lancaster, Pennsylvania, and expanded his inventory to include items that cost ten cents, and he was on his way. He opened his first New York store on Sixth Avenue at 17th Street in 1896.

77
NYC Police Headquarters

A ten-story cube cantilevered over a complex of buildings including a parking garage, detention facilities, and a pistol range, the triumph here is Police Plaza, which offers pedestrian access over Park Row from the Municipal Building. It arches past rows of locust trees, fountains, benches, and a monumental sculpture called *Five in One* created by Bernard Rosenthal.

78
United States Courthouse

Finished by the architect's son, Cass Gilbert, Jr., after his father's death, this building is more than just a courthouse. It originally housed the U.S. District Attorney's offices, the U.S. District Court, the Circuit Court of Appeals, and even a training center for the Treasury Department's enforcers, all in a twenty-story office tower rising up from a five-story base to the stepped pyramid on the roof. The row of Corinthian columns at the entrance is angled in a gesture of neighborliness to the other courthouse next door.

79
New York County Courthouse

If you get summoned for jury duty, you won't report here but you'll probably wind up here. In New York State, the Supreme Court is where most cases get their first hearing. The steps leading up to the portico and past its Corinthian columns have probably been in more movies and TV shows than any other location in the city. It's illegal to shoot film inside, but the steps do the job when the scene calls for someone being hauled off to court.

ST. ANDREW'S CHURCH
80

Established in the mid-nineteenth century to minister to newly arriving immigrants, the predecessor of this charming church also served the needs of printers and newspaper people working in the neighborhood with a special mass at 2:30 in the morning.

MURRAY BERGTRAUM HIGH SCHOOL
81

Financed by the sale of air rights for the equally brutal New York Telephone Company switching center to its east, this brown brick structure with narrow windows has all the earmarks of a prison, including the towers at the corners that house stairways and mechanical equipment.

PACE UNIVERSITY
82

Pace University, which also occupies the former New York Times Building at 41 Park Row, a landmark designed by George B. Post in 1889, was established in 1947 as a school for training certified public accountants. It became a university in 1973, and now offers degrees in such disciplines as publishing and computer sciences as well as psychology and law. It also has campuses in midtown Manhattan and Westchester County. This modern structure is dominated by a metal sculpture over the main entrance.

CITY HALL
83

The landmarked interior of this building, where the Mayor and the City Council report for work, is accented by a rotunda over a graceful pair of cantilevered staircases. For years, visitors were afraid to climb the steps, but when President Lincoln's body lay in state under them as it was being moved from Washington to Illinois, the only way to get a good look was to climb those stairs. When they didn't fall down, the office-holders upstairs began receiving more visitors.

HOME LIFE INSURANCE COMPANY BUILDING
84

The top of this building is distinguished by a high mansard roof and a loggia behind Ionic columns. Its rusticated base is decorated with busy ornamentation and columns, but the middle is comparatively plain. Home Life Insurance, which built it as its headquarters, was among the first to guarantee insurability for prospective policy holders and the first to develop insurance plans to help families pay college tuition.

CRIMINAL COURTS BUILDING AND MEN'S HOUSE OF DETENTION
85

Usually called "the Tombs," the nickname of its predecessor, which resembled an Egyptian tomb, this building's façade more closely resembles Rockefeller Center, whose design was also worked on by Harvey Corbett. The prison contains cells for inmates awaiting their trials.

NEW YORK CITY FAMILY COURT
86

Once known as the Domestic Relations Court, this institution, now renamed Family Court, is technically a part of the New York State court system, handling juvenile and family-related matters such as divorces and child custody

cases. Hearings held here are among the most emotionally charged of those held in any court, and its security staff is easily the busiest.

87
NEW YORK COUNTY COURTHOUSE

A monument to graft, but a beautiful one nonetheless, the so-called "Tweed Court-house" cost as much to build as London's Houses of Parliament, with most of the money going into the pockets of Tammany boss William M. Tweed and his cronies. The building, which has been maligned and threatened over the years, is the future home of the Museum of the City of New York.

88
MUNICIPAL BUILDING

One of the problems with putting municipal offices in a skyscraper behind the diminutive City Hall is being careful not to overpower it, and this does the job very well. From some angles, it even seems to be embracing the true center of power. The tower at the top pays homage to City Hall's cupola, but in this case instead of featuring a statue of Justice, it is topped with Adolph A. Weinman's gilded *Civic Fame*, the largest statue in Manhattan. This, by the way, is where you go if you want to get married "at City Hall."

89
SURROGATE'S COURT/ HALL OF RECORDS

One of the nice things about New York is that you can tour the world without ever leaving town. Want to see the Paris Opera? Step into the lobby right here. When it was built, the Hall of Records was hailed as "the

most Parisian thing in New York." Ironically, its designer, John Thomas, was possibly the only architect working in New York at the time who had never been to Paris.

90
JACOB K. JAVITS FEDERAL OFFICE BUILDING

With so many architects involved, you might wonder why they didn't produce something more pleasing. It may have been the client. The government built an addition around the corner on Broadway in 1977, and the results weren't much better. During his post-Presidential years in New York, Richard Nixon maintained an office here.

91
HONG KONG BANK BUILDING

Very few of New York's ethnic enclaves contain reminders of the lands the immigrants left behind them. We don't look for Greek temples in Astoria or English manor houses in Chelsea, but somehow it seems appropriate to bring a little of Chinese tradition into Chinatown. This is one of the better attempts. The ornamentation and tiles that embellish the façade of the red pagoda-style office building were imported from Taiwan.

92
254–260 CANAL STREET 🌀

Resembling an Italian Renaissance palazzo, this is among the earliest examples of cast-iron architecture in New York, not to mention one of the largest. Its arched windows seem to go on forever, and because of the building's cast-iron construction, they probably could. The innovation freed builders from the constraints of massive masonry walls, and allowed them to create structures with open interiors and more light than ever before.

93
HSBC BANK

This building's magnificent bronze dome was built as a Classical counterpoint to the now down-at-the-heels Manhattan Bridge approach across the street. That treasure, designed by Carrère & Hastings in 1915, has a grand arch and impressive colonnades that have been allowed to deteriorate over the years. The Department of Transporation has been promising to restore it, but other projects keep getting in the way.

94
CHINESE MERCHANT'S ASSOCIATION

The neighborhood known as Chinatown was already built when the first Chinese immigrants settled here in the 1850s, and there are still only a few architectural reminders of their former home. This attempt to remedy that problem is colorful, but as far from authentic Chinese architecture as the pagoda-inspired phone booths on every corner in the neighborhood.

95
BIALYSTOKER SYNAGOGUE 🌀

Native stone called "Manhattan schist" is used in the façade of this nineteenth-century building that was built for the Willett Street Methodist Episcopal Church. It was converted to a synagogue in 1905 to serve a congregation that had been formed twenty-seven years earlier in Bialystok, a part of the Russian Empire that is now Poland, and that remained together after emigrating to New York.

96
RITUAL BATHHOUSE

Originally the Young Men's Benevolent Society, this building now serves Orthodox Jewish women who follow the requirement of a ritual bath, or *mikveh*, for purification and cleansing before marriage and monthly afterward. There are strict rules and guidelines involved, and the ritual can only be performed in a special location such as this.

97
HENRY STREET SETTLEMENT 🌀

In 1893, Lillian Wald founded the "Nurse's Settlement" at 263 Henry Street to help Americanize the Eastern European Jewish

immigrants on the Lower East Side. Later, as the Henry Street Settlement, it attracted the support of philanthropists Jacob Schiff and Morris Loeb, who bought the other two neighboring buildings and donated them to the effort. The structures are late Federal residences reflecting the character of this neighborhood in the early nineteenth century, when it was a semi-rural outpost at the edge of town.

98
JACOB RIIS HOUSES

These nineteen buildings, ranging from six to fourteen stories, were placed at an angle to the street grid to create an area that would serve as a tree-lined park. It had badly deteriorated by the 1960s, prompting the Parks Department to turn it into a park with innovative playgrounds, fountains, and an outdoor theater. After its dedication by Lady Bird Johnson, the *Village Voice* exulted that, "For once, the poor of the city have the best of it." That was in 1966. Today, much of Riis Houses' plaza has been destroyed because of what city officials have deemed safety problems.

99
ST. GEORGE'S UKRAINIAN CATHOLIC CHURCH

This is a glistening reminder of the Old Country for the more than 1,600 Ukranians who live in this part of the East Village. The church was established by Byzantine Rite Catholics at a former Baptist church on East 20th Street. When its first bishop, Soter Ortynsky, came here in 1907, his first mass in America was said there. The parish moved into this neighborhood in 1911.

100
STUYVESANT POLYCLINIC HOSPITAL

At the time of its founding, this clinic, established to offer free outpatient care for the poor, was called the "Deutsches Dispensary." The name was changed after it was sold in 1906 to the German Polyklinik, but during World War I, anti-German sentiment forced it to change again, and although it was changed back after the war, it was renamed Stuyvesant Polyclinic, once and for all, during World War II.

101
ST. MARK'S-IN-THE-BOWERY CHURCH

After St. Paul's Chapel on lower Broadway, this is Manhattan's second-oldest church building. It occupies the site of Peter Stuyvesant's private chapel, and he himself is buried in its churchyard. Once the centerpiece of a fashionable neighborhood, the church and its congregation deteriorated over the years, but both the structure and the people's faith were restored in a neighborhood renovation project that continued from 1975 through 1983.

102
STUYVESANT-FISH HOUSE

This larger-than-average Federal-style townhouse was built by Petrus Stuyvesant, the great grandson of the Nieuw Amsterdam's Director General, as a wedding gift for his daughter Elizabeth when she married Nicholas Fish. The land had been part of the original estate where Stuyvesant spent his last days, after having been recalled to the Netherlands to answer charges that he had given away the colony to the British. The authorities allowed the

case to die in committee and he was allowed to go home again, free to grumble about the way things were being run around here.

103
JOSEPH PAPP PUBLIC THEATER

This was New York's first major public library, eventually combined with the Tilden Foundation and the Lenox Library to create today's New York Public Library. After the Hebrew Immigrant Aid and Sheltering Society, which had been here since 1921, moved to larger quarters in 1965, Joseph Papp, the founder of the New York Shakespeare Festival, convinced the city to buy the Italian Renaissance Building and lease it to his organization as theater space. The conversion by Georgio Cavaglieri carefully retains the original interior details with a minimum of alteration.

104
COOPER UNION FOUNDATION BUILDING

This is the oldest iron-framed building still standing in the United States, but these aren't ordinary construction beams. Among his many talents, Peter Cooper, the founder of this institution, made the first rails for railroads. He rolled some for this building, too, stretching them across brick arches to support the massive brownstone building, the dimensions of which were dictated by the standard length of his rails. He established Cooper Union as a free educational institution that gives students the equivalent of a college degree while stressing the practical arts and trades. The only requirement then, as now, was good moral character.

105
BOUWERIE LANE THEATER

Built to be a bank, this building was abandoned for half a century until 1963 when it became an off-Broadway theater, resurrecting an old tradition of the Bowery as a theater district. In the 1800s it was lined with concert saloons and minstrel theaters and it was the site of the Great Bowery Theater, America's largest, in the 1820s.

106
MCSORLEY'S OLD ALE HOUSE

Although there are some naysayers, McSorley's claims to be oldest continuously-operating saloon in New York. The main attraction here are steins of the house ale, sold two at a time. Until 1970, when the law said that they had to allow women to belly up to the bar, this was strictly a male preserve. And law or no, the proprietors have refused to add a ladies' room.

107
ENGINE COMPANY NO. 33

Built as the headquarters of the New York City Fire Department, this perfect example of the French Beaux Arts style was the creation of Ernest Flagg, who designed several of the city's firehouses. The street is called "Great Jones" to avoid confusion with the block-long Jones Street in Greenwich Village between Bleecker and West Fourth Streets, or nearby Jones Alley, connected to it via Shinbone Alley south of Bond Street.

108
SCHOLASTIC BUILDING

Scholastic Publishers moved here from a 19th-century loft building further up Broadway, providing an impressive new New York home for Harry Potter, Clifford the Big Red Dog, and the Babysitter's Club. The world's largest publisher and distributor of children's books, the company also publishes 35 school-based magazines, and its products include software that helps youngsters learn how to read. Its divisions run the gamut from television programming to teaching via the Internet, and it has a presence in nearly every school across the United States.

109
CIVIC CENTER SYNAGOGUE

A ribbon-like wall of marble tiles hides a wonderful garden behind this modern addition to a street of nineteenth-century cast-iron buildings. Many of the early buildings in this former shopping district were either faced with marble or used it to enhance iron and other materials. The stone, known as Tuckahoe marble, was quarried in nearby Westchester County.

110
AT&T HEADQUARTERS

An expansion of an earlier office building, this huge Art Deco structure once housed the biggest long-distance telephone center in the world. Its landmarked lobby has ceramic tile walls with marble and bronze trim. There is a tile map of the world on one wall, and the ceiling is covered with glass mosaics celebrating telephone communications to far-away continents.

111
SAATCHI & SAATCHI

It's a long way from Madison Avenue, but this is the home of one of the world's biggest advertising agencies, as well the book publisher Penguin Putnam. It is a late addition to a neighborhood of massive buildings, most of which were built on land leased from Trinity Church as the center of the city's printing industry.

112
CHARLTON-KING-VANDAM HISTORIC DISTRICT

This tiny Historic District, of which these Greek Revival and Federal style row houses are a part, was the site of Richmond Hill, a 1776 Georgian mansion that overlooked the Hudson River. It served as George Washington's headquarters, then as the official residence of Vice President John Adams, who moved there in 1789. Aaron Burr bought Richmond Hill four years later. Burr sold the estate to John Jacob Astor, who leveled the hill and divided the property into twenty-five-foot building lots for many of the houses that are here now.

113
172 DUANE STREET

Cast-iron arches from the original building frame an elegant and modern new one built of glass block. Originally the Weber Cheese Company, one of hundreds of such companies in this neighborhood, whose merchants were commonly-known as the "big butter and egg men," it is now the home of the law firm of Lovinger Mahoney Adelson.

114
155 WEST BROADWAY

A frequent destination of Manhattanites summoned for jury duty, this building has a double effect on the local streetscape. On West Broadway, it is a handsome Anglo-Italianate building, while the façade around the corner on Thomas Street is just plain brick. Jurors can adjourn to a gourmet lunch across the street at the trendy Odeon, a gentrified former cafeteria.

115
319 BROADWAY ✲

Originally one of a pair of Italianate cast-iron buildings that once guarded the western entrance of Thomas Street and were known as "the Thomas Twins," this survivor was once the headquarters of the Metropolitan Life Insurance Company and also the home of the New York Life Insurance Company before it moved into its own building further down on Broadway in 1899.

116
36–57 WHITE STREET ✲

This row includes the Woods Mercantile Buildings (46–50), built of Tuckahoe marble with cast-iron storefronts. In the 1850s and '60s, blocks like this one, off Broadway above City Hall, were part of New York's most fashionable shopping district. This block included the upscale saddlery company run by James and Samuel Condict, at no. 55. Architect John Kellum also designed the nearby "Tweed" Courthouse.

117
AT&T LONG LINES BUILDING

This pile of pink granite doesn't have a window in sight because the electronic equipment inside can't stand the heat. On the other hand, the heat generated by the machines themselves is enough to warm its 29 eighteen-foot-high floors. This building is also certified safe from nuclear fallout, and it has enough food and energy supplies to remain sealed off for two weeks no matter what happens outside.

118
EMIGRANT INDUSTRIAL SAVINGS BANK ✲

The Emigrant Savings Bank was founded in 1850 by the Irish Emigrant Society, with a boost from Roman Catholic Bishop John Hughes, to encourage saving habits among new arrivals from Ireland. By the time this structure, the third building on this same site, was built, it was the most successful savings bank in the city. It flaunted the distinction with this Beaux Arts confection. It is New York's first building designed with an H-shaped plan, giving daylight to nearly all of the office space. The interior is landmarked and worth a visit, even if it is now occupied by the Department of Motor Vehicles.

119
BROADWAY-CHAMBERS BUILDING ✲

This was Cass Gilbert's first commission in New York, and one of the first to use steel-frame construction. The base is pink granite, the shaft is red and beige brick, the capital is colorful terra-cotta, and the cornice is beautifully weathered copper, all of it working in graceful harmony. It is located a few blocks up Broadway from Gilbert's other contribution to the neighborhood, the Woolworth Building.

120
E. V. HAUGHWOUT BUILDING ⁓

One of the most impressive cast-iron buildings in the city, its Venetian Renaissance façade came from the catalogue of Daniel Badger's Iron Works, a local firm that made cast-iron panels that architects mixed and matched to create the effect they wanted. Cast-iron was especially appropriate for retail stores like this one because its strength allowed large open spaces for show windows. Eder V. Haughwout sold cut glass, silverware, clocks, and chandeliers in his cast-iron palace, and he made it more attractive to his customers by installing the first commercial elevator ever to appear in a store.

121
NEW ERA BUILDING

A gorgeous example of the Art Nouveau style, this copper-roofed gem was built as a retail store for Jeremiah C. Lyons, who expanded his business here at a time when others were moving uptown and taking fashionable customers with them. Within a few more years, the neighborhood became home to dealers in waste paper and marginal manufacturing enterprises, in spite of the presence of wonderful buildings like this one.

122
POLICE BUILDING APARTMENTS ⁓

The grand scale and baroque detail of this building make it a standout in a neighbor-hood of lofts and tenements—but of course the effect was intentional: It was originally the headquarters of the New York City Police Department. This was the place where gangsters in 1930s movies went when they were sent "downtown." The department moved even further downtown in 1973, and this magnificent building stood forlornly empty for fifteen years before it was converted into luxury apartments favored by models and actors.

123
PUCK BUILDING ⁓

A Massive Romanesque Revival building with repeated round-arched arcades and intricate brickwork, the Puck Building is actually two separate structures. When Lafayette Street was extended through the block in the early 1890s, two bays of the original building were removed and its entire west wall was destroyed. Herman Wagner, a close relative of the original architect, designed the new Lafayette Street elevation as a seamlessly perfect match to the previous work, moving the main entrance over to the new section. The signature sculpture of Shakespeare's Puck that stood over the original main entrance was duplicated rather than moved. The building was extensively rehabilitated in 1984 as office, gallery, and party space, and also serves as the exterior shot of Grace's design office in the TV sit-com *Will and Grace*.

124 GRACE CHURCH 🔊

The huge urn that stands in front of the rectory to the north of Grace Church is a relic from ancient Rome, a gift to a former rector from one of his parishioners. The church, along with the rectory and other buildings in the complex—including the school behind it on Fourth Avenue—were designed by another parishioner, James Renwick, Jr. Renwick was also the architect of New York's St. Patrick's Cathedral and Washington's Smithsonian Institution, the latter when he was just twenty-three years old. The church, one of the country's most elegant Gothic-style structures, is famous as the spiritual home of some of the city's most influential families, but it also pioneered community outreach among New York's churches in 1876, by establishing Grace Chapel on East 14th Street (now Immaculate Conception Church) to offer classes in English and other services to new immigrants. The parish built a mission house on the Lower East Side several years later, and today it maintains a homeless shelter within its original complex. The wife of the architect was a descendant of Henry Brevoort, who refused to sell his garden on this site to allow Eleventh Street to push through, and then held out against the surveyors of Broadway, forcing the bend in the thoroughfare that makes Grace Church's marble steeple visible all the way down to Houston Street.

125 NEW YORK MERCANTILE EXCHANGE

The busy cast-iron façade of this former financial institution that is now a retail store is decorated with reliefs of roses and lilies, and its delicate columns are ridged to represent bamboo. One of the great advantages of cast-iron is that the material can be made to resemble anything that a designer can imagine. Few buildings in the city are as imaginatively decorated as this one by the chief architect of the 1876 Centennial Exposition in Philadelphia.

126 ONE FIFTH AVENUE

New York's enthusiasm for skyscrapers during the Roaring Twenties spilled over to apartment buildings, and One Fifth Avenue was among the first to take advantage of the trend. Twenty-seven stories tall, it has only one connected neighbor, which allows it to soar as a virtual freestanding tower above Washington Square Park. The lobby is unmistakably residential in a grand way, with a symphony of Doric elements.

127 THE NEW SCHOOL FOR SOCIAL RESEARCH

Founded in 1919 as an intellectual center for adults, the New School evolved into a university in the 1930s as a haven for intellectuals escaping Nazi Germany. Its major commitment is still to adult education, and it offers a broad range of innovative programs. This building, one of New York's earliest examples of the International Style, was designed by Joseph Urban, who was well known as a designer of theaters and stage sets.

128
WASHINGTON MEWS

Originally called "Stable Alley" when it served the Washington Square mansions, these former carriage houses were converted to private homes in 1916. The residences on the south side were rebuilt in 1939 when some of the original houses on the square were turned into apartments. The house on the southeast corner, at University Place, is New York University's Maison Française, remodeled in 1957 in the style of a French country bistro.

129
127–131 MacDougal Street

This row of tiny Federal houses was built for Aaron Burr who, among his other activities, dabbled in real estate. The iron pineapples at the entrance to no. 129 are a symbol of hospitality that began in Nantucket when the masters of whaling ships brought home souvenirs from their South Seas adventures, including pineapples, which they placed on the newell posts outside their front doors as a signal that they were home and eager to receive visitors.

130
CABLE BUILDING

This building was originally the headquarters of the Broadway Cable Traction Company whose cars, like the ones in San Francisco today, were propelled by cables that moved in slots under the street. One of the company's powerhouses was located forty feet under this eight-story building that was built to keep noise and vibration to a minimum. New York's cable cars, which were once the only way to go along Broadway and Third Avenue, were replaced by streetcars at the beginning of the twentieth century.

131
THE ATRIUM

This was originally Mills House No. 1, a residential hotel built for working-class bachelors who couldn't afford to live alone. It was constructed as two twelve-story blocks, each containing 750 bedrooms and common toilets to serve them. All of the bedrooms had windows overlooking the street or a large interior courtyard, and the building also included smoking rooms, reading rooms, lounges, and restaurants. The price for all of this, including elevator service, was twenty cents a night. It was converted to apartments (with considerably higher rents) in 1976.

132
1–13 WASHINGTON SQUARE NORTH

This row of Greek Revival houses was built on land owned by Sailor's Snug Harbor, an institution founded to serve the needs of retired seamen, which drove a hard bargain with the developer. The contract stipulated that the houses should be set back at least twelve feet from the street, that they should be at least three stories high, and that they should be built of stone or brick. The brickwork, which alternates long and short bricks in each row, is called Flemish Bond, and was only used in the most expensive houses. The entranceways include marble columns and carved wooden colonettes, another symbol of gracious living. The interiors of nos. 7–13, off Fifth Avenue, were gutted and converted to apartments in 1939 in an attempt by Sailor's Snug Harbor to boost its income. The row is now owned by New York University.

133
NEW YORK STUDIO SCHOOL OF DRAWING, PAINTING AND SCULPTURE

This Art Deco building with peeling paint was once the home of Gertrude Vanderbilt Whitney, a member of not one but two of New York's wealthiest families. An accomplished sculptor, she converted a stable in MacDougal Alley behind this building into a studio and gallery in 1907. It ultimately became the Whitney Museum of Art. The collection was moved from here in 1949, to a spot adjoining the Museum of Modern Art before moving again in the 1960s, to Madison Avenue at 75th Street.

134
JUDSON MEMORIAL CHURCH

Designed by Stanford White, this Italian Renaissance church and the adjoining bell tower are built of Roman brick and terra-cotta. As he often did, White called on the best artists of the day to embellish his work and the interior is lighted by stained glass windows executed by John La Farge. The tower once held an orphanage, but now houses the history department, among others, for New York University.

135
RENWICK TERRACE

This row of apartments was inspired by London's rows of townhouses called "terraces." These Anglo-Italianate houses were the first to break with the tradition of brownstones with high stoops (a term that comes from the Dutch word for "step," popularized by the Dutch who placed their living quarters above the street as protection against floods). The appeal

to early tenants was the fact that it was difficult to tell where one unit began and another left off, so that visitors might assume that it was a single, very large mansion.

136
JEFFERSON MARKET LIBRARY

A flamboyant Victorian Gothic structure designed by Calvert Vaux, the architect of the buildings and bridges of Central Park, this building stood empty and abandoned for twenty-two years before being converted into a branch of the New York Public Library in 1967. Its conversion was the result of a long battle by Greenwich Villagers, led by architectural activist Margot Gayle, to save the clocktower. Originally the Jefferson Market Courthouse, it stands on the site of one of the city's major food markets of the early nineteenth century. The courthouse itself also adjoined a large jail, which was replaced in 1931 by the massive Art Deco Women's House of Detention. The detention center was demolished in 1974 and replaced by a neighborhood garden called the Jefferson Market Greening.

137
GAY STREET

The row of Federal houses on the west side of this short street were built in 1833, and their Greek Revival neighbors on the east side were added after 1844. Its residents in the 1850s were mainly working class people, but its most famous resident was Ruth McKenney, who lived at 14 Gay Street in the 1930s and wrote of her experiences as a Greenwich Village Bohemian in *My Sister Eileen*, which became the hit Broadway musical, *Wonderful Town*.

138
4–10 GROVE STREET

These houses are among the last survivors of the early Federal-Style homes that dominated the city in the first quarter of the nineteenth century. The wrought iron work (including the boot scrapers) is all original, as are the paneled doorways. Later, houses in the style eliminated the dormer windows from the top floor, which was reserved for the use of the servants and the family's children.

139
ST. VINCENT'S HOSPITAL

St. Vincent's was founded by the Sisters of Charity in 1849 and moved to this location from the Lower East Side seven years later. It has been jointly administered by the Order and the Roman Catholic Archdiocese of New York since 1975. It is designated a "level one" trauma center and an AIDs center by New York State. It is a teaching affiliate of the New York Medical College, and houses a large school of nursing. This rather eccentric building contains the offices of its affiliated physicians.

140
"TWIN PEAKS"

This wood-frame house was altered in 1925 by Clifford Reed Daily, who said it was his intention to turn the Village's "desert of mediocrity" into something more hospitable to creativity. It became a half-timbered version of a house in Nuremberg, thanks to funding provided by financier Otto Kahn. On the day it was formally dedicated, movie star Mabel Normand was hoisted up to one of the peaks to break a bottle of Champagne on its ridge.

141
39 AND 41 COMMERCE STREET

A local legend that walking tour guides perpetuate is that this pair of elegant houses, separated by a courtyard, was built by a sea captain for his two daughters who wouldn't speak to each other. City records indicate that they were actually built for a milk dealer, but do not reveal why they were built as a pair.

142
6 ST. LUKE'S PLACE

When this elegant row of brick and brownstone Italianate townhouses was built in the 1880s, their addresses were on Leroy Street. But when James J. Walker, the city's mayor from 1926 until 1932, lived at no. 6, his girlfriend, Betty Compton, lived at the other end of the block. To remove the connotation from the public's mind, he used his powers and Tammany Hall connections to rename its western end St. Luke's Place. It was the only bow he ever made to anything resembling propriety. In those days, when mayors lived in their own houses, they were the only homes allowed to have lampposts at the bottom of their stoops. It made it easier to track down the mayor in his own surroundings.

143
U.S. FEDERAL ARCHIVE BUILDING

This huge structure, in a style architectural historian Henry Hope Reed has called "Roman Utilitarian," was originally built as a warehouse for cargo passing through customs. After ships stopped berthing at the nearby Morton Street pier, it was converted to a storehouse for federal records including, in pre-computer days, all the income tax

returns filed in the Eastern District. It was converted to an apartment/ office building in 1988 with the help of the New York Landmarks Conservancy, an organization that provides technical and financial help for landmark preservation and reuse.

144
"NARROWEST HOUSE"

Often called the "Edna St. Vincent Millay House" because it was one of the poet's several homes in the Village, this structure is only nine-and-a-half feet wide. Before it was built, there was an alley here leading to a brewery yard in back (the former brewery is now the Cherry Lane Theater), which is now a courtyard.

145
CHELSEA HOTEL

This building was originally a forty-unit cooperative apartment building, among the city's first. It became a 250-unit hotel in 1905, and, although transients are welcome, most of its tenants are permanent residents. Its early guests included actresses Sarah Bernhardt and Lillian Russell, and writers O'Henry and Mark Twain. In later years it has attracted such writers as Arthur Miller, Dylan Thomas, and Brendan Behan, and composer Virgil Thompson, who lived here for nearly fifty years. The lobby and stairways are crowded with original works by such artists as Larry Rivers and Patrick Hughes, who were habitual hotel guests.

146
HUGH O'NEILL DRY GOODS STORE

Hugh O'Neill, the man who built this huge store, was the P. T. Barnum of the retail trade, and was known as "The Fighting Irishman of Sixth Avenue." While other merchants catered to the upper-middle class, O'Neill concentrated on the working class, holding almost unbeliev-able sales at prices his competitors couldn't dream of matching. He was the first to offer merchandise below cost as "loss leaders" to lure customers into his store, making sure that the customers would come by mounting aggressive advertising campaigns.

147
SALVATION ARMY CENTENNIAL MEMORIAL TEMPLE

Built to mark the hundredth anniversary of the birth of the organization's founder, William Booth, this Art Deco citadel is also the national

headquarters of the Salvation Army. The Army, which was established in the slums of London in 1878, arrived in New York two years later, and consisted of a missionary accompanied by seven women "soldiers."

148
428–450 WEST 23RD STREET

In the years just before the Civil War, rows of Anglo-Italianate brownstone houses like these lined street after street in Manhattan, as New Yorkers began building homes that they hoped would reflect their affluence and social status. This surviving row is often overlooked in the shadow of London Terrace on the other side of 23rd Street, which itself replaced a row almost exactly like this one.

149
STARRET-LEHIGH BUILDING

This nineteen-story warehouse was built for the Lehigh Valley Railroad, whose trains pulled into the ground floor where elevators waited to carry the loaded freight cars up to the floors above. Each floor sprawls over 124,000 square feet of space under 20-foot ceilings. The building was included in the Museum of Modern Art's 1932 International Exposition of Modern Architecture, which gave its name to the International Style.

150
JOYCE THEATER

Formerly the Elgin movie theater, this building was the sort of place kids in small-town America would have characterized as "the itch." In its new configuration, sparkly clean, of course, it has since become one of New York's foremost dance venues.

151
CHURCH OF THE HOLY COMMUNION

This was the prototype for Gothic Revival church buildings across the United States in the nineteenth century. It was also an early example of a "free" church, which abolished pew rentals. After the neighborhood became less fashionable, the parish consolidated with Calvary and St. George's Church and the building was transformed to secular purposes, including a popular disco.

152
GORHAM SILVER COMPANY BUILDING

This Queen Anne structure is one of New York's earliest mixed-use buildings. Its first two floors served as Gorham's retail store, but the rest was used as bachelor apartments. It had become an entirely commercial building by 1912, when remodeling by John H. Duncan removed its corner tower and added dormers to the roof. Today it is a cooperative apartment building with stores at the sidewalk level.

153
LORD & TAYLOR BUILDING

Established in 1826 as a small shop on Catherine Street, Lord & Taylor moved twice before settling here in 1871. After continuing its march uptown to Fifth Avenue and 39th Street in 1914, the Broadway façade of its grand French Second Empire emporium was rebuilt and its ground floor was altered yet again in the 1990s when the neighborhood began showing signs of life again.

154
SIEGEL-COOPER DRY GOODS STORE

Its original owner, master merchant Henry

Siegel, advertised this as "The Big Store: A City in Itself," and even such a designation was an understatement. Its biggest crowd-pleaser was a marble terrace on the main floor with a replica in marble and brass of Daniel Chester French's statue, *The Republic*, a hit at the recent Chicago World's Fair. Jets of water accented by ever-changing colored lights played around the pedestal, making it impossible to miss and "Meet me at the fountain," meant only one thing to New Yorkers in the 1890s. Siegel's store was among the first of its kind to sell food, and he pioneered the concept of giving away free samples to build sales. He also hired demonstrators to push everything from sheet music to can openers. The store was among the first to be air-cooled, and the first to hire women as sales clerks. Changing habits among shoppers took them out of this neighborhood and, by World War I, Siegel-Cooper was converted into a military hospital. Retailing has come back to the corner of Sixth Avenue and West 18th Street, but it isn't the same somehow. The statue that graced the fountain has been relocated to the Forest Lawn Cemetery in Glendale, California.

155
CHURCH OF THE HOLY APOSTLES

This building was severely damaged in a 1990 fire that destroyed some of its priceless windows by William Jay Bolton, America's first stained glass maker, several of which have thankfully survived. Always a socially active church, it opened a soup kitchen in 1982, and has since become the largest such facility in the city. The day after the fire, the kitchen opened as usual in the gutted church and served more than 900 meals.

156
LONDON TERRACE

There are fourteen buildings and 1,670 apartments in this sixteen-story complex arranged around an interior courtyard. Its swimming pool was once the largest in Manhattan, and its roof deck had all the attributes of the deck of an ocean liner. The first tenants here, who moved in at the height of the Great Depression, were provided with housekeeping services, three restaurants, and shops along the ground-floor level.

157
NATIONAL MARITIME UNION, JOSEPH CURRAN ANNEX

The building that serves the Maritume Union is appropriately nautical, its façade pierced with round porthole-like windows. The façade itself is sloped like the hull of a ship, but evocations of seafaring life probably had little to do with it. Instead, zoning laws seem to have entered into the equation, placing the emphasis on sky-exposure planes of tall buildings. Housing the union's medical and recreation facilities, the Curran Annex reflects the style of its headquarters' building on Seventh Avenue at Thirteenth Street, designed by the same New Orleans-based architect.

158
STUYVESANT FISH HOUSE

This house, whose mansard roof was added in 1860, was once owned by Stuyvesant Fish, president of the Illinois Central Railroad. His wife, Mary, whom everyone knew as "Mamie," inherited the mantle of Queen of New York Society from Mrs. William Astor, and made this her headquarters. In 1931, after years of neglect, it became the home of the city's most successful public relations man, Benjamin Sonnenburg, who, after furnishing it with fine art and antiques, began hosting the city's most glittering parties here, mixing the crème of politics, business, society, and the arts in gatherings of 20 to 200 guests nearly every night of the week.

159
3 AND 4 GRAMERCY PARK WEST

The beautiful cast-iron verandas on this pair of houses are attributed to Alexander Jackson Davis, one of the most highly respected architects of the early nineteenth century. Although they suggest New Orleans or Charleston, here in New York they have become symbols of Gramercy Park itself. Across the street in the park is an apartment house for birds, purple Martins specifically, an amenity once found in every park in the city.

160
THE PLAYERS

This was a simple Gothic Revival brownstone until actor Edwin Booth bought it to convert it into an actors' club. Stanford White added the two-story porch, the great wrought-iron lanterns, and the graceful iron railings. Booth's statue, in the character of Hamlet, by Edmond T. Quinn, stands across the street in Gramercy Park.

161
FRIENDS MEETING HOUSE
AND SEMINARY

This austere red brick building was built by a branch of the Quakers called Hicksites who held to the original practices of their faith, as opposed to the so-called Orthodox Quakers who had adopted some new doctrines from evangelical Christians. The two groups, which split in 1828, came together again in 1958 and kept this building as their principal meeting house in the city.

162
OLD STUYVESANT HIGH SCHOOL

Founded in 1904 to prepare immigrant children for science careers, Stuyvesant has evolved into one of America's most prestigious high schools, open only to students who can pass a tough entrance examinaton. They routinely win the Westinghouse Science Award, an honor that pits them against the Bronx High School of Science, itself one of the country's best. The school moved from here to a new building at West and Chambers Streets in 1992.

163
326, 328, AND 330
EAST 18TH STREET

This trio of tiny houses is set back behind landscaped front yards, a rarity in Manhattan, which makes it easier to admire the details of their cast-iron porches. What is really amazing about them is how they managed to survive, intact for all these years. This block

was the last outpost of genteel civilization at the eastern edge of the infamous Gashouse District well into the twentieth century.

164
ONE UNION SQUARE SOUTH

If you hear something you like in a movie at one of the fourteen theaters in this building, you might find a recording of the soundtrack at the Virgin Megastore here. There are also 240 apartments here, so some people can do all that without technically ever leaving home. Judgment on the beauty of the building's "Artwall" façade, facing up the length of Park Avenue South, is probably best left to the eye of the beholder.

165
WESTERN UNION TELEGRAPH BUILDING

Completed during the same year as Hardenbergh's Dakota apartment house and twenty-three years before his Plaza Hotel, this building isn't as celebrated as either of them, although it deserves to be. When it was built, its neighbor across 23rd Street was the Fifth Avenue Hotel, since replaced by the Toy Center. It was the city's most luxurious in the mid-19th century, and headquarters of the state Republican machine. Its boss, Senator Thomas Platt, schemed there to get rid of Governor Theodore Roosevelt by engineering the Vice-Presidential nomination for him. Less than a year later, T.R. was President and in Platt's hair more than ever.

166
CON EDISON BUILDING

This building was created as the home of the Consolidated Gas Company, which joined with the Edison Electric Company to become known as Consolidated Edison. It was built in stages as the company grew, and the tower was installed as a memorial to its employees who died in World War I. This is the site of two historic buildings: the "Wigwam," home of Tammany Hall, and the Academy of Music, a lavish opera house that for thirty years was a Mecca for high society patronizing visiting opera singers. It was also the home of the New York Philharmonic Orchestra, which performed in an annex on Irving Place at 15th Street.

167
MARBLE COLLEGIATE CHURCH 🐚

Established in 1628 in Nieuw Amsterdam, this is the oldest religious congregation in the city. The name "Collegiate" refers to its system of operating under co-equal pastors. The most famous of this church's pastors was Dr. Norman Vincent Peale, who became a pastor here in 1932 and brought a new theology of optimism with him. His book, The Power of Positive Thinking, was a runaway best-seller in the 1950s, and he lured thousands to this church, where he preached until his death in 1993.

168
METROPOLITAN LIFE INSURANCE COMPANY 🐚

The tower rising above the Met's complex of offices was originally much more richly ornamented but sadly, it was savaged during a 1964 restoration. The extension along 23rd Street to Park Avenue South was built in 1913, on the site of McKim, Mead & White's Madison Avenue Presbyterian

Church, which was only seven years old when it was demolished. The tower, at 700 feet, topped the old Singer Tower as the tallest building in the world.

169
NEW YORK LIFE INSURANCE COMPANY

This full-block building with a gilded pyramid twenty-six floors above the street fills the site of the original Madison Square Garden. The company, which acquired the site through foreclosure on Stanford White's old Garden, moved here from lower Broadway after its rival, the Metropolitan Life Insurance Company, established Madison Square as the center of the insurance industry.

170
SERBIAN ORTHODOX CATHEDRAL OF ST. SAVA

Originally Trinity Chapel, this complex, consisting of a brownstone church, a former school used as a parish house, and a clergy house, was bought by the Serbian community in 1942. All that's missing here is a churchyard, but a monument at the corner of Fifth Avenue and 25th Street marks the last resting place of Major General William Worth (for whom Fort Worth, Texas is named). Except for Grant's Tomb, it is the only burial site directly on a Manhattan street.

171
FLATIRON BUILDING

This may be the most photographed building in New York, not just because its composition makes it so photogenic, but because, since the 1960s, the neighborhood around it has harbored a large concentration of photographers. Although only 23 stories, it was the first really tall building north of City Hall, and it has symbolized skyscraper style ever since it was built. Its formal name is the Fuller Building, but the unusual shape gave it its more popular name. The shape was dictated by the variation in Manhattan's grid pattern caused by Broadway's march uptown on an east-west diagonal. One of the earliest buildings in New York supported by a steel cage, its heavy limestone walls, which appear to be supporting the building, give it a sturdy look in spite of its slim profile.

172
GILSEY HOUSE

At the time that this delightful French Second Empire hotel was built, there were six major theaters less than two blocks from it, including Weber & Field's Music Hall, one of the original vaudeville showcases, across the street. After the theater district moved uptown, the hotel became a factory. It was restored as apartments in 1980.

173
ESTONIAN HOUSE

This Beaux Arts clubhouse was built for the Civic Club by Frederick Goddard, a philanthropist dedicated to providing uplift in the lives of people living between 23rd and 42nd Street on the East Side. The Goddard family sold the building to the Estonian Educational Society in 1946.

174
THEODORE ROOSEVELT BIRTHPLACE

Now a National Historic Site, this house is not where young Teddy Roosevelt spent his boyhood, but it is a very close facsimile. The original house was demolished while

Roosevelt was still alive. After demolishing the uncle's house next door, the Women's Roosevelt Memorial Association commissioned Theodate Pope Riddle, one of America's first female architects, to reconstruct the late president's birthplace as it had been in 1865, when Teddy Roosevelt was seven years old.

175
KIPS BAY PLAZA

These two twenty-one-story concrete slabs set parallel to each other contain 1,136 apartments. Although they completely ignore their surrounding neighorhood, their placement creates a pleasing interior park for the people who live in the midst of the isolation they create, even if it does cancel out one of the best reasons for living in the city in the first place, the joy of people-watching.

176
ST. VARTAN CATHEDRAL

This is a bit of old Armenia writ large on Second Avenue. An adaptation of the small Romanesque churches of Asia Minor, its gold dome dominates the streetscape for several blocks uptown. The ten-foot bronze sculpture, *Descent from the Cross*, in the cathedral's plaza is by Reuben Nakian. It is an abstract translation of the Rubens painting, *Raising of the Cross*, in Antwerp.

177
PUBLIC BATHS

Back when this was a neighborhood of densely packed slums, most of which lacked running water, the city built this structure to cope with the sanitary problems. Appropriately modeled after the baths of ancient Rome, it

was converted to a recreation center with a swimming pool in 1990.

178
BELLEVUE HOSPITAL CENTER

Established in 1736, this is the oldest municipal hospital in the United States, and one of the largest. Until the 1950s, when it had 2,700 beds, it was by far the biggest hospital in New York before being eclipsed by mergers of other large medical institutions. Among the "firsts" in Bellevue's history are the first cesarean section performed in the United States, the first use of hypodermic syringes, and the first hospital-owned ambulance service.

179
WATERSIDE

This development includes 1,600 apartment units in four towers on a platform over the East River. Nearly 400 of them are designated for moderate-income families and many have rents set at public housing levels. The rest of the complex is rented according to tenants' income following a complicated rate system. Realization of this project was a long time coming. The original plans were developed in 1963, but the first families didn't begin moving in until 1974.

180
UNITED NATIONS HEADQUARTERS

This international zone in the heart of the city was built on land donated by John D. Rockefeller, Jr. It is dominated by the 544-foot slab building housing the Secretariat, flanked by the General Assembly Building to its north, the Conference Building on the east, and the Library at the 42nd Street end. The complex extends out onto a platform over the FDR Drive, and a tunnel diverts First Avenue traffic away from it. The UN's gardens and the General Assembly lobby are open to the public, and tours of the other buildings are available.

181
1 UNITED NATIONS PLAZA

The first combination hotel/office building ever attempted in New York, critics despised no. 1 UN Plaza, a thirty-nine-story structure sheathed in blue-green glass. The *Times*' Paul Goldberger complained that the glass façade "hides what is going on inside," and the *AIA Guide* sniffed that it looked like "folded graph paper." But in spite of its critics, the public loved the place and it was duplicated seven years later by the identical no. 2 UN Plaza.

182
BEEKMAN TOWER 🏛

This was built as the Panhellenic Tower, an apartment hotel for women college graduates belonging to Greek letter sororities. It was an architectural landmark from the very beginning, hailed as a perfect example of vertical force. It is now an apartment building.

183
TRUMP WORLD TOWER

After the United Nations complex was built, the city fathers reserved a block-long space, called Dag Hammarskjöld Plaza, around the corner on the south side of 47th Street, as the only place where protest demonstrations could be held. In the years since, every grievance imaginable has been aired there, but few of the protests were as impassioned as those mounted by residents of this upscale neighborhood protesting Donald Trump's plan to build this building, which he claims is the world's tallest apartment house.

184
FORD FOUNDATION BUILDING 🏛

This L-shaped building is built around a 130-foot-high "greenhouse," whose plant life rotates with the seasons. It is a terraced garden with seventeen full-grown trees and thousands of plants, including aquatic plants growing in a peaceful pool. The architects said that they had a proper environment for the building's staff in mind, but even if you aren't lucky enough to work here, you are free to visit the gardens on weekdays.

185
TUDOR CITY 🏛

Apart from "prewar," the most common pitch in classified ads for apartments is "walk to work," which first appeared in print for the 3,000 apartments in this twelve-building complex. One thing the ads didn't mention was that in the 1920s this neighborhood was mainly tenements and slaughterhouses, which is why these buildings face inward and there are almost no river views.

186
VILLARD HOUSES ⬧

This U-shaped group of six houses was built for Henry Villard, an immigrant who went on to control the Northern Pacific Railroad, among others. His own house occupied the entire south wing, but he only lived in it for three years. The Palace Hotel was built above the houses in 1980, and the south wing became part of its entrance. The north wing is a bookstore and exhibition space for the Municipal Arts Society.

187
885 THIRD AVENUE

Office buildings are generally named for their principal tenant, but this one is called the "Lipstick Building" because of its brown and pink telescoping tiers. The name stuck quickly, even before the first tenants moved in, but none of them are in the cosmetics business.

188
DAILY NEWS BUILDING ⬧

Among Raymond Hood's considerable talents was his ability to give buildings a character all their own, and this is Hood at his pinnacle. Its original tenant, the *New York Daily News*, has since moved over to the far West Side, but the spectacular lobby in this building, intended as an educational exhibit for the newspaper, is still intact. Its centerpiece is the world's largest interior globe, whose details are constantly updated.

189
J. P. MORGAN CHASE BUILDING

This 53-story tower rising straight up from Park Avenue actually begins at the second floor, as do many in this neighborhood that were built above the tracks and railroad yards serving neaby Grand Central Terminal. Union Carbide, its original tenant, moved out to suburban Connecticut in the 1980s. The Chase Manhattan Bank merged with J. P. Morgan & Co. and changed its name in 2001.

190
GENERAL ELECTRIC BUILDING ⬧

This building was the original home of Radio Corporation of America and became the General Electric Building when RCA moved over to Rockefeller Center to a structure that is now known as the GE Building. They're both buildings any company could be proud of. The Art Deco, almost Gothic, crown at the top of this one, intended to suggest radio waves, is a marvelous addition to the skyline, but this building is especially notable for its relationship to St. Bar-tholomew's Church behind it. Cross & Cross sensitively designed this spire using materials and colors compatible with the church and treated the rear façade so that it recedes into the background, forming a backdrop for its low neighbor.

191
TURTLE BAY GARDENS ⬧

In an effort to reclaim what was then a run-down neighborhood, Charlotte Martin bought these twenty houses and renovated them into single-family houses and apartments. The façades were all redone and the yards behind them were combined into an Italian Renaissance common garden. Among the people who have lived here are Katharine Hepburn, Mary Martin, Tyrone

Power, and Stephen Sondheim. Writer E. B. White, a longtime resident, immortalized a tree in its garden, which he said, "symbolizes the city: life under difficulties, growth against odds, sap-rise in the midst of concrete, and the steady reaching for the sun."

192
CHANIN BUILDING 🦋

There is enough fascinating detail on this façade to keep you busy for days, and there is even more in the lobby. Above the storefronts, black marble and bronze frame a frieze telling the story of evolution from one-celled creatures to fish and birds. The piers above it are embellished with sea serpents, and the terra-cotta panels at the fourth floor have a busy pattern of flowers. Inside, the theme is the "City of Opportunity," with bas-reliefs and grilles that tell the story of how a humble man can become rich and powerful by sheer will. That man was Irwin Chanin, who built this architectural treasure.

193
MOBIL BUILDING

At the time it was built, this was the largest office building erected since Rockefeller Center. It was originally the Socony-Vacuum Building, named for its principal tenant, which became known as Socony-Mobil the year it moved here. The stamped stainless steel panels that make up its façade prompted architecture critic Lewis Mumford to write that it makes the building look like it is "coming down with the measles."

194
CHRYSLER BUILDING 🦋

Every New Yorker's favorite skyscraper, this wasn't built as offices for Chrysler Motors, but as a monument to its owner, Walter P. Chrysler, and that meant it had to be the world's tallest building. The earliest sign of a race to the sky came when J. E. R. Carpenter, architect of the Lincoln Building on 42nd Street facing Vanderbilt Avenue, announced that he was going up to fifty-five floors. William Van Alen, Chrysler's architect, countered by announcing fifty-six stories. Then, when Carpenter topped that with plans for a sixty-three-story building, Van Alen went to sixty-five. But it was only a bluff. Carpenter never intended to go above fifty-four floors. However, Van Alen had a fiercer competitor in his former partner, H. Craig Severance, who said his building for the Bank of the Manhattan Company (now the Trump Building), in the financial district, would be the world's tallest. Van Alen countered by adding more floors to his with the blessing of his client, who knew a good publicity stunt when he saw one. The last straw was Severance's addition of a lantern to the top of the bank building, and then a flagpole on top of it, after the Chrysler Building's crown had gone as far as it could go. Van Alen countered the affront by secretly building a 185-foot stainless steel spire inside his building's fire shaft, and, as Severance was topping off his downtown building, he hoisted what he called the "Vertex" into position. The result was that Chrysler's sevety-seven-story monument was the world's tallest building, only to be topped by the Empire State Building in less than a year.

195
GEORGE S. BOWDOIN STABLE 🦋

This former carriage house is guarded by carved bulldogs that share the Dutch gable

with with horses wearing wreaths around their necks. When a railroad ran down the center of Park Avenue, these blocks east of it, "the wrong side of the tracks," were filled with stables set at a discrete remove from their owners' homes. Unlike other similar stable areas, though, many of the East Side's service buildings made their own elegant statements.

196
BOWERY SAVINGS BANK

This is a Roman basilica with rich ornamentation, including a rooster symbolizing punctuality (possibly in making payments on loans) and a squirrel as a symbol of thrift. The monumental arch at the entrance leads to a banking room that qualifies as one of the city's greatest interiors. When the bank stopped operating, this wonderful space became a catering hall, run by Giuseppe Cipriani, who has also taken over the space in the Rainbow Room at Rockefeller Center.

197
ANDY WARHOL'S "FACTORY"

This building, which also has an entrance on Madison Avenue, was originally a substation for the Edison Electric Company. Artist Andy Warhol used it as a studio, office space, and a gathering place for a wide array of artists, actors, models, and musicians throughout the sixties and seventies. Lou Reed's *Velvet Underground* was considered the "house band" and parties there often turned into "happenings."

198
VANDERBILT HOTEL

Now an office building, about all that remains as a reminder of the original hotel

is the landmarked Della Robbia Bar, once known as "The Crypt," a space vaulted with Guastavino tiles reminiscent of the Oyster Bar in Grand Central Terminal, conceived by the same architect. He added colorful ceramic ornament to this space.

199
PHILIP MORRIS HEADQUARTERS

This headquarters building of the tobacco and food conglomerate includes the downtown branch of the Whitney Museum. It stands at the edge of Pershing Square, a little park that never was. When the Grand Union Hotel at 100 East 42nd Street at Park Avenue was torn down in 1914, the city reserved its site for a plaza named for General John J. Pershing, commander of the American forces in World War I. The plot sat empty until 1920 when the city fathers sold it to a developer who built a twenty-four-story building there and named it the Pershing Square Building. The name also lives on in a plaque on the viaduct over 42nd Street.

200
MET LIFE BUILDING

This behemoth was originally conceived as the ultimate revenue producer for the railroad that owned the site. In its planning stages as the Grand Central City Building, it became the subject of heated controversy while it was still on the drawing boards. In spite of the bitter criticism, most of its space was leased before construction actually began to Pan American World Airways, which added a heliport to the roof. Before the newly named Pan Am Building was finished, an unprecedented ninety-three

percent of its space had been rented. As the tenants were moving in, the *New York Times* editorialized, "We have gained the world's largest office building. We have lost some of the world's most impressive views." The world also lost Pan Am, the airline, in 1992, and the building was acquired by the Metropolitan Life Insurance Company.

201
GRAND CENTRAL TERMINAL

More than just a pretty face, this Beaux-Arts masterpiece is also an engineering triumph. Charles Reed of the St. Paul firm of Reed & Stem conceived the "elevated circumferential plaza" to carry Park Avenue around it. He also borrowed an idea from Stanford White's original Madison Square Garden for interior ramps to speed the flow of passengers. The trains arrived on a two-level fan of tracks south of 49th Street. He designed a bridge over them strong enough to support a neighborhood of skyscrapers. Reed also designed a terminal building, but work had barely begun when Whitney Warren was hired to design another, which is the building that exists today.

202
WALDORF-ASTORIA HOTEL

This grand hotel replaces the combined Waldorf and Astoria Hotels that were torn down to make way for the Empire State Building. References to its predecessors live on in its Empire Room and Peacock Alley. The three-story Grand Ballroom can comfortably accommodate 6,000 people, but it was strained to its limit the night the hotel opened and 20,000 guests showed up. Those who came by car arrived via a covered driveway that runs right through the building. This, among other more obvious amenities, has made the hotel a favored destination of security-conscious world leaders since the beginning.

203
HELMSLEY BUILDING

When the New York Central Railroad built Grand Central Terminal, it also built this palatial thirty-five story building straddling Park Avenue for its offices. Its north elevation paid homage to the cornice line of buildings marching up the Avenue before rising up to the impressive tower with a cupola that could be seen for miles. Two arcades allow pedestrians to walk under the building at the sidewalk level, and two larger portals carry vehicles up and around the terminal. The pedestrian paths once continued on up Park Avenue itself, but they were removed to make more room for cars.

204
ST. BARTHOLOMEW'S CHURCH

High on the list of New York's wealthiest and most fashionable churches, this building was built on the original site of a brewery that had been turning out beer here for nearly sixty years. It replaces the parish's former church on Madison Avenue at 44th Street, and the entrance portal, designed by Stanford White with sculptures by Daniel Chester French and Philip Martiny, was reinstalled here on Park Avenue. In the 1980s, the church proposed replacing its adjacent parish house with an office tower, but after a long court battle, a decision by

the United States Supreme Court saved the beautiful low-rise building.

205
CONSULATE GENERAL OF POLAND

This extravagant mansion, now restored as the Polish Consulate, was built by Captain Raphael De Lamar, who was master of his own ship at the age of twenty-three, and eventually struck it rich in the Colorado gold fields. His New York house had two elevators, one for the servants and the other for De Lamar and his ten-year-old daughter (his wife had divorced him). While the house had an elaborate ballroom, it was never used. The Captain was described as "aloof" and uninterested in entertaining.

206
IBM BUILDING

International Business Machines, the electronic equipment manufacturer headquartered in New York since 1924, moved to a building on this site in 1938. Although it later moved its headquarters to Armonk, in Westchester County, its New York City operations kept growing, making this larger building necessary. It includes an indoor park on the 57th Street side, connecting it with Nike Town and Trump Tower to its west.

207
CROWN BUILDING

Originally the Hecksher Building and later the Genesco Building, this was the first tall office structure in the Fifth Avenue retail district and the first skyscraper built following the dictates of the 1916 zoning law, which set out unprecedented restrictions on the massing of such buildings. Its silhouette was intended to serve as a friendly backdrop to the Vanderbilt mansion, which stood on the opposite corner of West 57th Street.

208
TRUMP TOWER

A multilevel shopping mall with high-end luxury apartments over the stores, the Trump Tower is very high on the list of must-see attractions among out-of-town visitors who are dazzled by the liveried attendants, the grand piano just inside the entrance, and the spectacular waterfall, as well as by the prices they encounter when they explore the shops themselves.

209
HENRI BENDEL

Long a fixture around the corner on West 57th Street, when Bendel's expanded and moved here, it discovered, to everyone's surprise, that the painted-over windows on the second floor of the uptown building they merged with were rare examples of glass by René Lalique.

210
UNIVERSITY CLUB

This High Renaissance Italian palazzo is nine stories tall, but it is divided into three equal parts by high arched windows to make it appear to be a three-story building, closer in scale to its Italian precedents. The lowest of the levels is the lounge, whose ceilings are visible from the sidewalk. The other two main sections house the library and the dining room. The building's focal point is its library that, at 13,000 volumes, is the largest collection of any private club in America.

TIFFANY'S
[211]

This famous jeweler dismissed the retail trade's march up Fifth Avenue until 1940, when it moved from its former location in a McKim, Mead & White palace at 48th Street into this new granite and limestone structure. The nine-foot Atlas clock over the entrance, which became the company's trademark in 1853, has accompanied the company to six different locations. Created by Frederick Metzler, whose main business was carving figureheads for ships, the clock has earned a reputation over the years as the city's most accurate timepiece.

CARTIER'S
[212]

The Vanderbilts once ruled these Fifth Avenue blocks with three elabrate mansions on its west side. To insure that commerce wouldn't intrude, William K. Vanderbilt sold the land at the corner of 52nd Street to fellow millionaire Morton F. Plant, with the stipulation that it be used for a residence for twenty-five years. After the Vanderbilts themselves moved on, Plant asked to have the covenant lifted. Instead, Vanderbilt bought the house for $1 million, much more than it was worth at the time, and rented it to Cartier's for $50,000 a year, far and away the highest rent anywhere on Fifth Avenue.

SAKS FIFTH AVENUE
[213]

Almost as soon as this giant department store was completed, its owner, Adam Gimbel, began redesigning it, first expanding its show windows along Fifth Avenue, and then hiring architect Frederick

Kielser to design displays for them. It marked the first time that retailers did much more than haphazardly fill their windows with whatever happened to be on sale at the time. Naturally, other stores followed his lead, much to the delight of window-shoppers all over the city.

INTERNATIONAL BUILDING
[214]

Lee Lawrie's fifteen-foot bronze statue, *Atlas*, perfectly matches the form and function of the International Building. The sphere on the figure's shoulders is twenty-one feet in diameter and was made transparent because the artist didn't want it to obstruct views from the building or to cast unwanted shadows. Among Lee Lawrie's other contributions to Rockefeller Center are the limestone panels and glass screens over the entrance to 30 Rockefeller Plaza.

ST. PATRICK'S CATHEDRAL
[215]

The Catholic Church bought this plot of land in 1828 intending to use it as a cemetery, but the plan was abandoned when gravediggers hit solid rock just below the surface. In 1850, Archbishop John Hughes announced plans to build a cathedral here and work began eight years later. It was dedicated in another twenty-one years at a cost more than double the original estimate, but consecrated in 1910 completely debt-free. The Archbishop's (Cardinal's) Residence on the Madison Avenue side was finished in 1880 and the towers were put in place in 1888. The Lady Chapel behind the High Altar, designed by Charles T. Matthews, was added in 1906.

ASSOCIATED PRESS BUILDING 🐚
₂₁₆

This is the home of the Associated Press, founded in 1848 to augment the newsgathering operations of several New York City newspapers. Today it serves more than 1,700 American newspapers and some 8,500 abroad. The stainless steel plaque over the entrance was created by sculptor Isamu Noguchi. Its overall theme is "the march of civilization," expressed by a group of five men with a reporter's notebook, a telephone, a camera, a wirephoto machine, and a teletype machine.

THE PLAZA HOTEL 🐚
₂₁₇

The day this French Renaissance hotel opened in 1907, a line of automobiles gathered at the Fifth Avenue entrance to help the partygoers get home. They were New York's very first taxis, so-called because of a taxi-meter that recorded the time it took to get from here to there and how much the ride cost. In the years since, history has been made in all sorts of ways here, prompting a long running advertising campaign that claimed, "Nothing Unimportant Ever Happens at the Plaza."

BERGDORF GOODMAN
₂₁₈

The William K. Vanderbilt mansion, one of the most lavish in the city's history, originally stood on this site. After it was torn down in 1926, its elaborate wrought iron gates were moved up to the entrance of Central Park's Conservatory Gardens on Fifth Avenue at 105th Street. This complex is actually seven different buildings joined by an arcade and a common façade, built to serve a variety of retail operations. Its principal tenant is Bergdorf Goodman, a women's specialty shop. In its early days, no merchandise was displayed in the individual salons. After a customer made her wishes known, the garments were displayed for her on living models.

GENERAL MOTORS BUILDING
₂₁₉

This was the site of the elegant Savoy Plaza Hotel, demolished to make way for a massive office building. Among its attractions is the F. A. O. Schwarz toy store and the windowed studios used for CBS's early-morning television show. It was recently remodeled by the ubiquitous Donald Trump, who created condominium offices inside and covered the useless plaza below the Fifth Avenue sidewalk.

ALGONQUIN HOTEL 🐚
₂₂₀

Decorated with comfortable eighteenth-century English and American furnishings, this hotel has always been a center of literary and theatrical life. It is most famous as the meeting place of the Algonquin Roundtable, a group of intellectuals who met here for lunch every day in the 1920s and traded witticisms and insults well into the afternoon. The group included newspaper columnists like Franklin P. Adams, and magazine writers such as Dorothy Parker and Robert Benchley. Actors and other artists, Douglas Fairbanks and Harpo Marx among them, were often invited to match wits with the regulars.

RCA BUILDING 🐚
₂₂₁

In 1929, after he had assembled parcels of land extending from 48th to 51st Streets

between Fifth and Sixth Avenues as a site for the new home of the Metropolitan Opera, John D. Rockefeller, Jr. was informed that the Great Depression had made it impossible for the opera company to move, and he was stuck with all that property, whose value was profoundly compromised. His response was to build this complex of office buildings, stores, and theaters. Its centerpiece is this monumental skyscraper, leased to the Radio Corporation of America, owner of, among other things, the National Broadcasting Company, whose studios and offices are in this building. RCA was acquired by General Electric in 1986, and the building's name was officially changed to the GE Building.

222
RADIO CITY MUSIC HALL 🖐

This 6,200-seat temple to the performing arts was originally intended to be a variety playhouse, but when ticket-buyers didn't respond, it was quickly transformed into a movie theater with stage shows. Because of its reputation for family entertainment, the decline in the quality of films that could be shown here resulted in an announcement in 1978 that the Rockettes had kicked up their heels for the last time and the theater would be torn down. It was saved in the nick of time by the state's Urban Development Corporation, has undergone extensive renovation, and although movies with stage shows are a thing of the past, it still presents traditional Easter and Christmas shows, live rock concerts, and similar events.

223
NEW YORK YACHT CLUB 🖐

This is a club for well-heeled gentleman sailors and yachtsmen. At the time it was built, its members ran a fleet of more than 150 ocean-worthy sailboats and an equal number of steam-powered yachts. The roster included William K. Vanderbilt's 312-foot Valiant and J.P. Morgan's 304-foot Corsair II. The club held, and successfully defended, the America's Cup from 1851, before finally losing it to an Australian vessel in 1983. The bay windows were designed to resemble the sterns of ships that Dutch seamen originally called "jachts."

224
NEW YORK PUBLIC LIBRARY 🖐

One of the world's most important libraries is housed in one of the city's most impressive buildings, a Beaux-Arts masterpiece inside and out. Its collection contains some 49.5 million items, including more than 18 million books. None of it is allowed to leave the building, but materials can be examined by selecting an item from a computerized data base. The volume is retrieved from underground stacks and delivered in minutes. Library cardholders (anyone who lives, works, or is a student in New York State is eligible) can borrow items from eighty branches. Those lions lounging on the steps are by Edward C. Potter, who also fashioned the lionesses outside the Morgan Library.

225
AMERICAN STANDARD BUILDING 🖐

Originally the American Radiator Building, this is now the Bryant Park Hotel. It is a simple but powerful design in black and gold by the master, Raymond Hood, who had supported himself in his early career by designing radiator covers for the company then known as the American Radiator and Standard

Sanitary Company. He apparently liked his former employer because when the company commissioned this building as a showroom and offices, Hood never batted an eye at their demand that it be designed and constructed in thirteen months. After delivering on their demand, he said that, "I had exactly the sort of client an architect desires."

226
PIERPONT MORGAN LIBRARY

J. P. Morgan was one of the most active art collectors of his time. Both his house at 36th Street and Madison Avenue and his house in London were overflowing, so in order to consolidate his collection of rare books and priceless manuscripts, he built this wonderful building in what had been a garden behind his house. The exterior is made from blocks of stone laid without mortar, fitted so closely together that a knife blade couldn't be inserted between them. The interior contains three grand rooms: an elaborate entrance rotunda, a library to its east lined with three tiers of books, and Morgan's study on the west side. It was Morgan's intention that his library would make his collection permanently available for "the pleasure of the American people," and this core building is exactly as he left it.

227
EMPIRE STATE BUILDING

Although its height of 1,250 feet no longer qualifies it as the world's tallest building, this tower still offers the best skyscraper views in this or any other city. It was dedicated at the height of the Great Depression and its 2 million square feet of space remained half empty for a dozen years, until wartime prosperity helped fill the empty offices. Officially, the Empire State Building is 102 stories tall, but only eighty-five floors are rentable commercial space. The rest is an observation deck and a cupola that was intended for use as a mooring mast for dirigibles, and served as a perch for the great ape, "King Kong," in the movie of the same name.

228
MACY'S

The original department store building, whose entrance on Broadway forms the backdrop at the end of Macy's Thanksgiving Day Parade, contains 800,000 square feet of space, but as other department stores began expanding, the company built a 400,000 square-foot addition so as to maintain its status as the "World's Largest Store." It might have been a bit bigger, but the store's major competitor, Henry Siegel, secretly bought a thirty- by fifty-foot plot on the 34th Street corner and built a thriving little store there. After all these years, that plot is still not owned by Macy's, but the store leases space on the roof for a giant billboard directing customers to its entrances around the corner.

229
CHURCH OF THE INCARNATION

This church building contains some of the most important ecclesiastical art in the country, including stained glass windows by William Morris and Louis Comfort Tiffany, sculpture by Augustus Saint-Gaudens and Daniel Chester French, and murals by John La Farge.

HOTEL MARTINIQUE
230

A Holiday Inn by the architect of the original Waldorf-Astoria and Plaza Hotels, this opulent building was converted into a homeless shelter before being returned to use as an urban motel. It was originally one of several hotels in the neighborhood that thrived during the days of rail travel, when visitors arrived at nearby Pennsylvania Station and didn't want to wander too far to find a place to sleep.

CBS BUILDING
231

Placed in the center of the site above a plaza, this building soars thirty-eight stories without a single setback. The 490-foot tower was one of New York's first skyscrapers built in reinforced concrete rather than around a steel frame, which allowed Saarinen to alternate the structural columns with deep-set gray-tinted glass, giving the building a feeling of solidity that earned its nickname, "Black Rock." Its interiors were as carefully designed as the exterior, and when the Columbia Broadcasting System moved here from its former home at 485 Madison Avenue, its chairman, William S. Paley, decreed that employees were forbidden to decorate their desks with personal photographs or their children's artwork. Art on the walls and in the corridors was all selected by the decorator and nothing else was permitted. All desks, each of which had a company-approved ashtray but little else, were to be swept clean of work-related materials at the end of the business day.

COLUMBIA ARTISTS MANAGEMENT
232

Originally a school of dance operated by Louis H. Chalif, this concert and recital space is known as CAMI Hall, and provides a showcase for the clients of the musicians' talent agency, Columbia Artists Management.

ART STUDENTS LEAGUE
233

This was the first headquarters of the American Fine Arts Society, which it funded through an agreement with the Art Students League and the Architectural League to share exhibition space. Once it opened, it became the scene of every major art and architectural exhibition held in the city.

CARNEGIE HALL
234

Built by steel magnate Andrew Carnegie as a home for the Oratorio Society, the New York Philharmonic's opening night concert here was conducted by Pyotr Ilich Tchaikovsky. One of the most acoustically perfect concert halls in the world, it was nearly demolished after the Philharmonic moved up to Lincoln Center, but was saved by violinist Isaac Stern and others who convinced the city to buy it.

CITY CENTER 55TH STREET THEATER
235

This was originally the Mecca Temple of the Masonic Ancient and Accepted Order of Nobles of the Mystic Shrine, which helps explain its Moorish architectural style. The city turned it into a performing arts center in the early 1940s, and it became home to the New York City Ballet and the New

York City Opera. After they were moved to Lincoln Center, it became a leading venue for a variety of dance companies. The sixty-nine-story tower next door, called CitySpire, was built using air rights from this building, making it solvent for years to come.

236
BRILL BUILDING

This building, which for many years housed Jack Dempsey's restaurant, was the ultimate location of Tin Pan Alley, an aggregation of music publishers and song writers that blossomed on West 28th Street between Broadway and Sixth Avenue in the 1890s. It earned its name from the tinny sound of pianos being played by song-pluggers trying to sell sheet music. The business, which kept New York at the forefront of popular music for nearly a century, faded in the 1960s with the advent of rock 'n' roll.

237
THE OSBORNE

Don't let the heavy-handed stone exterior fool you, it's the interiors that matter here, and you can get a taste of its luxurious detail with a peek into the lobby through the front door. This was one of several early apartment houses built on standard-size city lots, and all of them suffered from cramming too much into too little space. In spite of their touches of elegance, they were often shrugged off as "tenements for the rich."

238
ONE TIMES SQUARE

Spend a couple of minutes in Times Square and you're sure to hear someone say, "That's where they drop the ball on New Year's Eve." Yes, it is. They've been doing it every year since 1904, when *The New York Times* first moved into this building. The *Times* relocated around the corner to West 43rd Street in 1913, but didn't sell the building to Allied Chemical until forty-three years later. The new owner stripped its limestone façade and replaced it with marble, nearly all of which is now hidden behind super billboards that bring in more rent than the office space inside. There are two subcellars under the subway station here that once housed the paper's presses, but almost nobody remembers that they are down there.

239
REUTERS BUILDING

The corner of Seventh Avenue and 42nd Street was once the site of the Victoria Theater where showman Willie Hammerstein promoted such attractions as the Cherry Sisters, which he billed a "the world's worst act." After architect Stanford White was shot dead over the affections of showgirl Evelyn Nesbitt, Hammerstein paid her $3,500 a week to appear on his stage here as "The Girl in the Red Velvet Swing." Today the site is the home of one of the world's largest news-gathering organizations.

240
CONDÉ NAST BUILDING

With a glitzy façade on the Times Square side, this home of the publisher of *The New Yorker*, *Vogue*, and *House and Garden* presents a different, more conservative face to the east and Sixth Avenue. Among its tenants is the NASDAQ Exchange, which anchors the 43rd Street corner with the biggest advertising sign in Times Square. That corner was once

an outpost of Coney Island's pride, Nathan's Famous Hot Dogs.

PARAMOUNT BUILDING

241

Architectural historian Andrew Dolkart has suggested that the mountain that is the trademark of Paramount Pictures Corporation was the inspiration for the massiveness of its headquarters. It is topped by a four-faced clock whose numbers are stars, also part of the Paramount symbol, and a huge glass globe above it represents the company's world-wide reach. The building once included the legendary Paramount Theater, converted to office space in 1967.

LYCEUM THEATER

242

This is the oldest New York Theater still in use and the first to have landmark status. It was built by producer Daniel Frohman, who included the innovation of a Green Room where performers could relax, and a lavish apartment for the producer. Frohman fell on hard times in the Great Depression and the Lyceum was threatened with demolition by his creditors. It was saved from the wrecker's ball in 1939.

NEW AMSTERDAM THEATER

243

Once the home of the Ziegfeld Follies, this wonderful Art Nouveau theater became a movie palace in the 1930s and then deteriorated into virtual ruin. In the 1990s, the Walt Disney Company invested $8 million in resurrecting it, and began the inexorable march of Disney across what had become one of the city's seediest neighborhoods. The Disney magic worked, and dozens of other companies moved in, too, creating the "New" Times Square.

SHUBERT ALLEY

244

Anchored by the Booth Theater at 45th Street and the Sam S. Shubert Theater on 44th, this little passageway has access to the offices of the Shubert Organization, which owns these and dozens of other theaters in the district. The Booth, designed in 1913 by Henry B. Herts, was named for actor Edwin Booth. The Shubert, which Herts designed in the same year, stands as a memorial to the man who founded the theatrical empire that his brothers, Lee and J. J., inherited and have run since his death. Both theaters are landmarked inside and out.

ACTOR'S STUDIO

245

Founded in 1947 by Elia Kazan, Robert Lewis, and Cheryl Crawford, the studio was where Lee Strasberg introduced the "Method," made famous by Marlon Brando. After Strasberg died in 1982, Ellen Burstyn and Al Pacino became the studio's leaders and six years later, Frank Corsaro became its artistic director. Its present home is the former Seventh Associate Presbyterian Church.

ED SULLIVAN THEATER

246

Now well known as David Letterman's home base, this theater is named for Ed Sullivan, whose *Toast of the Town* was broadcast from here in the early days of television. It was built

by Arthur Hammerstein and named for his father, the first Oscar Hammerstein. He lost it four years after it was built, but it reopened with a blockbuster show that included appearances by Jerome Kern and George Gershwin.

247
MUSIC BOX THEATER

The Music Box was built by songwriter Irving Berlin and producer Sam H. Harris. The musical *Of Thee I Sing*, the first ever to win a Pulitzer Prize, opened here in 1931 and during the Depression, when scores of theaters went dark, it kept this one thriving. Playwright George S. Kaufman saw many of his hits produced at the Music Box, and William Inge's *Picnic* won the Pulitzer Prize here in 1952.

248
NEW YORKER HOTEL

Now owned by the Unification Church, the New Yorker was, with 2,503 guest rooms, one of the city's biggest when it was built. An early advertisement boasted that its bell boys were "as snappy-looking as West Pointers," that it had a radio in every room with a choice of four stations, that its barber shop had twenty-five chairs and its laundry 150 employees. The ad also mentioned ninety-two "telephone girls," and kitchens "as clean as a model private home kitchen."

249
GENERAL POST OFFICE

Soon to be converted into the "new" Penn Station, this building was designed to complement the old one that stood across Eighth Avenue. In this "city that never sleeps," all of the post offices are closed at night except this one. It's especially busy at midnight on April 15, the deadline for postmarks on tax returns.

250
JACOB K. JAVITS CONVENTION CENTER

This is the ultimate glass box, with glass covering 1.8 million square feet of floor space—enough to accommodate six simultaneous events and 85,000 people at one time in its exposition halls and meeting rooms. More than 3 million visitors pass through its doors every year for events that include the Auto Show and the Boat Show.

251
LIGHTHOUSE 🐚

This fifty-foot granite lighthouse was said to have been built by an inmate of the Lunatic Asylum, who left this inscription on it: "This is the work/ Was done by/ John McCarthy/ Who built this light/ House from top to bottom/ To all ye who do pass by may/ Pray for his sould when he dies." Whether or not this is really the work of John McCarthy is anybody's guess, but there was an asylum inmate by that name who had been allowed to build a small fort on this spot because he was afraid of an attack by the British. It was torn down when the lighthouse was built. Although not an official Seamark, the tower overlooks Hell Gate, a narrow strait that connects Long Island Sound to the East River. The powerful tide surge that runs through it, along with underwater rocks, made it the most treacherous spot in all the waterways around New York. It was widened and deepened in the late nineteenth century, but mariners navigating it still need to keep their wits about them.

252
GOOD SHEPHERD ECUMENICAL CENTER 🐚

Originally the Episcopal Chapel of the Good Shepherd, this little country church was built to serve the inmates of the various public institutions that were here when this was known as Welfare Island. The two porches marked separate entrances for men and women.

253
JAMES BLACKWELL FARMHOUSE 🐚

This simple farmhouse was the home of the Blackwell family that once owned this entire island. It was named for them until 1828, when the city bought it as the site of a prison.

254
MOTORGATE

It is forbidden to drive a car on Roosevelt Island, but certainly not to own one. Automobiles reach this huge garage facility across the Roosevelt Bridge from Queens. Electric buses transport their drivers from the garage to their apartments. Most Roosevelt Islanders come and go via the tramway that parallels the Queensboro Bridge, or through a subway station built in 1989.

255 CITICORP CENTER

The cost of the site for this building came to $40 million, making it Manhattan's most expensive real estate, and there was one holdout at that: St. Peter's Lutheran Church, which refused to sell its building. Citibank agreed to pay the church $9 million and to build them a new building as part of its development. The tower itself rests on columns that give it an openness at ground level, and allows light and air to penetrate its market area on the first three levels as well as allowing breathing space to the church at the 54th Street corner. The tower's distinctive sloping roof was originally intended to be a solar collector that would power the air-conditioning system, but it was never installed. What was installed up there is a 400-ton concrete block riding on rails, called a "tuned mass damper," which slows the building's tendency to sway in high winds.

256 SEAGRAM BUILDING

This masterful example of the International style has been imitated literally hundreds of times around the city, but never once equaled. One of its best features is the plaza in front. Nobody was quite sure why it worked so well, including the architect himself, but urban planning consultant William H. Whyte put his finger on it. It was the steps, he said, "they are the best of any office building." In 1960, a tax assessor measured the ninety-foot Seagram Plaza and concluded that the city was being cheated out of something like $300,000 a year in tax revenues because of all that wasted space. The city's lawyers agreed and the tax law was changed to take "prestige value" into account along with rentable space.

257 CENTRAL SYNAGOGUE

Recently restored after a disastrous fire, this Moorish structure, based on the Dohany Street Synagogue in Budapest, is the oldest continually used synagogue in New York. It is the fifth house of worship of Congregation Ahawath Chesed, formed by immigrants from Bohemia in 1846 on the Lower East Side. The synagogue took its present name in 1920.

258 40 EAST 62ND STREET

The image of starving artists working in cold, drafty garrets flies out the window in elegant surroundings like this. But this building was built with artists in mind. It is an eight-story neo-Medieval structure with endless floor-to-ceiling bay windows and a richly ornamented base that its builders hoped would appeal to artists. It undoubtedly did, but although rents were relatively low in 1910, it's hard to believe a "starving artist" could really come near the place—then or now.

259 SHERRY-NETHERLAND HOTEL

This hotel's original restaurant at the back of the lobby was placed on a lower level with high ceilings to make it appear larger, but it was actually much smaller than a guest might expect from the world's tallest apartment hotel. The reason was Prohibition. Since a bar would have been illegal, the management encouraged its guests to rely on room service and the availability of bootleg liquor.

RACQUET AND TENNIS CLUB

When this building was built, both Charles McKim and Stanford White were dead and William Rutherford Mead had retired, leaving their tradition to W. S. Richardson, who was true to the legacy in his fashion. Although far from the firm's best work, it is still head and shoulders above just about everything else built in New York in 1918. The indoor tennis courts are behind the blind arches at the top of the façade.

HERMÈS

This little bandbox was originally Louis Sherry's restaurant. It was altered for use as stores in 1950, and then again, in 1986, as the local flagship of *The Limited*, a women's wear store. Now *Hermès* has turned it into a little bit of Paris on Madison Avenue.

LEVER HOUSE

Although the glass-walled United Nations Secretariat was under construction when Lever House was finished, this is New York's first all-glass building, and still one of the most beautiful. Among the problems nobody anticipated was how to wash those windows, few of which can be opened. It was an especially vexing issue for the tenant who gave the building its name, the prominent purveyor of soap.

EDITH AND ERNESTO FABBRI HOUSE

This house was built by Mrs. Elliot F. Shepard, née Vanderbilt, for her daughter, Edith and her new husband, Ernesto Fabbri. After living here for a few years, the Fabbris moved to Paris, where he had been offered a job at his uncle's bank. Soon afterward, Mrs. Fabbri's cousin, Alfred Gwynne Vanderbilt, leased the house for what he characterized as a "bachelor's hall." It is now the residence of the Japanese Representative to the United Nations.

BLOOMINGDALE'S

One of the reasons why it is so hard to find your way around in this fashionable department store is that it is actually two buildings superimposed on one another. It was the result of the store's expansion that began with a small dry-goods store on Third Avenue, and continued a little bit at a time between 1872 and 1927, reaching its peak with the even bigger annex on the Lexington Avenue side that swallowed its predecessors three years later. The store, once called "The Great East Side Bazaar," was founded by Lyman and Joseph Bloomingdale, and its name has nothing to do with the old Bloomingdale neighborhood on the Upper West Side.

NEW YORK ACADEMY OF SCIENCES

Originally built as a residence for William Ziegler, Jr., president of the Royal Baking Company, this is now the headquarters of an organization dedicated to such sciences as biology, chemistry, geology, and astronomy. It sponsors research and interacts with the scientific community. Among its other activities is the Junior Academy of Sciences, which encourages high school students to participate in scientific projects.

ABIGAIL ADAMS SMITH MUSEUM

This is the headquarters of the Colonial Dames of America, which restored and furnished the building's nine period rooms in 1939. Originally a carriage house, it was part of a twenty-three-acre estate owned by Colonel William S. Smith and his wife, Abigail, the daughter of President John Adams. Before its current restoration, the building was a fashionable resort hotel called the Mount Vernon.

CYRIL AND BARBARA RUTHERFORD HATCH HOUSE

This townhouse, with a beautiful interior courtyard, was commissioned by Mrs. William K. Vanderbilt's daughter, Barbara Rutherford and her husband Cyril Hatch. When they were divorced three years later, it was sold to theatrical producer Charles Dillingham, and in 1940, it became the home of Louise Hovick, better known as stripper Gypsy Rose Lee. In the 1980s, it was the home of painter Jasper Johns.

SOTHEBY'S

The auction house moved into this former Eastman Kodak building in 1980, and then went right to work making it bigger and better. Sotheby's traces its history back to 1744, when a London bookseller began auctioning rare books. Today, its auctions include rarities of every kind from baseball memorabilia to estate jewelry, art and antiques, and, yes, rare books. It conducts auctions worldwide, even on the Internet, but this is the center of the action.

NEW YORK PRESBYTERIAN HOSPITAL-NEW YORK-CORNELL MEDICAL CAMPUS

New York Hospital was established in 1771 as a facility for charity cases. It became associated with Cornell University's Medical College in 1912, and began planning this building fifteen years later.

45 EAST 66TH STREET

The firm of Harde & Short designed several lavishly decorated New York apartment buildings, including the Red House on the Upper West Side, and Alwyn Court near Carnegie Hall. This ten-story structure brought their style to the Upper East Side, but in keeping with East Side tradition, it was not given a name, only a street address. It is such a standout on the Madison Avenue streetscape that it probably doesn't need one.

J. P. MORGAN-CHASE BANK

Like its neighbor down the avenue, the Bank of New York, this neo-Georgian branch bank building is out of scale with its neighbors, but right on the money when it comes to charm. As a branch of the Bank of the Manhattan Company, it was originally furnished with reproductions of colonial museum pieces, including hooked rugs.

EDWARD DURRELL STONE HOUSE

This house once looked just like its next-door neighbor to the west, but when architect Edward Durrell Stone moved here in 1956, he pushed the front out to the sidewalk and faced

it with the terrazzo grille that is similar to his design of the American Embassy in New Delhi.

273
SARA DELANO ROOSEVELT MEMORIAL HOUSE

This pair of houses was built by Mrs. James Roosevelt. She herself lived in the eastern half, while her son, Franklin D. Roosevelt, lived in its twin with his wife, Eleanor. This was where FDR recovered from polio, confined to a fourth-floor bedroom for more than a year in 1921 and 1922. The houses are now owned by Hunter College.

274
CHURCH OF ST. VINCENT FERRER

This church complex, built by the Dominican Order, includes a Victorian Gothic priory, a school, and a neo-Gothic Holy Name Society building. After St. Patrick's Cathedral, this is the number-one choice for society weddings.

275
TEMPLE EMANU-EL

Before the synagogue was built, this was the site of the Astor mansion, which made the Upper East Side a fashionable neighborhood. The temple, whose sanctuary seats 2,500, is ornamented with beautiful stained glass and mosaics. To get the full effect of their beauty, visit here as the sun is setting. As the light streams through the west-facing windows, a special glow is cast on everything inside.

276
UNION CLUB

This is New York's oldest men's club, and most of the others were spun off by its members who disagreed with its policies. While many of those upstart clubs are dedicated to sports and other special interests, the Union still sticks to its roots as a gentleman's club of the old school. This building provides its members all of the comforts of home, and then some. It was one of the first buildings in the city with central air-conditioning.

277
HUNTER COLLEGE

Originally the Normal College of the City of New York, Hunter also operates a high school, providing its education students with hands-on experience in the classroom. Named for its first president, Hunter is now part of the City University of New York. It accepted only women before 1964, but today the sexes are equally represented in the student body, which has risen to more than 20,000.

278
FRICK COLLECTION

When steel magnate Henry Clay Frick first arrived in New York, he took a carriage ride through Central Park, past the mansion of his arch-rival, Andrew Carnegie. He resolved to build a mansion for himself, "... that will make Andy's look like a miner's shack," and this was the result. Frick was already one of the country's premier art collectors, thanks to the salesmanship of dealer Joseph Duveen, who steered him to architect Thomas Hastings for a building worthy of his collection. The dealer also recommended interior decorator Elsie de Wolfe to select antique furnishings from his own warehouse. After Mrs. Frick died in 1931, Duveen oversaw the mansion's transformation into a major art gallery.

279
SEVENTH REGIMENT ARMORY ⟲

The Seventh Regiment was formed as a successor to the city's volunteer militias by some of New York's most prominent men, who personally paid for their own weapons and uniforms. In 1874, the city presented them with this site and, in the tradition of the regiment, its members paid for the armory. They engaged such designers as Louis Comfort Tiffany and Stanford White to create the first-floor public rooms and individual company rooms upstairs. The huge drill shed, extending out to Lexington Avenue, is modeled after the train shed in the original Grand Central Terminal. It is used today by the New York National Guard, but is also famous as the location of the annual antiques show and similar public events that require such an immense amount of open space.

280
POLO/RALPH LAUREN ⟲

If Ralph Lauren had started from scratch, he couldn't have built a building that suits his image quite like this one does. It was built for Gertrude Rhinelander Waldo, but in spite of its charming personality, she chose to live across the street with her sister rather than move into her new home because her husband, former police commissioner Francis Waldo, died before it was finished. While it was being built, Mrs. Waldo toured Europe, picking up art objects to furnish it, but never unpacked the things she bought. Her mansion stood empty until 1920, when it was converted into retail space. It was returned to its original glory in 1984, when Ralph Lauren brought his boutique here.

281
LYCÉE FRANÇAIS DE NEW YORK ⟲

Appropriate for a French school (which has since decided to move elsewhere), these two buildings are as reminiscent of Paris as any others in New York, not to mention that they may be the most beautiful townhouses in the city. The one on the left, no. 7, was built as a home for businessman Oliver Jennings, and its neighbor was intended as the home of furniture store heir, Henry T. Sloan. He and his wife were divorced less than two years after they moved into it. Publisher Joseph Pulitzer bought it and later sold it to banker James Stillman.

282
ISTITUTO ITALIANO DI CULTURA ⟲

This house was built as the residence of William Sloane, president of the W. & J. Sloane furniture store. Today it houses the cultural division of the Italian Consulate, which has been located in the mansion next door since 1952. All of the impressive mansions on this wonderful block were built right after the railroad tracks that had previously run down the center of what is now Park Avenue were covered.

283
ASIA SOCIETY

This institution was organized in 1957 to encourage relations between Asia and the West. The building contains galleries displaying art from Japan, China, Tibet, and India, among other places. Most of its exhibitions are drawn from its own collections, which include the Mr. & Mrs. John D. Rockefeller III Collection of Asian

Art. It also presents concerts and dance programs, as well as film screenings.

284
FRENCH CONSULATE

Although new apartment buildings had replaced most of the Fifth Avenue mansions by the mid-1920s, making them passé, there was still room for one more, or least millionaire Charles E. Mitchell thought so when he built this one. It has the distinction of being the last mansion on the avenue, and it is every bit as beautiful as its predecessors that were destroyed in the name of progress.

285
980 MADISON AVENUE

This building originally housed the auction galleries of Parke-Bernet, which merged with Sotheby's in 1964. The auction house is now on East 72nd Street and York Avenue, but its real estate division is still located in this building. The bronze allegorical sculpture on its façade by Wheeler Williams, representing Venus and Manhattan, symbolizes enlightenment brought to the city through the arts of distant lands.

286
ST. JEAN BAPTISTE CHURCH

This church, which would be very much at home in Rome, was built for the French-Canadian community that dominated the neighborhood after the turn of the last century. It replaces an earlier one on the same site, and was funded by streetcar millionaire Thomas Fortune Ryan because, it was said, he had been forced to stand during mass one day at the smaller original. The building is especially notable for its Corinthian portico and its twin towers. Its French-style organ is among the best anywhere in New York, and its musical programs are among the city's most popular.

287
EAST 73RD STREET

Every one of the charming houses on this block was originally a stable or carriage house. When the Upper East Side was developing into an enclave for the wealthy, these blocks east of Park Avenue were literally the other side of the tracks because of the railroad running down the center of the avenue. But it was the right side for housing horses, and their owners made sure their digs were classy. Near the close of the nineteenth century, there were about 5,000 stables of all types in the city, and its population of horses was close to 74,000. The less wealthy kept theirs in large communal stables, predecessors of today's parking garages.

288
WHITNEY MUSEUM OF AMERICAN ART

Before he began this project, architect Marcel Breuer, a member of the Bauhaus group, announced that his Whitney Museum would reflect the vitality of the street. But somehow that objective got lost at the drawing board. He wound up designing a structure separated from the street by what is best described as a moat, complete with a simulated drawbridge at the entrance. Nevertheless, this is an art museum and it's what's inside that counts. The highly innovative gallery space inside the Whitney makes it possible to showcase modern American art without any fussy distractions from the building itself.

289
UKRAINIAN INSTITUTE

This French chateau, complete with a moat, was built for Isaac D. Fletcher, a self-made man who had become president of the New York Coal Tar Company and the Barrett Manufacturing Company. He commissioned C. P. H. Gilbert to build him a mansion that resembled William K. Vanderbilt's home down Fifth Avenue at 58th Street, and the architect succeeded brilliantly. Fletcher filled the house with one of the city's finest art collections, including a French Impressionist painting of this house. When he died, he left 251 paintings and $3 million to take care of them to the Metropolitan Museum.

290
CULTURAL SERVICES, EMBASSY OF FRANCE

This house was commissioned by Oliver Whitney as a wedding gift for his nephew, Harry Payne Whitney, and his bride, the former Gertrude Vanderbilt. Payne Whitney was the son of William C. Whitney, of the family of financiers, who was one of America's foremost horse-breeders. When the elder Whitney died in 1904, he owned no fewer than ten mansions in the city.

291
ISELIN HOUSE

Built for lawyer John H. Iselin, this is one of four adjacent landmarked houses that made this block one of the city's most fashionable addresses in the years before the First World War. It is an unusual combination of French Renaissance and Classical styles that harmonize wonderfully.

292
CHURCH OF ST. IGNATIUS LOYOLA

This huge church was erected on the foundations of an earlier church dedicated to St. Laurence O'Toole, the patron saint of the Irish immigrants who settled in this neighborhood when it was still a factory district, and when Park Avenue was the right-of-way for a railroad whose smoke-belching trains established a quality-of-life standard for people who had never heard the term "air pollution."

293
DEKOVEN HOUSE

The original owner of this Elizabethan house, Reginald DeKoven, was a songwriter, and he included an old English minstrel gallery at the back of the Great Hall, a baronial room behind the huge bay windows overlooking Park Avenue. All of the woodwork, the fireplaces, and the plaster ceilings were modeled after English manor houses and inns.

294
METROPOLITAN MUSEUM OF ART

This great building was begun in the 1870s based on designs by Calvert Vaux and Jacob Wrey Mould, who created most of the buildings and architectural features of Central Park. The core building for the museum has long since been swallowed up by a host of later wings, including the elegant central façade and the East Wing, which contains the inspiring Main Hall. They were designed in 1902 by Richard Morris Hunt. The original building is exposed at the southeast wall of the Lehman Wing, which was added in 1975. Among the

other additions are the Thomas J. Watson Library, housing 150,000 books, built on the west side in 1964, and the Sackler Wing, whose centerpiece is the ancient Egyptian Temple of Dendur, opened in 1978. The Great Hall was altered and restored in 1970. The biggest museum in the western hemisphere, the Met attracts more than six million visitors a year to its eighteen diverse departments. Its holdings include more than 3.3 million treasures, and in spite of almost continuous expansion, there still isn't enough space to display them all.

DUKE HOUSE 🕸

295

This Beaux Arts townhouse was built as a speculative venture, but it wasn't on the market very long before it was sold to Benjamin Duke, a director of the American Tobacco Company. Various members of the Duke family have lived here over the years since then.

NATIONAL ACADEMY OF DESIGN 🕸

296

This institution was formed in 1896 by Samuel F. B. Morse and others as an association to promote artistic design, with membership limited to professional artists. This building was once the home of Collis P. Huntington, whose wife, the brilliant sculptor Anna Hyatt Huntington, was a member of the Academy. It houses a major art school and gallery space for changing exhibitions of the work of its members.

CONSULATE OF THE RUSSIAN FEDERATION 🕸

297

When Mr. & Mrs. William J. Sloane built a house for their daughter, Adele, they also built this one next door for their younger daughter, Emily, and her husband, John Henry Hammond. When young Hammond was told of their intentions, he protested that "I am not going to be considered a kept man," but he accepted the gift anyway. Their son, John, was a famous jazz promoter and when he invited Benny Goodman to play at one of the musicales that were common in the mansion's music room, his mother wouldn't hear of it unless the clarinetist promised to confine himself to Mozart. Goodman later became her son-in-law when he married John's sister, Alice.

COOPER-HEWITT MUSEUM 🕸

298

In 1898, when Andrew Carnegie bought this plot of land at the highest point along Fifth Avenue, nobody would even think of building a mansion north of the Metropolitan Museum, and that was what the steel baron liked about it. He hired an agent to secure options on this and other nearby lots and swore him to secrecy so that the sellers wouldn't know who their new neighbor would be and raise their prices accordingly. Carnegie then ordered his architects to give him the "most modest, plainest and most roomy house in New York," adding, "building a grand palace is foreign to our tastes." The result was a plain Georgian mansion, but it certainly wasn't modest. The house was converted, but little changed, to the Smithsonian's National Museum of Design in 1977.

SOLOMON R. GUGGENHEIM MUSEUM 🕸

299

Built to house the vast collection of non-

objective paintings assembled by minerals millionaire Solomon R. Guggenheim, this is Frank Lloyd Wright's only New York building, other than a residence on Staten Island. His involvement in the project began in 1943, but the building itself did not become a reality until sixteen years later. As completed, it contains a ramp coiling at a five-percent grade five times around the ninety-five-foot-high rotunda. The *Times's* art critic, John Canaday, proclaimed, "the pictures disfigure the building and the building disfigures the pictures." The paper's architecture critic, Ada Louise Huxtable, on the other hand, felt that, "Mr. Wright has given us an impressive demonstration of modern construction in reinforced concrete at its most imaginative."

300
1321 MADISON AVENUE

This Queen Anne-style brick-faced house with a pyramid roof at the corner was built as the anchor for a row of five brownstone-fronted houses, all of which have since disappeared. Its entrance on the street side is set above an impressive high stoop made of stone.

301
EL MUSEO DEL BARRIO

This is the northernmost of the institutions along "Museum Mile." The East Harlem neighborhood, bounded by Fifth and Third Avenues, East 120th and East 96th Streets, was largely an Italian enclave before Puerto Ricans began settling here in the 1920s, calling it *El Barrio*, "the neighborhood." After World War II, other Latin American groups settled here, too, and this museum is a showcase for the art of their combined cultures.

302
TERENCE CARDINAL COOKE HEALTH CARE CENTER

This facility was converted into a nursing home by the Roman Catholic Archdiocese of New York in 1979. It was originally the Flower Fifth Avenue Hospital, a teaching facility associated with the New York Medical College.

303
THE JEWISH MUSEUM

This was originally the home of Felix and Frieda Warburg, whose fortune was made through the Wall Street firm of Kuhn, Loeb & Company. Among its original furnishings was a pipe organ that was outfitted with piano rolls, much like the band organs on carousels. Mrs. Warburg gave the house to the Jewish Museum in 1944, and it has since been expanded to more than twice its original size in a seamless reconstruction.

304
SQUADRON A ARMORY FAÇADE

When the armory was demolished in 1966 to make way for the new Hunter College High School, this portion of its battlemented façade was preserved to be used as a very unusual entrance to the school's playground, and a memorial to the massive building that once filled an entire block.

305
ISLAMIC CULTURAL CENTER

At a time when other religions were reporting declining memberships, Islam was growing by leaps and bounds in the city. Although there have been Muslims in New York since colonial times, their numbers started

to grow in the early part of the twentieth century as immigrants began arriving from Eastern Europe for the first time. After the United Nations moved to New York, delegates from Islamic countries, led by the Pakistani delegation, formed the Islamic Center, which planned and eventually built this impressive mosque. The building, which combines the traditional dome and minaret with modern touches, is angled on the site to face Mecca. Financing for the building was largely arranged by Kuwaiti interests.

306
St. Nicholas Cathedral

Russian immigrants established their Orthodox religion in New York in the early years of the twentieth century, and this elaborate Victorian structure, with its traditional onion-shaped domes, was among the first visible signs that they were here to stay. Mass is still said here in Russian.

307
Duchene Residence School

When Andrew Carnegie began selling off his excess buildings lots, he sold this mid-block site to Mr. & Mrs William J. Sloane with the understanding that only a one-family house could be built between it and the Fifth Avenue corner, leaving a seventeen-foot swath of undeveloped land to ensure light and air for the freestanding mansion they themselves would build. The mansion is now part of the Convent of the Sacred Heart, which occupies the corner house that was eventually built.

308
Ruppert Towers

This huge apartment complex and its similar neighbor, Yorkville Towers, are on a site once occupied by a brewery owned by Jacob Ruppert, who also owned the New York Yankees. Although his sideline makes Colonel Ruppert the best-remembered of the men who ran some 125 breweries in New York and Brooklyn in the 1870s, his operation ranked eighth among all the competitors.

309
Museum of the City of New York

This Georgian building houses art and artifacts that reflect life in the city from Colonial times. The treasures include costumes and decorative materials related to the theater, and several fascinating period rooms. The Museum has announced plans to move from here down to the newly restored Tweed Courthouse behind City Hall.

310
Henderson Place

These twenty-four Queen Anne houses grouped together in a little enclave were built as speculative housing for "persons of moderate means" by John C. Henderson, who had grown rich himself selling fur hats.

311

FRIEDSAM MEMORIAL CAROUSEL

There has been a carousel in Central Park for more than a century, but the original was virtually destroyed by a fire in 1950. This one was donated by the Michael Friedsam Foundation a year later. The remains of the original were reassembled at Bronx Beach Playland. The Foundation also rebuilt the carousel in Brooklyn's Prospect Park the following year. Both merry-go-rounds have horses that were recycled from Coney Island, when they'd outlived their usefulness there. They represent a proud tradition dating back to the 1870s, when animal carvers created the first—and the best—carousel horses in what was known as the "Coney Island Style." The Central Park horses were hand-carved by Harry Goldstein, a master of the style.

312

THE DAIRY

The entire southern end of Central Park was originally intended as the province of mothers and their children. There were no playgrounds in any other part of the park. The Dairy was used as a refreshment center for them back at a time when fresh milk was prohibitively expensive and of poor quality. A herd of cows, which grazed in the nearby meadows and added to the park's bucolic atmosphere, provided the milk. It has now been transformed into the park's information center. The hilltop immediately to the west was originally called the Kinderberg, or "children's mountain." In 1954, a small version of the carousel pavilion was built as a shelter, so that park visitors could enjoy games of chess and checkers out of reach of the noonday sun.

313

THE ARSENAL

This is the headquarters of the city's Parks Department, which moved here in 1934. Prior to that, it served as a police precinct, and the office of the weather bureau. For a time it was the home of the American Museum of Natural History, as well as the menagerie that later became the Central Park Zoo. In the beginning, though, it was an ammunition dump for the city's militia. Reminders of those glorious days live on in the central stairway, whose newell posts resemble cannons. The balusters on the railings represent rifles, and the artillery theme continues with cannonballs guarded by a carving of an eagle. Its eight crenellated towers complete the image. Despite all that, this is a peaceful place within the city's greatest sanctuary.

314

TAVERN-ON-THE-GREEN

Originally called the Sheep Fold because of its use as quarters for the herd of sheep that kept the grass clipped on the meadow across the Drive, this building was converted into a restaurant in the 1930s. After expansion and remodelling twenty years later, it became what it remains to this day: one of the most successful restaurants anywhere in the United States. Its new incarnation was the inspiration of the late Warner LeRoy, who added a highly theatrical dining room that could be the setting for a Viennese operetta. As he described it, he intended to make it "a kind of living theater in which the diners are the most important members of the cast." The glass walls of the dining room overlook a topiary-filled outdoor dining area with glittering

lights shining from the trunks and branches of the surrounding trees. Eating there is like celebrating Christmas all year round.

315
HARLEM MEER BOATHOUSE
All of the bodies of water in Central Park are man-made and filled with water from the city system. ("Harlem Meer" means "sea" in Dutch.) The boathouse was, for a time, a nightclub here at the edge of Harlem, and is now a discovery center offering such things as fishing rods and tackle for the fun of catch-and-release fishing by neighborhood youngsters.

316
BELVEDERE CASTLE
This information center operated by the Central Park Conservancy is also the local outpost of the U.S. Weather Service, which has been reporting temperature and rainfall measurements at this spot since 1919. In the park's original plan, the diminutive castle was built on this 135-foot rock (the highest point in the park) to present a vista for strollers down on the Mall. Because of its size, its appearance off in the distance makes it seem to be miles away rather than just a couple of blocks. It also looks down into the Delacorte Theater, providing unusual views of the free productions of Shakespeare in the Park presented there every summer. The best way to approach Belvedere Castle is from the West Drive at the Swedish Cottage, where a paved pathway climbs up through the Shakespeare Garden, among the best gardens Central Park has to offer.

317
TRUMP INTERNATIONAL HOTEL AND TOWER
Gulf+Western, the conglomerate that built this rectangular tower on a triangular lot, became known as Paramount Communications in 1989, the year it moved away without ever looking back. The building seemed to have been jinxed with leaks and drafts from the day they had moved in. Donald Trump grabbed it as a fixer-upper, then stripped it down to its steel skeleton and started over, with the help of first-class architects and even masters of feng shui, who showed him how to reconfigure it as an exclusive hotel and apartment tower.

318
LINCOLN CENTER FOR THE PERFORMING ARTS
In the early 1950s, Robert Moses assumed responsibilty for developing a seventeen-block area called Lincoln Square, west of Columbus Avenue and Broadway, between 62nd and 70th Street. He had his own ideas, but he approached the Metropolitan Opera Association, which had been looking for a new home for twenty-five years, to see if they wanted to relocate here. His offer was accepted, followed closely by interest from the New York Philharmonic, and at the end of 1955, the decision was made to build a center for all the perfoming arts. Apart for the cost of the land, which came as federal aid, and the cost of building the New York State Theater, for which the state footed most of the bill, the money for all the buildings in the complex came from private contributions.

319
200 CENTRAL PARK SOUTH

A small apartment house and a row of brownstones were demolished, in spite of strong local protest, to make way for this Modernist apartment building, which many feel would be more appropriate in Miami Beach. Its mass is set back back forty feet from the intersection and swoops around it to create more park-facing apartments. The small plaza in front was considered a daring innovation when it was created.

320
FIRST BATTERY ARMORY

When television came into our lives in the 1950s, the American Broadcasting Company bought a former stable at 7 West 66th Street and turned it into a broadcasting studio. Before long, ABC began expanding all over the neighborhood and eventually converted this National Guard armory into studio space as well. Fortunately for the neighborhood, they left the façade intact for everyone to enjoy.

321
CENTURY APARTMENTS ☙

In 1909, the New Theater on Central Park West was built. It was the most elegant theater the city had ever seen. The trouble was that the acoustics were terrible and even season ticket holders stayed away. Changing its name to the Century didn't hide its defects and in 1930, the wreckers moved in to make way for this Art Deco masterpiece. Irwin Chanin, the developer, was so impressed that he moved here himself.

322
TRUMP PLACE

A work in progress, these apartment buildings mark the first stage of Riverside South, a development planned to extend from West 59th Street along the Hudson River north to Riverside Park over the abandoned New York Central Railroad's freight yards.

323
PYTHIAN TEMPLE

The building with its strange combination of Sumerian, Assyrian, Babylonian, and Egyptian motifs, is now a condominium apartment building. It was originally the home of the fraternal organization, the Knights of Pythias, which decorated its lodge rooms inside in even more different exotic styles. The twin towers are embellished with King Solomon's golden basin, complete with attendants.

324
HOTEL DES ARTISTES ☙

The artists' studios behind double-height windows have been leased to such notables as Isadora Duncan, Norman Rockwell, and Noel Coward. The building is best-known for the Café des Artistes on the ground floor. Its menu makes it memorable, but diners get a bonus in the murals by Howard Chandler Christy, one of the most successful painters of pin-up girls in the 1920s, who was among the tenants upstairs.

325
THE CHATSWORTH ☙

A complex of three buildings, the early tenants here (who included a young songwriter named Irving Berlin) were lured to the

edge of the Upper West Side not only by its beautifully decorated façade overlooking Riverside Park, but by a host of services from a billiard room to a hairdresser, a barber, and a tailor. The landlord also provided valet service and operated a café for his tenants. But the best part was an electric bus that whisked them to the subway on Broadway and over to Central Park.

326
CHRIST AND ST. STEPHEN'S CHURCH

This country church in the city, complete with a tile roof and a wide front yard, was originally St. Stephen's Church, which merged with Christ Church, its neighbor on 72nd Street. Dozens of Manhattan churches reach out into the city with impressive music programs, and this is one of the most active, not to mention one of the best.

327
MAJESTIC APARTMENTS 🐚

When newspaper columnist Walter Winchell wasn't out chasing gangsters and gossip, this was what he called home. The Majestic was also home to Frank Costello, the "Prime Minister of the Underworld," who survived an assassination attempt in the lobby. The eleven-story hotel it replaced was home to such people as composer Gustav Mahler and novelist Edna Ferber. Its roof garden was the city's most fashionable in the 1890s.

328
DAKOTA APARTMENTS 🐚

Originally, only the first seven stories of this early luxury apartment building were used as residences. The two top floors were set aside for servants, who also had quarters in the apartments themselves. There were just sixty-five apartments, ranging from four to twenty rooms. Just before it became a co-op in 1961, a seventeen-room apartment with six baths and eight fireplaces was renting for $650 a month at the Dakota.

329
THE DORILTON 🐚

This is a litle bit of Paris overlooking what was known as "The Boulevard" before it was renamed Broadway in 1899. When it was built, the neighborhood was still largely undeveloped and wouldn't become prime real estate until four years later, when the subway arrived with an express stop just across the street. Before much longer, the area became one of Manhattan's largest upscale Jewish neighborhoods.

330
SAN REMO APARTMENTS 🐚

At the time the San Remo was built, the city's building code allowed apartment buildings to rise to thirty stories as long as there was a base of at least 30,000 square feet and it had the prescribed setbacks. Emery Roth used the restrictions to his advantage by building two central towers instead of one, a pattern that was followed by three more Central Park West apartment buildings, the Century, the Majestic, and the El Dorado.

331
NEW YORK HISTORICAL SOCIETY 🐚

This is the oldest continuously operated museum in the city and the second-oldest historical society in the United States. Founded

in 1804, the collection now includes the papers of architects Cass Gilbert and McKim, Mead & White, as well as manuscripts, letters, and newspapers important to tracing the city's history. It has nearly all of the watercolor illustrations created by John James Audubon for his Birds of America.

332
AMERICAN MUSEUM OF NATURAL HISTORY

This is where you'll find the dinosaur bones, but there are also plenty of unexpected surprises waiting for you. The museum's various departments conduct field studies in disciplines ranging from astronomy to anthropology, a department once headed by Margaret Mead. The new knowledge resulting from these expeditions have made its ever-changing displays among the most important of their kind in the world.

333
THE RED HOUSE

Apartment houses began to invade the Upper West Side at the beginning of the twentieth century, and this is one of the best of them. If the dragon represented in the cartouche looks familiar, you may have seen its cousins, the salamanders that cover the façade of the Alwyn Court Apartments on Broadway at 58th Streets, which is the work of the same architect.

334
CENTRAL SAVINGS BANK

Now the Apple Bank for Savings, this free-standing high Renaissance structure is among the best of York & Sawyer's bank buildings.

A smaller rendition of their Federal Reserve Bank on Liberty Street, it was originally named the German Savings Bank, but the name was dropped with the approach of World War I.

335
FIRST BAPTIST CHURCH

The two unequal towers on this church have been intentionally left that way. Some say it is to symbolize the fact that all life is a work in progress. The taller one represents Christ as the light of the world and the smaller, unfinished one represents the wait for His return. The lights inside are left on at night so that everyone can appreciate the beauty of its stained glass windows.

336
APTHORP APARTMENTS

This full-square-block apartment house with a glorious interior courtyard was built by the Astor Estates, and remains the best of their apartments in the city. It was named for Charles Ward Apthorp, who built a mansion he called "Elmwood" in the 1770s at what is now Columbus Avenue and West 91st Street. Apthorp was highly regarded for his hospitality, but he was also a smart businessman who imported Spanish gold for the American Army and then sold them the supplies they needed, collecting handsome commissions at both ends. His estate in this area covered 300 acres of orchards and meadows.

337
ANSONIA HOTEL

This confection was built for W. E. D. Stokes, a finicky West Side developer, as an apartment hotel. Stokes insisted on fireproof masonry construction and ordered that all of the

apartments must be soundproof behind three-foot-thick walls, which made it attractive to such guests as singers Lauritz Melchior and Ezio Pinza, as well as Arturo Toscanini and Igor Stravinsky. Showman Florenz Ziegfeld lived here, too, but a name not often mentioned in the Ansonia's long and illustrious guest list is that of Babe Ruth. He was following a tradition already established by almost the entire New York Yankees baseball team.

338
THE MONTANA

This is a latter-day interpretation of the twin-towered apartment buildings on Central Park West, with a name apparently intended to recall the Dakota, although the developers might have been thinking of the original Montana Apartments on Park Avenue that were demolished to make way for the Seagram Building.

339
BELNORD APARTMENTS

A larger version of the Apthorp seven blocks downtown, this massive apartment building is overwhelming on the outside, but the garden court inside is wonderful. When the building opened, rents averaged $7,000 a year, $500 more than the Apthorp, possibly because its garden is bigger.

340
THE BERESFORD

In the race to build bigger apartment houses in the Roaring Twenties, the Beresford ended the decade as the clear winner. Its façade faces both Central Park and the patch of green that was called Manhattan Square in those days, and its twenty-two stories are topped by three towers, while most of its

neighbors settled for two. It was among the first with elevators whose doors opened directly into the apartments rather than into a central hallway.

341
THE ELDORADO

When novelist Sinclair Lewis came to live in New York, he chose an apartment in this building because it had a view of all of the city's bridges. It was also the fictional address of "Marjorie Morningstar," the heroine of Herman Wouk's popular 1955 novel.

342
6–8 WEST 95TH STREET

This is among the best of the Upper West Side's "park blocks" that real estate agents love to lure their clients to. Besides the diversity of styles in its row houses, its trees, arching gracefully over the street, bring Central Park out into the city. This pair of mansions is among many in the area whose ground floor is the main floor. But their designer added gentle stoops in a bow to row house tradition.

343
FIRST CHURCH OF CHRIST, SCIENTIST

The Christian Science Society of New York was incorporated in 1887, and moved into this building sixteen years later. This structure is built of granite imported, like the religion itself, from New England. This was one of the first of the so-called "skyscraper" churches that included not only space for worship, but rooms for social activities as well. There is a fascinating example of a church within a skyscraper on the other side of West 96th Street, where an apartment tower completely surrounds a Presbyterian church.

344
ST. MICHAEL'S CHURCH

There are many church buildings in Manhattan with stained glass windows from the studios of Louis Comfort Tiffany, but those with Tiffany interiors are rare, and this is one of them. The altar, and much of the rest, is a dazzling display of mosaics and glass. The rectory behind it, like several in the area, is at odds with the regular grid pattern of the street. It probably conforms with the meandering route of the old Bloomingdale Road that was straightened to become Broadway.

345
THE CHILDREN'S MANSION

This chateau was built for Morris Schinasi, a millionaire cigarette manufacturer, whose brother and business partner owned 20 Riverside Drive, the only other remaining freestanding mansion on the drive. This one became a girl's finishing school in the 1930s, and was later used as a day-care center by Columbia University. It is now a school.

346
MASTER APARTMENTS

Among the best Art Deco apartment towers in New York, this building vaguely resembled the same architect's One Fifth Avenue at Eighth Street in Greenwich Village. The building also houses the Equity Library Theater in a space that was originally the auditorium of Nicholas Roerich's Master Institute of United Arts. The Institute is now a museum in a neighboring townhouse at 319 West 107th Street, dedicated to the work of Roerich, the Russian artist and mystic who wrote the scenario for Stravinsky's *Rite of Spring*.

347
POMANDER WALK

This wonderful double row of twenty-four tiny houses along a private path was modeled after the stage set for a play called *Pomander Walk*. Naturally, it became a popular place for actors to call home, and among those who lived here have been Humphrey Bogart, Gloria Swanson, and Rosalind Russell.

348
854–858 WEST END AVENUE

Before the huge apartment towers began lining West End Avenue, several of its corners were developed as rows of brownstone houses with a larger one at the corner and another facing the side street (in this case, 254 West 102nd Street). This row is one of the few still remaining.

349
CALHOUN SCHOOL

If the parents who send their children to this private school hope to see them go on to Ivy League universities, it's not because they will already be familiar with the architecture. The neighbors here were enraged when several elegant row houses were demolished to make way for what looks very much like a giant television set. The space inside the building, which is known as the Learning Center, has been left open, without interior walls, in keeping with the school's progressive approach to learning. There are more than sixty so-called "independent" schools in the city, with a total enrollment of some 25,000 students.

ST. PAUL'S CHAPEL AND LOW MEMORIAL LIBRARY

The Columbia campus was designed by Charles F. McKim, and his Low Library is its centerpiece. It became the University's administrative center in 1934, when the library collection was moved to Butler Hall across the quadrangle. This building was a gift of Seth Low, a former mayor of the City of Brooklyn, who became Columbia's president in 1890. The former library honors the memory of his father, a ship-owner. The non-denominational St. Paul's Chapel, donated by Olivia and Caroline Phelps Stokes, is a memorial to their parents, and was designed by their nephew, I. N. Phelps Stokes.

CATHEDRAL CHURCH OF ST. JOHN THE DIVINE

All things considered, this is the world's largest cathedral. Some are longer, some wider, and some higher, but by any measure, it is easily one of the world's most impressive and inspiring houses of worship. Its cornerstone was laid in 1892, and it still isn't finished. Work stopped on Pearl Harbor Day in 1941, a week after the nave was dedicated, and didn't resume until 1978. Lack of funds has halted work once again.

AVERY HALL

The home of Columbia's School of Architecture, the library here contains America's largest collection of architectural resources. Charles F. McKim proposed several buildings for the inner campus, but this was the only one actually built.

GRAHAM COURT

Harlem's most elegant apartment house was built by William Waldorf Astor in the style of his Upper West Side buildings, the Apthorp and Belnord Apartments, with an interior garden court accessed through passageways lined with Gustavino tile. It did not accept black tenants until 1928.

GRANT'S TOMB

Who's buried in Grant's Tomb? The correct answer is nobody. The remains of President Ulysses S. Grant and his wife, Julia, are well above ground in the very impressive crypt inside. The design, a cube supporting a drum ringed by a colonnade and topped by a stepped roof, was inspired by Napoleon's Tomb at Les Invalides in Paris. Up until the end of the First World War, Grant's Tomb was far and away the most popular tourist attraction in the city, inspiring more crowds of visitors than the Statue of Liberty.

RIVERSIDE CHURCH

This interdenominational church is affiliated with the American Baptist Church and the United Church of Christ. Harry Emerson Fosdick, who served as pastor here from 1931 until 1946, had scandalized the Baptist Church by preaching against fundamentalism, resulting in charges of heresy. John D. Rockefeller, Jr. built this church as a forum for Fosdick's non-sectarian, international, and interracial beliefs. Its 392-foot tower houses offices up to the twenty-third floor, and the space from there to the twenty-eighth houses the Laura Spellman Rockefeller Mem-

orial Carillon, the world's largest. There is an observation deck up there, too.

UNION THEOLOGICAL SEMINARY
357

This non-denominational school for future clergy is widely regarded as a center of liberal theology. Its faculty has included such well-known theologians as William Sloan Coffin and Reinhold Niebuhr, whose philosophies, which the latter described as "applied Christianity," reshaped Protestantism in the twentieth century. It had been an affiliate of the United Presbyterian Church for many years, and in the beginning it was dedicated to revivalism and the Reformed traditions that began to emerge in the mid-nineteenth century. The Seminary had become independent by the time it moved into this Gothic building from its original location on the Upper East Side. It has been a neighbor of Columbia University here in Morningside Heights since 1910.

WASHINGTON APARTMENTS
358

This was Harlem's first middle-class apartment building. It originally had thirty apartments that were rented to businessmen who commuted down to midtown on the new elevated railroad, which had a station nearby on 125th Street and Eighth Avenue.

ST. MARY'S CHURCH-MANHATTANVILLE
359

In the mid-nineteenth century the little village of Manhattanville was surrounded by open fields, and this church reflects its original character. Home to several hundred working-class people, it was centered around the present-day intersection of 125th Street and Broadway, and was served by a ferry line on the Hudson River.

JEWISH THEOLOGICAL SEMINARY
360

This institution was founded in 1887 to train Conservative rabbis and to encourage traditional Judaism in America. It also has a school for training cantors, and began admitting women in the 1970s. The Seminary has been an active promoter of Zionism since the early 1900s.

WADLEIGH HIGH SCHOOL
361

This was the first high school in the city for girls only. It was named for Lydia F. Wadleigh, an early crusader for women's education, and was built in response to growing demand for girls' education. It was closed in 1954, but restored in the 1990s, when it became a Junior High School open to both sexes.

THERESA TOWERS
362

Now an office building, this was the Hotel Theresa, long known as "the Waldorf of Harlem." After it was desegregated in 1940, it became a favorite meeting place for black celebrities. It gained a kind of fame in 1960, when Fidel Castro stayed here and entertained Soviet premier Nikita Khrushchev in his suite. It also housed the offices of Malcolm X's Organization of Afro-American Unity, and A. Philip Randolph's March on Washington Movement.

363
APOLLO THEATER

Originally a burlesque house, this theater became the black equivalent of the Palace Theater, *the* place to perform for musicians, comedians, and dancers. It led the way in the development of swing, bebop, rhythm and blues, modern jazz, gospel, soul, and funk, and launched the careers of countless important black artists since the 1930s. It became nationally known when its Wednesday "Amateur Nights" were broadcast live on twenty-three radio stations around the country, giving audiences their first taste of black swing music, and ushering in the Big Band Era. In later years, Elvis Presley honed his style through regular visits to the Apollo, and when the Beatles first came to New York, this was the first place John Lennon asked to see.

364
ST. ANDREW'S CHURCH

When its parish outgrew St. Andrews' original church building on East 127th Street, it was dismantled and moved a couple of blocks west, where it was rebuilt and expanded. It is among the very best Victorian Gothic structures anywhere in the city, and it is also one of the very few nineteenth-century Harlem churches that is still serving its original congregation.

365
17 EAST 128TH STREET

San Francisco, eat your heart out. Few of the "painted ladies" that make the West Coast city famous could possibly compete in a beauty contest with this charmer in the heart of Harlem. It is a rare survivor from a time when Harlem was a tiny farming village filled with small wooden houses. It has obviously been lavished with great loving care over the years.

366
STRIVER'S ROW

Originally called The King Model Houses and now the St. Nicholas Historic District, these four block fronts, with 146 row houses and three apartment buildings, were the brainchild of developer David H. King, Jr., who described it as a neighborhood "independent of surrounding influences." All of the homes were intended for white middle-class families and were not open to blacks until the 1920s, when the area became known as Striver's Row, representing the aspirations of such residents as songwriter Eubie Blake, bandleader Fletcher Henderson, and musician W. C. Handy.

367
HAMILTON GRANGE

This was the country home of Alexander Hamilton, located nine miles out of town. Hamilton himself lived here for just two years before being shot by Aaron Burr in a duel, but the house remained in his family for another thirty years. It was sold to St. Luke's Episcopal Church in 1899, and moved two blocks south of its original location. It is now operated by the National Park Service as a National Monument.

368
ABYSSINIAN BAPTIST CHURCH

This church is famous for its prominent

ministers, Adam Clayton Powell and his son, Congressman Adam Clayton Powell, Jr. The elder Powell lured thousands of blacks to Harlem, preaching a "social gospel" which combined spirituality with social activism. The church, which was organized downtown in 1808 by people who had split from the First Baptist Church, takes its name from the ancient name of Ethiopia.

369
135TH STREET GATEHOUSE🐚

Some people say they'd like to live in a lighthouse, and others dream of inhabiting a castle. Although this is neither, it has all the qualities of both—and it is standing empty. This was originally one of the pumping stations of the New Croton Aqueduct, successor to the smaller original pipeline from the upstate reservoirs that went into service in 1842. It is one of several surviving Gatehouses, but few of the others stir the imagination quite like this one does.

370
CITY COLLEGE

Although this is now officially part of the City University of New York, it is still most often called CCNY. This complex, built sixty years after the school's founding, is built of Manhattan schist, the stone that underlies most of the island, excavated during the building of the first subway. It originally included an amphitheater, donated by Adolph Lewisohn, that was used for summer concerts by the New York Philharmonic. The stadium was demolished in 1973 to help make way for the huge modern buildings that dominate the western edge of the campus.

Among its graduates are Secretary of State Colin Powell, former Mayor Ed Koch, physician Jonas Salk, and former Supreme Court Justice Felix Frankfurter.

371
AUDUBON TERRACE🐚

This complex of small museums was built by railroad magnate Archer Huntington. It was designed by his cousin, Charles P. Huntington, and the wonderful sculptures in its court are by his wife, Anna Hyatt Huntington. One of its original institutions, the Museum of the American Indian, has been relocated. The Hispanic Society of America, reflecting one of Huntington's passions, contains an important collection of masterworks from Spain and Portugal. Other institutions here are the American Numismatic Society and the National Institute of Arts and Letters. Often overlooked is the wonderful Church of Our Lady of Esperanza, containing art and artifacts donated by King Alfonso XIII of Spain, located around the corner on 156th Street. This site was originally part of the estate and game preserve of the naturalist John James Audubon.

372
CHURCH OF THE INTERCESSION🐚

The cemetery that surrounds this church on both sides of Broadway is a successor to Trinity Churchyard in the Wall Street area. Among those who are buried here are John Jacob Astor and Alfred Tennyson Dickens, the son of the novelist. The grave of Clement Clark Moore, who wrote the poem, "'Twas the night before Christmas,"

is the destination of a candlelight procession every year on Christmas Eve.

373
MORRIS-JUMEL MANSION

This house, built by Colonel Roger Morris, was occupied at various times during the Revolution by George Washington and the British army. It became a tavern before it was bought by Stephen and Eliza Jumel, who lavishly decorated the house in the French Empire style. After having been widowed, she was married to former vice president Aaron Burr. Her divorce from him was granted on the day he died in 1836, and she continued to live here for the rest of her life.

374
UNITED CHURCH

Once the Loew's 175th Street movie theater, this is the headquarters of the flamboyant evangelist who calls himself Reverend Ike (his real name is Frederick Eikerenkoetter). His essential message is that "no one has to be poor, and no one has to be a failure," and in addition to preaching here, he spreads the word through a national network of some 1,500 radio stations.

375
HIGHBRIDGE WATER TOWER

This 200-foot tower originally housed a water tank that provided gravity water pressure for Manhattan's water supply. Without it, it would have been impossible to have running water on any but the lowest floors of the buildings downtown. The water was pumped into it from upstate reservoirs across the Harlem River via the nearby High Bridge aqueduct, which is the oldest of the 2,027 bridges in the city. The system of reservoirs wasn't put into service until 1842, before which New Yorkers relied on wells and occasional streams for bathing and drinking water. It has been modified and expanded several times since then, and one of the casualties of the progress is this tower, which is no longer needed.

376
THE CLOISTERS

This branch of the Metropolitan Museum of Art is built around fragments of cloisters and other Spanish and French medieval buildings that had been collected by George Gray Barnard. They were bought by John D. Rockefeller, Jr. for the museum, and he funded the construction of this building. It is not itself a historic structure, imported stone-by-stone, but a copy of a French Romanesque Abbey. It houses the museum's collection of medieval art, including the priceless Unicorn tapestries. When Rockefeller bought this site, he also bought a stretch of the Palisades across the Hudson River to guarantee that future development wouldn't spoil the view.

377
DYCKMAN HOUSE

This is the only eighteenth-century farmhouse still standing in Manhattan. It replaced an earlier version that was destroyed by British forces during the Revolutionary War. The farm itself was originally established by Jan Dyckman in 1861, and the present house was built by his grandson, William. The family lived

here until it was sold in 1868. When it was threatened with demolition in 1915, his descendants bought it back, restored it, and gave it to the city, which operates it as a museum. The hilly landscape here in northern Manhattan is typical of what the whole island looked like when the Dutch arrived. Nearly all of the hills were leveled, often with nothing more than picks and shovels, and the low places were filled with the resulting debris. What was left over was dumped into the rivers, making Manhattan bigger as well as smoother.

378
BRONX COUNTY BUILDING

Also known as the Bronx County Courthouse, its sculptural elements are what make it appealing. The frieze, by Charles Keck, represents productive employment, a popular theme in the Depression years. The eight marble sculptures flanking the four entrances in pairs refer to achievement, progress, and the law. Two of them are the work of sculptor Adolph Weinmann, who also supervised the work for the others.

379
PARK PLAZA APARTMENTS

There are a host of Art Deco apartments houses in the Bronx, but few of them are as well-done as this one, which was among the first. The façade is the work of Marvin Fine, who was influenced by the Chrysler Building in Manhattan. Among the colorful terra-cotta panels that adorn it, one is a representation of the architect offering a model of the building to the Parthenon.

380
PUBLIC SCHOOL 27

Also known as St. Mary's Park School, this is one of the early designs by C. B. J. Snyder, the Superintendent of School Buildings. Like most of his other work, its style reflects a city policy to build schools that would impress local parents with the importance of education.

381
ST. ANN'S CHURCH

The oldest church building in the Bronx stands on the original site of the estate of Governor Morris. Active in the formation of the American Republic, Morris proposed turning

his estate, Morrisania, into the nation's capital. His arguments were persuasive, and the Continental Congress took them seriously. After all the pros and cons were debated, and the time came to build the Capitol Building in Washington, its immense cast-iron dome was fabricated in this neighborhood.

382
OLD BRONX BOROUGH COURTHOUSE ☙

After serving for a time as the Bronx County Branch of the City Criminal Court, this impressive Beaux Arts building was boarded up and forgotten. It was originally built as the borough's only courthouse by Michael J. Garvin, a friend of the borough president. He turned the actual design over Oscar Bleumner who, although he had architectural training, thought of himself as a painter.

383
MORRIS HIGH SCHOOL ☙

This Collegiate Gothic-style building is among the best public schools in any borough. Its auditorium, called Duncan Hall, has landmark status on its own. It is an unusually high space with an ornate balcony, elaborate plasterwork, and Tudor arches. It also has stained glass windows and decorative organ pipes. The room is decorated with a series of murals, including Auguste Gorguet's World War I memorial, called *After Conflict Comes Peace*.

384
1969–1999 MORRIS AVENUE ☙

This is part of the Morris Avenue Historic District, which continues across the street and around the corner on 179th Street. All of these houses were designed by the same architect and built by developer August Jacob. The three-story, two-family, neo-Renaissance brick row houses are notable for their full-height bays, as well as for their well-preserved wrought-iron details.

385
EMIGRANT SAVINGS BANK ☙

Originally the Dollar Savings Bank, designed by the architects of Brooklyn's famed Dime Savings Bank, this structure was built in stages, culminating with the ten-story tower with its four-faced clock in 1938. The interior, lavished with marble and gold leaf, has a series of four murals by Angelo Magnanti tracing the history of the Bronx.

386
LOEW'S PARADISE THEATER ☙

Now the Paradise Twins, an unremarkable pair of small theaters, this movie palace, called "Low-eys" by its patrons, had a lavish 4,200-seat auditorium and a lobby resembling a Spanish patio. Literally every inch of its interior was dripping with ornamentation, and its ceiling was studded with twinkling stars and lazily moving clouds. The balconies were decorated with artificial flowers, and there were potted palms and gigantic sculptures everywhere.

387
BRONX ZOO/WILDLIFE CONSERVATION PARK

Beginning with the aquatic bird house, completed in 1899, work has almost never stopped, with new exhibit space being added and older ones rebuilt in this park setting. A pioneer in the concept of allowing animals

to live in naturalistic replicas of their native habitats, the Wildlife Conservation Society is also a world leader in breeding endangered species. Its 252-acre site here is small compared to some other urban zoos, but its practices have had a profound effect on all of them. The Society also operates four other zoos, one in each borough, and the aquarium at Coney Island.

388
ENID A. HAUPT CONSERVATORY

This group of Victorian greenhouses, patterned after the Palm House at the Royal Botanic Gardens at Kew, England, is the centerpiece of the Botanical Garden established here in the early 1890s and landscaped by Calvert Vaux and Calvert Parsons, Jr. The Parsons family were pioneer horticulturalists who imported many trees and plants from abroad that we consider native today, including the most common plant in the city, the ailanthus tree, which they brought from Asia as an ornamental plant, never dreaming it would thrive in any nook and cranny, and thus dominate entire urban neighborhoods. The ailanthus inspired the theme of the novel *A Tree Grows in Brooklyn*, but it grows like a weed in every borough.

389
ST. STEPHEN'S UNITED METHODIST CHURCH

This is the most prominent structure in Marble Hill, which is technically a part of Manhattan. It was once geographically in Manhattan, but was cut off in 1895, when the Harlem River Ship Canal was built to connect the Harlem and Hudson Rivers. At that time, this former marble quarry became

an island itself, bounded by the canal and Spuyten Duyvil Creek. It became part of the mainland after the creek was filled in 1938.

390
LEWIS MORRIS APARTMENTS

The Grand Concourse is four-and-a-half miles long between 138th Street and Mosholu Parkway. Eleven lanes wide, with two tree-lined dividers and wide sidewalks, it was the grandest boulevard in the Bronx when it was built in 1909, and it became the government center as well as a major shopping and entertainment district. It quickly became the favorite destination of new arrivals who could afford to live here, and this thirteen-story apartment house became their most favored address.

391
POE COTTAGE

This little cottage was moved here to Poe Park in 1913, from its original location on the other side of Kingsbridge Road. Edgar Allan Poe lived here for nearly three years before he died in Baltimore in 1913. It was here, one of several of his homes in the city, that he wrote "The Bells" and "Annabel Lee."

392
FORDHAM UNIVERSITY

This Roman Catholic university opened in 1841 as St. John's College, and came under control of the Society of Jesus, the Jesuits, five years later. Although highly rated academically, Fordham became known in the 1930s for its sports teams, especially football, with its defensive line, known as "the seven blocks of granite," one of whom was Vince Lombardi. The university, which has a

campus that includes its famous law school at the southern edge of Lincoln Center, began accepting female students in 1964.

393
LORILLARD SNUFF MILL

The setting for the Botanical Garden is the former estate of the Lorillard family, descendants of Pierre Lorillard, who established a snuff factory in lower Manhattan in 1760. The original mill on this site, built to take advantage of water power provided by the fast-moving Bronx River, ground more tobacco than any other in the United States by the end of the eighteenth century. This building stands at the edge of the Bronx River gorge, near the only remaining virgin hemlock forest remaining in New York City, which was once covered by them.

394
BEDFORD PARK PRESBYTERIAN CHURCH

The Bronx's Bedford Park section is the remnant of a planned community established in the 1880s and named for a town in England, which inspired the construction of buildings like this that would be right at home in its namesake. Many of the houses near here are in the Queen Anne style with several fine examples of Art Deco added after the Third Avenue elevated line reached here in 1920.

395
MONTEFIORE APARTMENTS II

One of the tallest apartment houses in the Bronx, you can see this building for miles. It serves the community around Montefiore Medical Center, which moved to the northern Bronx from Manhattan in 1913. The facility was originally established by Jewish philanthropists and was named for Moses Montefiore, a former London sheriff.

396
GREYSTON

This is one of the earlier country houses in Riverdale, which has what may be the finest collection of them anywhere in the city. It was built for William E. Phelps Dodge, a founder of the Phelps Dodge mining company. The company, which also controlled several railroads during its history (dating back to 1833), still produces thousands of tons of copper every year. The villa was sold to Columbia University Teachers College, which used it as a conference center. It was later turned into a Zen Buddhist retreat before finally coming full-circle back to a private residence.

397
WAVE HILL

This mansion was built by lawyer William Lewis Morris in 1843. It was acquired twenty-three years later by publisher William Henry Appleton, who added greenhouses and elaborate gardens. It was sold again to financier George W. Perkins, who added more land to the estate. He rented the stone house to Samuel Clemens (Mark Twain) for two years, and then to Bashford Dean, who added the impressive armor hall as a private museum. Other tenants since then have included conductor Arturo Toscanini and the British UN delegation. The property was deeded to the city in 1960 and converted to the Wave Hill Center for Environmental Studies, which includes a twenty-eight-acre garden, one of the finest anywhere in New York.

VAN CORTLANDT MANSION

398

Now a museum, this manor house was built on land given to Jacobus Van Cortlandt as a wedding gift by the Philipse family when he married Eva Philipse in 1691. The house served as George Washington's headquarters during the Revolution and later as a nerve center for General Lord Howe, who commanded the British forces. The Van Cortlandt family lived here until 1889, when they donated the estate to the city for use as a public park. The park covers 1,122 acres, and is part of a system of parkland that covers about sixteen percent of all the land in the Bronx. The borough has more park acreage within its borders than many cities, including Boston, Cleveland, and Detroit.

COLLEGE OF MOUNT ST. VINCENT

399

This liberal arts college moved here to North Riverdale in 1857. It was established in 1847 by the Sisters of Charity of Mount St. Vincent, whose convent was located above McGown's Pass overlooking Central Park's Conservatory Gardens. Its present location was formerly the estate of actor Edwin Forrest, whose original home, the faux castle he called "Fonthill," was the college's library until 1962.

RIVERDALE PRESBYTERIAN CHURCH

400

The owners of local estates donated the money to build this Gothic Revival church and its interesting stone manse, but William E. Dodge, Jr., whose nearby villa was under construction at the time, also donated the architect. He had hired James Renwick, Jr., the designer of Manhattan's Grace Church

and St. Patrick's Cathedral, to build the house he would call "Graystone," two blocks from here, and also engaged him to do these buildings in his spare time, as it were. But, of course, the architect didn't stint with either his time or his talent.

CO-OP CITY

401

This monster complex of apartment buildings is home to some 55,000 people (more than the entire population of Binghamton, New York), who occupy 15,372 individual units. In addition to its 35 bulky towers and 236 townhouses, the 300-acre site includes eight parking garages for 10,500 cars, three shopping centers, two junior high schools, four elementary schools, a power plant, and police and fire stations. The rest is landscaped open space. In spite of its name, these are rental apartments, not cooperatives. They were largely funded by a consortium of labor unions in a cooperative venture.

HUNTINGTON FREE LIBRARY

402

This free, noncirculating library was established in 1882, by philanthropist Peter C. Van Schaick for his neighbors in what was then the small village of Westchester. The villagers declined the gift until railroad magnate Collis P. Huntington bought it, enlarged it, and renamed it for himself in 1891. It still operates as a reading room.

ST. JOSEPH'S SCHOOL FOR THE DEAF

403

This still-operating Roman Catholic school became isolated in 1939 when the Bronx-Whitestone Bridge and its Hutchinson River

Parkway approach cut across part of its property. These days it stands as a curiosity for commuters and other travelers who are often backed up in traffic on the parkway.

404
21 TIER STREET

This is a classic example of the Shingle-style that was popular in suburban communities in the 1880s. But of course this isn't a suburb—it is as much a part of New York City as Times Square. It might qualify as a resort, though. With its endless water views, City Island is among the most tranquil, restorative spots anywhere inside the city limits.

405
173 BELDEN STREET

This is one of the most picturesque cottages anywhere in New York City. The view out over Long Island Sound from City Island's southern tip makes it all the more desirable. The only jarring note is a radio transmitter on a nearby island that sends a signal strong enough to turn any metallic object in the house, from a toaster to a radiator, into a radio receiver.

406
BARTOW-PELL MANSION

Built on the site of the original Pelham Manor, this country house overlooking Long Island Sound was built by Robert Bartow, a descendant of the Pell family, who originally settled this area. Its restoration was undertaken by the International Garden Club, which built the charming formal terrace garden in front of the house. Its Greek Revival interiors are a sensitive approximation of the original.

407
NEW YORK STATE SUPREME COURT

In 1870, the Queens County Seat was moved from Jamaica to Long Island City, making this courthouse a necessity. The center of government moved back further east after the consolidation of the five boroughs in 1898, and the center of justice eventually wound up on Queens Boulevard in Kew Gardens. In the meantime, after the state constitution created a supreme court appellate division, the early twentieth century saw a flurry of courthouse construction, beginning with the ornate appellate court on Manhattan's Madison Square, and the refurbishing of this building on Courthouse Square in Queens.

408
CITICORP BUILDING

At 663 feet, this forty-eight-story glass building is New York City's tallest tower outside of Manhattan. It is still 251 feet shorter than the Citicorp Center just across the East River, only one subway stop away. This one provides back-office space for the company. The bank was chartered in 1912 as the City Bank of New York. A half-century later, the name was changed to First National City Bank of New York to reflect its membership in the national banking system. Mergers and whims dictated several more name changes until it finally settled on "Citibank" in 1976.

409
QUEENS ATRIUM

This complex of three huge factory buildings included the Adams Chewing Gum factory, which turned out Chiclets by the millions, and the Sunshine Baking Company, which reproduced its "thousand windows" on every

box of crackers. The complex was transformed into the International Design Center in 1988, providing showroom space for interior designers and furniture-makers. It has now been transformed again into a general corporate center.

410
SILVERCUP STUDIOS

Now converted to television production studios (*Sex and the City* is filmed there, among many other popular shows), this building was formerly the bakery facility of the Gordon Baking Company, makers of Silvercup bread. The huge neon sign on its roof has served as a landmark across the river for generations of Manhattanites. It may be one reason why the new enterprise kept the old name.

411
CALVARY CEMETERY GATEHOUSE

This marvelous Queen Anne structure marks the entrance to the Roman Catholic Calvary Cemetery, part of the view from the Long Island Expressway. In terms of interments (more than 3 million), this is America's largest burial ground. It was originally the last resting-place of children and poor immigrants from the slums of the Lower East Side. Today, burials are restricted to family plots and reused graves.

412
STEINWAY MANSION 🐾

After William Steinway moved his piano factory to Astoria, he bought this riverfront villa, originally built for Benjamin T. Pike, a manufacturer of scientific instruments. Steinway was the youngest of three sons of the company's founder, Henry Steinweg.

His brothers refined the art of piano-making, but it was William who promoted the instrument as a symbol of refinement among the middle class.

413
LATHAN LITHOGRAPHY COMPANY

A refreshing change from the factory buildings of western Queens, this Tudor building with landscaping and wide lawns was originally a printing plant. Before its current high-tech occupant moved here, it was the home of the J. Sklar Manufacturing Company, a major producer of surgical instruments.

414
LOUIS ARMSTRONG HOUSE

The great "Satchmo" lived in this Corona house, now a museum, from 1943 until he died in 1971. He was one of several prominent jazz artists who lived in Queens. The Addisleigh Park section of St. Albans was the home of Lena Horne, Count Basie, and Fats Waller.

415
EDWARD E. SANFORD HOUSE 🐾

This small two-story building was originally the home of a farmer whose fields were at the edge of the little village of Newtown. The detail on the porch, the gable, and the wooden fence makes it an architectural treasure.

416
ADRIAN ONDERDONK HOUSE 🐾

Restored by the Greater Ridgewood Historical Society after a fire nearly destroyed it, this is a rare survivor of many Dutch Colonial farmhouses that once existed in Central Queens. It was the home of a farmer who

had married a daughter of the prominent Wyckoff family. His own descendants lived here until 1908.

417
WEST SIDE TENNIS CLUB

When the West Side Tennis Club moved here in 1915, it had already been in existence for twenty-three years, having played on leased courts on the west side of Central Park. They built this facility to host the Davis Cup matches, and later it became home to the prestigious U.S. Open. The club moved from Forest Hills to Flushing Meadows in 1978, when the larger USTA Tennis Center was built.

418
FOREST HILLS GARDENS

The original development of 1,500 houses on a 142-acre site resembled an English country village, with a green, an inn, and its own railway station. The brick-paved station square included a town clock and arched passage-ways leading to garden apartments resembling English town houses. Roads through the development are narrow and winding to discourage traffic and to make wide lawns possible.

419
JAMAICA BUSINESS RESOURCE CENTER🐦

An outstanding example of the streamlined Art Moderne style, this building was originally a nightclub and restaurant called La Casina. Its stainless steel façade was saved from the scrap heap in 1995.

420
JAMAICA ARTS CENTER🐦

This neo-Italian Renaissance building was constructed at the time Queens became a part of Greater New York (as a registry for property deeds). Until its conversion to an arts center, it was always known, simply, as "the Register."

421
MURDOCK AVENUE

This section, known as Addisleigh Park, is an affluent black community. The neighborhood was established in 1892 after developers bought a large farm, laying out streets and building lots. This section was developed, overlooking the St. Albans Golf Club, in 1926. The golf course became the site of a large naval hospital during World War II.

422
QUEENS COLLEGE

A division of the City University of New York, the college moved to this campus in 1937. The site originally consisted of nine Spanish-style buildings comprising the New York Parental School, called a "reform school" in those days. The complex has been expanded throughout the years to include, among others, the Colden Center, one of the city's premier music auditoriums.

423
ENGINE COMPANY 289, NYFD

This charming, diminutive French chateau houses a hook-and-ladder company under its dormered mansard roof. It is another beautiful example of the careful attention to architectural detail that makes firehouses in every part of the city assets to their neighborhoods. The neighborhood this one protects is Corona, in north-central Queens. Its name was changed from West Flushing in 1872, to signify its emergence as the

"crown" of the Long Island villages. Among Corona's early institutions was the Tiffany glass factory that anchored the community from 1893 through the mid-1930s.

424
NEW YORK STATE PAVILION

Philip Johnson's concept for this now-neglected structure was an elliptical canopy of acrylic panels he called "The Tent of Tomorrow." They were supported by three towers and reached by glass-enclosed elevators. The space under the tent held exhibition space arranged around a grand promenade.

425
HINDU TEMPLE SOCIETY OF NORTH AMERICA

The ornate Indian sculpture on the façade of this temple came to Flushing courtesy of the Department of Endowments, Andrhra Pradesh, in India. After the Immigration Act of 1965, new arrivals from South Asia began arriving by the thousands, and many professionals from India, including engineers, doctors, and scientists, chose to live here in Flushing.

426
LEWIS H. LATIMER HOUSE

The famous African-American inventor lived in this house from 1902 until he died in 1928. During his life, Latimer worked closely with Alexander Graham Bell, as well as Thomas A. Edison, for whom he developed the long-lasting carbon filament that made lightbulbs affordable.

427
ST. JOHN'S UNIVERSITY

This Roman Catholic university was estab-

lished in Brooklyn in 1870. It moved here to the former site of the Hillcrest Golf Club in the 1950s. It is America's largest Catholic University, with an enrollment of more than 21,000. It has eleven colleges offering ninety graduate and undergraduate degrees, but it is best known for its basketball team, the Redmen, a power in the Big East Conference and a frequent contender in the annual NCAA Championships.

428
ST. GEORGE'S CHURCH

Francis Lewis, a signer of the Declaration of Independence, was a warden of this parish, established in the 1750s. This building replaced its original church, which had stood on the site for nearly a century.

429
WILDFLOWER

This neo-Tudor house was built by Broadway producer Arthur Hammerstein (who also built David Letterman's Ed Sullivan Theater), and named for one of his hit Broadway musicals. Originally part of a waterfront estate, it is now surrounded by condominium apartment buildings.

430
BENJAMIN P. ALLEN HOUSE

This former farmhouse overlooking Little Neck Bay was designed in the Greek Revival style, but it has some fine Italianate touches in its cornices and the brackets on the porches. This area, in the northeast corner of Queens near the Nassau County line, was once a thriving little port that produced some of the best clams and oysters for a city whose population never seemed to get its fill of them.

2 AND 3 PIERREPONT PLACE [431]

These are unquestionably the most elegant brownstone mansions anywhere in New York City. They were built for tea merchant A. A. Low (no. 3) and fur dealer Alexander M. White (no. 2). A third house, One Pierrepont Place, was torn down in 1946 to open an entrance to the Esplanade overlooking the river. It created a perfect way for strollers to study the impressive rear façades of the surviving pair.

24 MIDDAGH STREET [432]

This gem of a Federal-style house is one of the oldest in the neighborhood. It is often called the "Queen of Brooklyn Heights." Considering the competition on the surrounding streets, this is high praise indeed. But even people who have lavished boundless love on their own Brooklyn Heights homes don't dispute the title.

HOTEL BOSSERT [433]

This hotel, now a Jehovah's Witnesses dormitory, was an "in" spot for flappers and their dates during the Roaring Twenties. Its Marine Roof, created by stage set designer, Joseph Urban, featured fine dining, vigorous dancing, and Brooklyn's best view of the Manhattan skyline.

105 MONTAGUE STREET [434]

This Queen Anne confection is a bright spot in the eclectic mix that Montague Street has become over the years. Part of the old Hezekiah B. Pierrepont estate, it was named in honor of the English author, Lady Mary Wortley Montague, a member of the Pierrepont family. In the 1850s, the street led to the harbor and the Fulton Ferry.

PACKER COLLEGIATE INSTITUTE [435]

This Gothic castle houses a private elementary and secondary school that was founded in 1854 as the Brooklyn Female Academy. It became co-educational in 1972. The building and its chapel are impressive, but the real beauty here is in its prize-winning Alumnae Garden. In 1919, Packer's college division, since discontinued, became the first junior college to be approved by the State Board of Regents. The Annex around the corner on Clinton Street was originally St. Ann's Episcopal Church, designed by James Renwick, Jr.

164–168 ATLANTIC AVENUE [436]

These commercial loft buildings reflect the nineteenth-century idea that merchants could benefit by building attractive buildings that would impress their customers. The storefronts that were added here in the twentieth century are evidence of the death of such ideas.

GRACE CHURCH [437]

This church, and its parish house, added in 1931, form a wonderful little shaded cul-de-sac, still charming in spite of an apartment building that was shoved into Grace Court in the 1960s.

RIVERSIDE APARTMENTS [438]

This low-rent housing project, which originally contained nineteen stores and 280 two-

to four-room apartments, was built at the river's edge by local businessman Alfred T. White. Its western unit was demolished to make way for the Brooklyn-Queens Expressway in 1953. The destruction also took several rows of brownstones, prompting the Brooklyn Heights Association to lobby highway czar Robert Moses to cover the resulting eyesore with an Esplanade overlooking the East River.

439
129 JORALEMON STREET

This apartment house was originally the David Chauncy mansion. It is a fascinating combination of the Romanesque and Colonial Revival styles. A massive stone and yellow brick structure, it was intended to resemble a bungalow.

440
ST. PAUL'S CHURCH OF BROOKLYN

This high Victorian Gothic church is more interesting on the inside. The pulpit is set halfway down the nave, and there is a double row of pews directly in front of it to allow the clergy and acolytes to hear the sermons, which is difficult from the sanctuary. It is known as St. Paul's of Brooklyn to distinguish it from St. Paul's Flatbush. At the time the two parishes were formed, Flatbush was a separate town. It joined the City of Brooklyn in 1894.

441
WORKINGMEN'S COTTAGES

These thirty-four cottages were part of a development built by Alfred Tredway White as low-rent housing for working people. The eleven-and-a-half-foot houses line a charming little mews.

442
301–311 CLINTON STREET

This beautiful row of Italianate houses, and its neighbors on Kane Street and Tompkins Place, are part of a development created by a New York lawyer named Gerard W. Morris. They avoid the monotony of many row houses through their projecting entranceways and joined pediments. The original ironwork, with a trefoil design, is still intact on most of them.

443
TEMPLE BAR BUILDING

This a good example of why you should always look up when you are exploring the city. Its copper-clad cupolas are well worth an upward glace, but there are plenty of other interesting things going on up there. It's true of many buildings whose ground floors may not be worth a second look. This was Brookyn's tallest building at the beginning of the twentieth century.

444
POST OFFICE BUILDING AND COURT HOUSE

The original building here was designed in the Romanesque revival style by Mifflin Bell, the supervising architect of the U.S. Treasury Department. When he resigned as construction was just beginning, his replacement added bolder details. A new wing was added to house the U.S. Bankruptcy Court and U.S. Attorney's offices during the Depression era. Cadman Plaza, officially called the S. Parkes Cadman Plaza, was named for a Congregationalist minister who became well known as a radio preacher.

445
Dime Savings Bank

This big building was designed to call attention to itself, in hopes that depositors would be lured in. The impressive dome was part of an addition created in 1932. At that time, the interior was made even more spectacular with a rotunda supported by twelve red marble columns whose gilded capitals are studded with Mercury-head dimes. As its name implies, the bank concentrated on small depositors, but before it merged with the Anchor Savings Bank in the 1990s, it had assets of more than $8.3 million. That's a lot of dimes.

446
Brooklyn Borough Hall

Before Brooklyn reluctantly joined Greater New York in 1898, this was its City Hall. It was America's third-largest city at the time, after New York and Philadelphia. As if to show that there were no hard feelings after its absorption into New York, the impressive cast-iron cupola was added within months of its downgrading to Borough Hall. The upstairs room that had been the meeting place of the former city's Common Council was converted into a Beaux-Arts courtroom. After a long period of deterioration, the building was carefully restored in 1989.

447
New York & New Jersey Telephone Company Building

The iconography on the Beaux Arts façade of this building is a dazzling array of old-fashioned telephones, bells, and other reminders that this was the headquarters of the telephone company. It was an early incarnation of the company now called Verizon, which originally included six companies serving New York, New Jersey, and parts of Pennsylvania. The marriage ended in 1927 with the formation of New Jersey Bell.

448
City of Brooklyn Fire Headquarters

This building, now an apartment house, is a powerful masterpiece of the Romanesque revival style made popular by Henry H. Richardson. It is the work of Frank Freeman, among the best architects ever to put his stamp on Brooklyn. The granite, brick, and sandstone structure with a red tile roof has a massive archway built to accomodate the horse-drawn fire apparatus that was housed on the ground floor. The tall tower rising above it was a lookout post for spotting fires. Brooklyn's Fire Department, along with commands in Queens, was absorbed into the NYFD six years after this building was finished.

449
The Clock Tower

This was originally one of a group of buildings (it was designated number seven of twelve) all representing the earliest use of reinforced concrete construction. They were built by Robert Gair for his corrugated box business. It is now condominium apartments, serving as an anchor for the emerging artists' colony called DUMBO, an acronym for "Down Under the Manhattan Bridge Overpass." There are literally hundreds of clocks like this one all over the city—on buildings, on street corners, and in store windows—but chances are good that if you take a walk today, someone will still ask you, "What time is it?"

450
FIRE BOAT PIER

This nearly-forgotten structure, with a tower for drying firehoses, was briefly the Fulton Ferry Museum, recalling busier days here when the ferry pulled up to a long-gone French Second Empire-style terminal on this spot. Steam ferries started regular service here in 1824, and by the last quarter of the nineteenth century, they were making twelve hundred crossings a day. Demand dropped after the Brooklyn Bridge opened in 1883, and service was suspended in 1924. Other attractions on this little plaza, apart from the bridge, include a converted barge that presents chamber music concerts, and another that has been converted into a restaurant called the River Café.

451
EAGLE WAREHOUSE

This huge fortress-like former storage warehouse is on the site of the original building of the *Daily Eagle*, and the newspaper's old zinc eagle is displayed next to the entrance. The bronze lettering on its arched entry is unique in modern New York. The building is now divided into condominium loft apartments.

452
WATCHTOWER BUILDING

This massive building was the headquarters and manufacturing facility of E. R. Squibb and Co., a leading pharmaceutical firm founded in Brooklyn in 1858. After the drug company moved to New Jersey in 1938, the building was acquired by the Watchtower Bible and Tract Society of Jehovah's Witnesses. Its semimonthly publication, *The Watchtower*, averages 20 million copies per issue and is published in 125 languages.

453
BROOKLYN ACADEMY OF MUSIC

This performing arts center includes three major spaces: the Opera House; the Playhouse (the former Music Hall); and Leperq Space (the former ballroom). It has a monumental 5,000-square-foot lobby. In 1981, the complex added several other performing venues nearby. Its resident orchestra is the Brooklyn Philharmonic. The institution, which calls itself BAM, concentrates on new and unusual productions in music, dance, and theater, and is perhaps best-known for its annual avant-garde Next Wave Festival.

454
179–186 WASHINGTON PARK

This was the most desirable street in fashionable Fort Greene in the 1870s and '80s. The lure was the thirty-acre Washington Park, designed by Frederick Law Olmsted and Calvert Vaux. It featured cobblestoned walks theading under large chestnut trees. It was later renamed Fort Greene Park when the Prison Ship Martyr's Monument was dedicated in 1908. Designed by Stanford White, the 148-foot granite shaft honors the patriot prisoners of war held in British ships here during the Revolutionary War. Of an estimated 12,500 men who were held here, only 1,400 lived to tell about it.

455
ST. JOSEPH'S COLLEGE

The entire block of Clinton Avenue between DeKalb and Willoughby Avenues is the most beautiful in Clinton Hill, thanks to four mansions built by members of the Pratt family, but this freestanding mansion is the grandest

of all. It was the manor house of Charles Pratt, who made his fortune with an oil refinery in nearby Fort Greene. It had a daily output of more than 1,500 barrels of kerosene, which Pratt called "Astral Oil," fueling the lamps of America. He sold the company to John D. Rockefeller in 1874, and became an executive of Rockefeller's Standard Oil Company.

PUBLIC BATH NO. 7

456

New York's first public bath house, a commercial enterprise called the "People's Bathing and Washing Establishment," opened on Mott Street in 1849. State law forced the city to open more of them after 1901. Although the architecture of most of them followed Roman precedents, this one broke the mold with white terra-cotta ornamentation evoking the sea.

RESIDENCE, BISHOP OF BROOKLYN

457

This mansion was built for Charles Millard Pratt. The semi-circular conservatory on the south side features a spectacular bronze lamp, which undoubtedly burned the elder Pratt's "Astral Oil." It is now used as the residence of Rt. Rev. Thomas Daily, Bishop of the Catholic Diocese of Brooklyn, whose jurisdiction extends into Queens.

BROOKLYN MASONIC TEMPLE

458

Thie elegant temple, with its imposing columns and colorful terra-cotta detail, reflected the grandeur of the entire Fort Greene neighborhood at the beginning of the twentieth century. Its architecture was inspired by ancient Greek temples, and the polychromed detail is a careful evocation of their painted façades.

VACHTE-CORTELYOU HOUSE

459

Long known as "the Old Stone House at Gowanus," this Dutch farmhouse was reconstructed, using its original stones, in 1935, as part of the James J. Byrne Memorial Playground. During the Revolutionary War Battle of Long Island, a small garrison held off the British from the shelter of this house, allowing General Washington to evacuate his army to the safety of Manhattan.

PRATT ROW

460

This is part of three rows of twenty-seven houses, extending to Steuben Street and Emerson Place. Among many built by the Pratt family in Clinton Hill, they were intended for "people of taste and refinement, but of moderate means." They are used as Pratt Institute's faculty housing.

PRATT INSTITUTE

461

Like Cooper Union in Manhattan, this liberal arts college established by Charles Pratt was originally intended to provide training for practical vocations. It now grants degrees in such areas as art, design, and architecture.

ALHAMBRA APARTMENTS

462

This was the first of three major apartment houses built here in Bedford-Stuyvesant by

developer Louis F. Seitz for affluent tenants. After a long abandonment, it was restored in 1998, to satisfy the need for solid housing in the neighborhood.

463 INDEPENDENT UNITED ORDER OF MECHANICS

This was originally the Lincoln Club, formed in 1878 to promote the interests of the Republican Party. Politics soon gave way to old-fashioned socializing, which is still the main purpose of the Order of Mechanics, which moved here in the 1940s after the Lincoln Club disbanded.

464 1281 PRESIDENT STREET

The southern section of Crown Heights was developed after 1900, and this imposing double house is a good example of the kind of housing that was built on what had previously been farmland.

465 TWENTIETH PRECINCT, NYPD

This police station and its stable, which became the 83rd Precinct before becoming the Brooklyn North Task Force, is a fanciful representation of a medieval fortress with battlements on the roof and a corner tower. It was restored by Ehrenkrantz & Eckstut in 1966, for the use of the Police Department.

466 RUSSIAN ORTHODOX CATHEDRAL OF THE TRANSFIGURATION OF OUR LORD

The five copper onion-domed cupolas here make an important statement in the lives of Eastern European immigrants who settled here in Williamsburg. The church is a tiny building but a powerful one. Inside, the altars are separated from the nave by an impressive hand-carved wooden screen with icons painted by monks in a Kiev monastery.

467 GREENPOINT SAVINGS BANK

This bank was founded here in Brooklyn's Greenpoint section in 1869. Today it is one of the largest savings institutions in the city, with more than twenty branches. In the nineteenth century, Greenpoint was an important industrial center, including shipbuilding and iron-making, which helped to give the bank a head start.

468 WILLIAMSBURGH SAVINGS BANK

This was the third home of the bank, remaining here until it moved into its grand tower in downtown Brooklyn in 1929. The interior of this building is an unusual example of early post-Civil War design, including beautiful, colorful, stenciled decoration in the cast-iron dome. The entire building was restored in the 1990s by Platt & Byard.

469 19TH PRECINCT STATION HOUSE

Although still a facility of the New York City Police Department, this building, which originally included a stable, is no longer a station house. It first served the Police Department of the City of Brooklyn, and set the standard for the layouts of all of its police stations.

470

GRANT SQUARE SENIOR CENTER

The American Eagle supporting the bay window and the images of Lincoln and Grant in the spandrels between its brownstone arches provide clues to this Richardson Romanesque building's original use. Now a gathering place for senior citizens, it was once the Union League Club of Brooklyn, an organization founded by members of the Republican Party in this Brownsville neighborhood. There is an equestrian statue of General Grant in the small park across the street. It was placed there six years after his admirers moved into their clubhouse.

471

HOLY TRINITY CHURCH OF UKRANIAN AUTOCAPHALIC ORTHODOX CHURCH IN EXILE

There are dozens of examples of New York churches that have become apartments, retail spaces, and even nightclubs. Hundreds were built for one denomination and converted to another. But this particular parish didn't buy an existing church. Their house of worship was originally a bank, the headquarters of the Williamsburg Trust Company. Its impressive terra-cotta façade and imposing dome provide just the right note of dignity for a church. The Ukrainian Autocephalous Orthodox Church was established in New York by immigrants from Ukraine in the 1920s. The name identifies them as independent of the main body of the church, with their own bishops, although in communion with it.

472

WILLIAMSBURGH SAVINGS BANK BUILDING 🏦

At 512 feet, this is Brooklyn's tallest office building. The decoration on its base includes such icons of thrift as bees and squirrels, and even a couple of pelicans. The interior, which its landmark citation identifies as a "cathedral of thrift," is decorated with twenty-two different kinds of marble on the walls, floors, columns, and trim. The mosaic ceiling is designed around the signs of the zodiac, and another mosaic masterpiece is an aerial view of Brooklyn. The bank, which takes its name from Brooklyn's Williamsburg section, retained the original spelling after the neighborhood dropped the last letter in 1855, when it joined the City of Brooklyn.

473

THE MONTAUK CLUB

This is a reminder of Venice in Park Slope, except in this case the Venetian palazzo is decorated with representations of the lives of American Indians and the plants and animals that were part of their world. This men's club was named for the Montauks, a Native American people that once dominated Long Island. Still one of New York's most prestigious clubs, its most famous member in the late nineteenth century was lawyer Chauncey Depew, a president of the New York Central Railroad who went on to become a U.S. Senator.

474

CONGREGATION BETH ELOHIM

This five-sided Beaux Arts Temple, whose name means "House of God," was said to

have been designed as a representation of the five books of Moses. The large dome over the entrance, which is set into a chambered corner of the building, is outstanding. It is supported by a beautiful pair of composite columns. Park Slope, the neighborhood it serves, was almost completely built in less than thirty years, beginning in the late 1880s, after the Brooklyn Bridge went into use and the area was connected to it by streetcar lines.

475
SOLDIERS' AND SAILORS' MEMORIAL ARCH

This memorial to the Civil War dead was created by the same architect as Grant's Tomb on Manhattan's Riverside Drive. Topping the eighty-foot structure is a marvelous bronze, *Triumphal Quadriga* by sculptor Frederick MacMonnies, depicting a female figure carrying a banner and a sword, flanked by two winged Victory figures. On the south side are military groupings, also by MacMonnies, representing the Army and the Navy.

476
LEFFERTS HOMESTEAD

This Dutch Colonial farmhouse was built by Peter Lefferts to replace the home burned by American troops during the Revolutionary War Battle of Long Island. It was moved into Prospect Park from its original location in 1918, and is now used as museum offering children's educational programs.

477
BROOKLYN PUBLIC LIBRARY

Although construction on this building was begun in 1912, because funding was slow

in coming, it wasn't completed for almost thirty years. The original library, opened in Bedford, in 1897, had two separate reading rooms, one for men and one for women. This Main Branch has large collections of sheet music, films, videocassettes, records, and compact discs, as well as books available in sixty-four languages.

478
BROOKLYN BOTANIC GARDEN GREENHOUSES

These sixteen glass structures are built over a series of below-ground gardens whose climatic zones range from a humid tropical jungle to a scorching dry desert. They also house the largest collection of bonsai trees in the western hemisphere. Outside, the greenhouses overlook a plaza with pools covered by water lillies, and, on the hillside beyond, a large grove of flowering magnolia trees. The Botanic Garden, which covers fifty acres, was established in 1910 with a donation from philanthropist Alfred Tredway White and matching funds from the city. The site was a wasteland then, but the soil had been enriched with the "byproducts" of breweries and stables of an earlier generation. The plant collections here include more than 13,000 species in specialized gardens of related types. New York's largest such institution is the Botanical Garden in the Bronx, and there are also smaller versions in Queens and on Staten Island.

479
MONTESSORI SCHOOL

This bow-fronted mansion was designed by Frank J. Helme, who also designed the

Boathouse on Prospect Park's Lullwater, as well as many banks. The school that occupies it today follows a system of motivating youngsters to educate themselves, developed in 1910 by the Italian educator, Maria Montessori.

480
944–946 PRESIDENT STREET

This elegant pair of mansions, featuring beautiful stained glass and terra-cotta as well as perfect wrought-iron work, are early examples of the glories of Park Slope. Their round-arch doorways and windows are the signature of the Romanesque style, which became the dominant statement in American architecture in the 1880s and 1890s. It died as suddenly as it emerged in New York, when homeowners became bored with its massive scale, which didn't adapt well to the demands of the standard rowhouse pattern. This was especially true in Manhattan, which limited rowhouse façades to twenty-five feet each.

481
182 SIXTH AVENUE

Many of the middle-class brownstone houses along Sixth Avenue have been altered over the years, and in this case the alteration included the addition of retail space. These late nineteenth-century rowhouses were built in the Italianate style with unusually high stoops that served to distance the parlor floor from the bustle of the busy street below. It made the added storefronts seem as though they had been part of the original design. The busy street, of course, also assured that the stores would thrive.

In this particular case, the high basement allowed for a two-story extension without encroaching on the house itself.

482
LILLIAN WARD HOUSE

This was the first house in the impressive row of four Romanesque Revival houses between the Grace United Methodist Church and Sterling Place. As is usually the case with corner houses establishing a row, it is more elegant than its neighbors, although each of them has a wonderful personality. It was originally owned by opera singer Lillian Ward.

483
ALBEMARLE TERRACE

This little dead-end street is lined on both sides with Georgian Revival homes that have Palladian windows interspersed with bay windows. They also have slate mansard roofs, often pierced with charming dormers. Of course, the best feature of Albemarle Terrace is that there is never a problem with traffic.

484
EAST 16TH STREET

This row was part of a suburban development called the Arts and Crafts Bungalows, and its name was aptly chosen. It is part of the Ditmas Park neighborhood, developed in the early part of the twentieth century into an enclave of 175 large frame houses on tree-lined streets. Even before these houses were built, a local neighborhood association, one of the city's first, had drawn up its own rules for zoning intended to preserve the character of the area.

485
FLATBUSH REFORMED DUTCH CHURCH

This church was established through an edict set forth by Peter Stuyvesant, in his continuing effort to turn the colonists of Nieuw Amsterdam away from what he considered their wicked ways. This building, the third on the site, continues the tradition in what is the oldest continuous church location in the city. Its seventeenth-century churchyard contains the graves of pioneering Brooklynites with names like Lefferts, Cortelyou, and Lott. The parsonage, built in 1853, is at the edge of a small Historic District that includes a row of charming cottages.

486
ERASMUS HALL MUSEUM

This building, in the courtyard of Erasmus Hall High School, originally housed the Erasmus Academy, a private school for boys. It was the first secondary school chartered in New York State. The high school complex that surrounds it, designed by C. B. J. Snyder in 1903, is a public high school, the most prominent in the Flatbush section, and among the best-known schools in all of Brooklyn.

487
CYCLONE

Although just about every theme park in the country touts its roller coaster as the best, people in the know say that this is the one to beat, and that nobody has succeeded. A chain drive hauls the three-car train to the highest point on the wooden structure, and then gravity takes over as it plunges through nine gut-wrenching drops and around six sharp curves at a speed of sixty-eight miles an hour.

488
F.W.I. LUNDY BROTHERS RESTAURANT

Now reopened after having been closed for nearly twenty years, this Sheepshead Bay landmark hasn't lost a bit of its original boisterousness and would-be patrons still hover over diners hoping to claim their seats. One of the best seafood restaurants anywhere in the city, Lundy's served more than 15,000 people a day at the height of its popularity during the 1950s. It was founded in 1920 by Frederick William Irving Lundy and his brothers, taking advantage of the abundance of fish and clams from Sheepshead Bay across the street. Before it closed in 1979 because of its owner's failing health, it employed 220 waiters who never seemed to stop running. Until it finally reopened, millions of Brooklynites and Long Islanders were in deep mourning for their favorite Sunday pastime.

GARIBALDI-MEUCCI MEMORIAL MUSEUM

489

The Italian patriot Guiseppe Garibaldi came here to the home of his friend, inventor Antonio Meucci, after fighting unsuccessfully for Italy's independence in 1849. Meucci, who is buried here, claimed to have invented the telephone in 1841, thirty-five years before Alexander Graham Bell took credit for the same thing. Meuccci's wife had thrown away all the evidence, and he could never prove his accomplishment in court.

WAGNER COLLEGE

490

This liberal arts college was founded in Rochester, NY, as the Lutheran Pro-Seminary. In 1918, it moved here to the eighty-six-acre former Cunard estate, formerly owned by a branch of the steamship family, and was renamed in honor of George Wagner, an important donor. The school kept its Lutheran affiliation until the early 1990s. The site is at the top of Grymes Hill, 370 feet above sea level. It is to the north of a valley, called the Clove, which became the right-of-way of the Staten Island Expressway.

53 HARRISON STREET

491

This huge mansion, dominating the entire block, was built as the home of a very important person: the brewmaster of Rubsam & Hohrmann's Atlantic Brewery. The last survivor of a dozen extremely successful Staten Island breweries, it was sold to Piel Brothers in 1954 and, when Piel's itself was sold in 1963, the old brewery closed its doors and a tradition died.

110–144 VANDERBILT AVENUE

492

This is one of a row of eight Tudor houses commissioned by George W. Vanderbilt as a speculative venture. The youngest son of William H. Vanderbilt and grandson of Cornelius Vanderbilt, George was born at the family home in New Dorp, and showed no interest in the family's Manhattan social life. He eventually moved to Asheville, N.C., where he built the famous "Biltmore Estate," designed by Richard Morris Hunt.

PARAMOUNT THEATER

493

No, this isn't Times Square, it's Stapleton, but the Paramount Theater here was designed by the same architects. Like their other masterpieces, this Art Deco building is no longer a movie palace. For several years, the Staten Island Paramount was turned into a nightclub that retained all of its original 1930s glories. But that is history, too, and now the building stands empty, waiting for someone with a vivid imagination to walk past.

FREDERICK I. RODEWALD HOUSE

494

This monumental Shingle-style house has porches on three levels at the rear. They not only capture the breezes off the bay but provide a great view of the harbor and the Manhattan skyline.

PRITCHARD HOUSE

495

This Italianate stucco house was one of the original mansions in Hamilton Park, one of the earliest limited-access suburban developments in the United States. Today, they are called "gated communities."

496
W. S. PENDLETON HOUSE

William Pendleton built several houses in this part of New Brighton and included this one for himself. He had a special interest in the development of Staten Island, as he was the owner of one of the ferry companies.

497
AMBASSADOR APARTMENTS

The doorway on this Art Deco gem is worth a trip to Staten Island all by itself. This neighborhood was originally the estate of businessman Daniel Low. Nearby Fort Hill was the site of earthwork fortifications built by the British during the Revolutionary War.

498
STATEN ISLAND LIGHTHOUSE

Surrounded by homes, this structure doesn't fit the mold of seaside lighthouses, but, unlike many of them, it is still operational. Its 350,000 candle-power beacon shines out from this perch, 231 feet above the sea, serving as a coordinate for the Ambrose Light Station at the entrance to New York Harbor. Like all the other lighthouses maintained by the Coast Guard, this one is automated, and there is no lighthouse keeper living at its base.

499
THE CONFERENCE HOUSE

The builder of this house was British naval officer Christopher Billop. After defeating the Americans in the 1776 Battle of Long Island, Admiral Lord Howe invited a delegation that included Benjamin Franklin and John Adams to meet him here for a peace conference. When they informed him that they had no intention of giving up their quest for independence, his lordhsip responded, "I am sorry, gentlemen, that you have had the trouble of coming so far for so little purpose."

500
CHURCH OF ST. JOACHIM AND ST. ANNE

This grand Gothic Revival church on the grounds of the Mount Loretto Home for Children was nearly destroyed by a disastrous fire in 1973. It was rebuilt as a simple A-frame structure with the original façade restored in front of it, creating an unusual mix of styles that works very well. A year before the fire the church was immortalized when it was used as the location for the opening wedding sequence in Francis Ford Coppola's 1972 film, *The Godfather*.

Index

INDEX